GOLF

The Ultimate Book

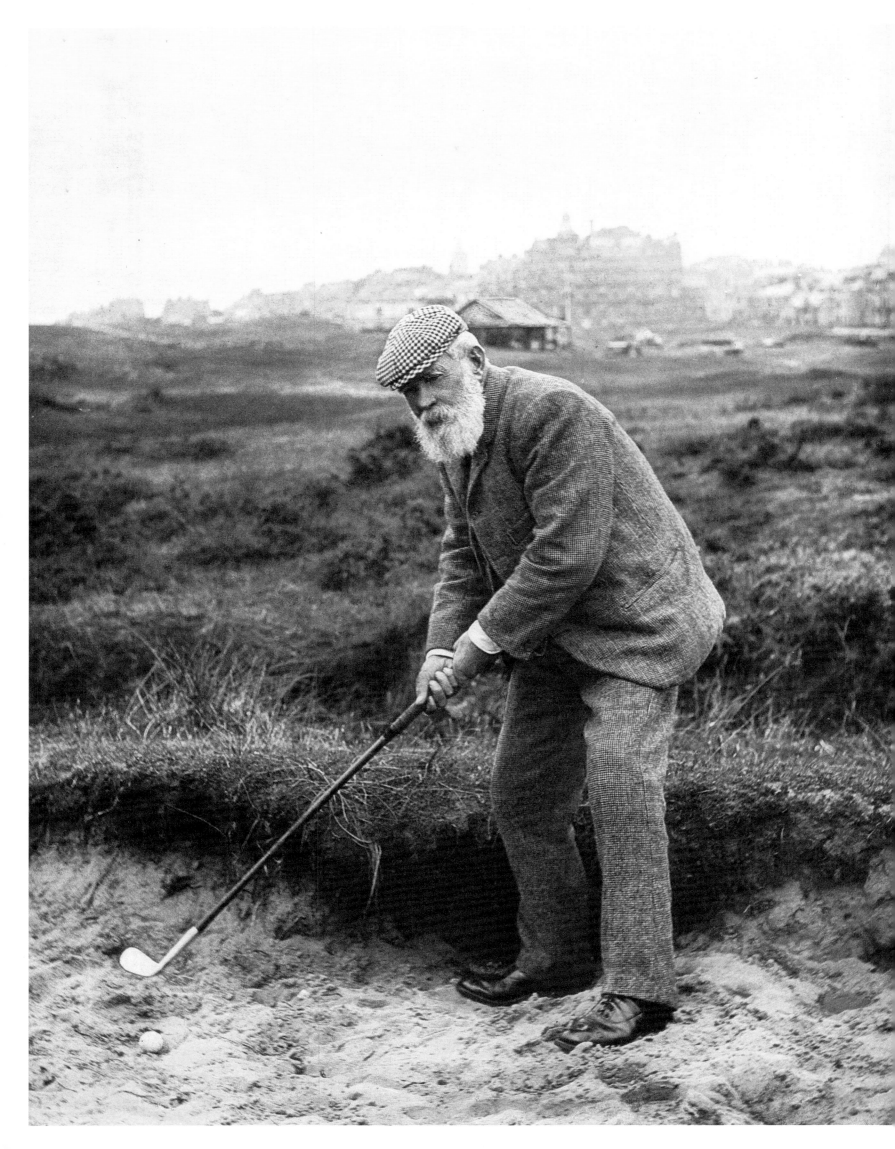

STEFAN MAIWALD · PETER FEIERABEND

GOLF
The Ultimate Book

teNeues

CONTENTS
INHALT

Maps of Resorts
Karte Resorts 6

Introduction
Vorwort 8

The Ball at the Center of it All
Der Ball, um den sich alles dreht 10

From Hazelnut to Titanium
Von der Haselnuss bis zum Titan 14

ST ANDREWS (Scotland / Schottland) **18**

The Open Championship 26

Young Tom Morris 30

KAWANA HOTEL GOLF COURSE (Japan) **32**

GLENEAGLES (Scotland / Schottland) **38**

AUGUSTA NATIONAL (USA) **44**

The Big Six 48

The Claret Jug 64

FINCA CORTESIN (Spain / Spanien) **66**

KIAWAH ISLAND (USA) **70**

Bear, Tiger, Hawk
Bär, Tiger, Falke 74

RESORT CASTELFALFI (Italy / Italien) **80**

ROYAL ST GEORGE'S (England) **84**

Fashion on the Green Runway
Mode auf den grünen Laufstegen 90

DOONBEG (Ireland / Irland) **96**

BAD GRIESBACH (Germany / Deutschland) **102**

THE GREENBRIER (USA) **108**

Clubhouses
Clubhäuser 114

GOLF CLUB LEUK (Switzerland / Schweiz) **120**

SANDY LANE (Barbados) **124**

John D. Rockefeller 128

Joe Louis 130

TERRE BLANCHE (France / Frankreich) **132**

CABOT CLIFFS (Canada / Kanada) **138**

THE COEUR D'ALENE RESORT (USA) **142**

How Golf Made it Big in the USA
Wie Golf in den USA groß wurde 146

CIRCOLO GOLF VENEZIA (Italy / Italien) **148**

PGA DE CATALUNYA (Spain / Spanien) **152**

LEGEND GOLF & SAFARI RESORT
(South Africa / Südafrika) **156**

Caddie 162

CAPE KIDNAPPERS (New Zealand / Neuseeland) **166**

WINSTON GOLF (Germany / Deutschland) **170**

The Millionaire Gurus
Die Millionen-Gurus 176

VALDERRAMA (Spain / Spanien) **178**

PEBBLE BEACH (USA) **182**

Presidential Swings
Präsidiale Abschläge 186

FONTANA (Austria / Österreich) **192**

TURNBERRY (Scotland / Schottland) **196**

The Best Duel—Ever
Das beste Duell der Golfgeschichte 202

The War Hero
Der Kriegsheld 203

The Most Notorious Hustler of All Times
Der größte Zocker aller Zeiten 204

Golfing During Wartime
Golfen im Krieg 205

GUT LÄRCHENHOF (Germany / Deutschland) **206**

Second Wind
Die zweite Luft 210

HERITAGE LE TELFAIR (Mauritius) **212**

BAD RAGAZ (Switzerland / Schweiz) **216**

Page 2: Though Old Tom Morris didn't invent golf he is recognized as one of the sport's founding fathers; he won the Open Championship four times

Seite 2: Old Tom Morris hat das Golfspiel nicht erfunden, gilt aber als einer der Gründungsväter des Sports. Er gewann die Open Championship viermal.

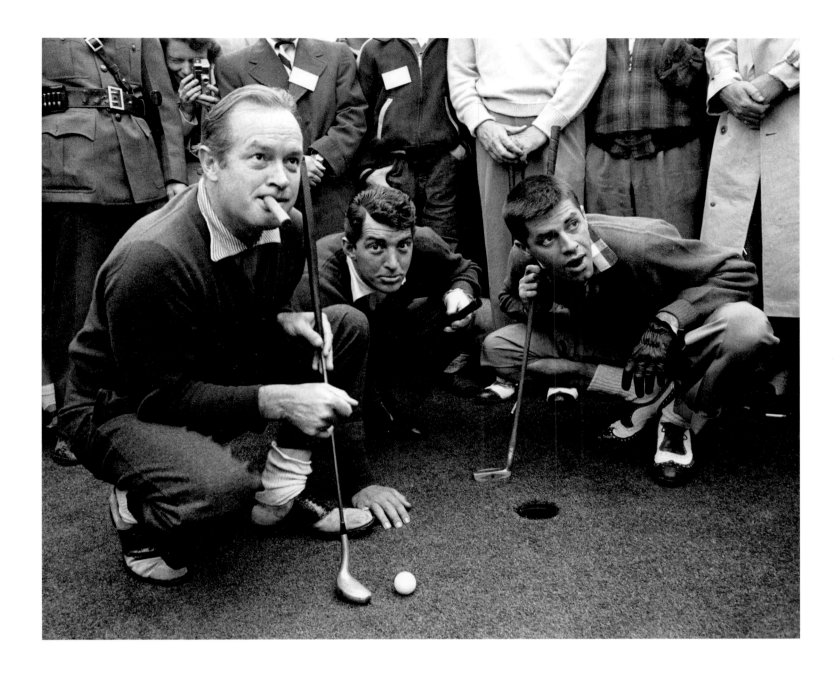

Golf in Space
Golf im Weltraum 220

Phantom of the Open
Das Phantom der Open 221

GC RADSTADT (Austria / Österreich) **222**

FURNACE CREEK (USA) **226**

The Most Extreme Golf Courses
Die extremsten Plätze 230

SUN CITY (South Africa / Südafrika) **236**

EASTERN AUSTRALIAN (Australia / Australien) **240**

KO'OLAU HAWAII (USA) **246**

A Nice Smile for a Luxury Watch
Lächeln für die Luxusuhr 250

Acknowledgments
Danksagung 254

Copyrights
Bildnachweise 255

Imprint
Impressum 256

Clowns and heroes: Bob Hope, Dean Martin, and Jerry Lewis at the National Golf Day, Illinois, 1953

Clowns und Helden: Bob Hope, Dean Martin und Jerry Lewis beim National Golf Day, Illinois, 1953

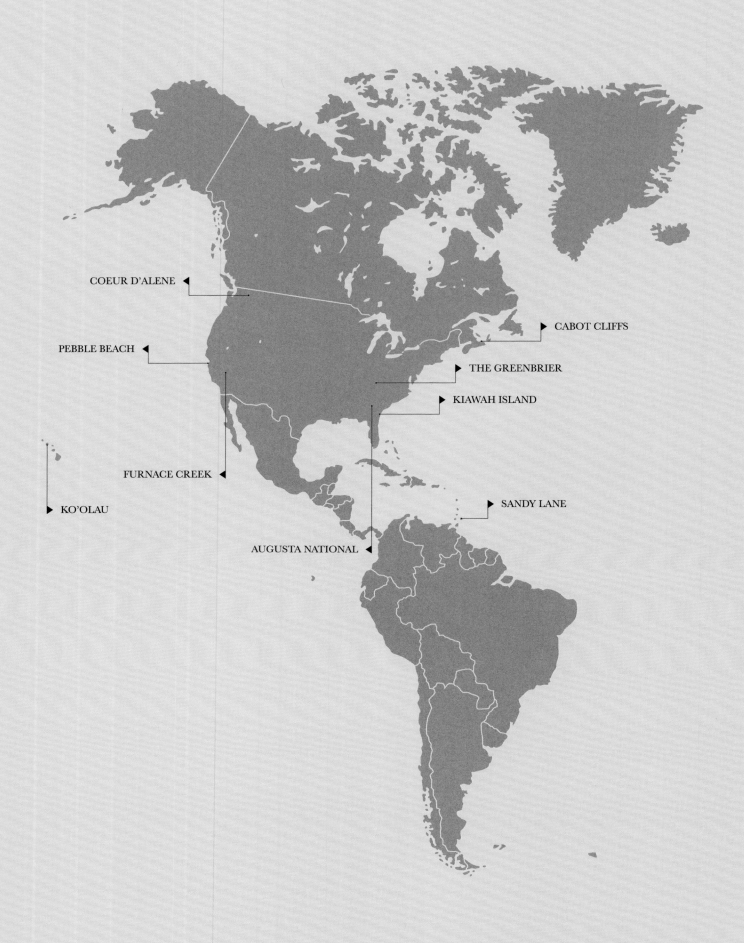

COEUR D'ALENE ◄

CABOT CLIFFS ►

PEBBLE BEACH ◄

THE GREENBRIER ►

KIAWAH ISLAND ►

FURNACE CREEK ◄

KO'OLAU ►

SANDY LANE ►

AUGUSTA NATIONAL ►

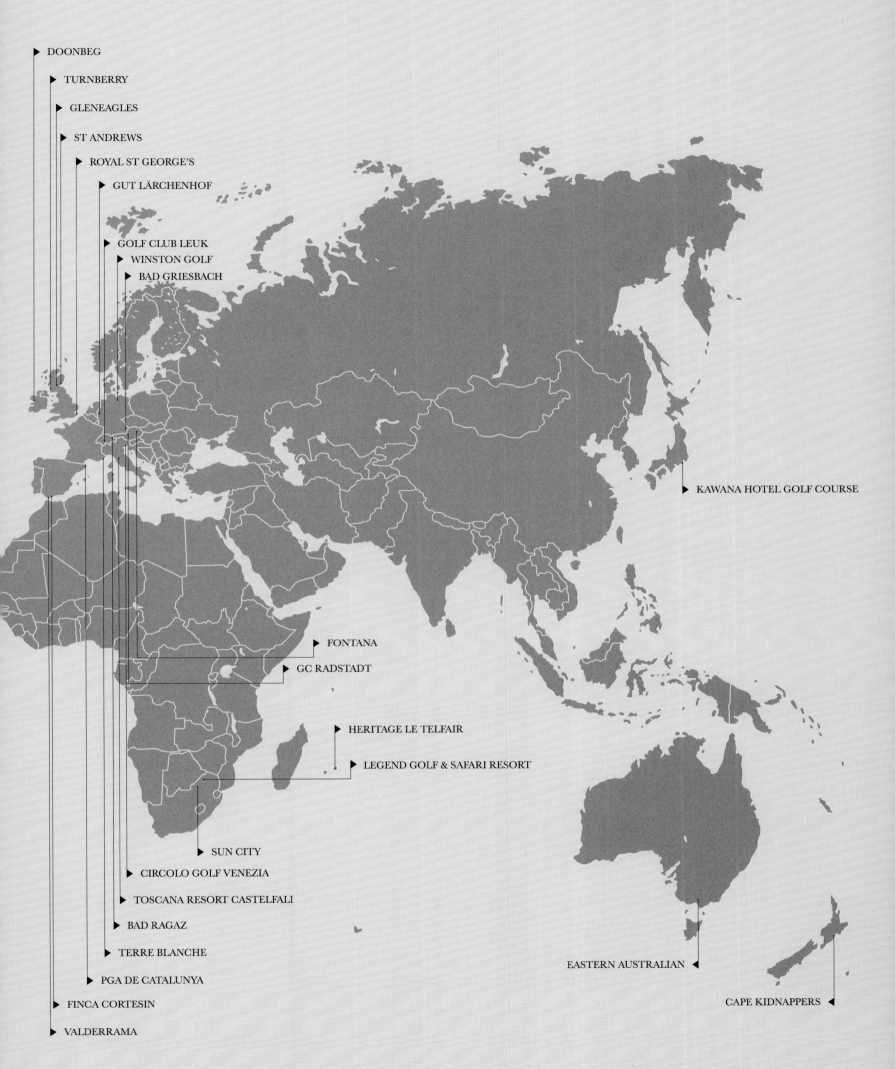

DOONBEG

TURNBERRY

GLENEAGLES

ST ANDREWS

ROYAL ST GEORGE'S

GUT LÄRCHENHOF

GOLF CLUB LEUK

WINSTON GOLF

BAD GRIESBACH

KAWANA HOTEL GOLF COURSE

FONTANA

GC RADSTADT

HERITAGE LE TELFAIR

LEGEND GOLF & SAFARI RESORT

SUN CITY

CIRCOLO GOLF VENEZIA

TOSCANA RESORT CASTELFALI

BAD RAGAZ

TERRE BLANCHE

PGA DE CATALUNYA

FINCA CORTESIN

VALDERRAMA

EASTERN AUSTRALIAN

CAPE KIDNAPPERS

THE WORLD IS ROUND!
DIE WELT IST RUND!

We have set ourselves an ambitious goal: over the next few pages we wish to share with you the lush, colorful, and global sport that is our passion.

This book won't just accompany you around the golf course: It will take you on safari in South Africa and helicopter you to your tee. You'll hear the waves of the Pacific crashing onto the beach in New Zealand, and in Canada you'll feel refreshing sea spray from the North Atlantic on your skin. You'll experience the oppressive heat of the world's low-lying courses and the cool winds of links in Great Britain and Ireland. You'll be awed by the rainforest's rich wildlife or find yourself passing a Venetian market square en route to your tee. You will play on courses frequented by legends such as Jack Nicklaus, Greg Norman, and Gary Player.

Furthermore, you'll encounter exciting stories from the fairways and beyond—stories about stars, hustlers, clubmakers, astronauts, gangsters, boxers, and billionaires.

The world of golf is far more exhilarating, varied, and dramatic than people might think—it exceeds its reputation by a long shot. We would like to introduce you to the many fascinating courses, personalities, and stories that make this sport such a beautiful game.

Wir haben uns viel vorgenommen: Wir wollen Ihnen auf den folgenden Seiten zeigen, wie üppig, bunt und weltumspannend unser Lieblingssport ist.

Während Sie dieses Buch genießen, gehen Sie nicht nur auf eine Runde Golf, sondern auch in Südafrika auf Safari – oder Sie fliegen gleich mit dem Hubschrauber zum Abschlag. Sie hören in Neuseeland die Brandung der Pazifikwellen und spüren in Kanada die erfrischende Gischt des Nordatlantiks auf der Haut. Sie erleben die drückende Hitze auf dem tiefstgelegenen Platz der Welt oder den kühlenden Wind auf den Links-Courses in Großbritannien und Irland. Sie bewundern die Artenvielfalt eines tropischen Regenwalds oder fahren auf dem Weg zum Abschlag an Venedigs Markusplatz vorbei. Sie spielen auf Plätzen, die von Legenden wie Jack Nicklaus, Greg Norman oder Gary Player entworfen wurden.

Dazu kommen spannende Geschichten von dies- und jenseits der Grüns und Fairways – von Stars und Schummlern, von Schlägerbauern und Raumfahrern, von Gangstern, Boxern und Milliardären.

Die Golfwelt ist viel spannender, facettenreicher und dramatischer als viele ahnen. Wir präsentieren Ihnen die faszinierendsten Plätze, Personen und Geschichten. Schönes Spiel!

Cape Kidnappers (page/Seite 196)

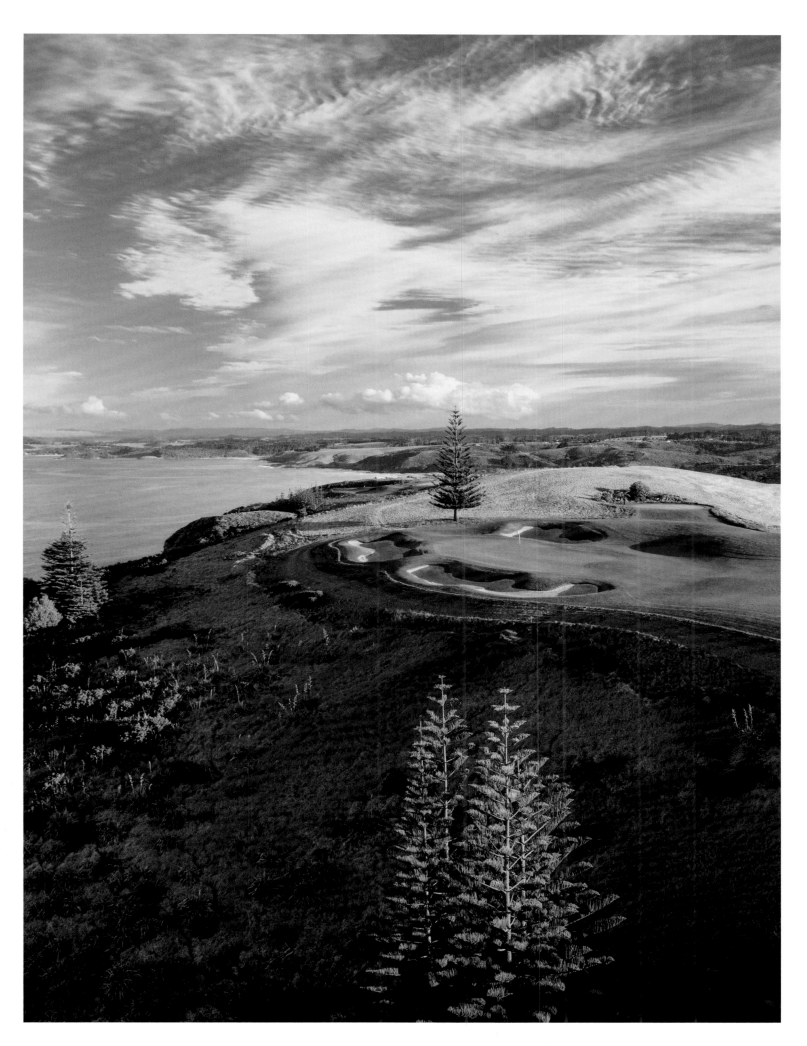

THE BALL AT THE CENTER OF IT ALL

Historians believe golf was originally played with wooden spheres, which would at best reach a driving distance of a 100 yards. By the mid-sixteenth century, thanks to shoemakers and leather specialists, the first leather-clad balls were being crafted. Their stuffing of tightly-packed chicken and goose feathers gave the ball its name: the feathery. Ball making was an arduous process. First a hatful of feathers was boiled down and then stuffed into a leather pouch, which was then stitched together. Craftsmen could only make a handful of balls a day, which drove the prices up, and small imperfections were normal. Nonetheless there is evidence that balls thus crafted could reach 200 yards. In 1836, a certain Samuel Messieux set a record at St Andrews when he shot his feathery an unbelievable 361 yards—however, the ground was frozen and he did have tailwind. In the mid-nineteenth century, the "gutty" or gutta-percha golf ball, made from the rubber-like sap of Malaysian Sapotaceae, was introduced. At the beginning of the twentieth century, gutta-percha was replaced by balatá latex. Since the 1960s, the artificial resin Surlyn has been used.

Featheries still have their value today: recently a 170-year-old Scottish feathery fetched a handsome sum of $11.500 at auction.

An original feathery, 1830
Ein original Feathery-Golfball von 1830

DER BALL, UM DEN SICH ALLES DREHT

Forscher vermuten, dass Golf in der Frühzeit mit Holzbällen gespielt wurde, mit denen man im günstigsten Fall gerade mal die 100-Meter-Marke knacken konnte. Schuhmachern und Lederspezialisten ist es zu verdanken, dass Mitte des 16. Jahrhunderts erstmals Bälle hergestellt wurden, die eine Lederhülle hatten. Das Innenleben bestand aus stark zusammengepressten Hühner- oder Gänsefedern, die dem Ball seinen Namen gaben: Feathery. Die Ballherstellung war extrem mühsam: Die Federn – so viele, wie in einen Hut passten – wurden eingekocht und in die Ledertasche gepresst, die dann vernäht wurde. Die Handwerker schafften nur wenige Bälle pro Tag, was die Ware teuer machte, und kleinere Unwuchten waren normal. Doch es gibt Belege, dass derart konstruierte Bälle knapp 200 Meter weit flogen. Den Rekord stellte wohl 1836 ein gewisser Samuel Messieux in St. Andrews auf. Er drosch einen Feathery unvorstellbare 340 Meter weit – allerdings auf gefrorenem Boden und bei starkem Rückenwind. Mitte des 19. Jahrhunderts kamen Bälle aus Guttapercha auf, ein kautschukähnlicher Stoff, der aus malaiischen Sapoten-Bäumen gewonnen wurde. Anfang des 20. Jahrhunderts ersetzte das günstigere Balata den Guttapercha, und etwa seit den 1960er-Jahren können Ballhersteller auf künstlich hergestelltes Surlyn zurückgreifen.

Featherys haben noch heute ihren Preis: Ein 170 Jahre alter schottischer Feathery-Ball erzielte kürzlich auf einer Auktion immerhin einen Preis von 11 500 Dollar.

Regular golf ball on a tee
Golfball auf einem Tee

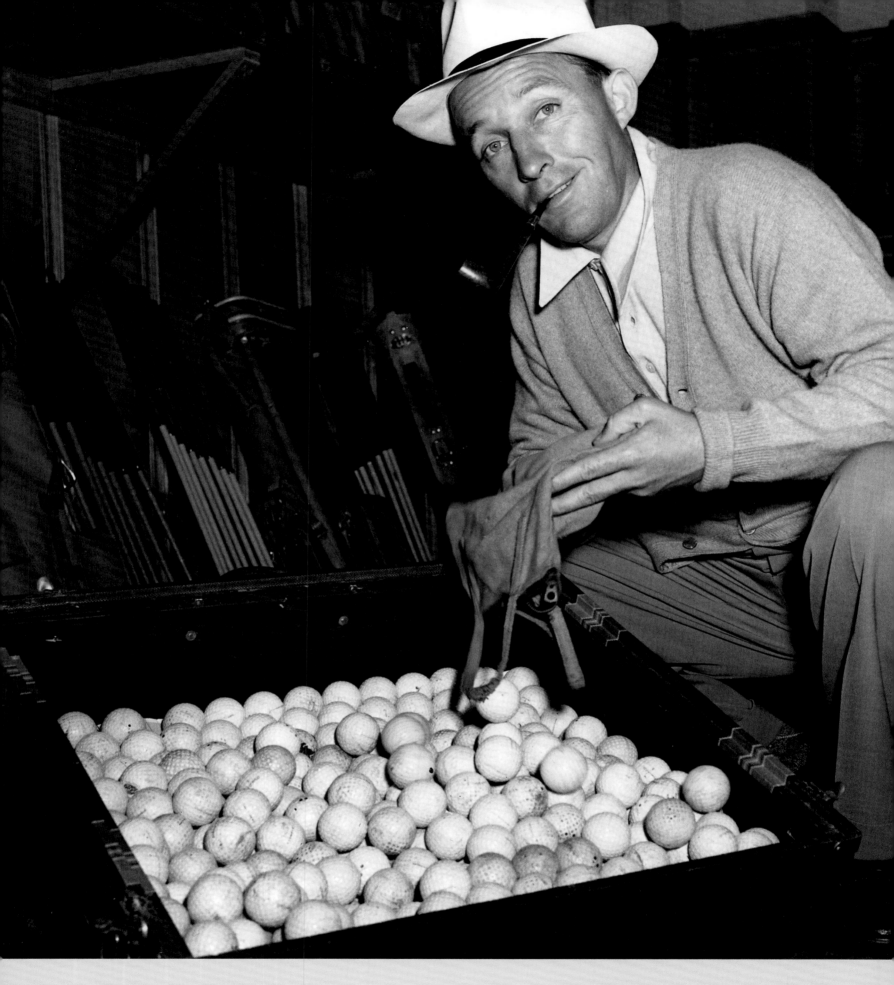

Bing Crosby squats in front of a box of golf balls, 1942

Bing Crosby hockt vor einer Kiste mit Golfbällen, 1942.

Actor Will Smith as Bagger Vance and Matt Damon as Rannulph Junuh eye up the ball in Robert Redford's *The Legend of Bagger Vance*

Die Schauspieler Will Smith als Bagger Vance und Matt Damon als Rannulph Junuh mustern den Golfball in Robert Redfords Film *Die Legende von Bagger Vance*.

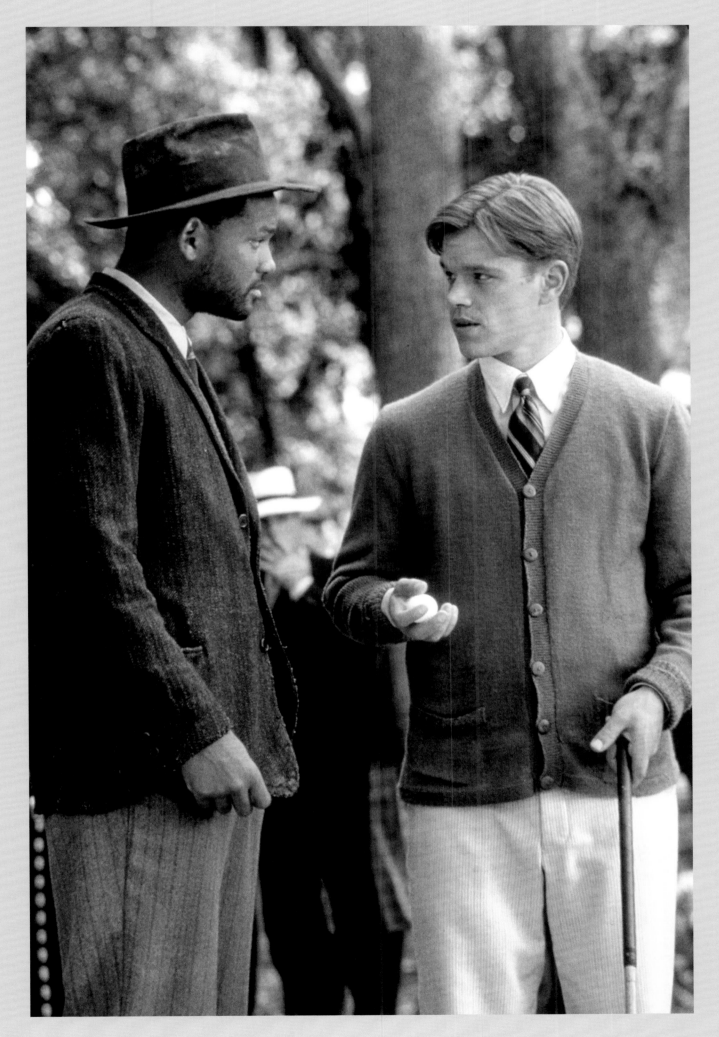

FROM HAZELNUT TO TITANIUM

A Short History of the Club

For centuries, golfers had their clubs made by carpenters or local blacksmiths. Woods were literally made of wood, initially from fruit trees such as apple or pear. The shafts where fashioned from ash or hazelnut until hickory was discovered, which is both hard and flexible. Hickory wood was and is still used to craft baseball bats, lacrosse sticks, and drumsticks too. The clubface of a wood had little inclination and so the ball only flew so far, but it did roll a fair distance: resourceful clubmakers knew to fill the head with lead, to add weight.

Clubs with iron heads were originally conceived for particularly tricky situations, for example if the ball got stuck in a carriage-wheel track. The grip was wrapped in sheep, cow or pigskin. In the nineteenth century persimmon wood—very light yet also incredibly robust—was used for the heads and in the 1920s, steel shafts caused a small revolution. Hickory shafts were common right through the fifties and persimmon heads were still around in the eighties. Meanwhile the hollow wood heads are made from lightweight titanium alloys.

Clubs over two hundred years old are exceedingly rare. Probably the oldest preserved clubs are eight Troon Clubs dating back to the 1650s, on exhibition at the British Golf Museum, St Andrews. A private collector reportedly offered the Troon Golf Club $4 million for the set: the committee unanimously rejected the offer.

The clubs in your golf bag must match your playing strength
Die richtigen Golfschläger im Bag müssen zur Spielstärke passen.

VON DER HASELNUSS BIS ZUM TITAN

Eine kleine Schlägergeschichte

Viele Jahrhunderte lang ließen Golfer ihre Schläger vom Schreiner oder örtlichen Hufschmied anfertigen. Die Hölzer waren tatsächlich noch aus Holz, und zwar zunächst aus Obsthölzern wie Apfel- oder Birnbaum. Für die Schäfte wurde Esche oder Haselnuss verwendet, doch dann entdeckte man Hickory, hart und flexibel zugleich. In Sportarten wie Baseball oder Lacrosse wurde ebenfalls Hickory verwendet, und auch Trommelstöcke sind aus diesem Holz geschnitzt. Die Schlagflächen der Hölzer hatten kaum Neigung, deshalb flog der Ball nur wenige Meter hoch, rollte dafür aber lange aus. Findige Schlägerbauer gossen Blei in die Rückseite des Schlägerkopfs, damit er schwerer wurde.

Schläger mit Eisenkopf waren ursprünglich nur für schwierige Lagen gedacht, etwa dann, wenn der Ball in der Radspur einer Kutsche liegen blieb. Die Griffe wurden mit Schafs-, Rinds- oder Schweineleder umwickelt. Im 19. Jahrhundert nutzte man die Vorteile des leichten, aber ungemein stabilen Persimmonholzes für die Schlägerköpfe, und um das Jahr 1920 sorgten Stahlschäfte für eine kleine Revolution. Hickoryschäfte wurde aber bis in die 1950er-Jahre hinein verwendet, Persimmonköpfe sogar bis in die 1980er-Jahre hinein. Inzwischen werden für die hohlen Holzköpfe immer leichtere Legierungen benutzt – vorzugsweise mit dem Leichtmetall Titan.

Schläger, die älter als 200 Jahre sind, gelten als absolute Raritäten. Die vermutlich ältesten erhaltenen Schläger sind die acht »Troon Clubs«, die im Golfmuseum von St. Andrews ausgestellt sind und um das Jahr 1650 gefertigt worden sein dürften. Ein anonymer Sammler bot dem Eigentümer, dem Troon Golf Club, vier Million Dollar. Der Clubvorstand lehnte einstimmig ab.

Early golf clubs, putters, and balls. From top to bottom: the earliest known brassie made and used by Tom Morris at St Andrews; old egg-shaped ball made about 1808; old ball found at Musselburgh about 1830; short thick grip used on all clubs; sand iron used about 1780; a track iron; wooden putter made by Hugh Philp about 1807
Frühe Golfschläger, Putter und Bälle. Von oben nach unten: der früheste bekannte Brassie, der von Tom Morris in St. Andrews hergestellt und verwendet wurde; alter eiförmiger Ball aus der Zeit um 1808; alter Ball, um 1830 in Musselburgh gefunden; kurzer dicker Griff für alle Schläger; um 1780 verwendetes Sandeisen; ein Schieneneisen, Holzputter von Hugh Philp um 1807

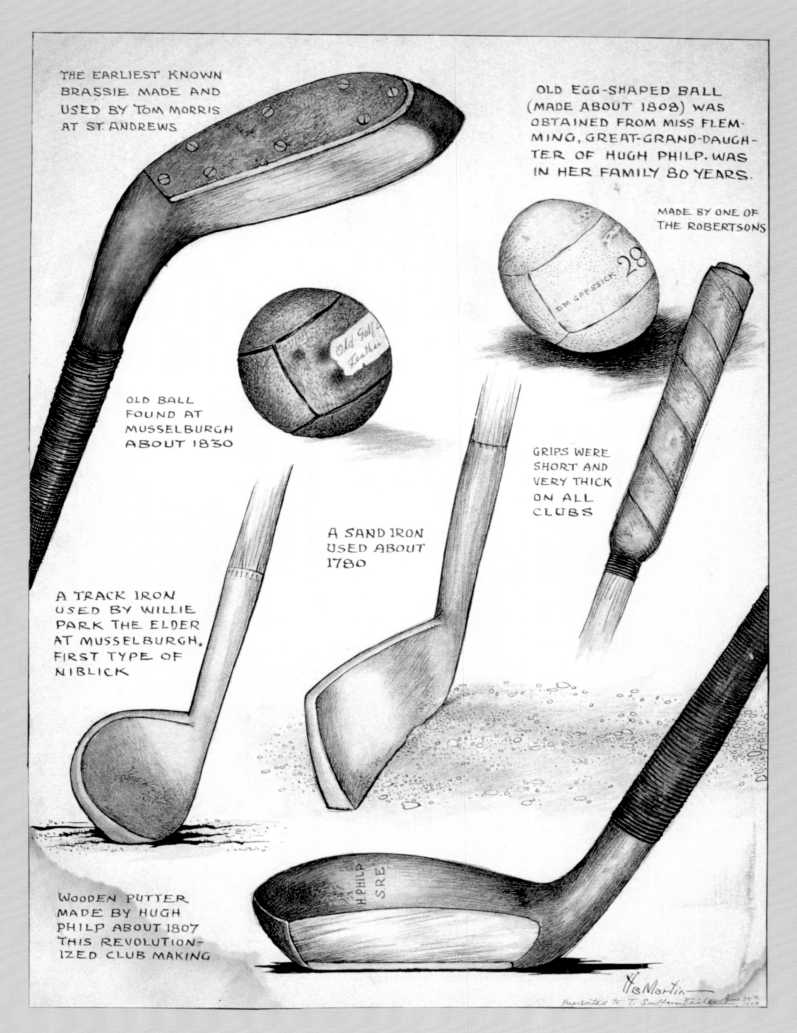

THE EARLIEST KNOWN BRASSIE MADE AND USED BY TOM MORRIS AT ST. ANDREWS

OLD EGG-SHAPED BALL (MADE ABOUT 1808) WAS OBTAINED FROM MISS FLEMMING, GREAT-GRAND-DAUGHTER OF HUGH PHILP. WAS IN HER FAMILY 80 YEARS.

MADE BY ONE OF THE ROBERTSONS

OLD BALL FOUND AT MUSSELBURGH ABOUT 1830

A SAND IRON USED ABOUT 1780

GRIPS WERE SHORT AND VERY THICK ON ALL CLUBS

A TRACK IRON USED BY WILLIE PARK THE ELDER AT MUSSELBURGH. FIRST TYPE OF NIBLICK

WOODEN PUTTER MADE BY HUGH PHILP ABOUT 1807 THIS REVOLUTIONIZED CLUB MAKING

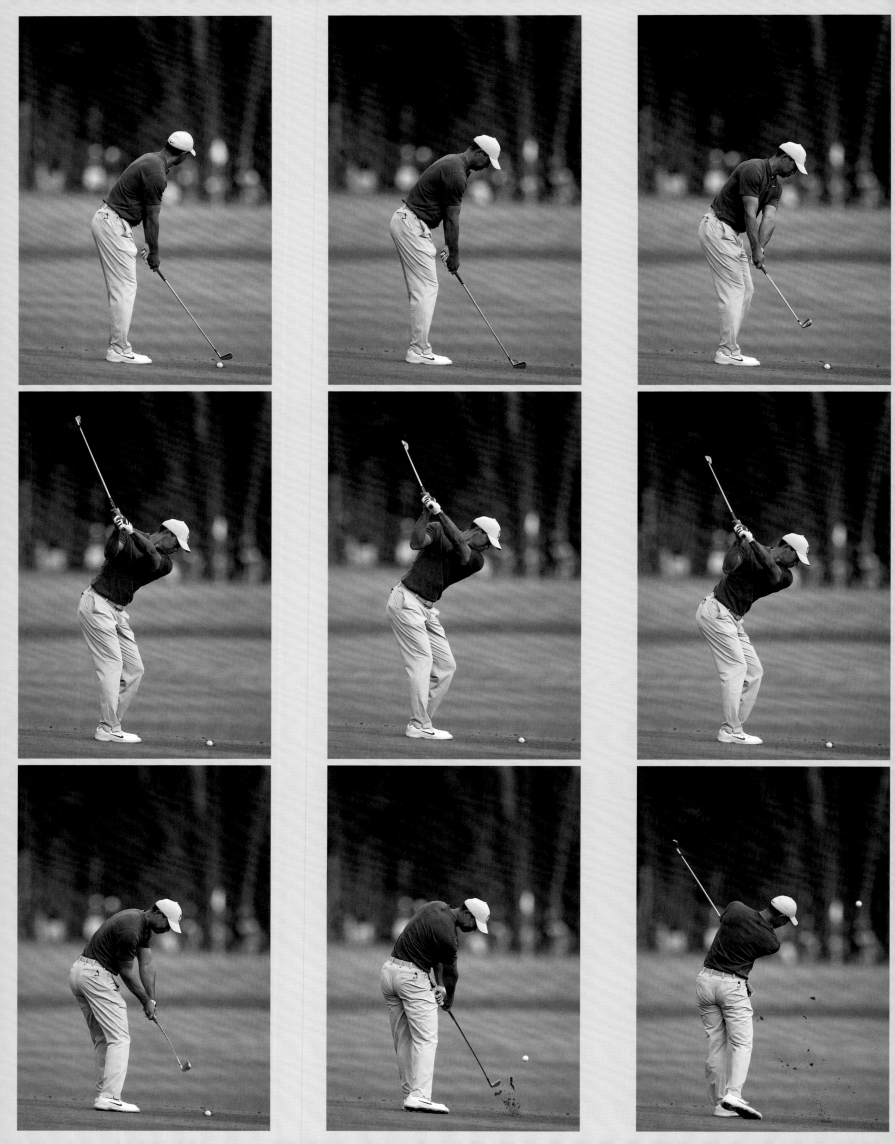

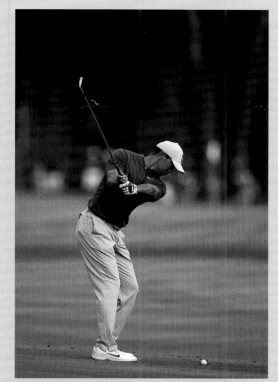

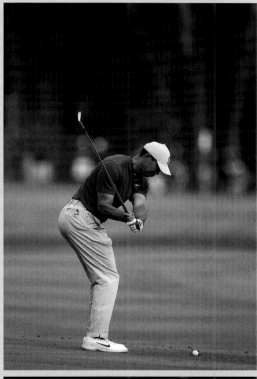
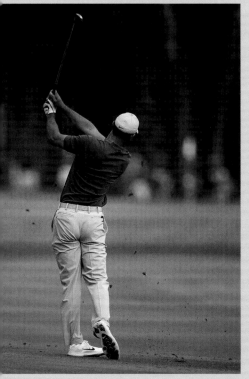
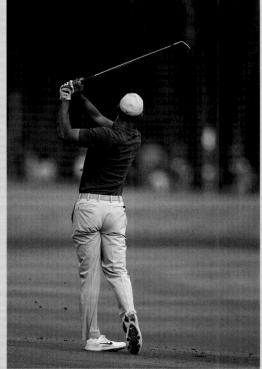

Tiger Woods' iron swing sequence, 2019

Tiger Woods' Schwungsequenz mit einem Eisen, 2019

17

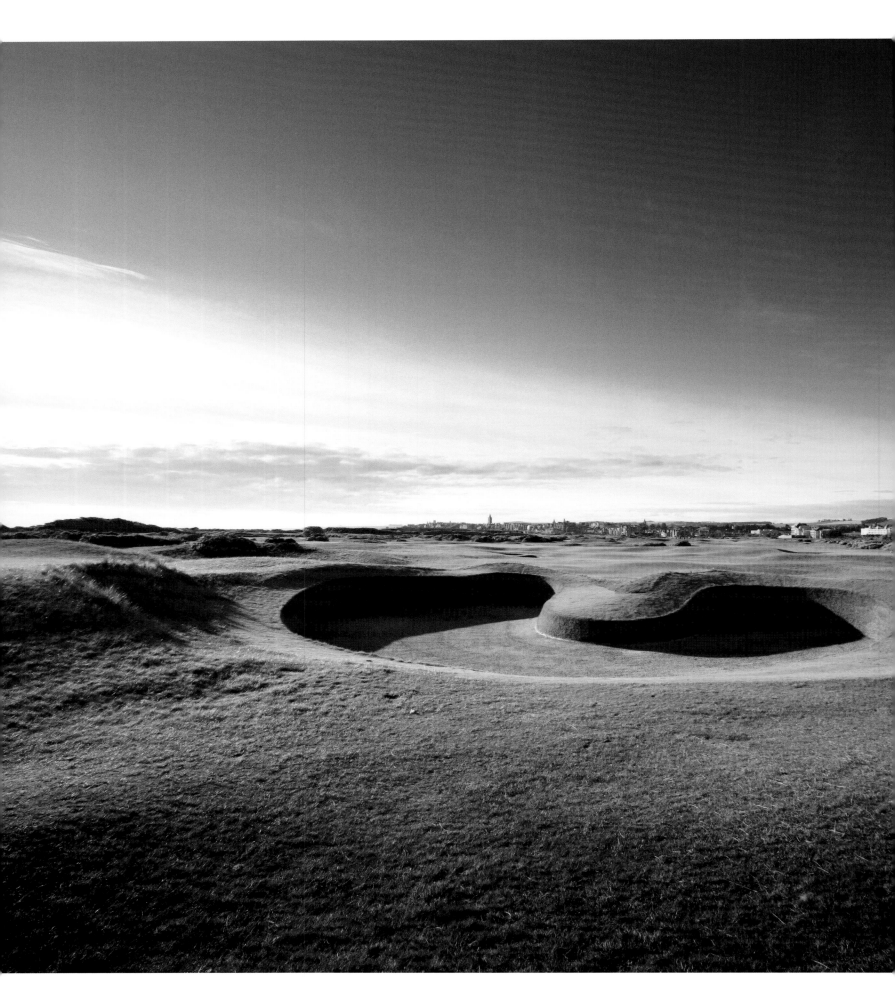

Nature and Old Tom Morris created this holy shrine of golf. The new clubhouse (right)

Die Natur und Old Tom Morris erschufen das Heiligtum der Golfwelt. Rechts im Bild das neue Clubhaus.

ST ANDREWS

SCOTLAND / SCHOTTLAND

The first mention of golf in Scottish public records dates back to 1457—when it was forbidden. King James II was concerned about his archers, who preferred golf to target practice. Maria Stuart is said to have teed off at Musselburgh Links, east of Edinburgh in 1567. The course still exists today, making it the world's oldest golf course still in use. On May 14, 1754, twenty-two merchants founded the Society of St Andrews Golfers. Though this was not the first golf club, it was soon to become the most significant, for until then golf was played differently all

Im Jahr 1457 wird Golf in Schottland erstmals urkundlich erwähnt – weil es nämlich verboten wird. König James II. macht sich Sorgen um seine Bogenschützen, die lieber golfen als das Zielschießen zu trainieren. Im Jahr 1567 soll Maria Stuart auf dem Platz Musselburgh Links östlich von Edinburgh abgeschlagen haben. Diesen Platz gibt es heute noch – er ist der älteste Course der Welt, auf dem noch gespielt wird. Am 14. Mai 1754 gründen 22 Kaufleute die Society of St Andrews Golfers – nicht der erste Golfclub, aber bald der wichtigste, denn Golf wird überall in

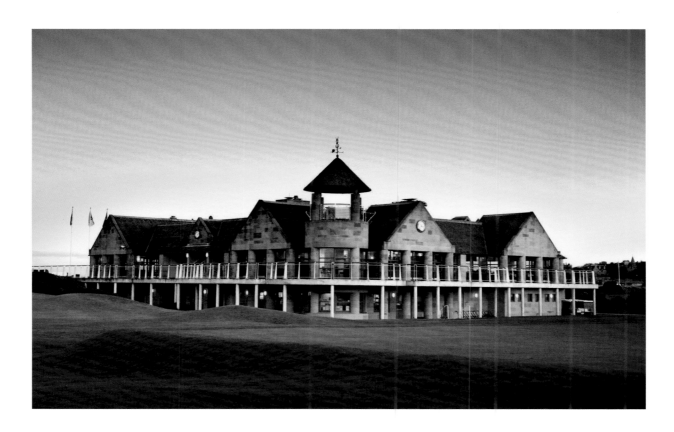

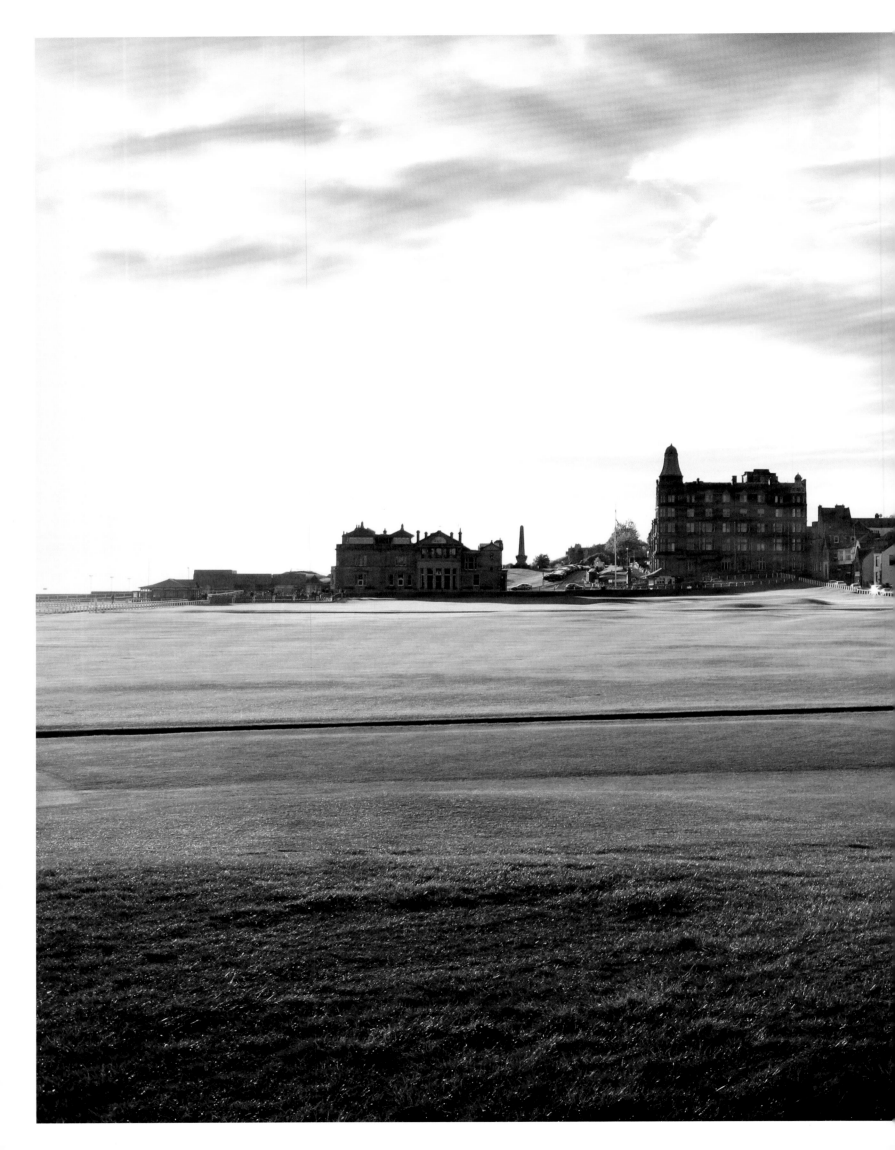

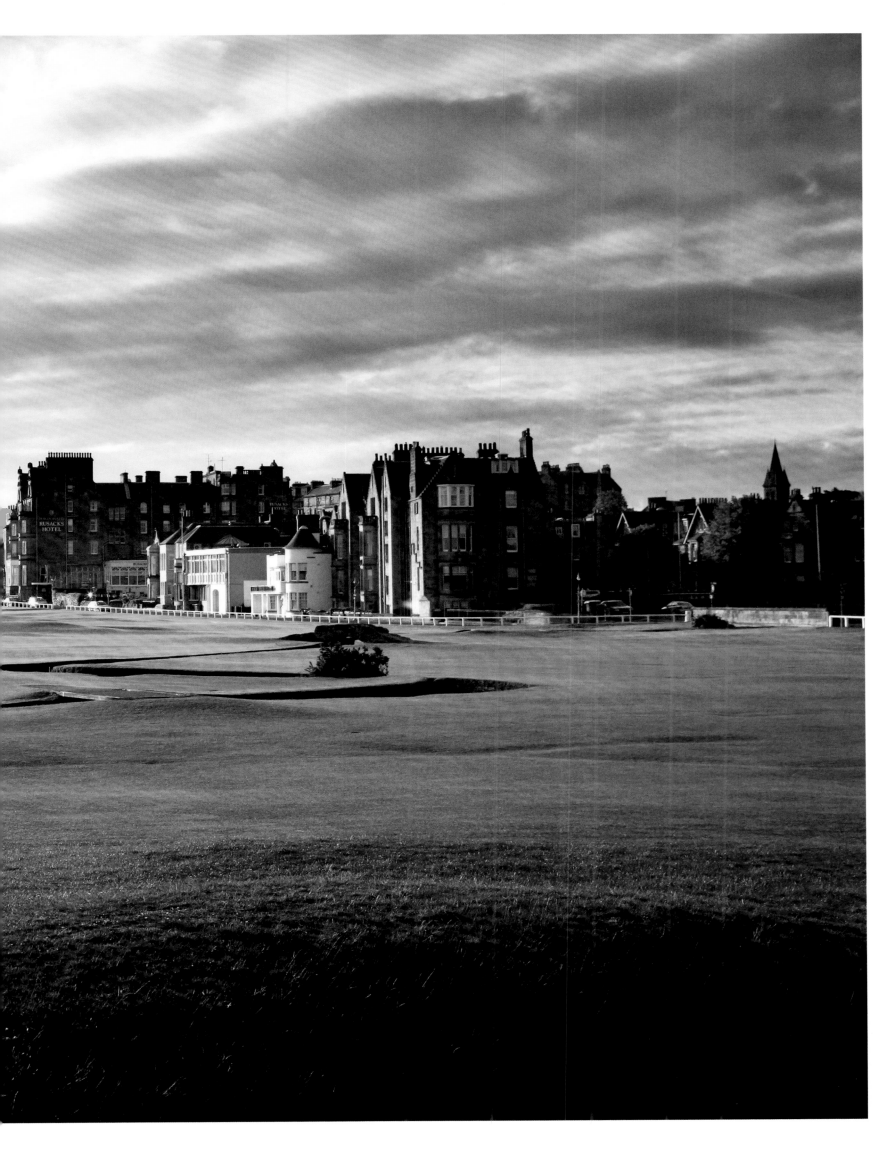

over Scotland. Some games had 7 holes, others 13 or 15. Sometimes players could knock their opponent's ball off the green, sometimes this wasn't permitted. Every club had its own rules, which led to all sorts of confusion. Now the gentlemen at St Andrews were asked to establish mandatory regulations, after all they were one of the few clubs with a golf course on their doorstep. Originally, the Old Course at St Andrews had 22 holes, but some were considered too short and consequently joined together. And that is how 18 became the standard requirement for golf courses all over the world. (The unofficial story tells of a Scotsman who personally tested how many holes a bottle of whisky would take him). In 1834, King William granted the club a royal seal. Henceforth it was called The Royal and Ancient Golf Club of St Andrews or the R&A for short.

No wonder that the world's most famous golf course was soon overrun. But how to regulate this onslaught? Fairly: through a democratic lottery. Every day before 2 p.m., players could throw their names into a draw pot: at 4 p.m. the following day's tee times would be pulled out. And for those who didn't get lucky, locals consider the neighboring New Course to be the best. Failing that, there is the Jubilee Course, the Eden Course, and further afield the new Castle Course as well as the beginners-friendly Strathtyrum Course or the 9-hole Balgove Course.

➤ Scotland, St Andrews, www.standrews.com

Schottland anders gespielt. Mal sind es 7 Löcher, mal 13, mal 15. Mal darf man den gegnerischen Ball vom Grün schubsen, mal nicht. Alle Clubs spielen nach ihren eigenen Regeln, was für arge Verwirrung sorgt. Also fragt man die Herren in St. Andrews, ob sie nicht für alle Golfer verbindliche Regeln aufstellen können – zumal es einer der wenigen Clubs ist, die einen Golfplatz direkt vor der Tür haben. Auf dem Old Course von St. Andrews gibt es zunächst 22 Bahnen, doch einige sind den Mitgliedern zu kurz und werden bald zusammengelegt. Daher kommt es, dass die Zahl 18 maßgeblich für die Lochzahl aller Plätze weltweit wird. (Die unautorisierte Version besagt, dass ein Schotte im Selbstversuch nachgemessen hat, wie lange eine Flasche Whisky hält.) 1834 verleiht König Wilhelm IV. dem Club die königlichen Attribute: Fortan heißt er The Royal and Ancient Golf Club of St. Andrews oder kurz R&A.

Kein Wunder, dass der berühmteste Golfplatz der Welt überlaufen ist. Wie wird der Ansturm geregelt? Ganz britisch-demokratisch per Lotterie. Bis 14 Uhr eines jeden Tages können Spieler einen Zettel mit ihrem Namen in einen Lostopf geben, und um 16 Uhr werden die Abschlagszeiten für den folgenden Tag bekannt gegeben. Falls es mit der Auslosung nicht klappt: Unter Einheimischen gilt der angrenzende New Course als der beste Platz, und dann gibt es ja noch den ebenfalls nahen Jubilee Course, den Eden Course und den ganz neuen Castle Course etwas außerhalb sowie den anfängerfreundlichen Strathtyrum Course und den 9-Loch-Balgove Course.

➤ Schottland, St. Andrews, www.standrews.com

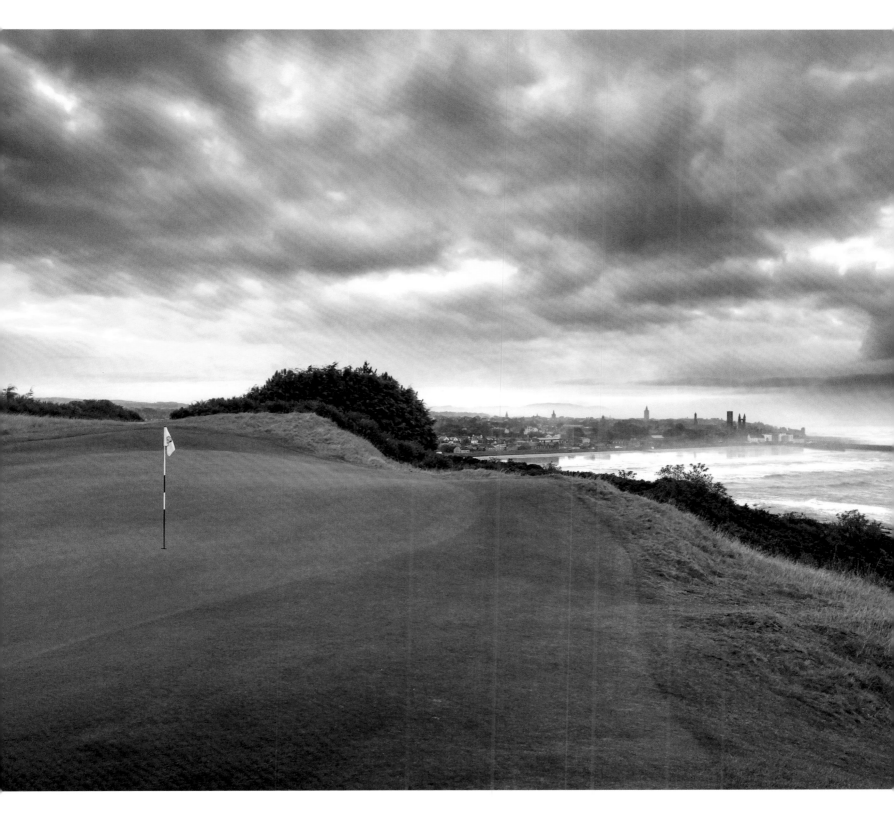

New additions: the Castle Course and the training center

Neue Ergänzungen: der Castle Course und das Trainingszentrum

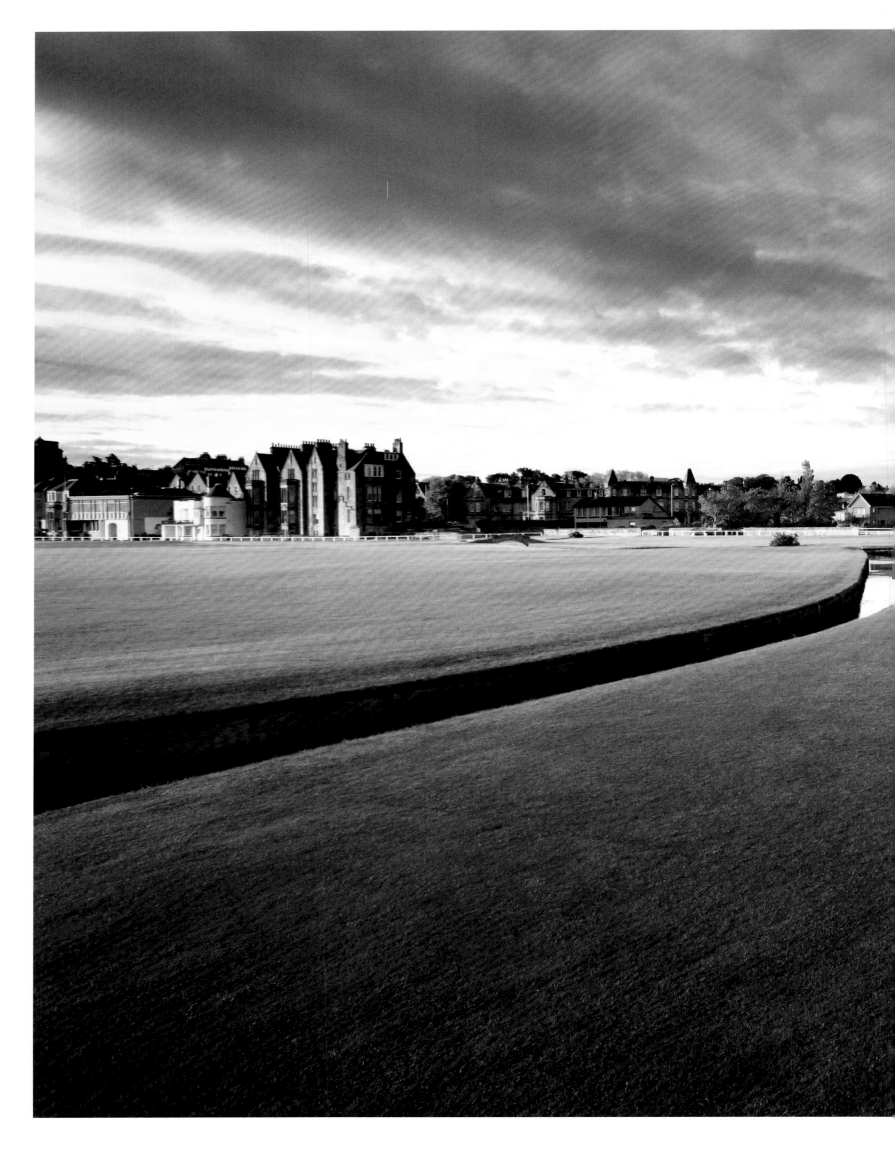

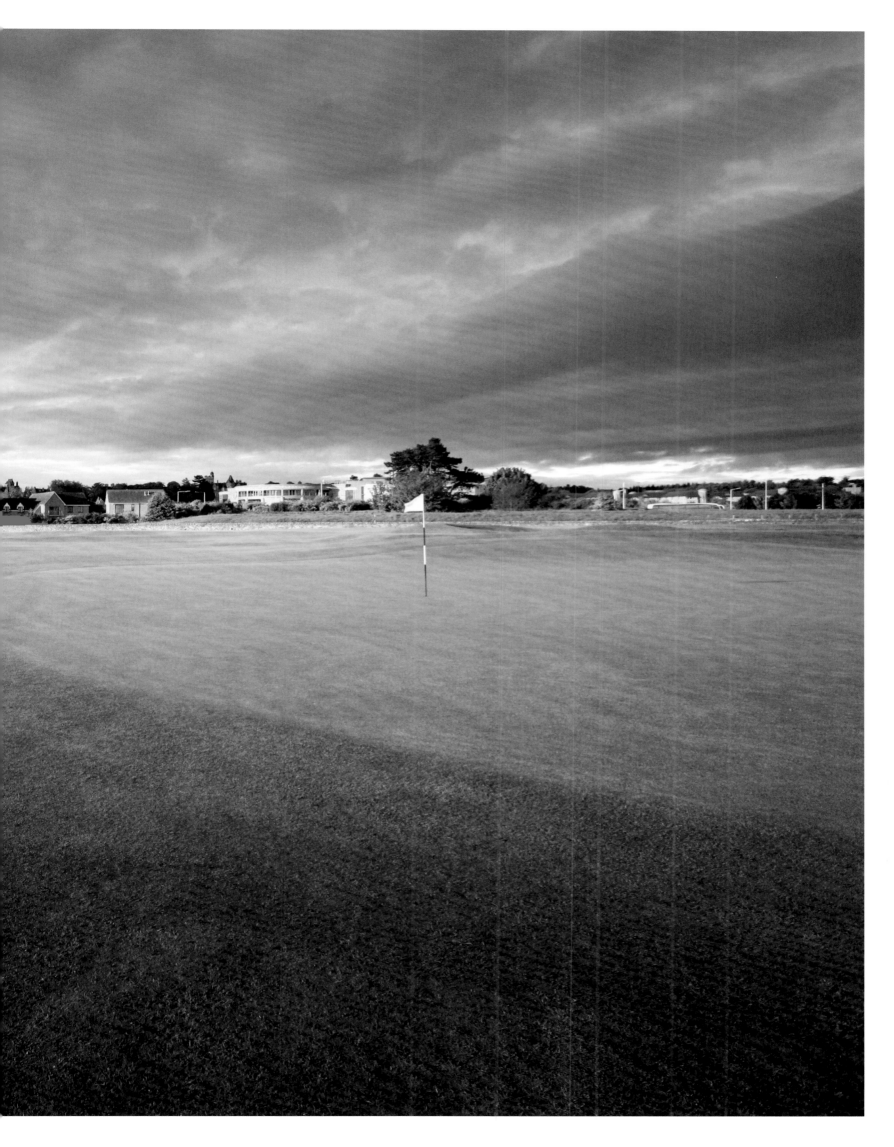

THE OPEN CHAMPIONSHIP
A History of the Oldest Golf Tournament
Die Geschichte des ältesten Golfturniers

As a moderate wind blew and the waves of the Irish Sea crashed wearily against the west coast of Scotland, eight golfers gathered round the first tee on the Prestwick Course. Little did they know they were about to make history. On the contrary: it is safe to assume that these professionals, who earned their income through so-called money matches, had only reluctantly joined the championship on October 17, 1860. The schedule stated three rounds in one day on a 12-hole course. The winner had not a monetary prize but a red leather belt with silver clasps to look forward to.

Old Tom Morris from St Andrews was set to be the favourite—he had, after all, designed the course. But that day Willie Park

Prestwick Golf Club was founded in 1851 and hosted the first twelve Open Championships between 1860 and 1872
Der Golfplatz Prestwick wurde 1851 gegründet und war zwischen 1860 und 1872 Austragungsort der ersten zwölf Open Championships.

Der Wind wehte nur mäßig, und die Wellen der Irischen See warfen sich eher gelangweilt an die schottische Westküste. Am ersten Tee des Golfplatzes von Prestwick standen acht Golfer versammelt, von denen vermutlich keiner ahnte, dass sie drauf und dran waren, Sportgeschichte zu schreiben. Im Gegenteil: Es darf angenommen werden, dass die Professionals, die damals ihr Geld ausschließlich mit sogenannten Money Matches verdienten, eher widerwillig angetreten waren, um an diesem 17. Oktober 1860 ihren Champion auszuspielen. Drei Runden an einem Tag waren auf dem Zwölf-Loch-Platz angesetzt, und dem Gewinner winkte nicht einmal ein Preisgeld, sondern lediglich ein nur mäßig hübscher Gürtel aus rotem Leder mit silberner Schnalle.

Old Tom Morris aus St. Andrews galt als Favorit, schließlich hatte er den Platz entworfen, doch an jenem Tag war Willie Park Senior besser. Er benötigte 174 Schläge auf den 36 Löchern, zwei weniger als der mächtige Morris. Park war damit der erste Open-Champion.

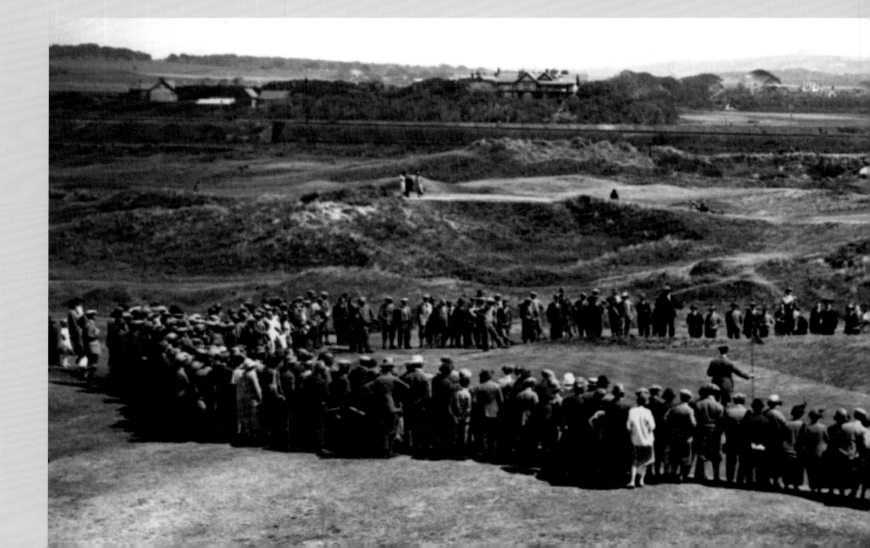

Senior played the 36-hole course with 174, winning it by two shots from the mighty Morris. And with that Park became the first Open Champion.

The following year, the second Open Championship took place. This time eighteen players gathered at the start, ten professionals and eight amateurs. This time the favourite prevailed: Morris won by four shots ahead of Park.

Slowly the whole affair began to gain momentum, particularly with the 1873 Open being held at St Andrews, a town that had caught the golf bug earlier in the century. The best golfers in the country all came together to compete against one another: a real championship. Like so many great ideas, with hindsight one wonders why no one had thought of it sooner. Historic photographs reveal that by 1875 tens of thousands of golf fans were pilgrimaging to the Open. Over time the prize money was increased: In 1864, the winner received six pounds, a meagre wage even in those days. By 1876, the winner's check had gone up to ten pounds and by 1893 it was 30 pounds. This was still not a large amount, however, a championship title meant higher entry bonuses for subsequent show games.

Only in 1907 did the first non-Brit, the Frenchman Arnaud Massy, triumph, and in 1921, the first US-American player won the title. The following year, Walter Hagen, the first star of the new era,

Im Jahr darauf fand die zweite Open Championship statt. Diesmal waren 18 Spieler am Start, zehn Professionals und acht Amateure. Nun setzte sich der Favorit durch: Morris gewann mit vier Schlägen Vorsprung vor Park.

Allmählich kam die Sache in Schwung, vor allem, nachdem die Open 1873 erstmals in St. Andrews ausgespielt wurde, einer bereits im 19. Jahrhundert golfverrückten Stadt. Die besten Golfer des Landes, die alle bei einem Turnier gegeneinander antreten: eine echte Meisterschaft. Wie bei so vielen großen Ideen fragt man sich hinterher, warum denn niemand schon früher darauf gekommen war. Aufgrund historischer Fotografien kann man wohl davon ausgehen, dass zumindest ab etwa 1875 Zehntausende Golffans zur Championship pilgerten. Allmählich wurde das Preisgeld erhöht: Seit 1864 gab es für den Sieger sechs Pfund, selbst für damalige Verhältnisse ein karger Lohn. Ab 1876 war der Siegerscheck auf 10, 1893 schon auf 30 Pfund ausgestellt. Viel Geld war das immer noch nicht, aber der Sieger konnte seinen Titel stets bei anschließenden Schauauftritten mit Antrittsprämien versilbern.

Erst 1907 triumphierte mit dem Franzosen Arnaud Massy der erste Nicht-Brite, 1921 konnte Jock Hutchison als erster US-Amerikaner den Titel gewinnen. Im Jahr darauf wurde in Royal Liverpool mit Walter Hagen der erste Star der neuen Ära zum Open-Champion gekürt. Hagen und Bobby Jones

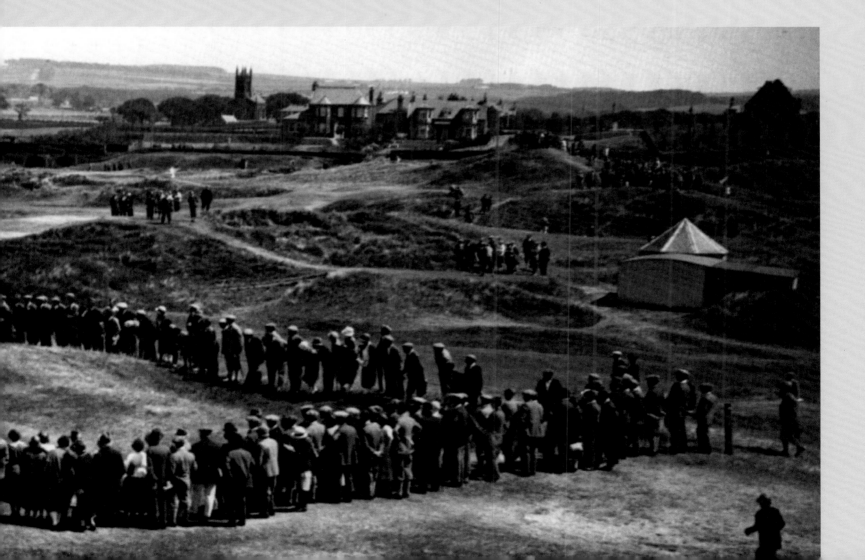

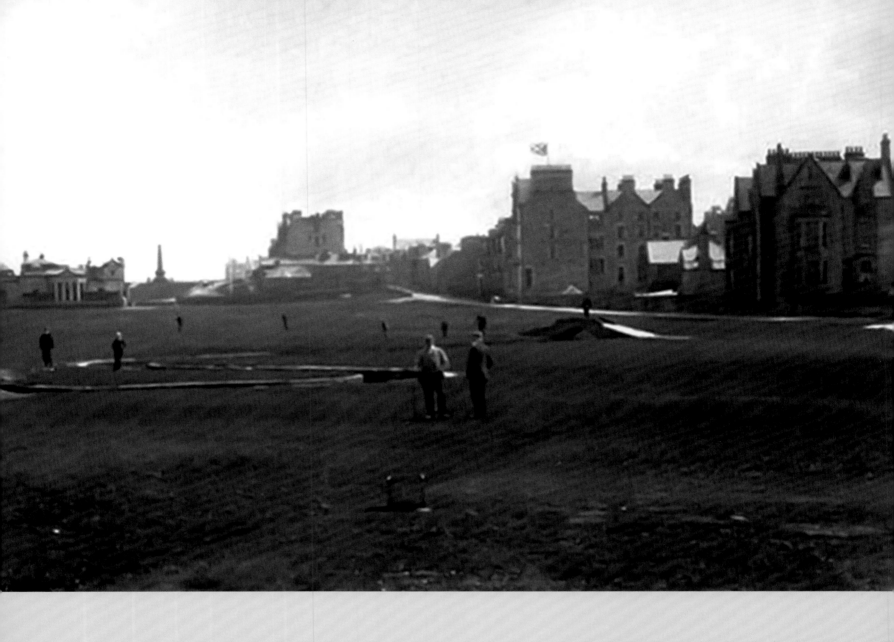

was crowned Open Champion in Royal Liverpool. Hagen and Bobby Jones not only dominated the game in the USA but also in Great Britain, and in the following years they won altogether seven Open titles in the Old World.

Gentleman golfer Bobby Jones was later to be made honorary citizen of St Andrews, despite a somewhat rocky start to his Open career: during his first game on the Old Course he snatched up the ball in a fury at hole 12, tore up his scorecard and stormed off to the clubhouse. The British press tore into the "spoiled, club-throwing hothead" from abroad. Gradually Bobby Jones fell in love with links golf and he soon became the most popular player since Old Tom Morris. A quote from his honorary citizenship acceptance speech has gone down in golfing history: "I could take out of my life everything but my experiences here in St Andrews and I would still have had a rich and full life."

dominierten den Golfsport nicht nur in den USA, sondern auch in Großbritannien und gewannen in den folgenden Jahren sieben Open-Titel diesseits des Atlantiks.

Bobby Jones, der Gentleman-Golfer, sollte später sogar zum Ehrenbürger von St. Andrews ernannt werden, dabei begann er sein Open-Abenteuer auf dem ganz falschen Fuß: Bei seiner ersten Teilnahme auf dem Old Course nahm er wutentbrannt an Loch 12 seinen Ball auf, warf die Scorekarte weg und stapfte ins Clubhaus. Die britische Presse zerriss den »Schnösel aus Übersee«. Erst allmählich verliebte sich Bobby Jones ins Links-Golf, und bald wurde er zum populärsten Spieler seit Old Tom Morris. Bei seiner Dankesrede zur Verleihung der Ehrenbürgerwürde sagte er einen Satz, der in die Golfgeschichte einging: »Selbst wenn man mir mein gesamtes Leben wegnähme und mir nur die Zeit in St. Andrews ließe, hätte ich dennoch ein erfülltes Leben gehabt.«

Having won the British Open Ben Hogan enjoys a typically New York reception, 1953
Ben Hogan wird nach dem Gewinn der British Open ein typisch New Yorker Empfang bereitet, 1953

The Old Course in 1891
Der Old Course im Jahr 1891

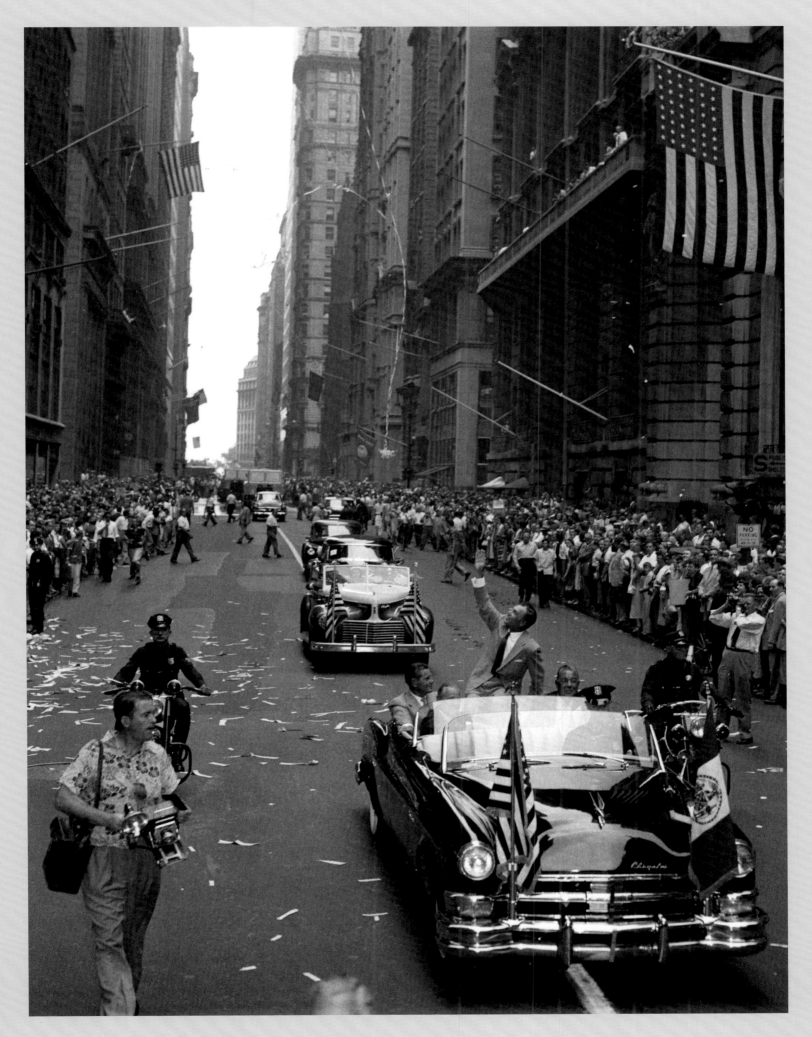

YOUNG TOM MORRIS
The First Superstar
Der erste Superstar

Young Tom Morris made golf a sport: the son of the great Old Tom Morris won the British Open in 1868, 1869, 1870, and 1872 (there was no tournament in 1871). In 1868, the eighteen-year-old achieved the tournament's first ever hole-in-one at the 8th hole at Prestwick; in 1869, his father, Old Tom Morris, finished second to him. Following his title hat-trick Tom was able to keep the Championship Belt In 1872 he held up the Claret Jug for the first time. However, the most significant achievement of the Tom Morrises is that their spectacular golfing appealed to the masses. Playing in show tournaments all over Scotland and England, their riveting 200-yard drives sparked off the world's first real golf boom. But Young Tom's life ended tragically early: In September 1875, whilst playing at a show tournament, he received a telegram saying his pregnant wife was dying. He hastened back to St Andrews, but arrived too late. Mother and child had both died. Tom was heartbroken. He died on Christmas Day of the same year at the age of twenty-four.

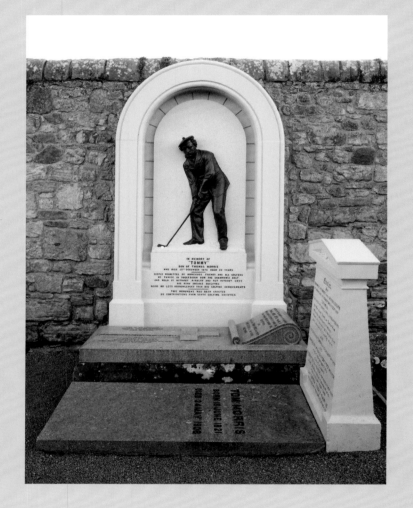

Mit diesem Mann wurde Golf zum Sport: Der Sohn des großen Old Tom Morris siegte bei der British Open 1868, 1869, 1870 und 1872 (1871 fand kein Turnier statt). 1868, als 18-Jähriger, schlug er das erste Ass der Open-Geschichte an Loch 8 von Prestwick, und 1869 wurde sein Vater Old Tom Morris hinter dem Sohn Zweiter. Nach seinem Titel-Hattrick durfte Tom den Championship-Gürtel behalten; 1872 stemmte er das erste Mal die Claret Jug in die Höhe. Das viel größere Verdienst von Vater und Sohn ist aber, dass ihr spektakuläres Golf die Massen anzog. Sie spielten in Schauturnieren quer durch Schottland und England und sorgten mit ihren faszinierenden 200-Meter-Drives für den ersten echten Golfboom. Das Leben des jungen Tom endete tragisch: Im September 1875, während eines Schauturniers mit seinem Vater gegen Willie und Mungo Park, erreichte ihn ein Telegramm, dass seine schwangere Frau im Sterben lag. Er reiste nach St. Andrews zurück, aber es war zu spät, Mutter und Baby waren bereits tot. Darüber kam er nicht hinweg: Young Tom Morris starb mit 24 Jahren am Weihnachtstag 1875.

Old and Young Tom Morris' gravestones in St Andrews Cathedral churchyard
Die Grabsteine des alten und jungen Tom Morris auf dem Gelände der St. Andrews Cathedral

Scottish golfer Old Tom Morris was a prominent figure of early competitive golf; his son Young Tom Morris was a born star
Der schottische Golfer Old Tom Morris war eine der herausragenden Persönlichkeiten des frühen professionellen Golfsports. Sein Sohn Young Tom Morris wurde der erste echte Superstar.

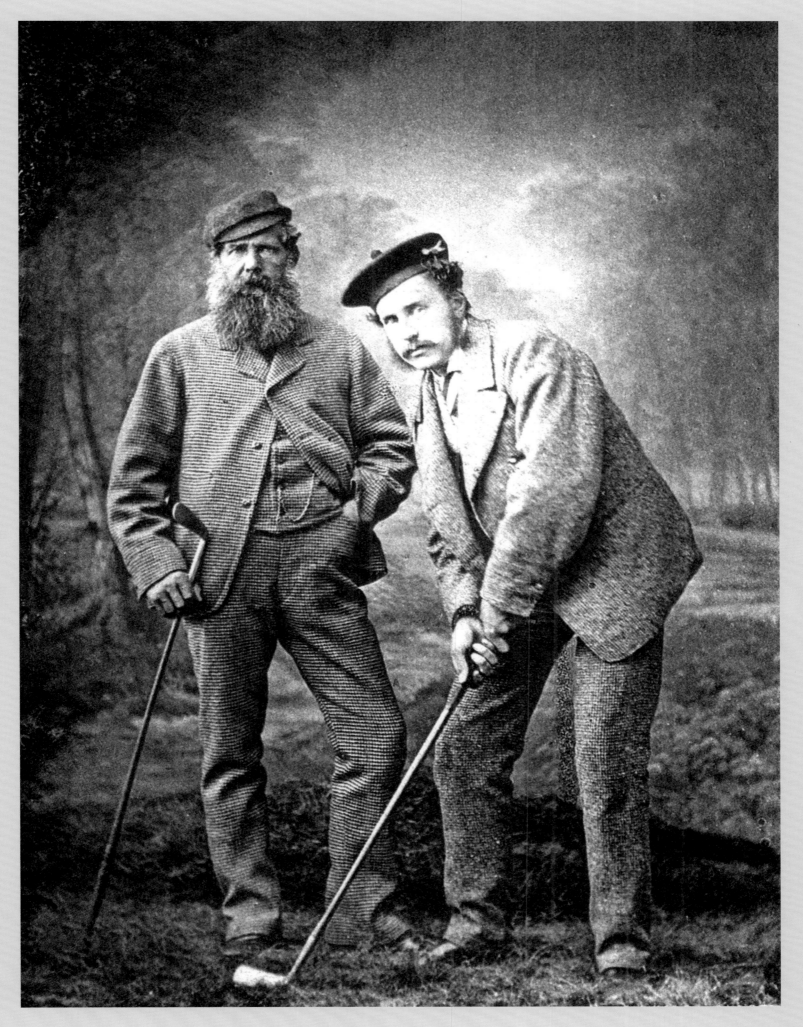

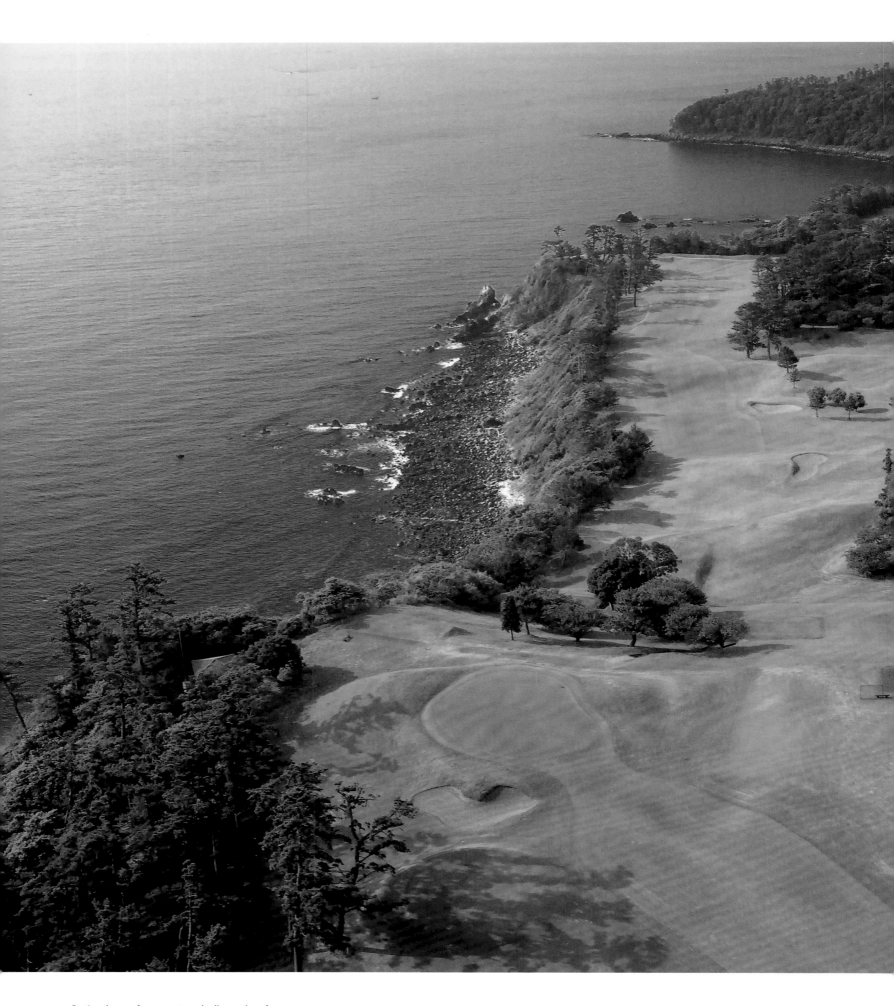

Optimal use of space, stray balls are lost forever

Beste Ausnutzung des Platzes: Verzogene Bälle verschwinden für immer.

KAWANA HOTEL GOLF COURSE

JAPAN

The Japanese are true golf enthusiasts, though unfortunately they are faced with spacial restrictions on the Islands. That is the reason why round-the-clock, three-floor driving ranges are so popular in Japan. But when an investor does commit to building a golf course, it usually results in something quite special, such as the 36 holes of the Kawana Hotel: the Fuji Course, is rated best course in Japan and features among the worldwide top one hundred, and the Oshima Course is highly valued by nature lovers and hobby golfers. Designed by British

Japaner sind ein golfbegeistertes Volk, doch leider haben sie auf ihren Inseln ein Platzproblem. Daher gibt es so viele mehrstöckige Driving Ranges, die rund um die Uhr gut besucht sind. Doch wenn sich einmal ein Investor entschließt, einen Golfplatz zu bauen, dann ensteht oft etwas Besonderes. So auch bei den 36 Löchern des Kawana Hotels: Der Fuji-Platz gilt als einer der besten der Welt, während der Oshima-Platz besonders von Freizeitspielern und Naturliebhabern geschätzt wird. Im Jahr 1935 eröffnete der von dem Briten Charles Hugh Alison entworfene

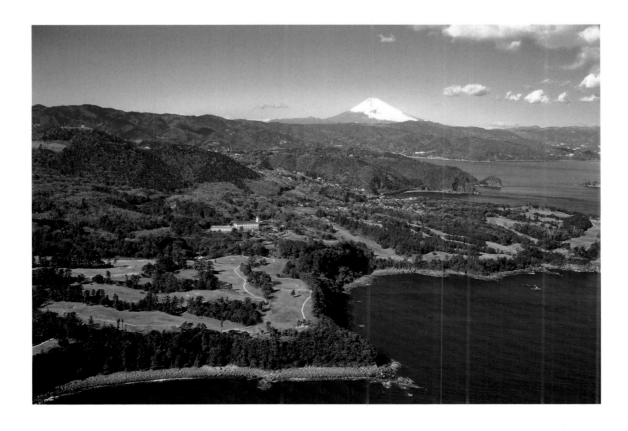

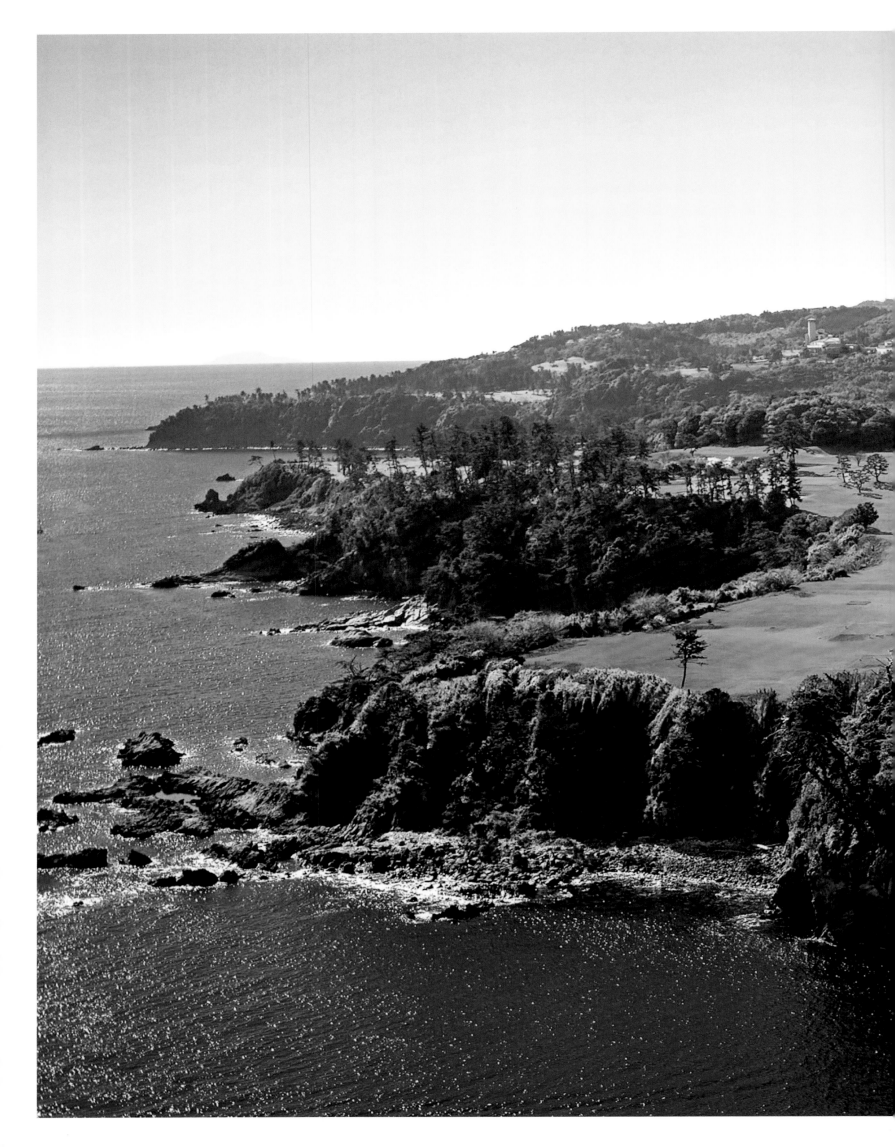

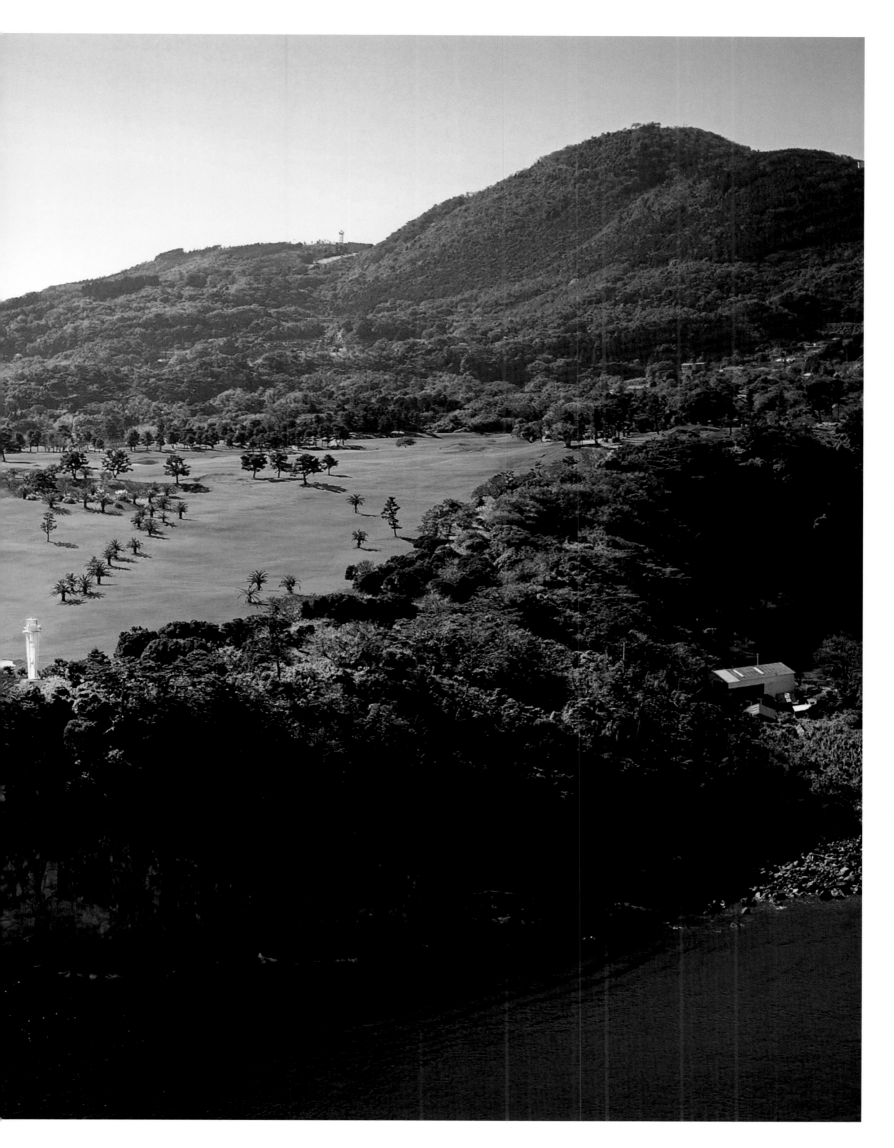

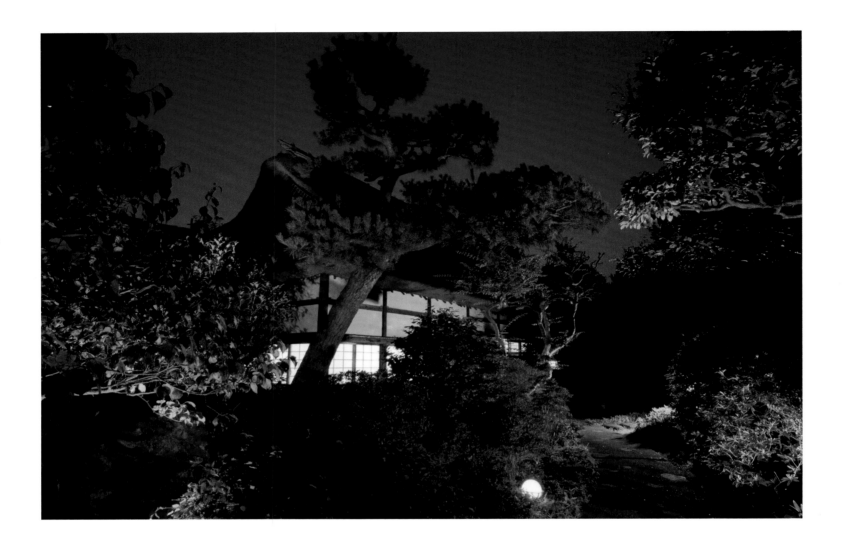

architect Charles Hugh Alison in 1935, the Fuji Course is held in high regard on account of its immaculate maintenance, slender fairways, and deep bunkers which pose a challenge even for the most-experienced golfer. The 15th is particularly exciting, a par-5, flanked by the ocean all along the left side. The slightly older Oshima Course, built by Komyo Otani in 1928, is also a masterpiece of rich greens harmoniously woven into the natural landscape and a beautiful ocean view across Sagami Bay. Kawana Hotel opened in the same year and is also popular among non-golfers for its spas and hot springs.

➤ **Japan, Shizuoka, www.princehotels.com**

Fuji-Course, der sich durch erstklassigen, makellosen Pflegezustand, schmale Fairways und tiefe Bunker auszeichnet, die auch erfahrene Golfer vor Schwierigkeiten stellen. Besonders spannend ist die 15, ein Par 5, das auf der gesamten linken Seite vom Ozean flankiert wird. Der Fuji gilt als bester Platz in Japan und findet sich regelmäßig in den weltweiten Top-100-Bestenlisten. Der Oshima-Kurs ist sogar noch ein wenig älter; er wurde 1928 von Komyo Otani designt und punktet ebenfalls mit sattem Grün, der harmonischen Eingebundenheit in die Natur und der fantastischen Aussicht auf die Sagami-Bucht. Aus demselben Jahr stammt das Kawana-Hotel, das mit seinem Spa und den heißen Quellen auch bei Nichtgolfern beliebt ist.

➤ **Japan, Shizuoka, www.princehotels.com**

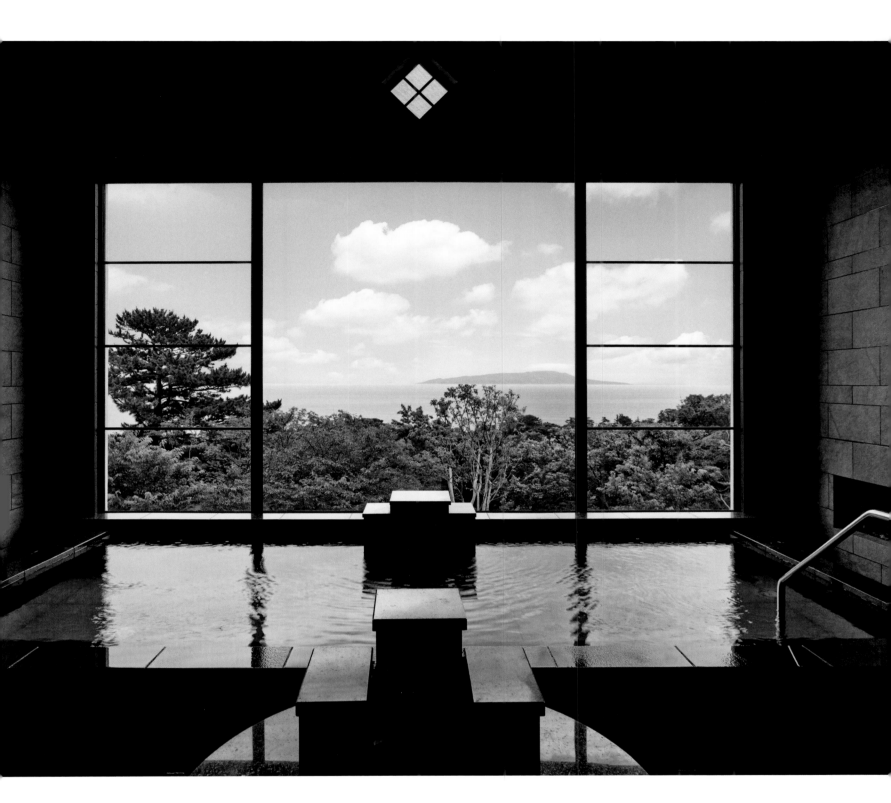

After a round, a first class spa beckons

Nach der Runde lockt das erstklassige Spa.

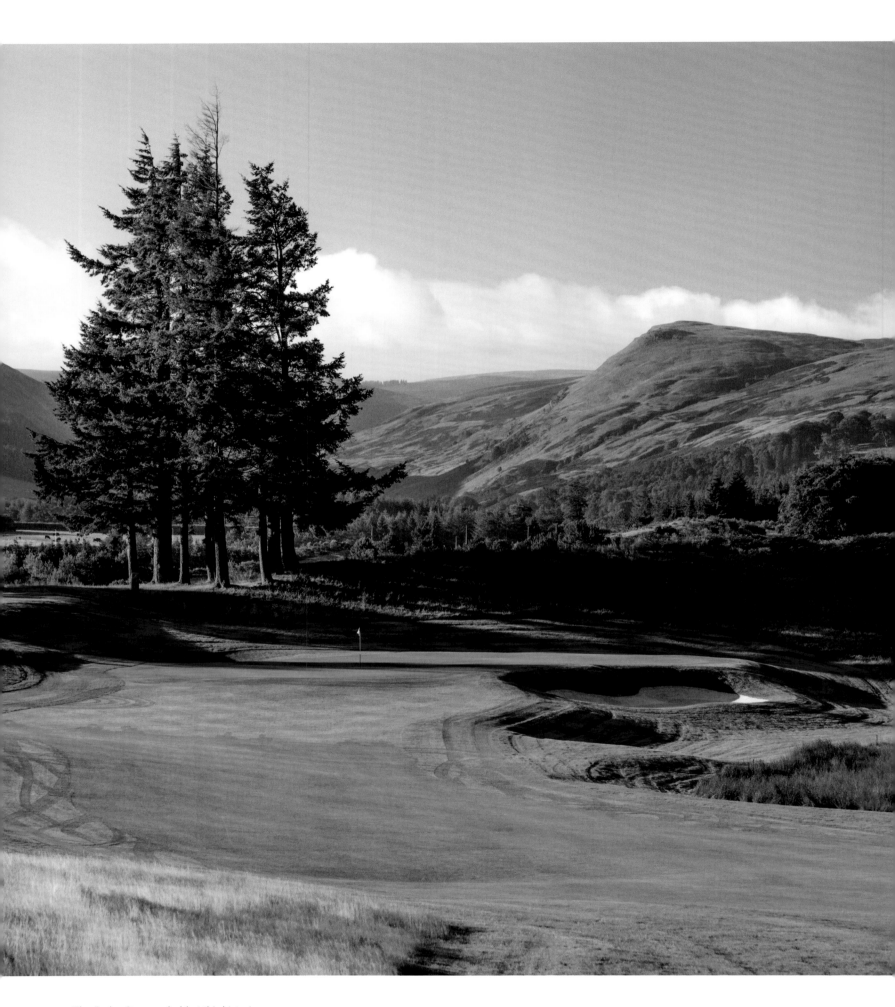

The Ryder Cup was held at this historic course

Der geschichtsträchtige Course war schon Schauplatz des Ryder Cups.

GLENEAGLES

SCOTLAND / SCHOTTLAND

Located between Glasgow and Edinburgh lies Scotland's most prestigious resort with three 18-hole courses, a luxury hotel, and a two-Michelin-starred restaurant—the most highly decorated in the land. Since 1924, the resort has accommodated distinguished guests seeking distraction in breathtaking surroundings: How about a bit of clay pigeon shooting or an off-road jeep tour? Horseback riding, archery, fly-fishing? Or a falconry lesson? You can also explore the area along one of ten five-to-sixty-mile cycle routes.

Zwischen Glasgow und Edinburgh gelegen, lockt Schottlands renommiertestes Resort mit drei 18-Loch-Plätzen, einem Luxushotel und erstklassigem Restaurant – übrigens dem höchstdekorierten des ganzen Landes. Seit 1924 werden hier anspruchsvolle Gäste empfangen, die sich auf Abwechslung in atemberaubender Kulisse freuen können: Wie wäre es mit Tontaubenschießen, Lektionen vom Falkner, Offroad-Touren mit dem Geländewagen, Reiten, Bogenschießen, Fliegenfischen oder der Erkundung der malerischen Gegend per Rad auf zehn Routen von 15 bis 100 Kilometern Länge?

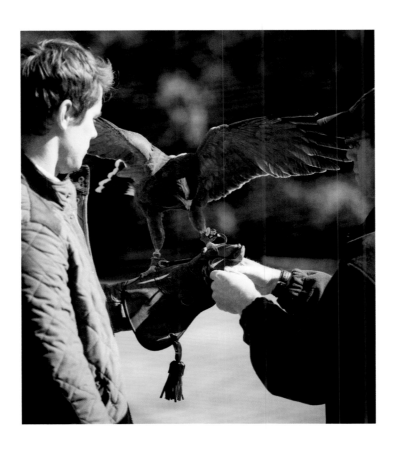

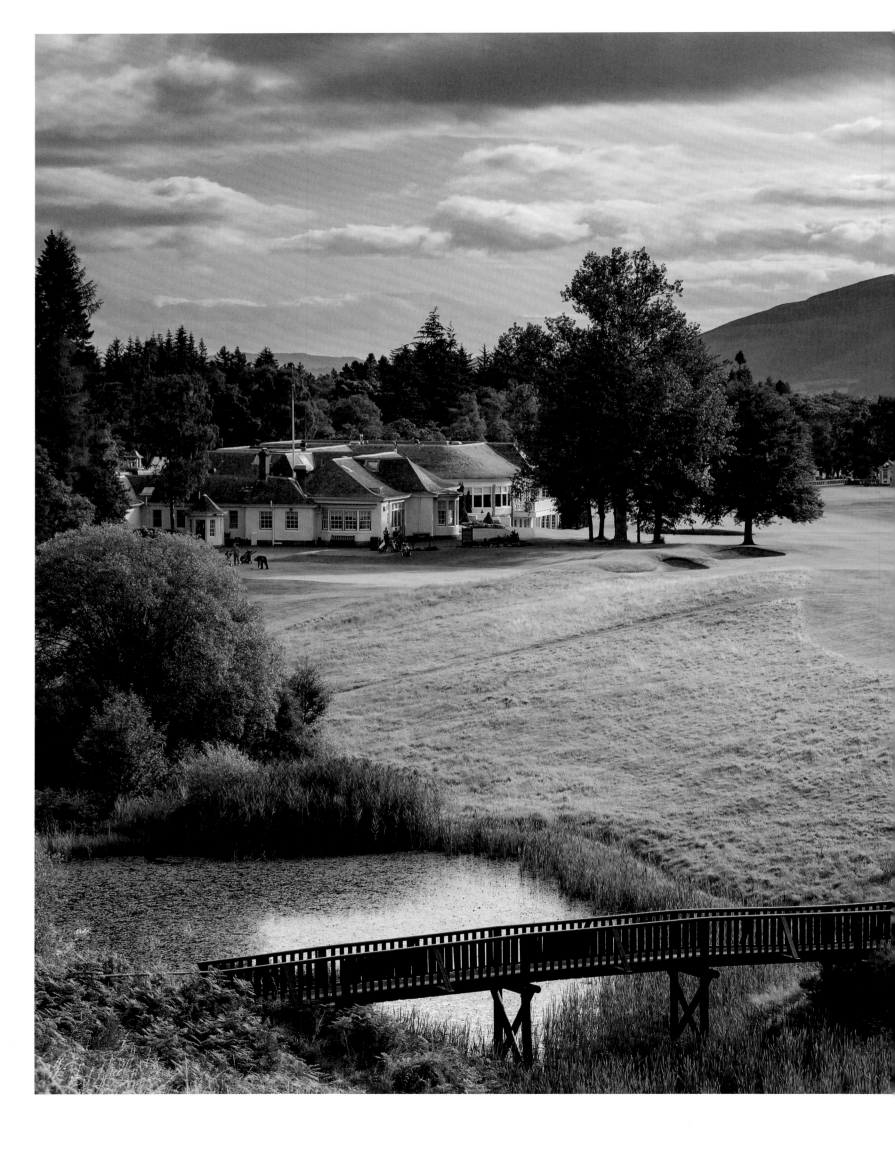

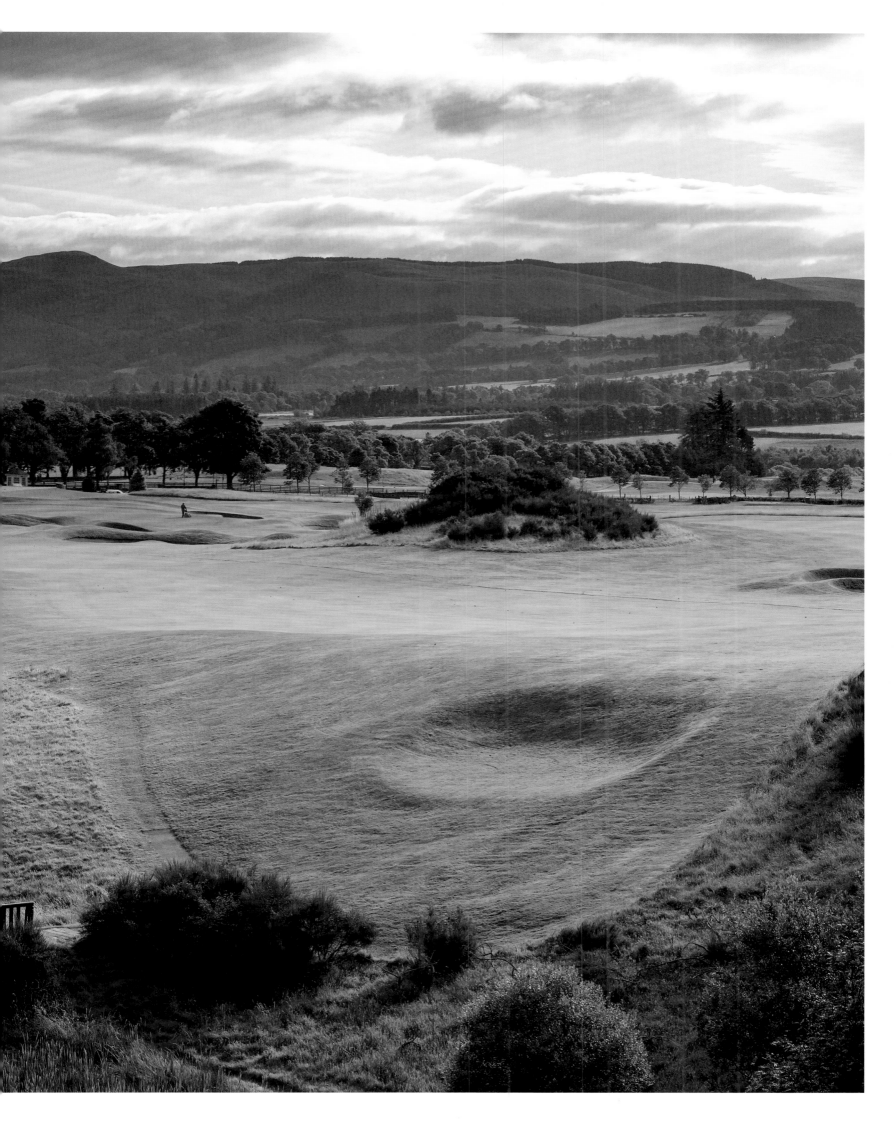

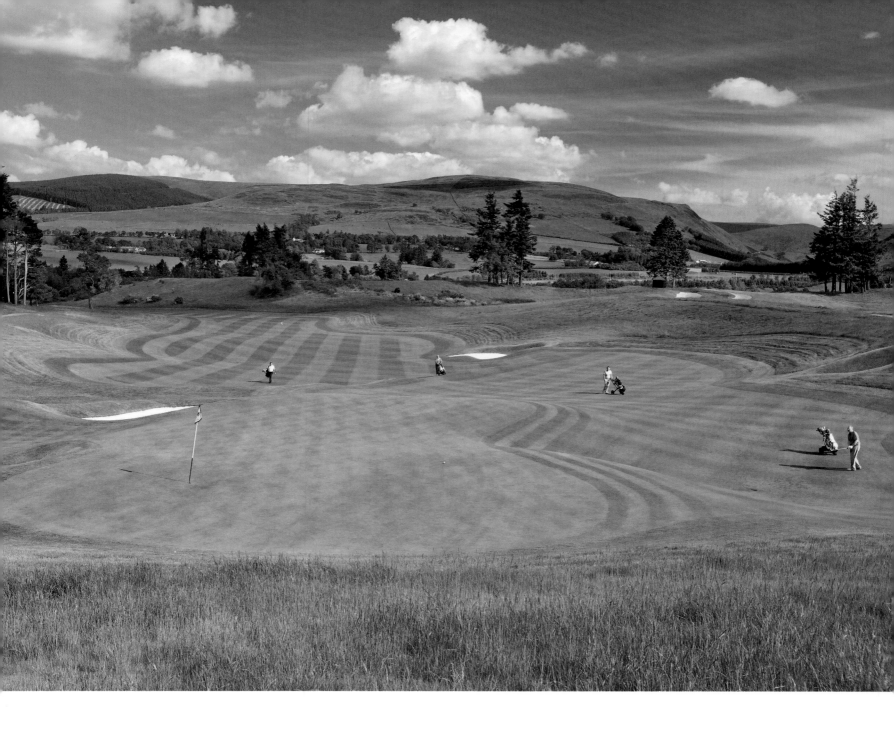

In 2014, the resort hosted the most renowned team competition in the golfing world, the Ryder Cup (see page 60), which was held in Scotland again for the first time in forty years. Jack Nicklaus built the PGA Centenary Course to mark the occasion. The final holes are particularly tricky: a short par-3 17th called Ca Canny, Scottish for "take care!" is guarded by three bunkers; the also not very long par-5 18th Dun Roamin' can hardly be completed in two on account of the many bunkers waiting for skewed balls. The Queen's Course and the Kings Course, a short round and excellent practice facilities, complete this golfers' paradise.

➤ Scotland, Auchterarder, www.gleneagles.com

Das Resort durfte im Jahr 2014 den Ryder Cup ausrichten, den renommiertesten Teamwettbewerb der Golfwelt (siehe S. 60), der zum ersten Mal nach mehr als 40 Jahren wieder auf schottischem Boden ausgetragen wurde. Jack Nicklaus baute dafür extra den PGA Centenary Course. Besonders die Schlusslöcher haben es in sich: Die kurze 17, ein Par 3 namens Ca'Canny (schottisch für: sei vorsichtig), wird von drei tiefen Bunkern bewacht, und die 18 namens Dun Roamin' ist ein nicht sehr langes Par 5, das aber trotzdem kaum in zwei Schlägen zu erreichen ist, weil jede Menge Bunker auf verzogene Bälle warten. Der Queen's Course und der King's Course, ein Kurzplatz sowie exzellente Übungsmöglichkeiten runden das Angebot dieses Golfparadieses ab.

➤ Schottland, Auchterarder, www.gleneagles.com

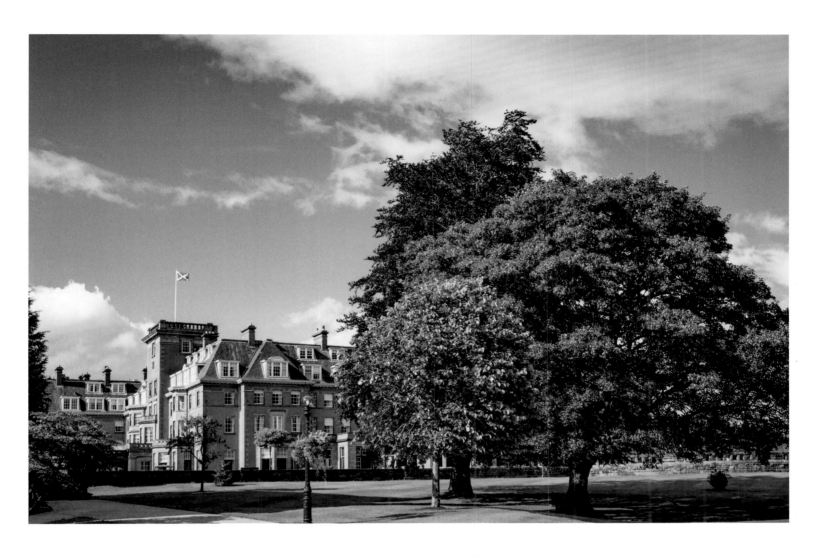

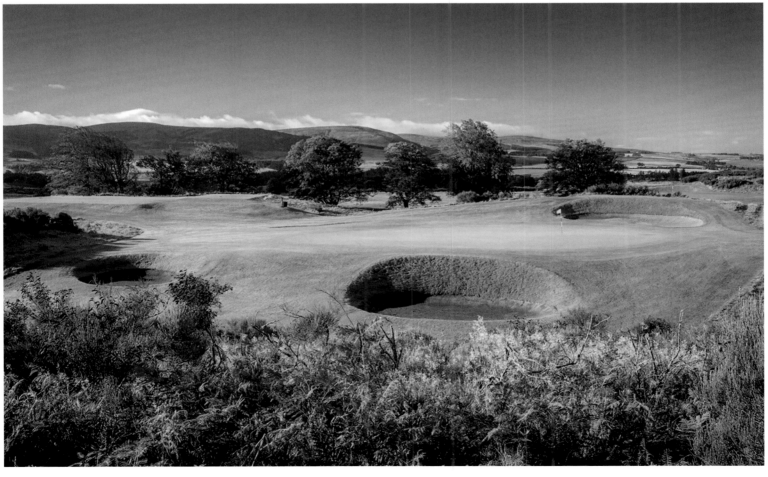

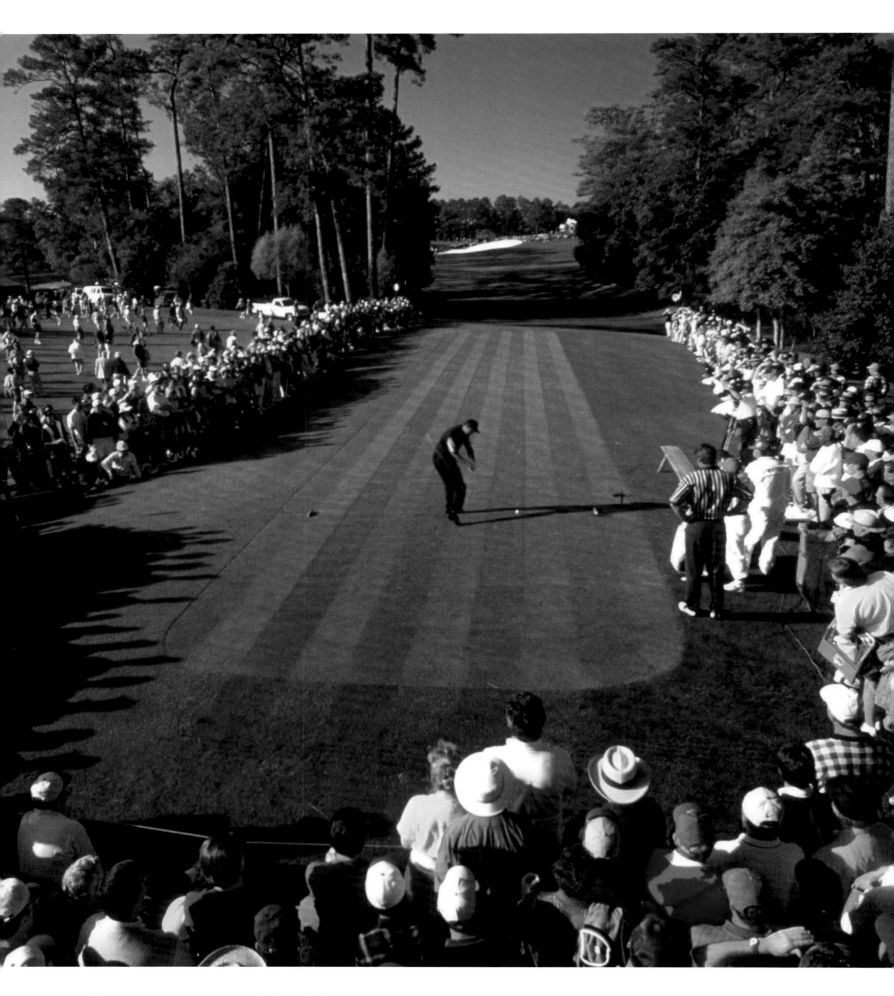

An all round picturesque course—not only the final 18th

Ein Platz wie ein Gemälde – nicht nur an der finalen 18

AUGUSTA NATIONAL

USA

Augusta is the most exclusive golf club in the world: its eighteen perfectly manicured greens are open to no more than three hundred privileged members. The waiting list is reportedly two thousand names long and includes ex-presidents and some of the world's richest men. Reportedly American golfers would forfeit a year of sex for a single game on this course.

After all, Augusta National Golf Club is not only the most exclusive but also one of the most beautiful places in the USA, as becomes evident every April when the flowers

Es gibt keinen exklusiveren Club. Die 18 perfekt manikürten Bahnen des Augusta National Golf Club sind 300 Privilegierten vorbehalten. Die Warteliste soll 2000 Namen umfassen, darunter Ex-Präsidenten und Männer, die zu den reichsten der Welt gehören. Angeblich würden golfende Amerikaner, bloß um nur ein einziges Mal dort spielen zu können, ein Jahr lang auf Sex verzichten.

Denn der Augusta National Golf Club ist nicht nur der exklusivste, sondern auch der schönste Platz der USA, wie sich jedes Jahr im April zeigt, wenn die Blumen blühen und

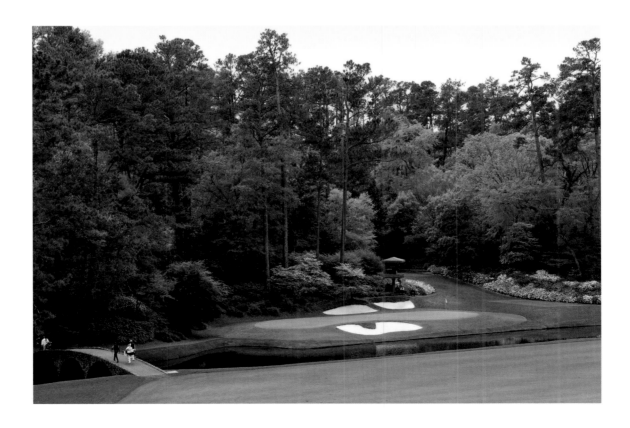

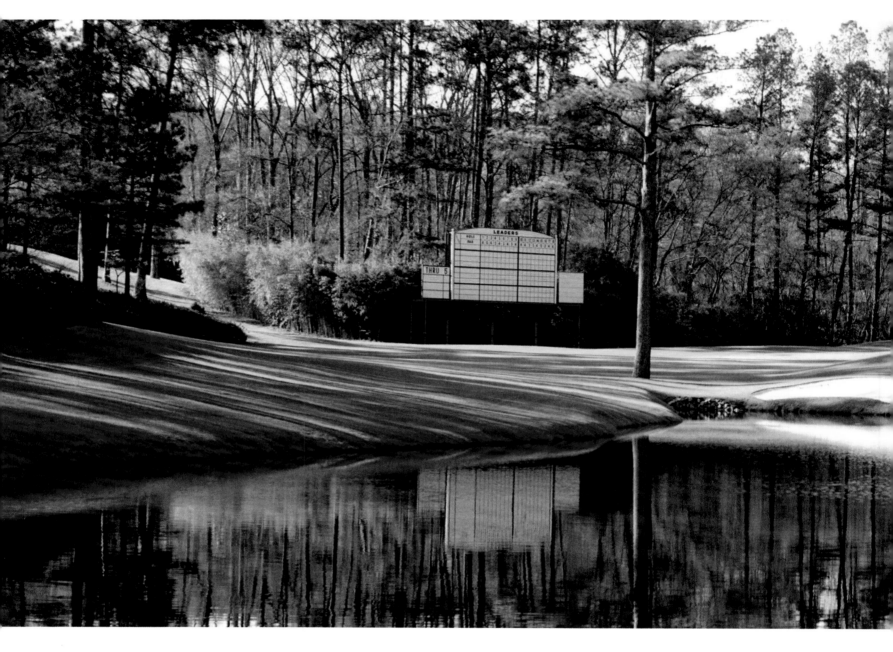

For most golfers a round at Augusta will remain only a dream

Für die meisten Golfer wird die Runde in Augusta ein Traum bleiben.

bloom and the world's best golfers compete for the Masters title, the only major championship held at the same location every year. Founded by golf legend Bobby Jones and businessman Clifford Roberts, every year the course plays host to some incredible spectacles—particularly around the last 9 holes, e.g. the notoriously tricky Amen Corner with its short 12th, where winners regularly score a double bogey, or the 13th and 15th, two par-5 holes, open to anything from an eagle to a triple bogey.

Though a Masters champion is granted honorary membership, this is a long way off from becoming a real member. The famed Green Jacket bestowed upon the winner may be taken home—but must be returned to the club the following year. Only Gary Player and Severiano

die besten Golfer der Welt um den Titel beim US Masters kämpfen – das einzige Major-Turnier übrigens, das stets auf demselben Course stattfindet. Golflegende Bobby Jones gründete gemeinsam mit Geschäftsmann Clifford Roberts diesen Platz, und besonders die letzten neun Bahnen bieten jedes Jahr aufs Neue unglaubliche Dramen. Da wäre etwa die schwierige Amen Corner mit der kurzen 12, an der die Führenden dennoch häufig Doppel-Bogeys kassieren, oder die 13 und die 15, zwei Par-5-Löcher, die für jeden Score zwischen Eagle und Desaster gut sind.

Selbst Masters-Champions werden nicht Mitglied, sondern Honorary Members, ein wichtiger Unterschied. Das legendäre grüne Jackett, das der Sieger übergestreift bekommt, darf mit nach Hause genommen, muss im Folge-

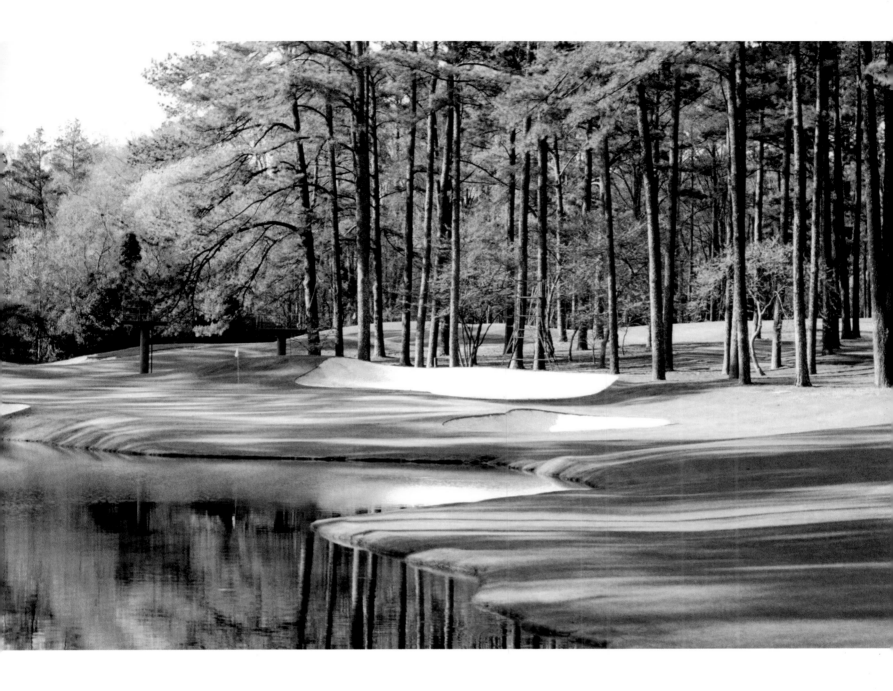

Ballesteros chose to keep their jackets at home in the closet. The idea for a jacket for each member came from Clifford Roberts, who was tired of his millionaire friends trying to outshine each other in the clubhouse with their latest suits and shirts.

Though playing a round at Augusta is no easy feat, for a member's guest who receives a tee time, the pleasure is free—the only charge being a tip for the caddie.

➤ USA, Augusta, Georgia, www.augusta.com

jahr aber wieder im Club abgegeben werden. Nur Gary Player und Severiano Ballesteros behielten ihre Exemplare lieber daheim im Schrank. Das Jackett, das jedes Mitglied tragen darf, war eine Idee von Clifford Roberts, der es satthatte, dass sich seine Millionärsfreunde im Clubhaus mit ihren neuesten Anzügen und Hemden zu übertreffen versuchten.

Es mag zwar schwierig sein, überhaupt eine Runde in Augusta zu drehen, doch wer als Gast eines Mitglieds eine Startzeit bekommt, für den ist das Vergnügen umsonst. Einziger Kostenpunkt: das Trinkgeld für den Caddie.

➤ USA, Augusta, Georgia, www.augusta.com

THE BIG SIX

The Major Tournaments
Die bedeutendsten Turniere

THE US MASTERS

The Masters is the first of the four major championships of the year, and the only one always played on the same course: the Augusta National Golf Club. One of the most beautiful and exclusive courses in the world, it was founded by golf legend Bobby Jones in his home state of Georgia. No other course looks as inviting on television, as does Augusta in Spring; flowers blooming around the holes, lush green fairways, and bunker sands glistening white as snow. Not to mention the—notoriously fast—undulating greens.

DAS US MASTERS

Es ist das erste der vier Major-Turniere des Jahres – und das einzige, das stets auf demselben Platz ausgetragen wird, dem Augusta National Golf Club, einem der schönsten und exklusivsten Plätze der Welt, gegründet von Golflegende Bobby Jones in seinem Heimatstaat Georgia. Kein Platz sieht im Fernsehen verlockender aus als Augusta im April, wenn die Blumen rund um die Löcher blühen, die Fairways saftig grün sind und der Bunkersand schneeweiß glitzert. Eine besondere Herausforderung sind die schnellen, extrem ondulierten Grüns.

Tony Finau of the United States and Bernhard Langer of Germany take a stroll along the blossoming fairways of Augusta National Golf Club on April 5, 2018

Tony Finau aus den USA und Bernhard Langer aus Deutschland flanieren am 5. April 2018 vor der Blumenpracht über die Fairways vom Augusta National Golf Club.

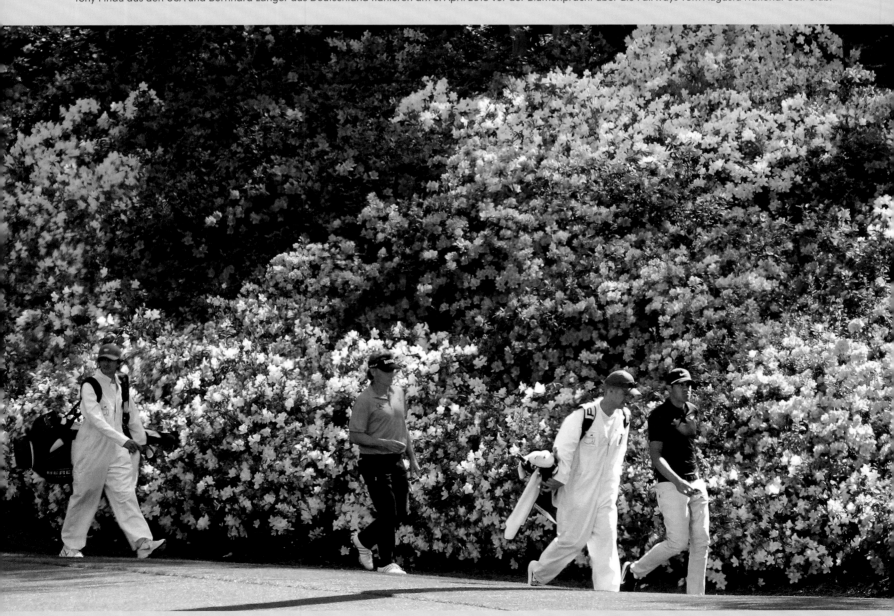

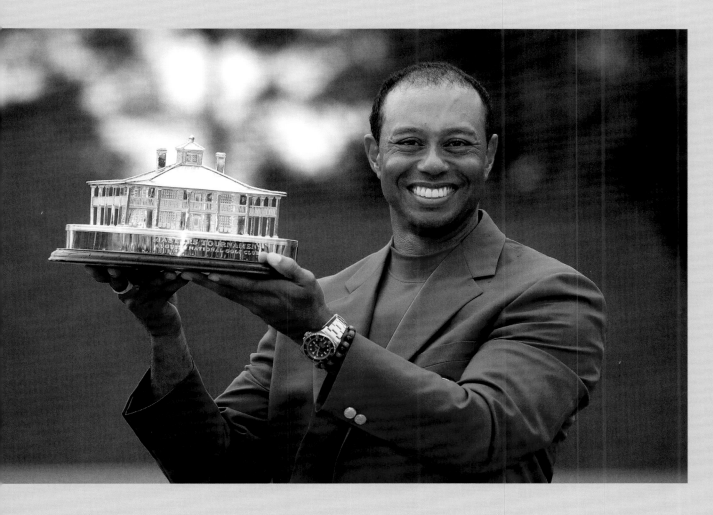

Tiger Woods sporting the Green Jacket and holding up the Masters Trophy, after winning the Masters on April 14, 2019 in Augusta

Tiger Woods im grünen Jackett zeigt stolz die Trophäe nach dem Gewinn des Masters am 14. April 2019 in Augusta.

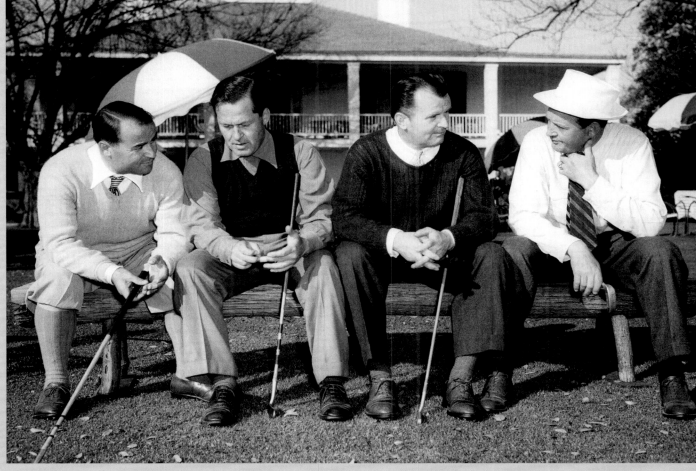

Gene Sarazen, Bobby Jones, and Ed Dudley sitting on a pine bench in front of the clubhouse

Gene Sarazen, Bobby Jones und Ed Dudley sitzen auf einer Kiefernbank vor dem Clubhaus.

Page 50: Horton Smith wins the Masters, beating Craig Wood by one stroke, 1934

Seite 50: Horton Smith gewann das Masters mit einem Schlag gegen Craig Wood, 1934

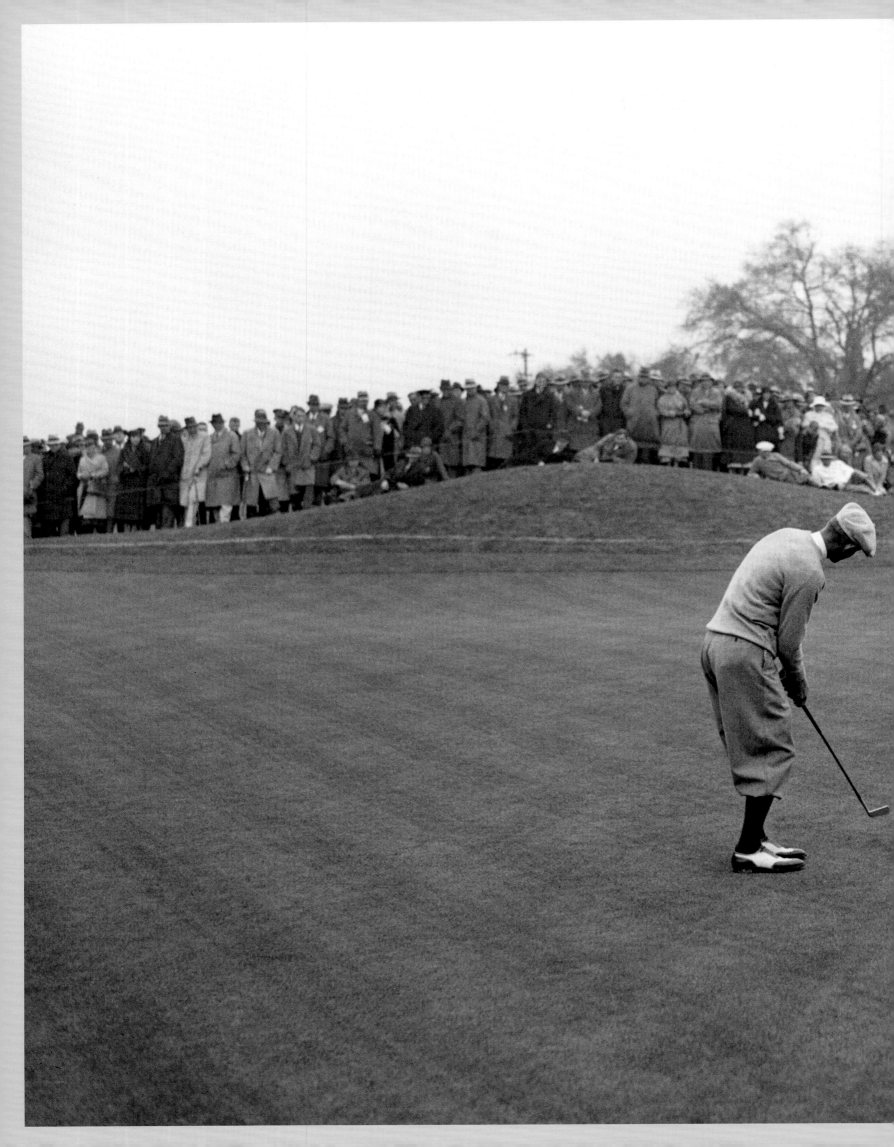

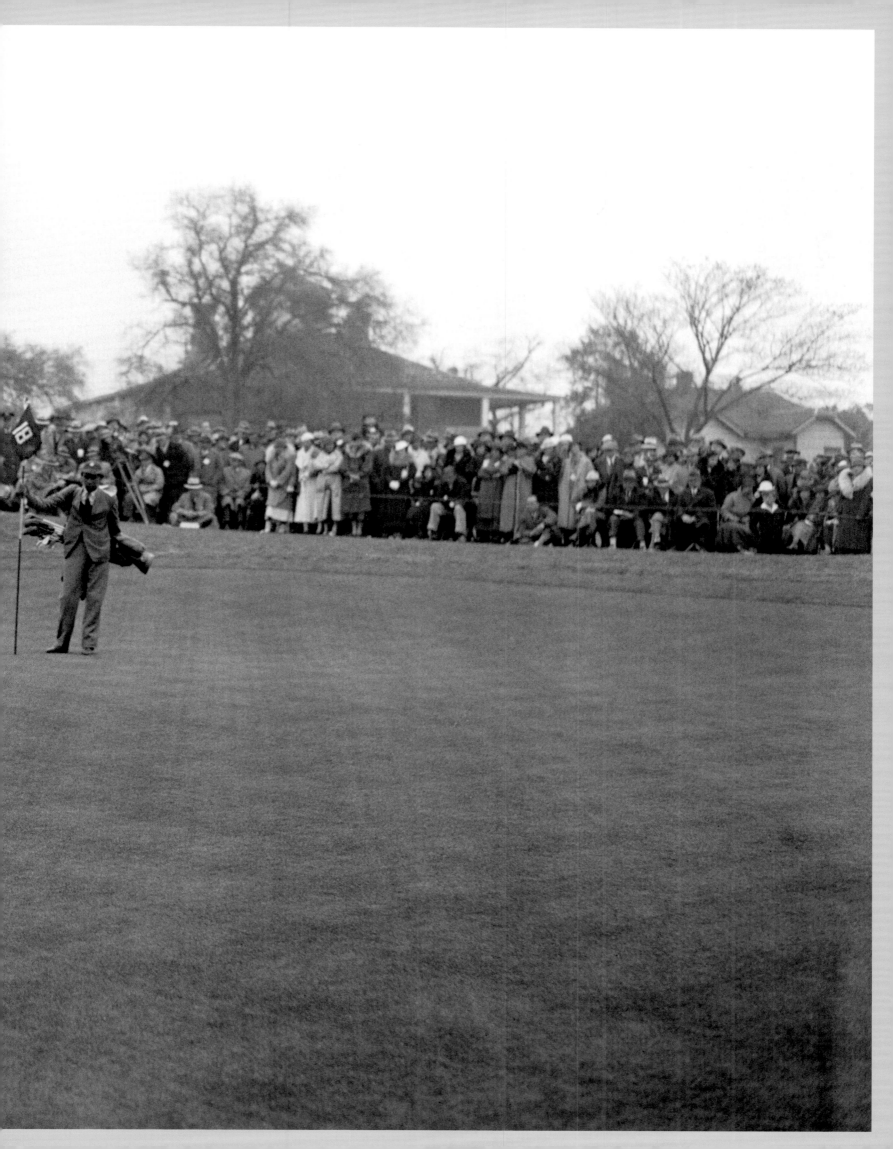

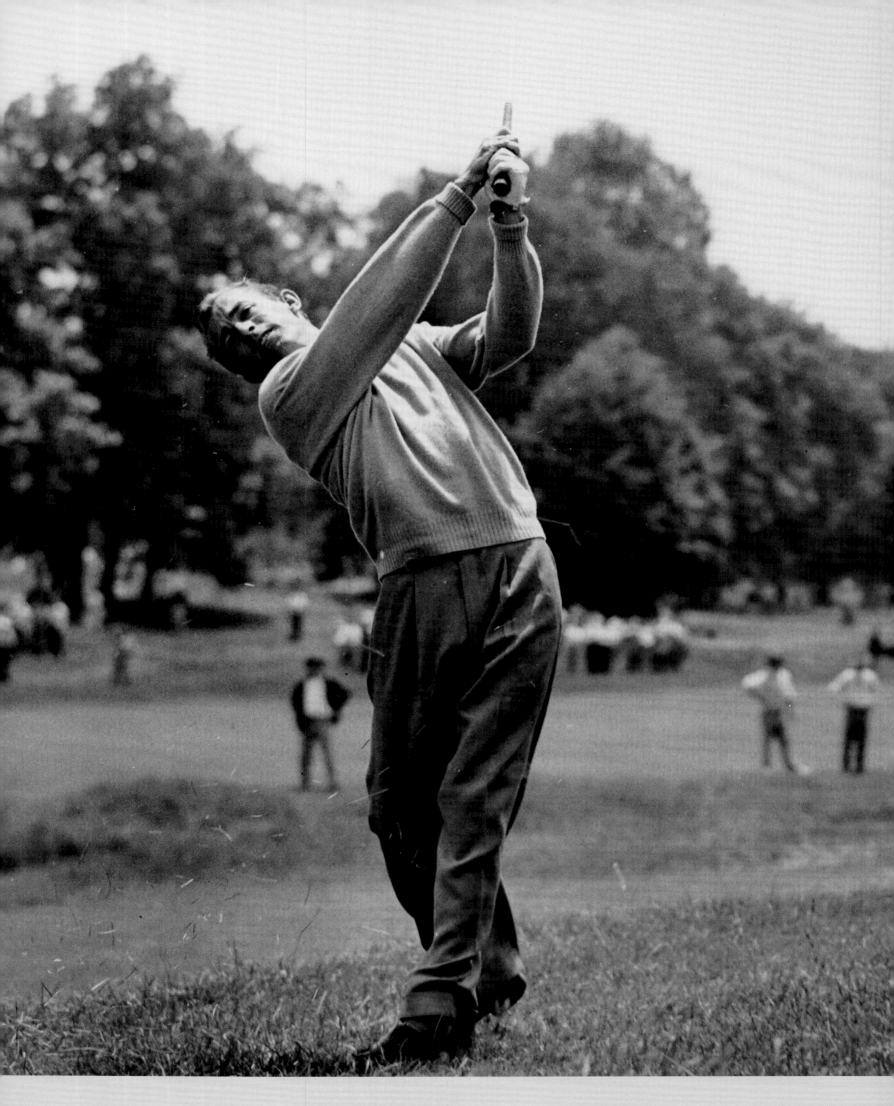

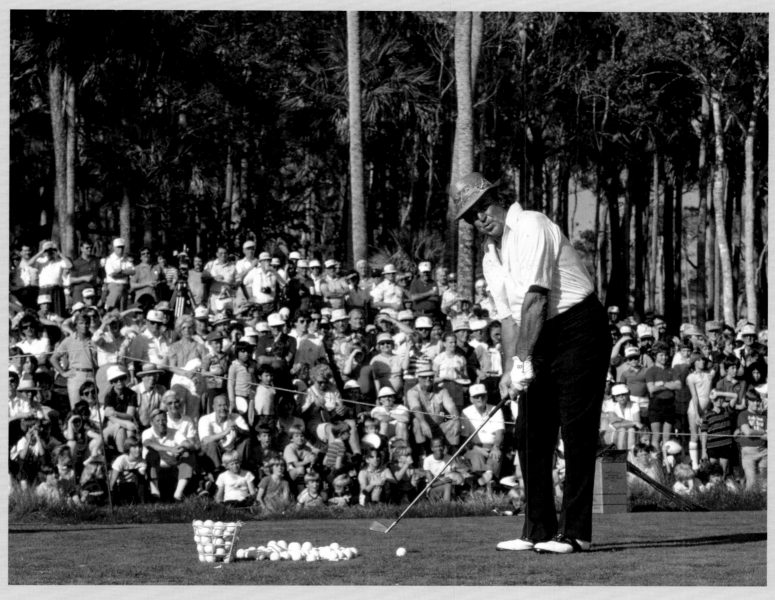

A stunning swing in action: Sam Snead hits the ball

Der schönste Schwung in Aktion: Sam Snead spielt den Ball.

THE US PGA CHAMPIONSHIP

Formerly held in August, the US PGA has from 2019 been moved to May making it the season's second major tournament. Despite its significance the championship has an image problem: it is considered the weakest of all four majors. This wasn't always the case, particularly when it was still a match play event. A return to the man-on-man duel is often debated, but TV companies warn against it: too much of a risk of should a superstar suffer defeat early in the tournament.

DIE US PGA CHAMPIONSHIP

Das zweite der vier Major-Turniere fand lange im August statt, doch seit 2019 hat man es in den Mai vorgezogen. Die PGA Championship hat nämlich trotz ihrer Bedeutung ein Imageproblem; die Meisterschaft gilt immer als schwächstes der vier Majors. Das war früher anders, als es noch im Matchplay-Modus ausgetragen wurde. Eine Rückkehr zu den Mann-gegen-Mann-Duellen wird immer wieder diskutiert, auch wenn TV-Verantwortliche davon abraten – es wäre ein zu hohes Risiko, wenn Superstars früh scheitern würden.

Bob Toski at Baltusrol Golf Club, 1954. Sam Snead gave him the nickname "Mouse"

Bob Toski im Baltusrol Golf Club, 1954. Sam Snead gab ihm den Spitznamen „Mouse".

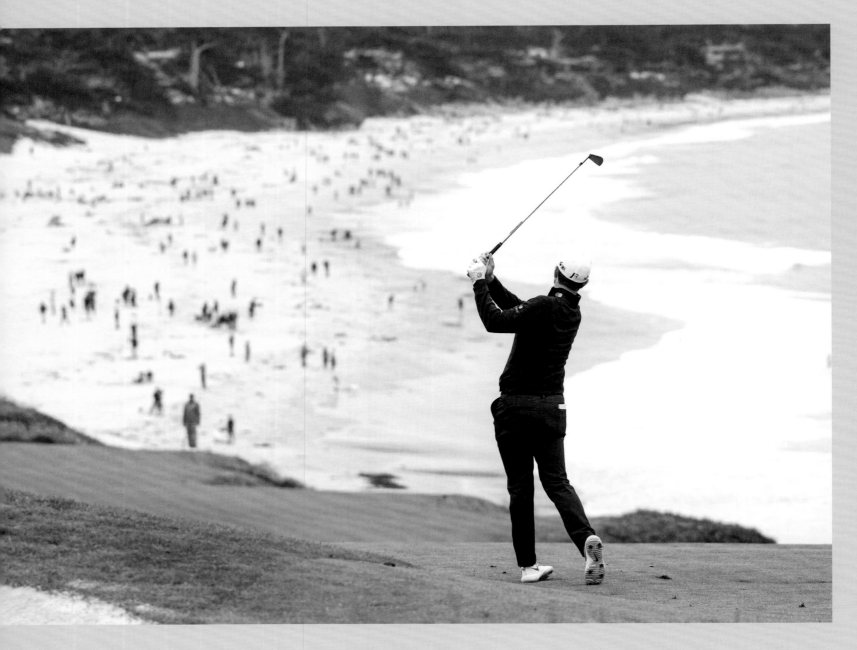

Justin Rose of England during the final round on June 16, 2019 at Pebble Beach

Der Engländer Justin Rose während der Finalrunde am 16. Juni 2019 in Pebble Beach

THE US OPEN

Traditionally, the US Open is the toughest major tournament, where a score close to par is enough to win. Every year the setup is brutal, even questionable, and sometimes downright unfair. The pros readily admit this is the most anxiety-inducing tournament, with every hole a source of stress and the dangers of a disastrous score lurking all around. "We're not trying to humiliate the best players in the world," Sandy Tantum, chairman of the competition committee famously said. "We're simply trying to identify who they are."

DIE US OPEN

Traditionell das härteste Major-Turnier, wo oft schon ein Score um Par herum ausreicht, um zu gewinnen. Das Set-up ist jedes Jahr extra schwierig, teilweise sogar grenzwertig und manchmal geradezu unfair. Pros gestehen, dass sie vor keinem Turnier nervöser sind – weil jedes Loch Stress pur bedeutet und die Gefahr eines desaströsen Scores überall lauert. Einmal beschwerte sich ein Spieler bei den Veranstaltern: »Wollt ihr die besten Spieler der Welt demütigen?« Die kühle Antwort: »Nein, wir wollen sie erkennen.«

Arnold Palmer and Jack Nicklaus with drivers, 1962

Arnold Palmer und Jack Nicklaus zeigen ihre Driver, 1962.

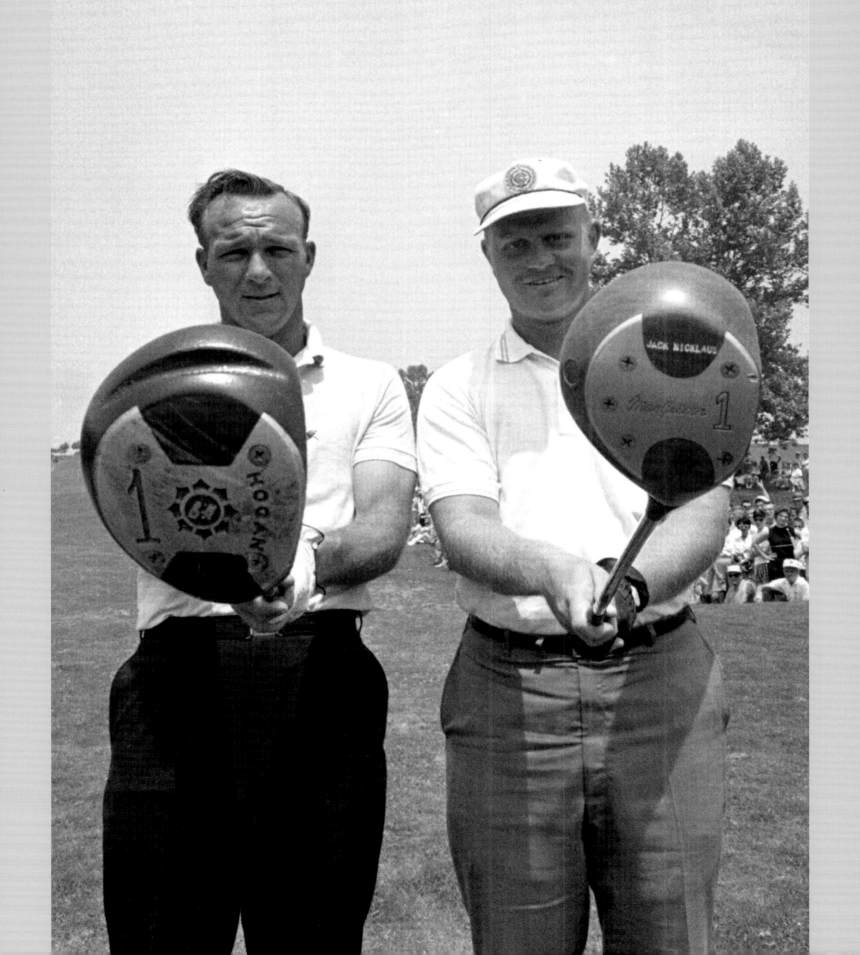

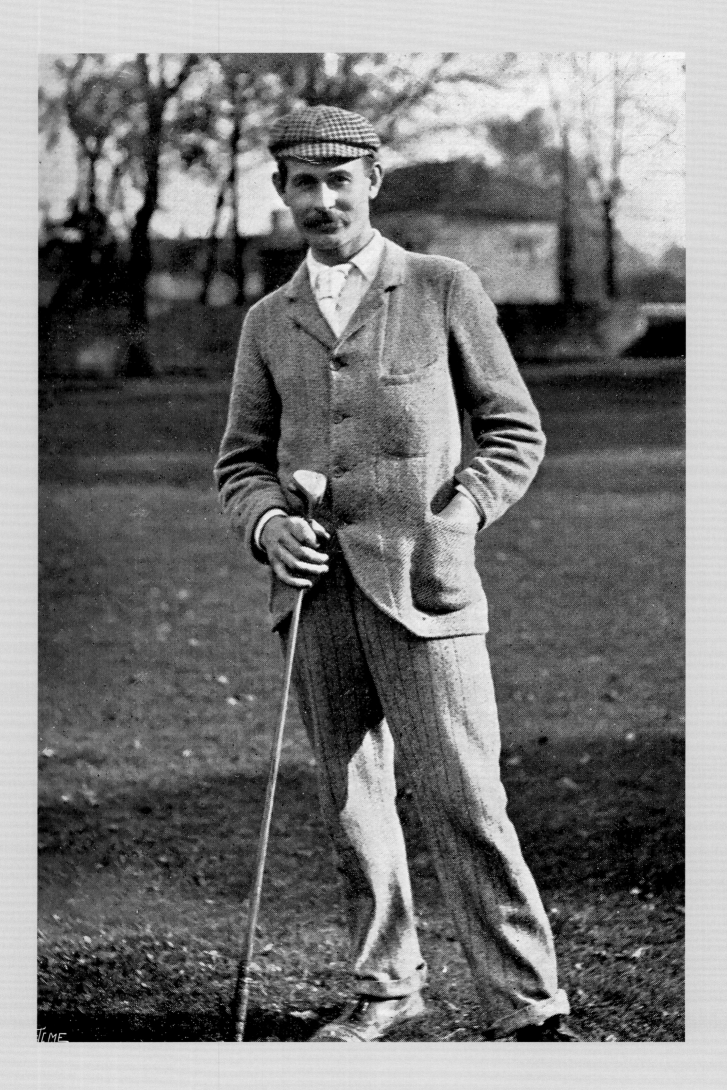

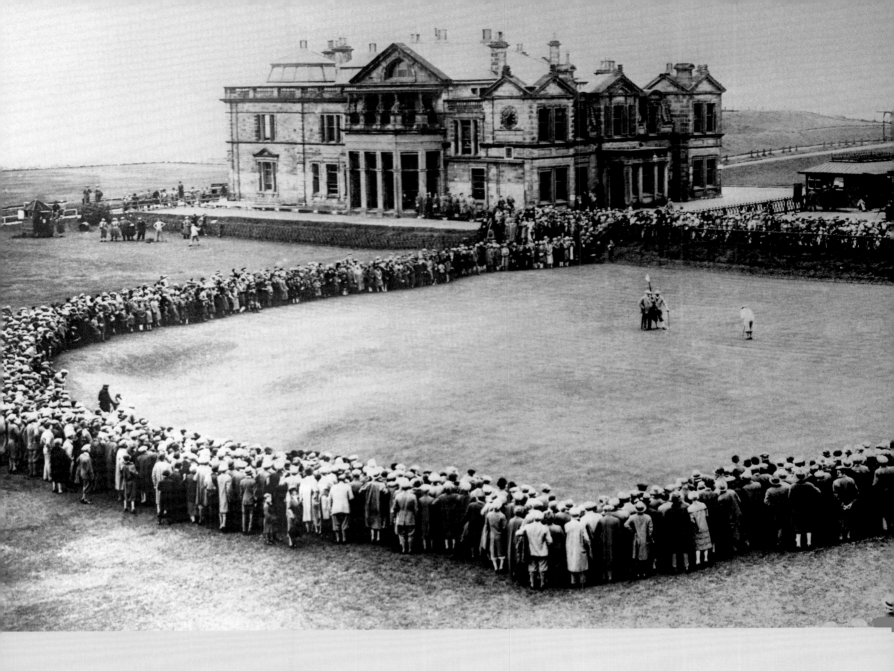

THE BRITISH OPEN

The most traditional of golf tournaments has been going since 1860, thus making it the oldest sporting event still running today. The Open Championship, as it is officially called, is held in England or Scotland, and in 2019, Northern Ireland rejoined the host community once again. In no other tournament does wind and weather set such a crucial challenge: who can best take on the elements? The winner receives the prestigious silver Claret Jug (see page 64), immortalizing him among British golf enthusiasts.

DIE BRITISH OPEN

Das traditionsreichste Golfturnier findet seit 1860 statt und ist damit eines der ältesten bis heute ausgetragenen Sportereignisse überhaupt. Meistens findet die Open Championship, so der offizielle Name, in England oder in Schottland statt, seit 2019 ist auch Nordirland wieder in den Gastgeberkreis aufgenommen. Bei keinem Turnier sind Wind und Wetter so entscheidende Faktoren – wer kann am besten mit den Elementen umgehen? Der Sieger bekommt die berühmte Silberkanne Claret Jug (siehe S. 64) und macht sich bei den golfbegeisterten Briten unsterblich.

In 1896, Harry Vardon won the first of six Open Championships—a number yet to be beaten

1896 gewann Harry Vardon seine erste von sechs Open Championships. Dieser Rekord ist bis heute unerreicht geblieben.

First qualifying round of the Open Championship at St Andrews, with E.R. Whitcombe and Bobby Jones, 1927

Die erste Qualifikationsrunde der Open Championship in St. Andrews zeigt E. R. Whitcombe und Bobby Jones, 1927.

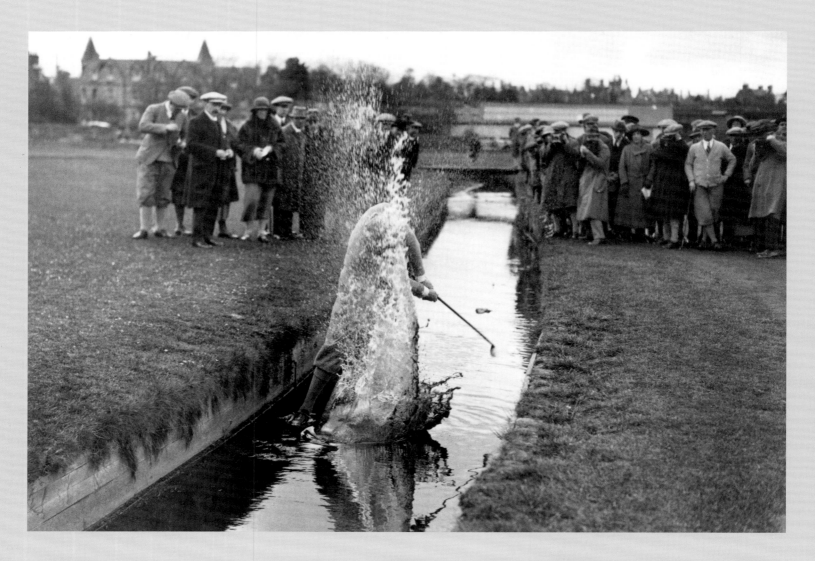

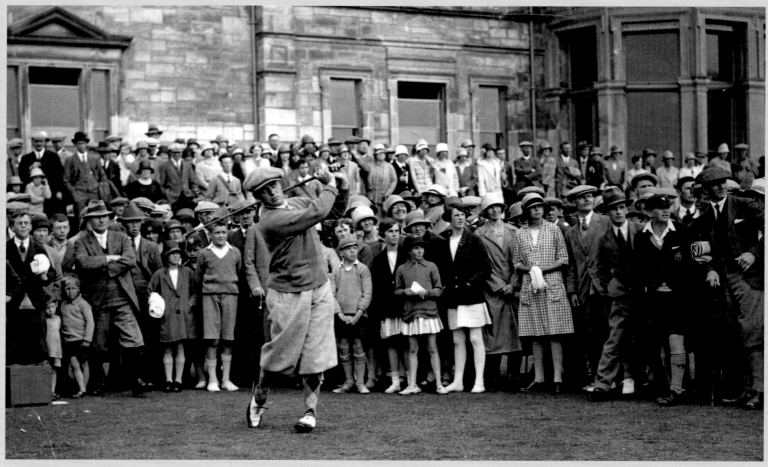

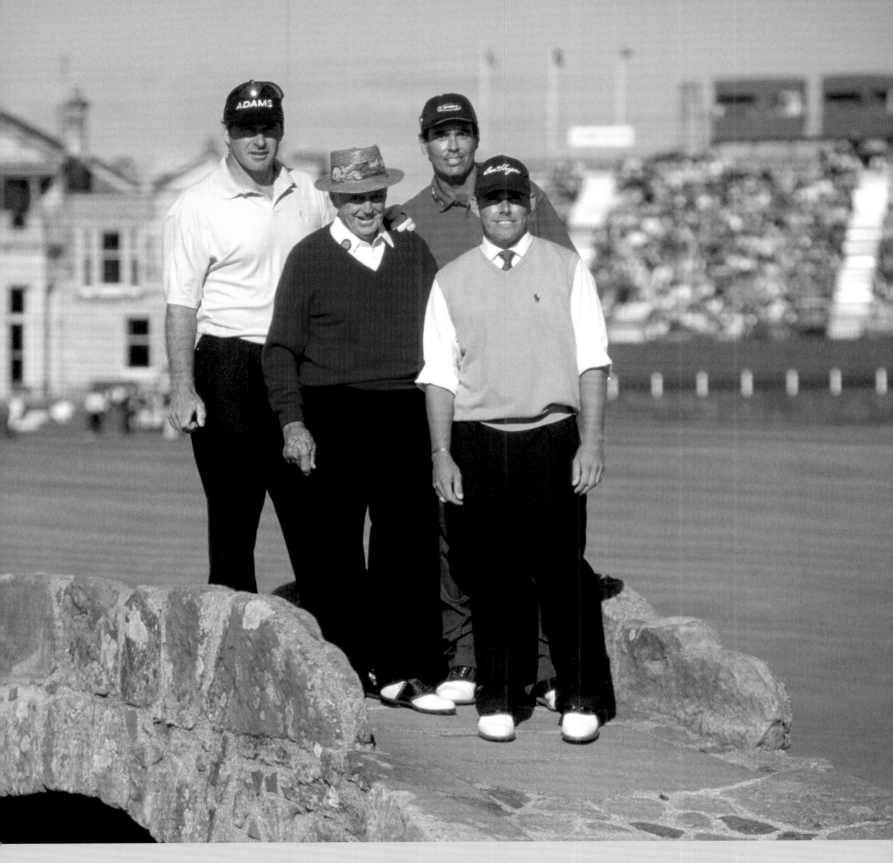

Left to right: Nick Faldo, Sam Snead, Ian Baker-Finch, and Justin Leonard pose on the famous Swilcan Bridge at St Andrews Golf Club in Scotland, 2000

Von links nach rechts posieren Nick Faldo, Sam Snead, Ian Baker-Finch und Justin Leonard auf der berühmten Swilcan-Brücke auf dem Old Course in St. Andrews, 2000.

Jack Neville takes a shot from a burn at St Andrews golf course

Jack Neville schlägt einen Ball aus dem Wassergraben in St. Andrews.

In front of the clubhouse in St Andrews Bobby Jones can be seen teeing

Vor der Kulisse des Clubhauses in St. Andrews ist Bobby Jones beim Abschlag zu sehen.

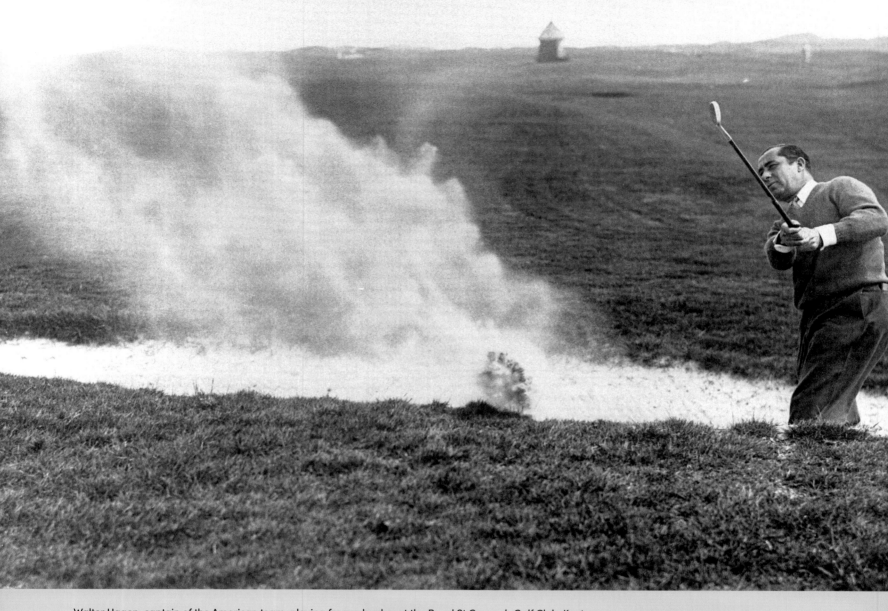

Walter Hagen, captain of the American team, playing from a bunker at the Royal St George's Golf Club, Kent

Walter Hagen, Kapitän der US-amerikanischen Mannschaft, spielt in einem Bunker im Royal St. George's Golf Club in Kent.

THE RYDER CUP

The Ryder Cup began in 1927 as a team competition between the USA and Great Britain and later Ireland; then, in 1979, it became a match between the US and Europe. Every two years the twelve best golfers step up to the challenge amidst a heated atmosphere reminiscent of a soccer stadium. It's not about the money—the winner doesn't get a dime—it is a matter of honor. And ratings are higher than at any other golfing event. In recent years, the Americans were always the favorites, and yet time again they've had to concede to the European's team spirit

DER RYDER CUP

Seit 1927 ein Teamvergleich zwischen den USA und Großbritannien, später kam Irland hinzu, und seit 1979 ist daraus ein Match zwischen den USA und Europa geworden. Die jeweils besten zwölf Golfer treten alle zwei Jahre in aufgeheizter Atmosphäre gegeneinander an, die Stimmung ähnelt der in einem Fußballstadion. Es geht nicht um Preisgeld – es gibt nämlich keinen einzigen Cent –, sondern nur um die Ehre. Die Einschaltquoten sind höher als bei jedem anderen Golfereignis. In den letzten Jahren galten stets die US-Amerikaner als Favoriten, jedoch mussten sie sich immer wieder dem Teamspirit der Europäer geschlagen geben.

The Ryder Cup Trophy in front of the Greenbrier Golf Resort, 1979

Die Ryder-Cup-Trophäe vor dem Greenbrier Golf Resort, 1979

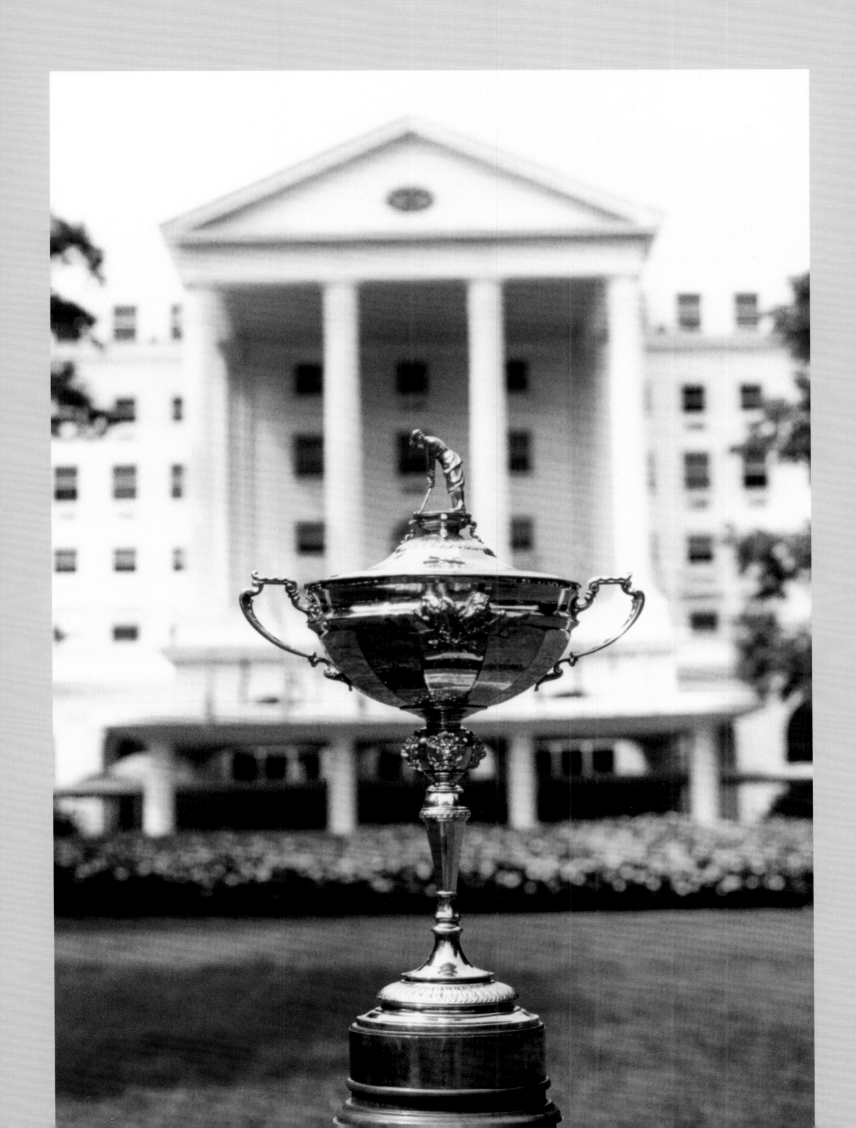

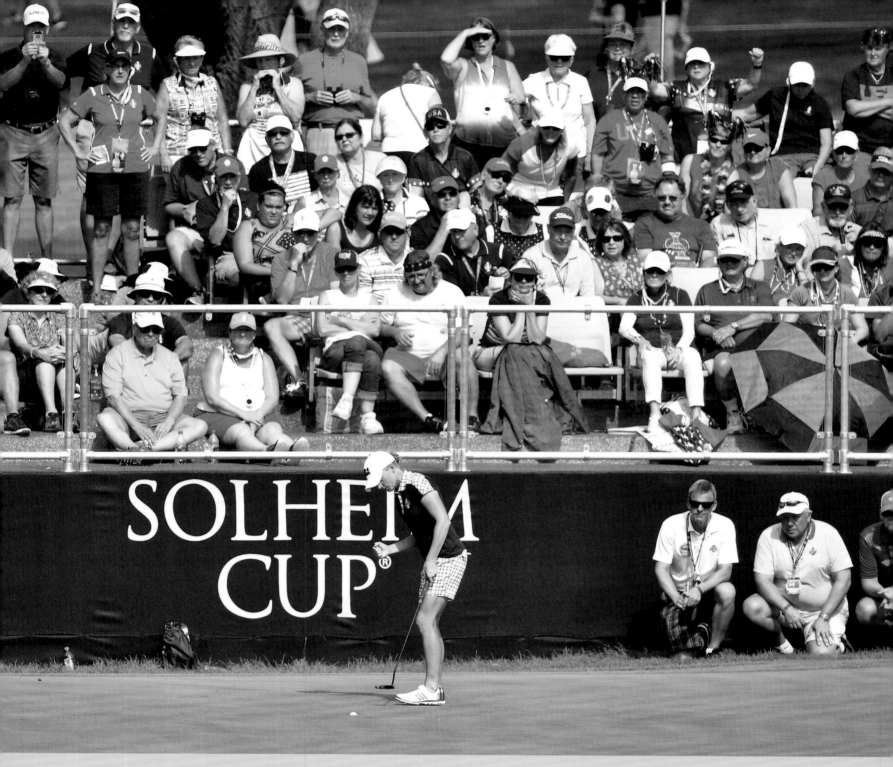

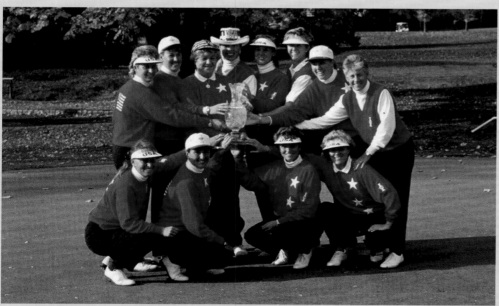

Stacy Lewis of Team USA holes a putt during
The Solheim Cup in Des Moines, 2017
Stacy Lewis vom Team USA spielt einen Putt
während des Solheim Cups in Des Moines, 2017.

Greenbrier Golf—victorious American Solheim
Cup team, 1994
Greenbrier Golf – das siegreiche amerikanische
Solheim-Cup-Team 1994

THE SOLHEIM CUP

The Solheim Cup, the women's equivalent of the Ryder Cup, began in 1990 and follows similar rules to the men's game. The idea for a women's Ryder-style cup came from club manufacturer Karsten Solheim (Ping). Although the Solheim Cup can't look back on as long a tradition as the Ryder cup, players and fans are just as emotionally involved—for here too it's not about the money. The event is hugely popular and ratings also soar. Here however, the US has so far seen more successes than Europe.

DER SOLHEIM CUP

Die Damenvariante des Ryder Cups wird seit 1990 nach ähnlichen Regeln wie bei den Herren ausgespielt. Die Idee zu einem weiblichen Ryder Cup hatte der Schlägerhersteller Karsten Solheim (Ping). Obwohl das Turnier noch nicht auf so eine lange Tradition wie der Ryder Cup zurückblicken kann, kochen die Emotionen bei Spielerinnen und Fans ähnlich hoch, dabei geht es auch hier nicht um Preisgeld. Das Zuschauerinteresse ist ebenfalls enorm. Meistens hatten die US-Damen die Nase vorn.

JoAnne Carner and Mickey Walker present the Solheim Cup at the Greenbrier Golf Resort, 1994

JoAnne Carner und Mickey Walker päsentieren den Solheim-Cup vor dem Portal des Greenbrier Golf Resort, 1994.

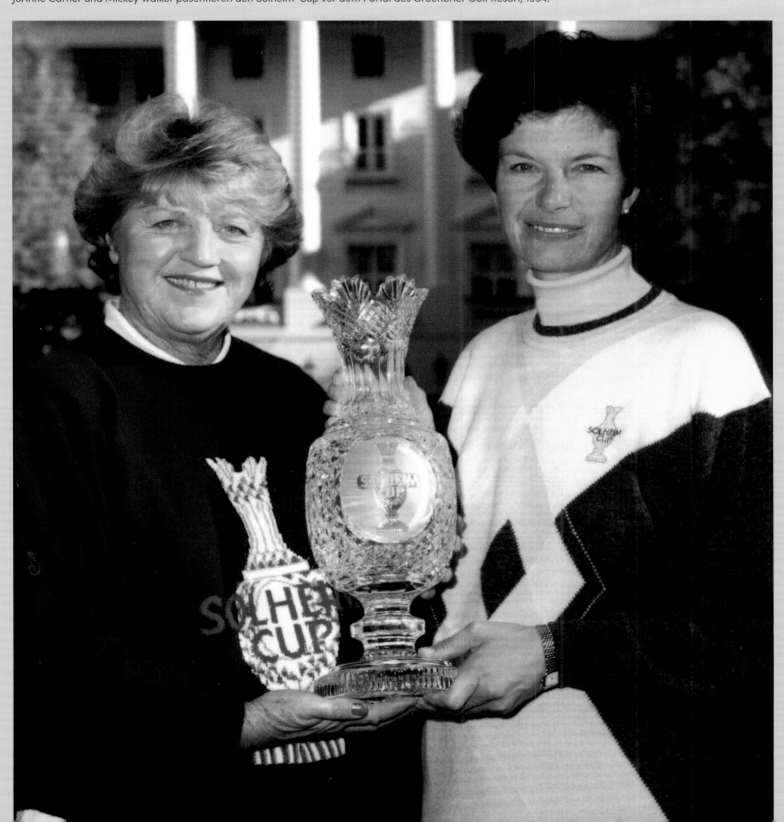

THE CLARET JUG
Golf´s Most Famous Prize
Die berühmteste Kanne der Golfwelt

Much like boxers, the first Open winners where adorned with championship belts: red leather with silver buckles. Having completed a hat trick (see also page 30), Young Tom Morris was allowed to keep his belt, so now a new trophy was needed. Silversmiths Mackay, Cunningham & Co from Edinburgh made a jug for the occasion worth 30 pounds. However, as the 1872 Open was a last minute affair the jug was not completed in time for Young Tom Morris' fourth victory—but his name was nonetheless the first to be engraved.

No champion is allowed to keep the Claret Jug for longer than a year, and the original never leaves the premises of the Royal and Ancient. The jug the winner hoists above his head is a replica—albeit almost of equal value—that must be returned in time for the next Open tournament. However, titleholders are permitted to have their own, slightly smaller, replicas made.

The silversmith has to work quickly because the winner of the Open is awarded the trophy with their name already engraved upon it. People enjoy speculating at what point during the final round the engraver gets to work. It is said that in 1999, the engraver had already started inscribing "Jean Van de Velde" on the jug, when the Frenchman was still on the fairway. When Mark Calcavecchia won the Open in 1989, the first thing he said was: "How's my name going to fit on that thing?"

Die ersten Open-Sieger schmückten sich wie Boxer mit einem Championship-Gürtel aus rotem Leder mit silberner Schnalle. Als Young Tom Morris die Open zum dritten Mal hintereinander gewann (siehe auch S. 30), durfte er den Gürtel behalten; eine neue Trophäe musste her. Die Silberschmiede Mackay Cunningham & Company aus Edinburgh fertigte eine Kanne an. Kosten: 30 Pfund. Weil aber die Open 1872 erst in letzter Minute zustande kamen, wurde die Kanne nicht rechtzeitig zu Young Tom Morris' vierten Sieg fertig – dennoch ist sein Name als erster eingraviert.

Kein Champion darf die Claret Jug länger als ein Jahr behalten; das Original verlässt ohnehin nie die Räumlichkeiten des Royal and Ancient, der Sieger stemmt ein – beinahe ebenso wertvolles – Replikat in die Höhe, das er aber vor dem nächsten Open-Turnier zurückgeben muss. Er darf aber seinerseits Replikate in Auftrag geben, die allerdings etwas kleiner als das Original sein müssen.

Der Silberschmied muss fix arbeiten, denn der Open-Champion erhält die Kannentrophäe bereits bei der Siegerehrung mit seinem darauf eingravierten Namen. Es ist beliebt, zu spekulieren, wann wohl mit den Gravurarbeiten in der Schlussrunde begonnen wird. So soll der Graveur 1999 angeblich bereits mit »Jean Van de Velde« begonnen haben, als der Franzose noch auf der Schlussbahn war. Und als Mark Calcavecchia 1989 die Open gewann, hat er als Erstes gesagt: »Wie um alles in der Welt wollen die meinen Namen auf das Ding bekommen?«

Open Champion Shane Lowry of Ireland celebrates with the Claret Jug at Royal Portrush Golf Club on July 21, 2019
Der irische Open-Sieger Shane Lowry feiert am 21. Juli 2019 mit der Claret Jug im Royal Portrush Golf Club.

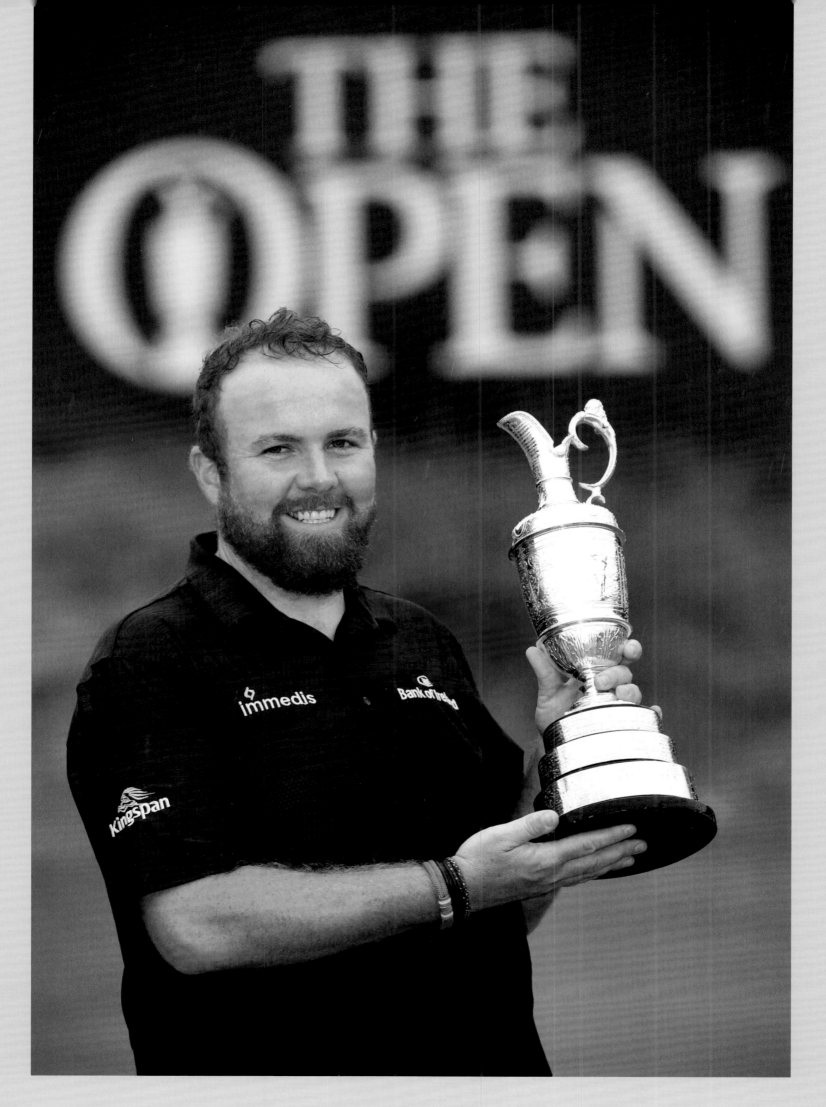

Ritzy, new, and tough: the golf gourmet's ideal destination

Edel, neu, schwierig: ein ideales Ziel für Golf-Gourmets

FINCA CORTESIN

SPAIN / SPANIEN

Finca Cortesín, the Andalusian newcomer, became an overnight sensation and has already hosted the Volvo World Match Play Championship and the European Tour several times over. Even top pros despair at the distances (e.g. at 494 yards, hole 7 is the longest par-4 on the Costa del Sol). Amateurs meanwhile encounter a whole new set of problems in the roughs around the green or on the dangerously-steep fairways. Masochists seeking a real challenge can play from the black tee boxes. With a rating of 75.3, Finca Cortesín is one of the most difficult courses in

Der andalusische Neuling hat sofort für Aufsehen gesorgt. Mehrere Male fanden hier die Volvo Matchplay Championship der European Tour statt, und auch die besten Pros verzweifeln an der Länge der Bahnen (Nummer 7 ist mit 452 Metern das längste Par 4 der Costa del Sol), während die Amateure am Rough rund ums Grün oder an so manchen dramatisch abfallenden Fairways ganz neue Schwierigkeiten finden. Wer als Masochist die Herausforderung sucht, spielt von den schwarzen Abschlägen, denn mit einem Course Rating von 75,3 zählt Finca Cortesin

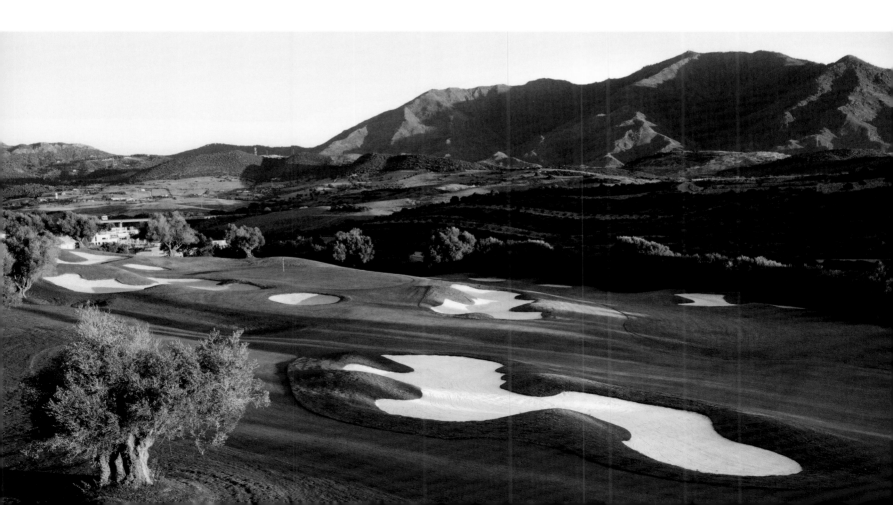

Tasteful interiors and tasty cuisine

Geschmackvolle Einrichtung, noch geschmackvollere Küche

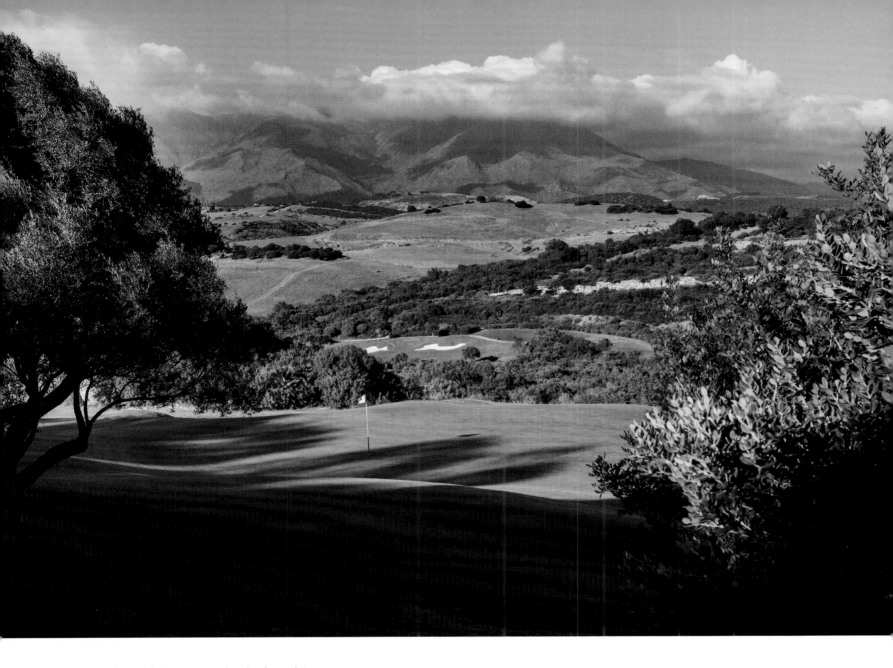

Long rounds, undulating greens—there's a lot to do!

Lange Bahnen, ondulierte Grüns – es gibt viel zu tun!

Europe. Even starting from a white teeing ground par-3 is over 200 yards, par-4 close to 440 yards, and par-5 almost 550 yards. Teeing off from red and yellow boxes doesn't save you from a traitorous bunker landscape with over a hundred hazards either. The steep fairways (e.g. at the 10th and 15th) lead to amazing moments in which you can watch your own ball fly through the air for what feels like minutes, only to land in a bunker like a smashed egg. The adjoining luxury Andalucían-style hotel, airy and opulent, is of the highest excellence throughout, whereby the kitchen's artful culinary creations deserve an extra mention.

➤ Spain, Casares, www.fincacortesin.com

von ganz hinten zu den schwierigsten Plätzen in Europa. Selbst von Weiß sind die Par 3 über 200, die Par 4 über 400 und die Par 5 über 500 Meter lang; doch auch von Gelb und Rot kommen die üppigen Bunkerlandschaften – es gibt mehr als 100 Sandhindernisse – ins Spiel. Dramatisch abfallende Bahnen (etwa an der 10 und der 15) sorgen für fantastische Spielerlebnisse, wenn man nämlich gefühlt minutenlang verfolgen kann, wie der eigene Ball durch die Luft saust – und als Spiegelei im Bunker landet. Das dazugehörige Luxushotel im luftig-opulenten andalusischen Stil ist in allen Belangen herausragend und verdient auch für seine raffinierten kulinarischen Kreationen ein Extralob.

➤ Spanien, Casares, www.fincacortesin.com

KIAWAH ISLAND

USA

Kiawah Island is an awe-inspiring luxury resort in South Carolina on the Atlantic with a large spa and altogether five golf courses, some designed by the legendary Jack Nicklaus and Gary Player. However, the resort's real claim to fame is the Pete-Dye's Ocean Course where in 1991 the "War on the Shore" was fought during a fierce Ryder Cup under strained conditions. Tensions built right up to the final few holes. Initially, US American Mark

Ein beeindruckendes Resort in South Carolina direkt am Atlantik mit allen Annehmlichkeiten, großem Spa und gleich fünf Golfplätzen, darunter von den Legenden Jack Nicklaus und Gary Player entworfene – doch berühmt ist Kiawah Island für seinen Ocean Course und die Dramen, die sich hier 1991 beim »War on the Shore«, beim „Krieg an der Küste" auf dem Pete-Dye-Design abspielten. Es war ein aufgeheizter Ryder Cup in feindseliger Atmosphäre. Es

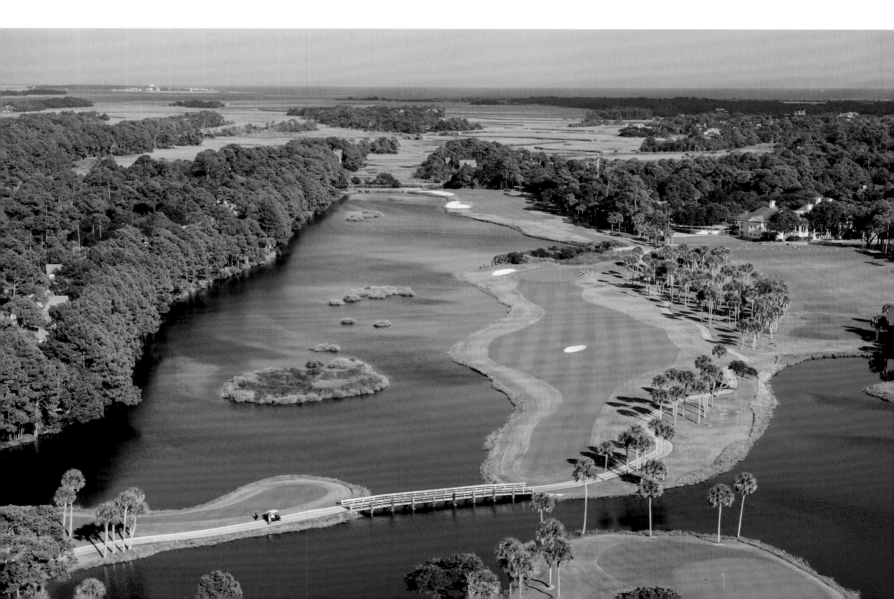

Calcavecchia was wiping the floor with Colin Montgomerie at four holes ahead with only four more to go. However, the brave Scot fought his way back into the competition winning holes 15 and 16. The 17th was a par-3, and Calc's nerves were beginning to show. A 3 iron is not a club you want to be using under pressure. And with it he achieved a perfect disaster: the ball travelled a whole 100 yards at knee-height—and then plopped into the water. Following that he gave away the 18th. Reportedly Calcavecchia spent the next hour alone, weeping on the beach. Now the final overall competition result rested on the last match between Hale Irwin and Bernhard Langer. Langer's six-foot putt touched the right side of the cup and then rolled on past. And with that, the US team won. "Nobody in the world would have made that putt under that pressure. Not even Jack Nicklaus in his prime," Severiano Ballesteros recalls.

➤ USA, South Carolina, www.kiawahresort.com

blieb dramatisch bis auf die letzten Löcher. Zunächst hatte der US-Amerikaner Mark Calcavecchia den Europäer Colin Montgomerie mit vier Löchern Vorsprung bei noch vier zu spielenden Löchern gegen die Wand gedrückt. Doch der tapfere Schotte kämpfte sich ins Match zurück und konnte die Bahnen 15 und 16 für sich entscheiden. Die 17 war ein Par 3, und »Calc« wurde zusehends nervöser. Ein Eisen 3 ist kein Schläger, den man in der Hand haben will, wenn man viel Druck spürt. Und er machte das Desaster perfekt: Der Ball flog kniehoch und 100 Meter weit, bevor er in einem Wasserhindernis verschwand. Anschließend gab Calcavecchia auch noch die 18 her; die Stunde danach verbrachte Calcavecchia heulend allein am Strand. Dann hing der Ausgang des gesamten Wettbewerbs vom letzten Loch im letzten Match von Hale Irwin gegen Bernhard Langer ab. Langers Putt aus zwei Metern rutschte im letzten Moment noch über die rechte Lochkante – das war der Sieg für Team USA. »Niemand hätte diesen Putt unter diesen Umständen gelocht, nicht einmal Jack Nicklaus zu seinen besten Zeiten«, sagte Severiano Ballesteros später.

➤ USA, South Carolina, www.kiawahresort.com

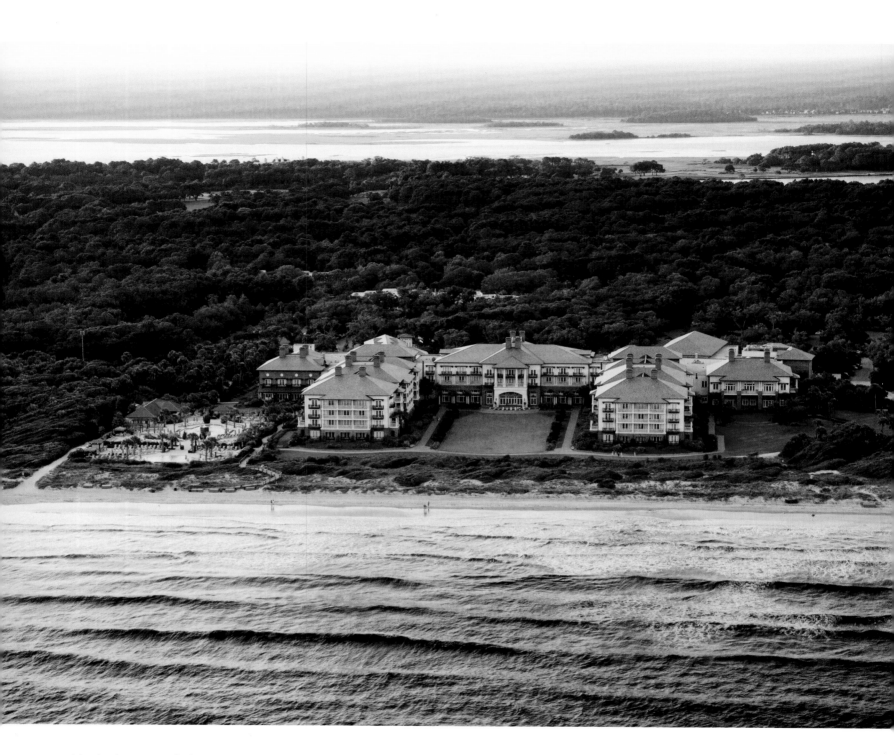

A fascinating course which made sports history

Der faszinierende Platz schrieb Sportgeschichte.

Tiger Woods gets out of a tricky situation, PGA Championship, 2012

Tiger Woods befreit sich bei der PGA Championship 2012 aus misslicher Lage.

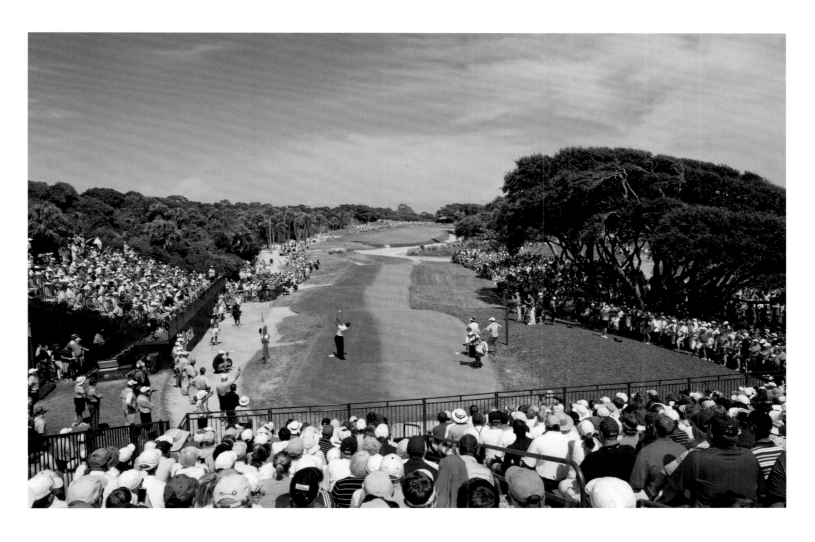

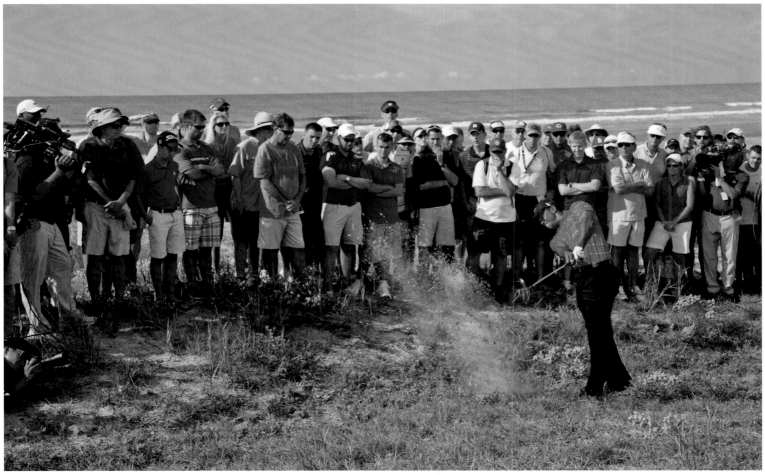

BEAR, TIGER, HAWK
The Best Players of all Times

BÄR, TIGER, FALKE
Die besten Spieler aller Zeiten

JACK NICKLAUS

Nicklaus has won more major titles than any other player: eighteen altogether, putting "The Golden Bear" at the top. He also came second nineteen times. No one played more consistently than the fair-haired fellow from Ohio. At age twenty he joined the tour, pulverizing the course with dynamic drives, playing his best games under pressure and rarely missing a crucial putt. His nerves of steel added to his ongoing dominance are impressive: for almost twenty-five years he was a golfer to be reckoned with, winning his last significant title at the US Masters in 1986 at forty-six years of age.

18 Major-Titel, mehr als jeder andere Spieler: Allein diese Zahl macht »The Golden Bear« zum Größten. Außerdem war er 19-mal Zweiter – niemand spielte konstanter als der Blondschopf aus Ohio, der als 20-Jähriger auf die Tour kam, mit seinen dynamischen Drives das Feld pulverisierte, besonders unter Druck stets sein bestes Golf spielte und kaum einen wichtigen Putt vorbeischob. Neben seiner Nervenstärke beeindruckt die Dauer seiner Dominanz: Fast 25 Jahre lang musste man mit ihm rechnen, seinen letzten großen Titel gewann er beim US Masters 1986 – als 46-Jähriger.

Augusta, Georgia: Jack Nicklaus (left) Arnold Palmer helps him into his second Green Jacket—symbolic of the Masters title, 1965

Augusta, Georgia: Arnold Palmer hilft Jack Nicklaus (links) in sein zweites Green Jacket – Symbol des Masters-Titels, 1965.

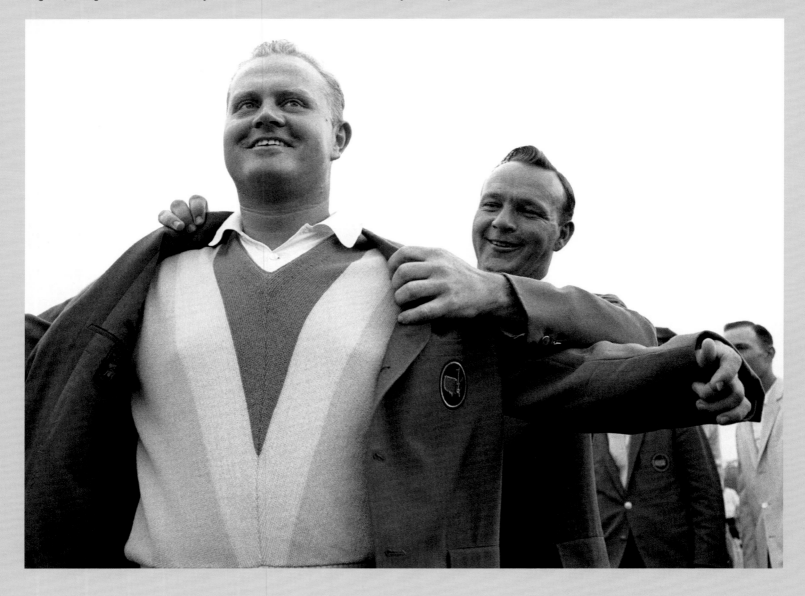

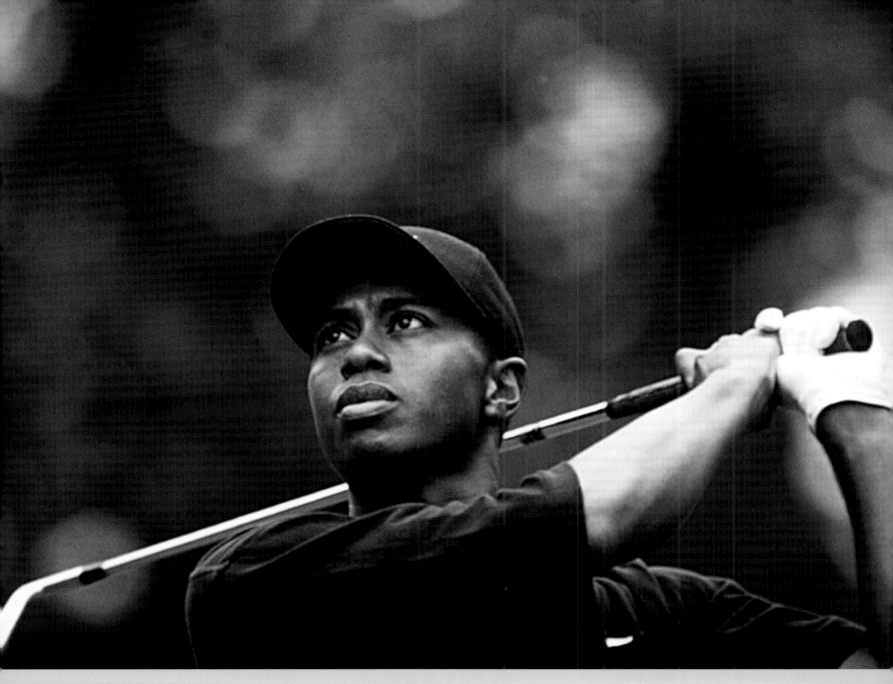

In 1997, Tiger Woods went on to win the US Masters at Augusta with a record score of 270, 18 under par.

Tiger Woods gewann 1997 das US Masters in Augusta mit einem Rekord von 270 Schlägen, 18 unter Par.

TIGER WOODS

It came as a shock to the golfing world: only twenty-one years old, Tiger Woods dominated the course as he pleased at the US Masters in 1997, setting a new score record. That weekend changed golf forever. The Tiger boom saw new courses popping up everywhere; ratings soared; prize money skyrocketed. The crowing moment of Woods' career was the "Tiger Slam" 2000/2001, when he won all four major titles in a row—albeit not in the same calendar year. After four back operations and some personal ups and downs Tiger's career appeared to be over. However in 2019, the forty-three-year-old secured his 15th major at the US Masters. Might he catch up with Jack Nicklaus after all?

Es war ein Schock für die Golfwelt: Der 21-jährige Tiger Woods dominierte das Feld beim US Masters 1997 nach Belieben und stellte zudem einen neuen Score-Rekord auf. Golf veränderte sich an jenem Wochenende für immer. Der Tiger-Boom ließ überall Plätze entstehen; Einschaltquoten und Preisgelder schossen in die Höhe. Die Krönung seiner Karriere war der »Tiger Slam« 2000/2001, als er alle vier Major-Titel hintereinander holte, wenn auch nicht im selben Kalenderjahr. Nach vier Rückenoperationen und privaten Turbulenzen schien Tigers Karriere vorbei zu sein, doch im Frühjahr 2019 gewann der 43-Jährige sensationell sein 15. Major, wiederum beim US Masters. Wird er Jack Nicklaus doch noch einholen?

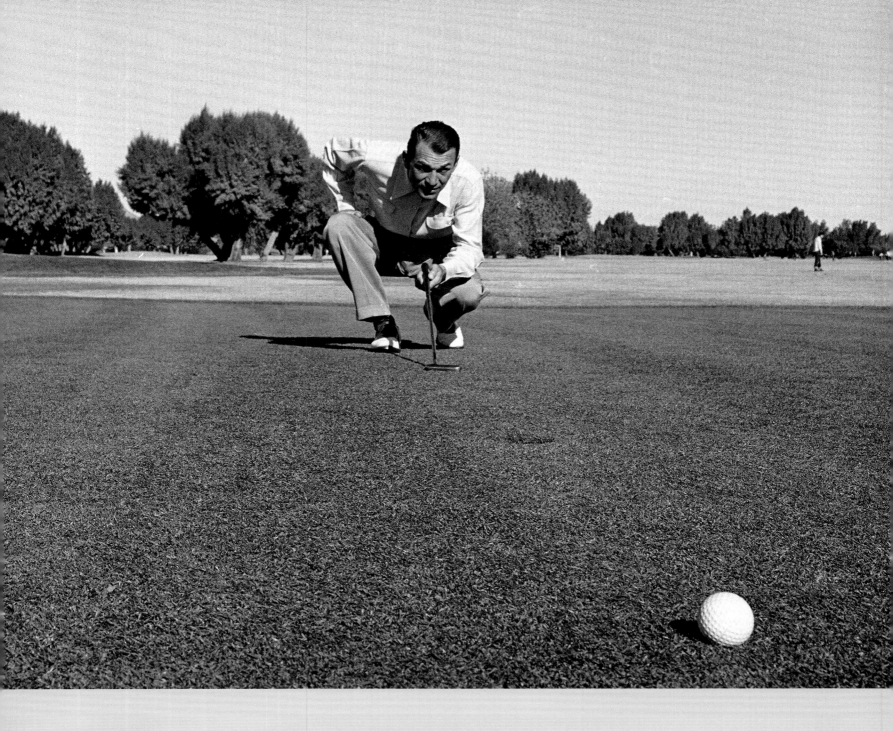

BEN HOGAN

Ben "The Hawk" Hogan was the best ball striker in golfing history: not only did he win nine major titles, but he trained harder than any of his competitors and was the first to fully explore the secrets of the swing. His book *Five Lessons, The Modern Fundamentals of Golf* is considered the standard work and serves as the basis of golf lessons to this day. Many golfers still emulate the Texan's swing, and who knows what heights he may have reached had not the Second World War robbed him of valuable years. On top of that a head-on collision with a Greyhound bus had doctors concerned he'd never walk again. Only a few months later, determined as ever, Hogan was back winning tournaments.

Der beste Ballstriker der Golfgeschichte gewann nicht nur neun Major-Titel, sondern trainierte härter als die Konkurrenz und beschäftigte sich als Erster ausführlich mit den Geheimnissen des Schwungs. Sein Buch *Der Golfschwung* gilt als wichtigstes Standardwerk und dient bis heute als Grundlage des Golfunterrichts. Der Schwung des Texaners findet noch immer viele Nachahmer, und wer weiß, um wie viel erfolgreicher seine Karriere verlaufen wäre, hätte ihm der Zweite Weltkrieg nicht wertvolle Jahre geraubt. Zudem wurde Hogan 1949 bei einem Frontalzusammenstoß mit einem Greyhound-Bus so schwer verletzt, dass die Ärzte befürchteten, er würde nie mehr laufen können – wenige Monate später gewann der willensstarke Kämpfer bereits wieder Turniere.

Ben Hogan lines up a shot, 1947
Ben Hogan nimmt Maß, 1947.

Grand Slam champion Bobby Jones posing in the finish position, 1930
Bobby Jones, der Grand-Slam-Sieger von 1930, posiert im Finish.

BOBBY JONES

Jones was a true gentleman golfer: he remained an amateur all his life. Between 1923 and 1930, he won the British Open three times and the US Open four times. In 1930, the man from Atlanta won all four major tournaments and was the first and only player to date to be awarded the Grand Slam—an achievement unlikely to be repeated. At age twenty-eight Bobby Jones retired from competitive golf and worked as a lawyer and author of golf books. His legacy: together with his business partner Clifford Roberts and architect Alister MacKenzie he gave us the US Masters, the first of the four annual major tournaments. One of his many wisdoms states: "I never learned anything from a match that I won."

Ein echter Gentleman: Zeit seines Lebens blieb Bobby Jones Amateur. Zwischen 1923 und 1930 gewann er dreimal die British Open und viermal die US Open. 1930 siegte der Mann aus Atlanta bei allen vier damaligen Major-Turnieren und holte sich als bislang einziger Spieler den Grand Slam – vermutlich eine Leistung, die nie wiederholt werden kann. Mit 28 Jahren zog sich Bobby Jones aus dem Profisport zurück und arbeitete als Rechtsanwalt und Autor von Golfbüchern. Sein Vermächtnis: Er schenkte uns gemeinsam mit seinem Geschäftspartner Clifford Roberts und dem Architekten Alister MacKenzie das US Masters, das erste der jedes Jahr stattfindenden vier Major-Turniere. Einer seiner klugen Sätze: »Die wichtigste Frage ist nicht, wie gut deine guten Schläge sind. Sie lautet: Wie schlecht sind deine schlechten Schläge?«

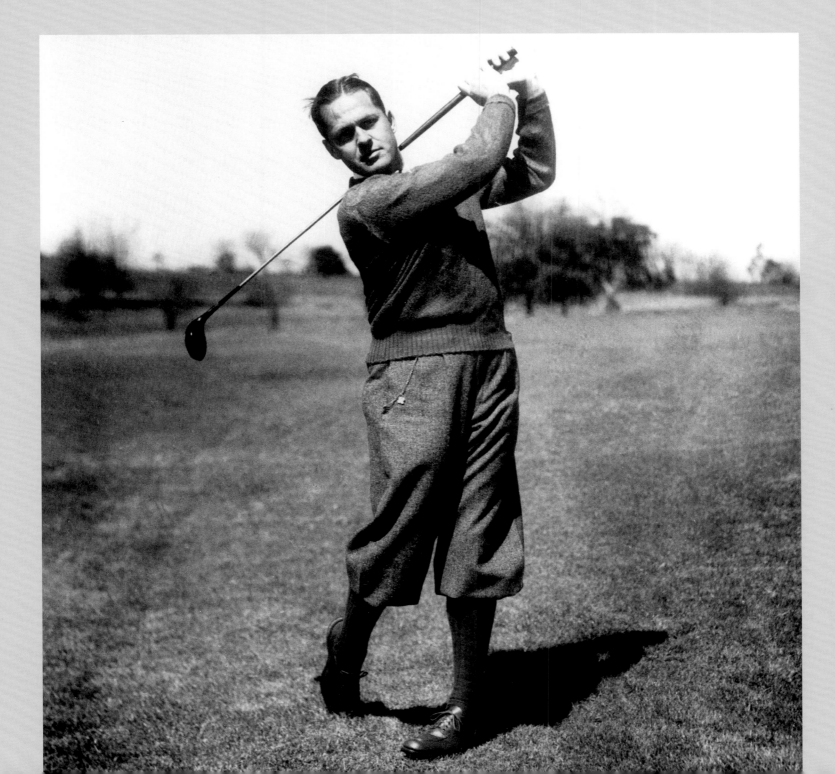

SAM SNEAD

Snead was famous for having the smoothest swing of all time. His flexibility was legendary—aged seventy he could still do the splits. The self-proclaimed country bumpkin, in his signature straw hat, won seven major titles and holds the world record of eighty-two PGA Tour events. Renowned golf coach Claude Harmon remembers a pupil who demanded to learn a Snead-style swing. When Harmon took him to the putting green the man complained: "Oh, I'm a fine putter I just want to hit some!" Harmon threw the ball into the hole and told him to pick it out without bending his knees. The confused pupil said he could not! "Sam Snead can do this in his sleep, so of course I can't teach you how to swing like Sam," Harmon assured him.

Den geschmeidigsten Schwung aller Zeiten hatte Sam Snead. Seine Beweglichkeit war legendär, noch mit 70 Jahren konnte er einen Spagat hinlegen. Das bekennende Landei aus Virginia, stets mit Strohhut, gewann sieben Major-Titel und hält den Siegesrekord von 82 Turnieren auf der US PGA Tour. Der berühmte Golflehrer Claude Harmon erzählte, wie einmal ein Schüler zu ihm kam und so schwingen wollte wie Snead. Harmon nahm ihn mit aufs Putting-Grün. »Ich will aber nicht putten, ich will schwingen«, beschwerte sich der Schüler. »Geduld, Geduld«, sagte Harmon und warf einen Ball ins Loch. »Holen Sie ihn heraus, ohne die Knie zu beugen.« »Das kann ich nicht«, antwortete der verdutzte Schüler. »Dann werden Sie auch nicht so schwingen können wie Snead«, erwiderte Harmon.

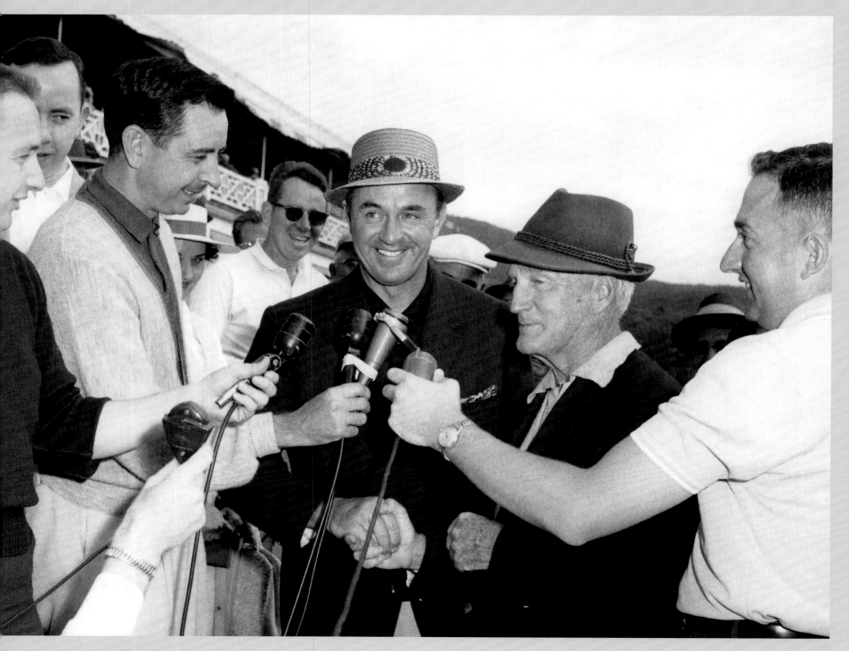

Sam Snead swings his club for the press at the Greenbrier Golf Resort, where he'd been official Head Pro since 1944

Sam Snead antwortet der Presse und schwingt im Greenbrier Golf Resort, wo er seit 1944 offizieller Head Pro war.

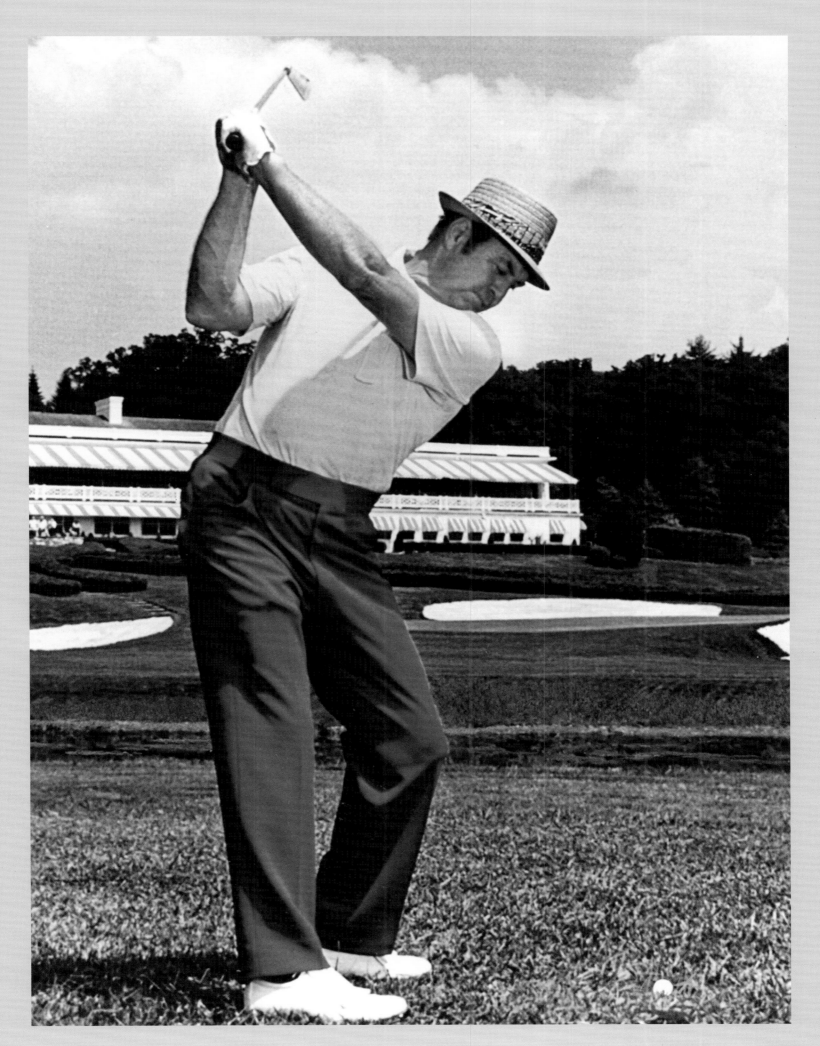

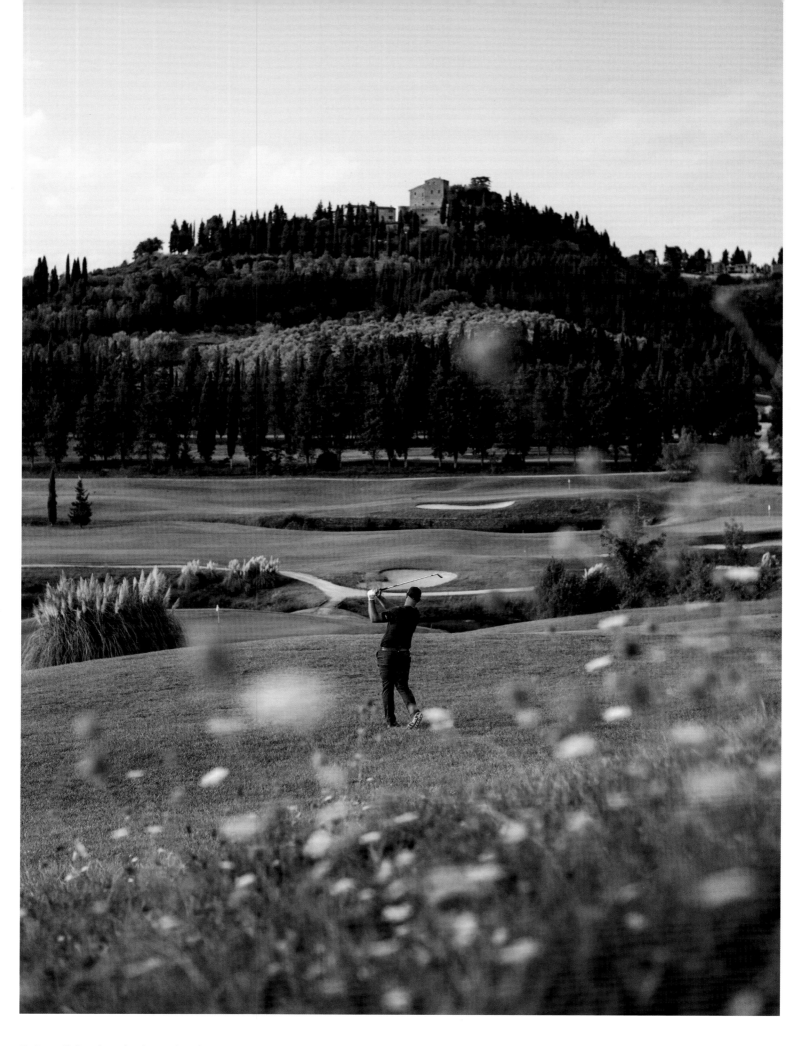

Teeing-off directly under the medieval Borgo

Abschlag direkt unter dem mittelalterlichen Borgo

RESORT CASTELFALFI

ITALY / ITALIEN

Less than twenty miles from Florence and not far from San Giminnano, in the midst of unspoiled nature and uncompromised panoramic views of vineyards, olive trees, cypresses, and lovingly restored Rustici, lies Castelfalfi. The 1,000-hectare-resort is an historic Lombard site that has, with great care, been converted into a sustainable guests' paradise with hotels, villas, apartments, and three restaurants—all in keeping with the medieval stonewalls. The five-star hotel Il Castelfalfi at the entrance of the Borgo that opened its doors in the spring of 2017, leaves nothing

Dreißig Kilometer von Florenz und nicht weit von San Gimignano entfernt, inmitten unberührter Natur: Nichts stört den Rundumblick über Weinberge, Olivenbäume, Zypressen und restaurierte Rustici. Das 1100 Hektar große Resort ist ein historischer Ort aus der Zeit der Langobarden, der behutsam zu einem nachhaltigen Gästeparadies umgebaut wurde, mit Hotels, Villen, Apartments und drei Restaurants, die sich alle perfekt in die mittelalterlichen Mauern einfügen. Das Fünfsternehotel Il Castelfalfi am Eingang des Borgo, eröffnet im Frühjahr 2017, lässt keine

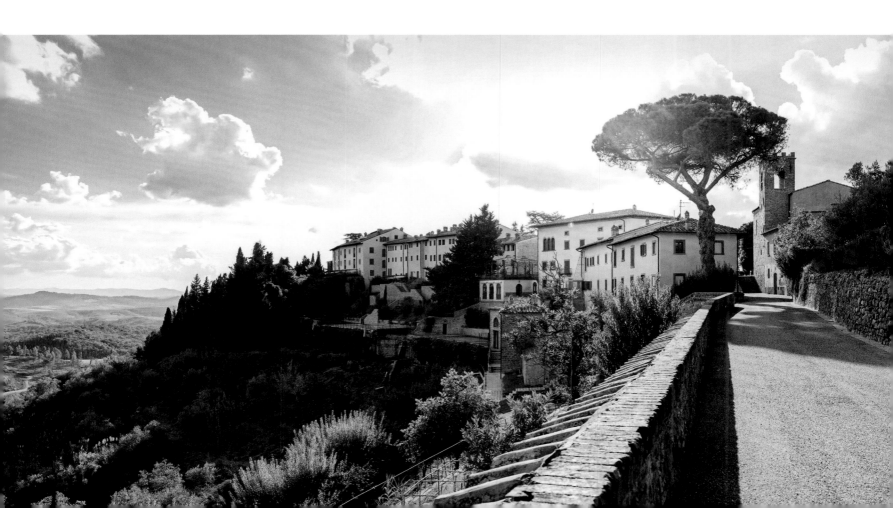

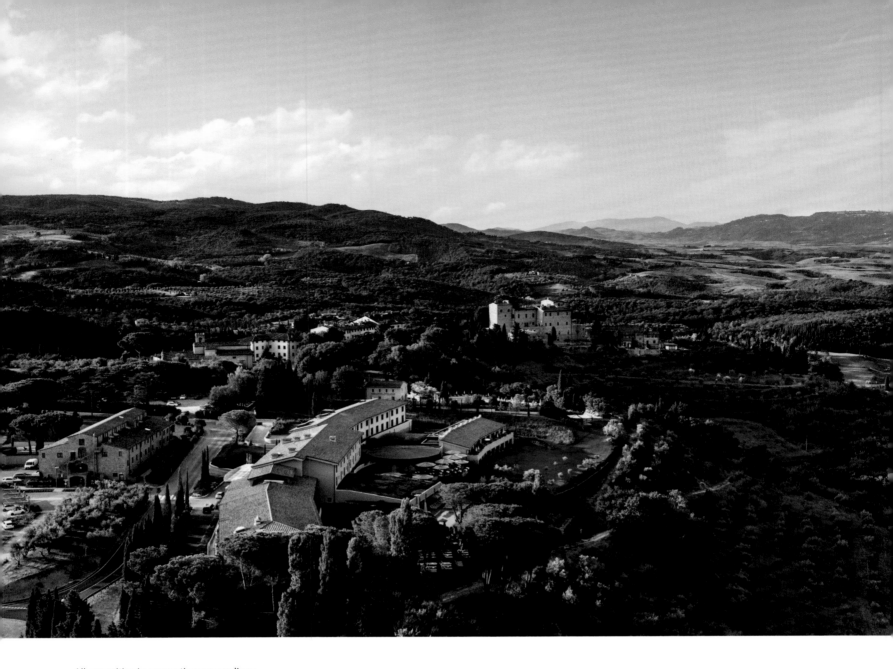

All amenities in romantic surroundings

Alle Annehmlichkeiten in romantischer Umgebung

to be desired: 120 spacious rooms with suites, a gym with a personal trainer, an indoor and outdoor pool, and a spa with every thinkable amenity as well as a high-class restaurant. And in the stunning Tuscan landscape beyond lie twenty-seven holes. The 18-hole Mountain Course, designed by German architect Rainer Preißmann, is not only one of the most challenging courses in Italy, but also the best-preserved. The 9-hole Lake Course is particularly good for beginners and has excellent training facilities to help one get into the swing of it. Wine and olives grown across twenty-two hectares are pressed in the resort's own Fattoria. Six hiking routes and cycle paths lead through the vines and groves.

➤ Italy, Castelfalfi (Toscany), www.castelfalfi.com

Wünsche offen: 120 großzügig geschnittene Zimmer und Suiten, Gym mit Personal Trainer, Innen- und Außenpool sowie ein Spa mit allen erdenklichen Anwendungen sowie ein gehobenes Restaurant. Drumherum 27 Löcher in toskanischer Traumlandschaft. Der Mountain Course (18 Löcher), entworfen vom deutschen Architekten Rainer Preißmann, ist nicht nur einer der schwierigsten Plätze Italiens, sondern auch einer der bestgepflegten. Der Lake Course (9 Löcher) ist besonders gut für Anfänger geeignet. Exzellente Übungsmöglichkeiten helfen, um in Schwung zu kommen.
Auf 22 Hektar werden Wein und Oliven angebaut und in der eigenen Fattoria gekeltert und gepresst. Sechs Wander- und Radwege führen durch die Reben und Haine.

➤ Italien, Castelfalfi (Toskana), www.castelfalfi.com

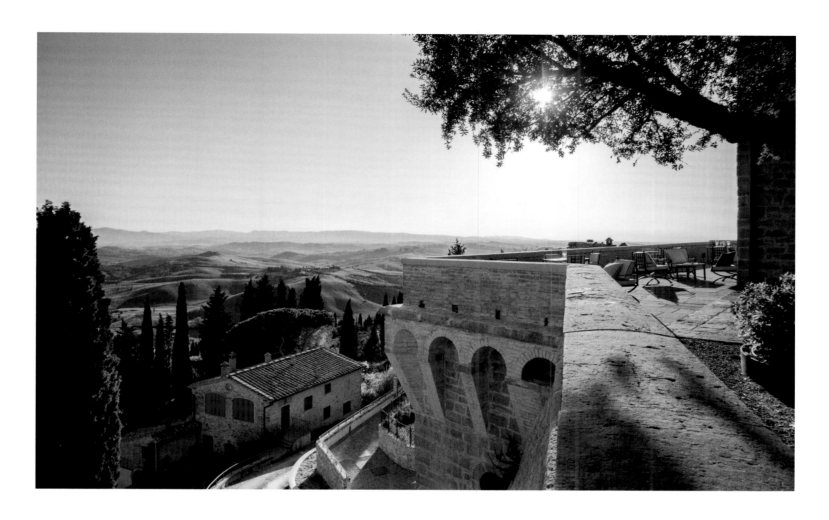

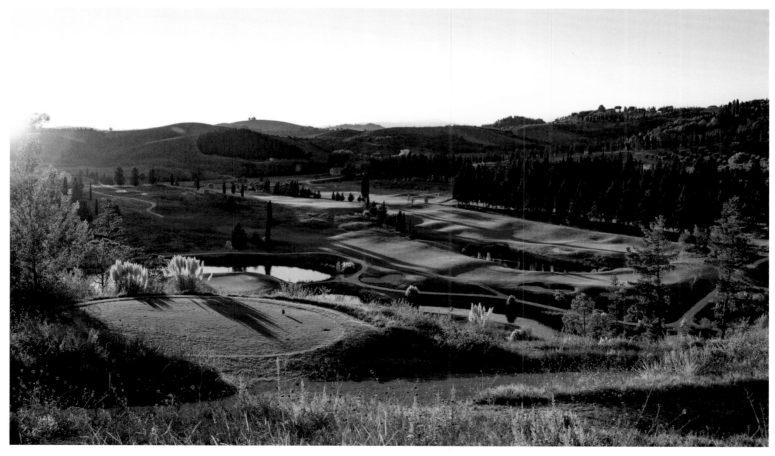

Long hitters will relish this course

Auf dem Platz fühlen sich besonders Longhitter wohl.

ROYAL ST GEORGE'S

ENGLAND

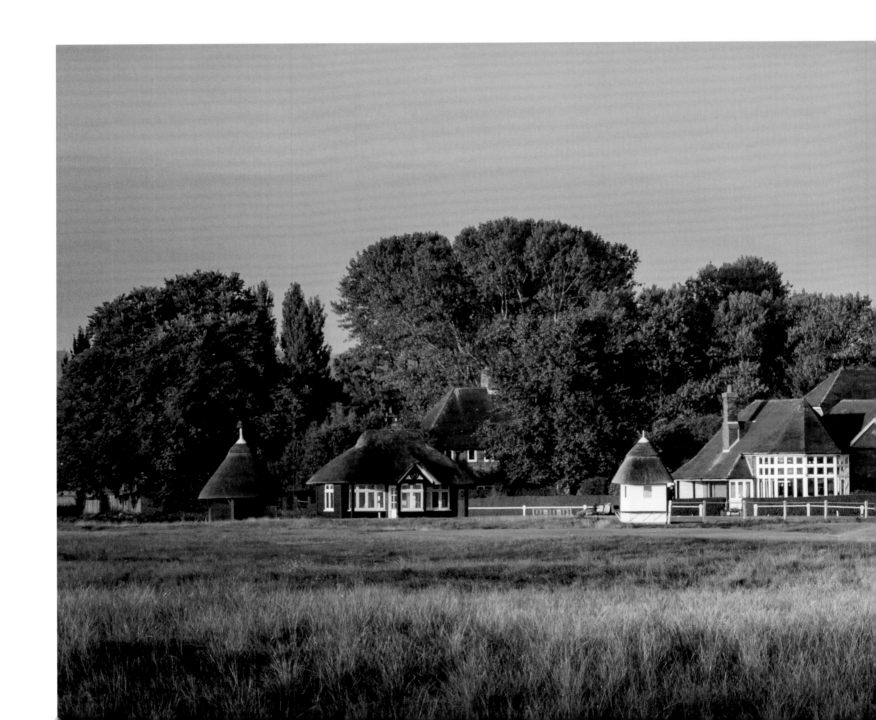

In the county of Kent in southeast England the world feels enchanted: quaint, picturesque villages, impeccable front gardens with immaculate hedges, floral splendor, and the hubbub of the pub. Londoners fed up with the hustle and bustle of city life like to retreat here: rural charm, a mere hour's drive away.

The Royal St George's Golf Club fits right in with its beautifully maintained grounds. Founded in 1887, the historic links course is repeatedly voted best course in England by journalists. It preserves a unique symbiosis between natural surroundings and landscaped holes–almost as if the terrain had been patiently waiting for the arrival of golf. According to wind and weather the challenges of each hole vary, meaning you never play the same course twice. The only continuity is the nearby North Sea. At regular intervals the course hosts the Open Championship, the most traditional of the major tournaments.

In der Grafschaft Kent im Südosten Englands ist die Welt wie verzaubert. Kleine hübsche Dörfer, perfekt gepflegte Vorgärten und akkurat rasierte Hecken, Blumenpracht und brummende Pubs. Londoner, die genug von dem Großstadttrubel haben, ziehen sich gern hierher zurück, schließlich sind die malerischen Ortschaften nur eine Autostunde entfernt.

Der Royal St. George's Golf Club passt sich der Umgebung mit seinem erstklassigen Pflegezustand perfekt an. Von Journalisten wird der historische Links-Course aus dem Jahr 1887 immer wieder zum besten Platz Englands gekürt. Er bietet eine einmalige Symbiose von Natur und Bahnenverlauf. Es wirkt, als hätte die Landschaft nur auf die Erfindung des Golfsports gewartet. Je nach Wetter und Windrichtung ändert sich die Schwierigkeit der Löcher: Nie spielt man ein und denselben Platz. Die einzige Konstante ist die nahe Nordsee.

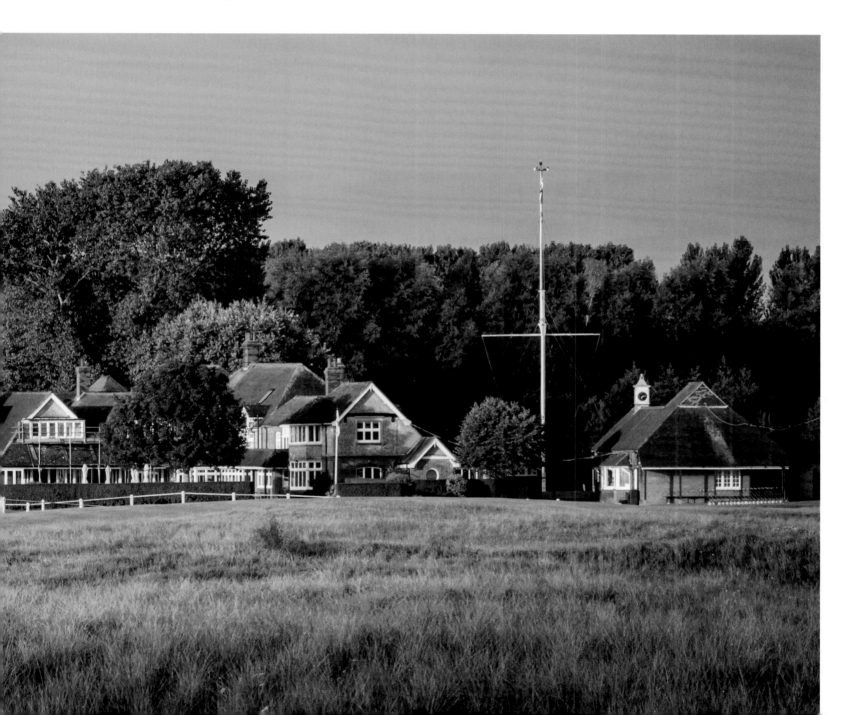

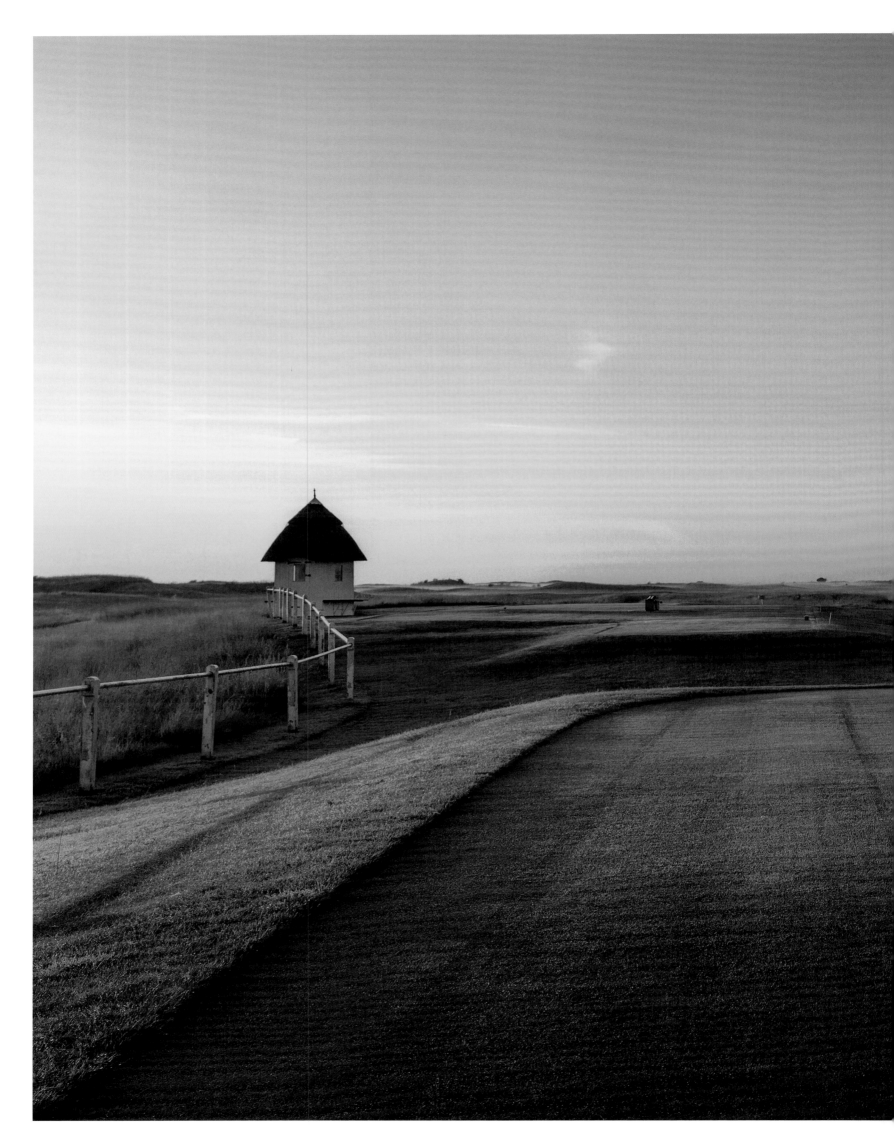

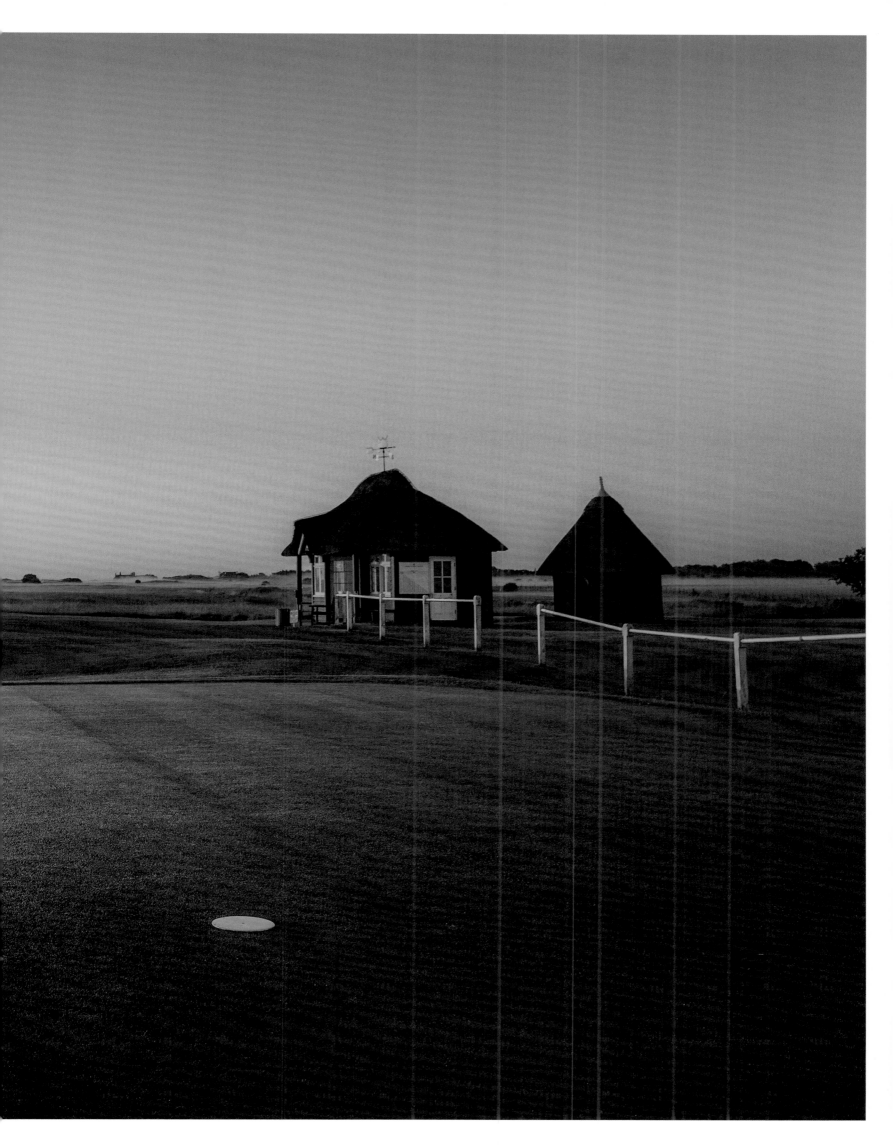

Each ball in the rough presents a challenge

Jeder Ball im Rough wird zu einer Herausforderung.

In 2011, Darren Clarke from Northern Ireland rose to the challenge of towering dunes and dizzyingly deep bunkers and secured the Claret Jug.
The clubhouse is traditionally British: jacket and tie are compulsory, visitors must ring at the door to enter.

➤ England, Sandwich, www.royalstgeorges.com

Der Course darf in regelmäßigen Abständen die Open Championship austragen, das traditionsreichste Major-Turnier der Welt; 2011 kam hier der Nordire Darren Clarke mit den Herausforderungen – wie turmhohen Dünen und metertiefen Bunkern – am besten zurecht und sicherte sich die Claret Jug.
Typisch britisch zeigt sich das Clubhaus: Jackett und Krawatte sind Pflicht, und wer Eintritt begehrt, muss klingeln.

➤ England, Sandwich, www.royalstgeorges.com

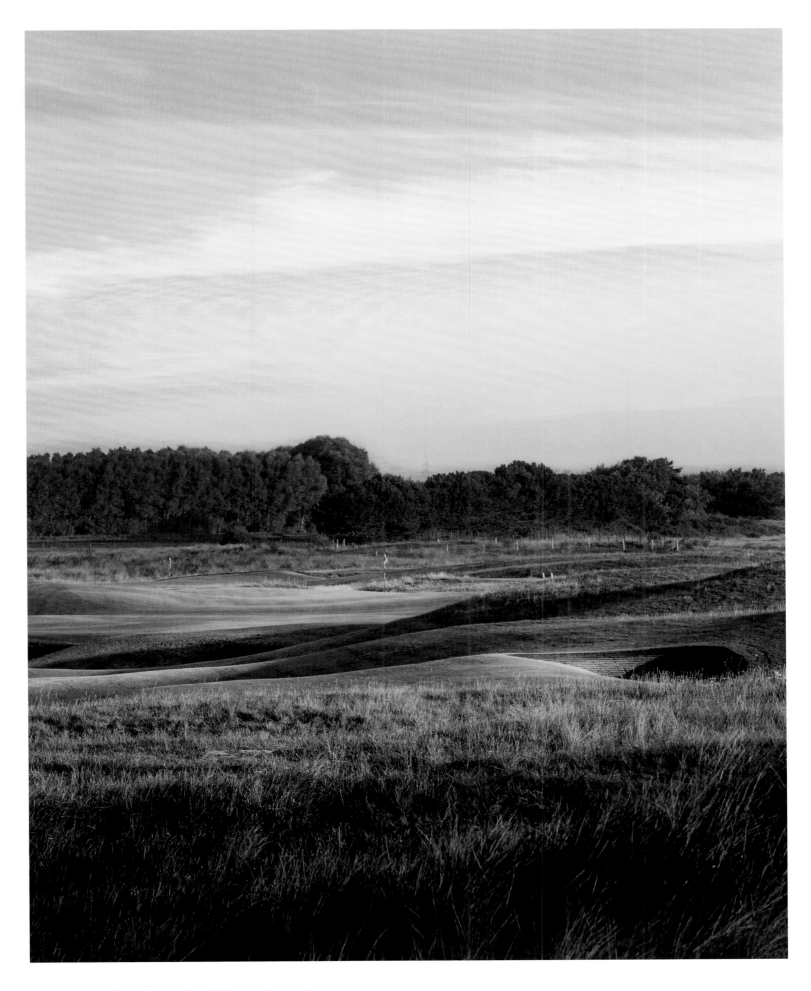

The romantic ambience is deceptive: pitfalls are abundant

Die Romantik täuscht: Der Platz hat seine Tücken.

FASHION ON THE GREEN RUNWAY Why do Golfers Love Checks?

You can usually spot a golfer from afar on account of their tartans. But how and when did this trend arise? Tartan is far older than golf: it has been around in Europe for over two thousand years and probably came from the Celts. The "Falkirk" tartan uncovered in Scotland dates back to the third century AD—which shows that check has been popular for quite some time. The tartan was adopted by Scottish clans, whereby each family had its own pattern. And with the nobility enjoying their golf so much, it became tradition for players to sport clan tartan on the green. (Incidentally anyone can register their own design with the Scottish Register of Tartans for a fee of seventy pounds sterling.)

In the twentieth century, designers incorporated the tartan tradition into their trousers and jumpers to great success on the golf course. Although it has been often proclaimed dead, most sportswear companies still include tartan patterns somewhere in their collections. As clothing conventions became less rigid, general fashion trends also seeped into golfing, as is evident in the footwear department: whereas golf shoes traditionally had metal spikes, today golfers often prefer more casual sports shoes with studded soles.

Young designers such as Johan Lindeberg have also taken up the tradition of checked clothing

Auf die tradionelle Karokleidung haben sich junge Designer wie Johan Lindeberg wieder besonnen.

MODE AUF DEN GRÜNEN LAUFSTEGEN Warum sind Golfer immer so kariert?

Viele Golfer sind schon von Weitem zu erkennen – nämlich am Karomuster ihrer Kleidung. Der Weg des Karos in die Golfwelt ist durchaus erstaunlich. Das Karo ist viel älter als der Golfsport; es ist in Europa seit etwa 2000 Jahren bekannt und stammt vermutlich von den Kelten. Das Stoffstück Falkirk Sett aus dem dritten nachchristlichen Jahrhundert beweist, dass das Karo in Schottland früh gebräuchlich war. Aus den Karos wurden bald die Sippenzeichen der Schotten, denn jeder Clan hatte sein eigenes Muster. Da Adlige sehr gern golften, war es üblich, dass die Spieler die Karos ihrer Sippe auf dem Grün trugen. (Übrigens kann jeder, adlig oder nicht, sein eigenes Muster beim Scottish Register of Tartans gegen eine Gebühr von 70 Pfund registrieren lassen.)

Die Tradition der Karokleidung wurde im 20. Jahrhundert von Designern aufgegriffen, und Karohosen wie -pullover wurden zu einem großen Erfolg auf dem Golfplatz. Obwohl schon öfter totgesagt ist das Karo bei den meisten Sportbekleidungsherstellern bis heute im Programm. Weil die Kleidungsnormen allerdings in allen Bereichen des Lebens aufgeweicht werden, orientiert sich auch die Golfmode immer mehr an allgemeinen Modetrends, was insbesondere an den Schuhen zu sehen ist – waren diese früher mit Metallspikes versehen, sind es heute oft ganz normale Sportschuhe mit Noppensohle.

Actor Sean Connery dressed in traditional tartan, 1969

Filmschauspieler Sean Connery trägt traditionelles Karo, 1969.

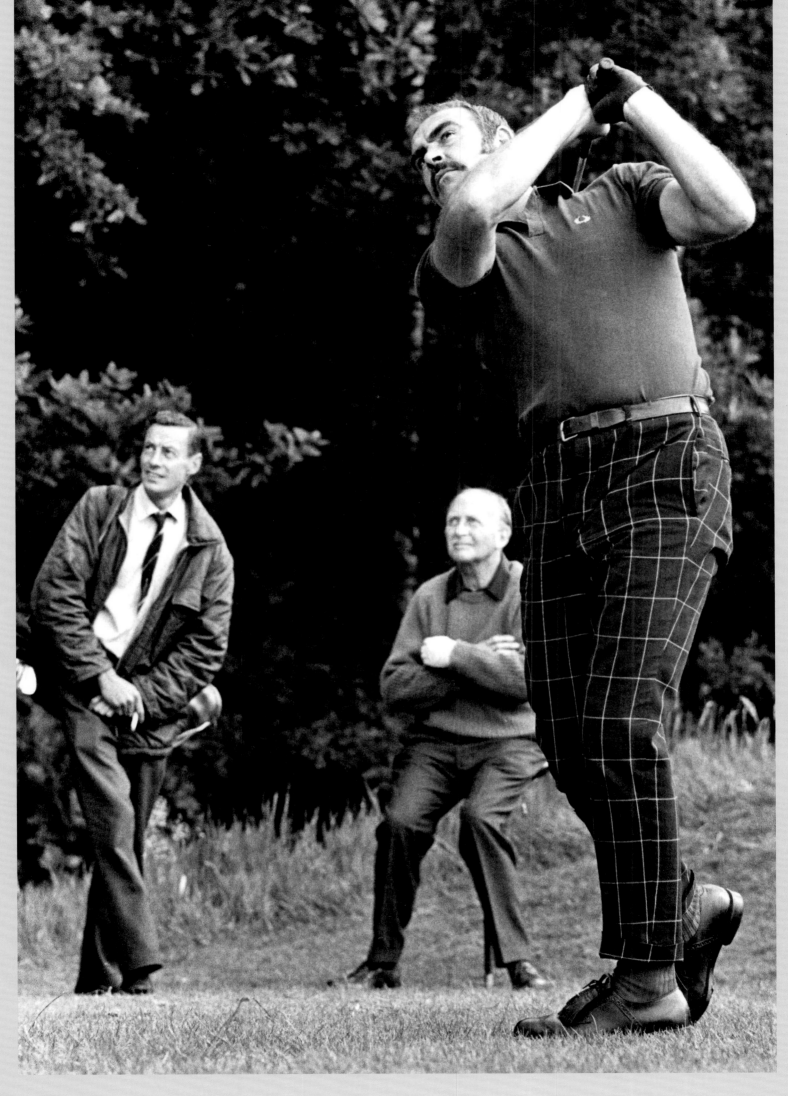

And then there's out and out flamboyance: the peacock of the fairways, Doug Sanders, liked to strut across the world's courses dressed in red shoes, pink trousers, and violet jumpers. His claim to fame goes back to missing a 3-foot putt to win at the 1970 British Open and losing the play-off against Jack Nicklaus by a single stroke. Today, he is renowned for his brightly-colored trousers by the US clothing company appropriately called Loudmouth. English eccentric Ian Poulter ventured to create his own clothing line that embraced gold and glitter—but he soon distanced himself from this, in favor of focusing on winning the big tournaments.

Aber es geht auch anders: Der erste Paradiesvogel auf den Plätzen dieser Welt war Doug Sanders, der sich gern in roten Schuhen, pinken Hosen oder violetten Pullovern kleidete. Berühmt wurde der »Pfau der Fairways« (so sein Spitzname) allerdings, weil er 1970 einen 90-Zentimeter-Putt zum Sieg bei der British Open vorbeischob – und im Stechen gegen Jack Nicklaus verlor. Heutzutage fällt vor allem John Daly mit seinen quietschbunten Hosen einer US-Firma mit dem passenden Namen Loudmouth auf. Der englische Exzentriker Ian Poulter wagte sich sogar an eine eigene Bekleidungslinie inklusive goldener Glitzerstoffe, doch er nahm schon bald Abstand davon und konzentriert sich nun wieder auf das Gewinnen großer Turniere.

Ian Poulter (right) with Craig Thorburn, winner of the Best-Dressed prize, at an invitational golfing event at Woburn, 2006

Ian Ian Poulter (rechts) in Pink mit Craig Thorburn dem Gewinner des Best-Dressed-Preises bei einem Golf-Event in Woburn, 2006

John Daly in one of his famously shrill outfits

John Daly in einem seiner berühmten schrillen Outfits

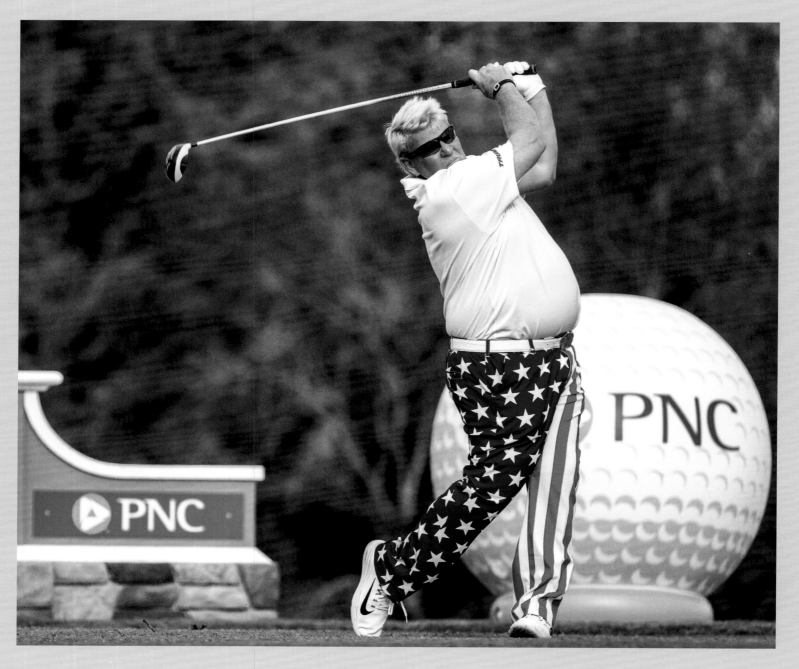

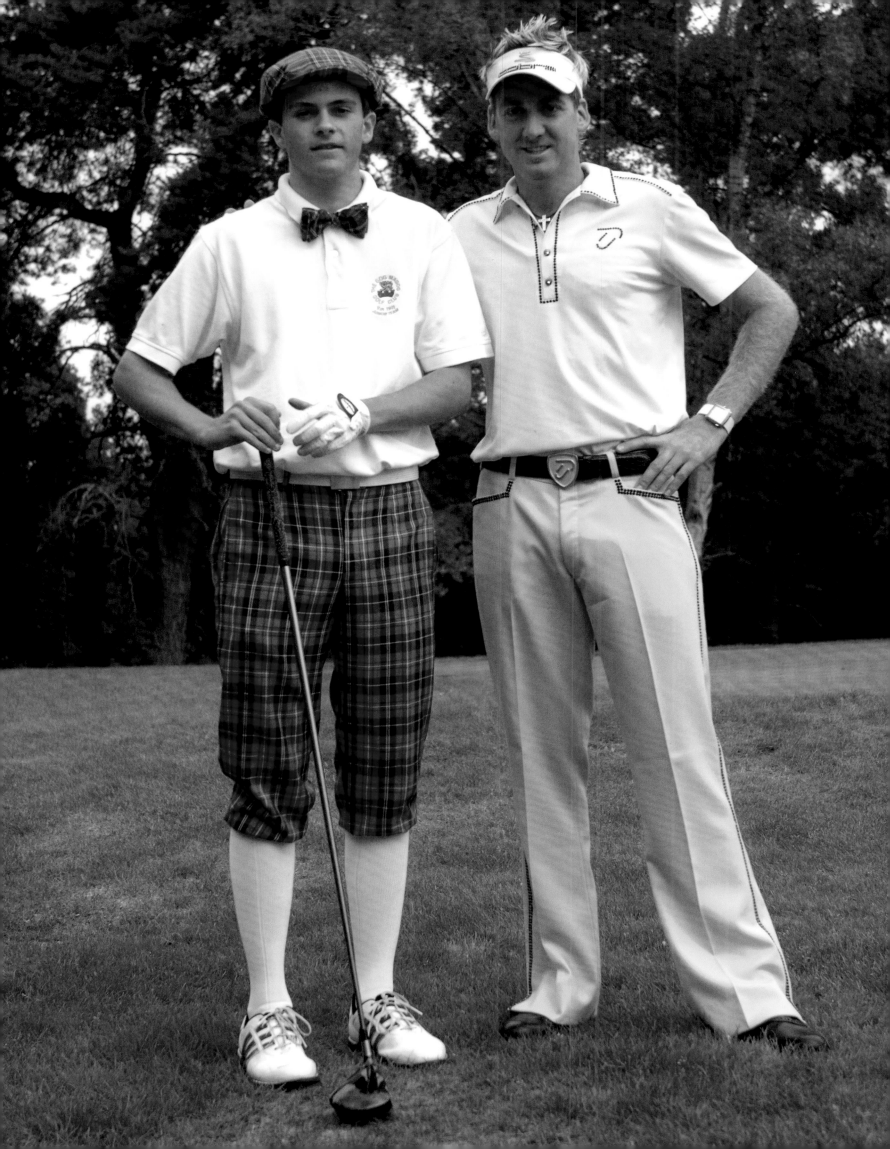

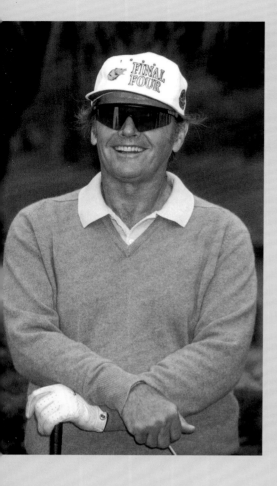

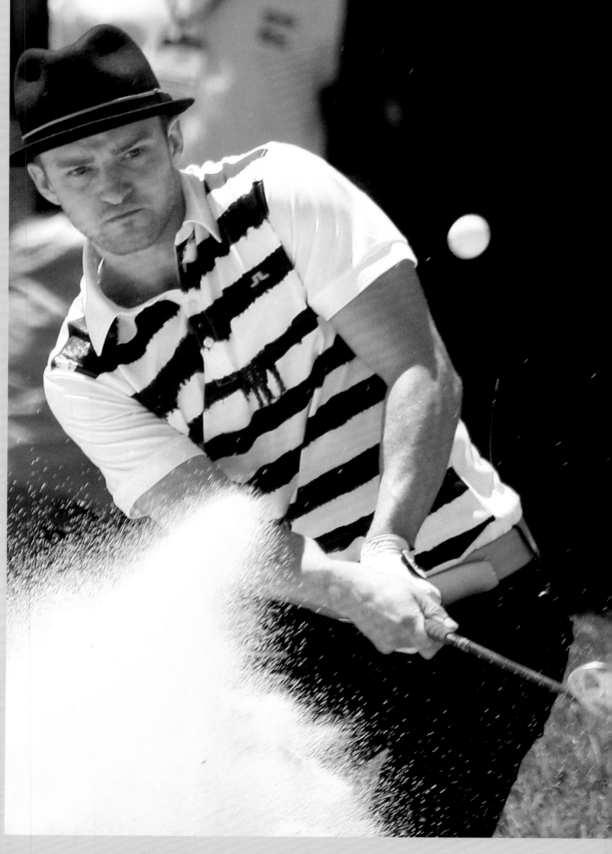

Justin Timberlake—with an orange belt to match the company logo—hits a bunker shot at the Torrey Pines Golf Course, 2008
Justin Timberlake mit orangenem Gürtel, farblich passend zum Herstellerlogo, schlägt auf dem Torrey Pines Golf Course den Ball aus dem Bunker, 2008

Jack Nicholson with extravagant sunglasses at the Rancho Park golf course in Los Angeles, 1995
Jack Nicholson mit extravaganter Sonnenbrille auf dem Rancho Park Golfplatz in Los Angeles, 1995

Sylvester Stallone and Michael Douglas in conservative black and white attire at a fundraiser tournament, 2004
Sylvester Stallone und Michael Douglas, konservativ gekleidet in Schwarz-Weiß bzw. Weiß-Schwarz, bei einem Charity-Turnier, 2004

Designers like Armani or Versace never ventured into golf apparel. However, in recent years young companies like that of Swedish designer Johan Lindberg aim to update golfing attire making it fresh and even slightly sexy. Calvin Klein, Boss, and Bogner also offer trendy golfing ranges. And large sports companies such as Adidas, Nike, and Puma are up there too. Traditionalist Lacoste profits from its sporting image—and from the fact that the polo shirt, with or without a crocodile, remains the perfect garment for a round of golf.

Designer wie Armani oder Versace haben sich nie an Golfmode herangewagt, aber immerhin versuchen in den letzten Jahren junge Designer wie der Schwede Johan Lindeberg, Golfmode moderner, frischer und auch ein wenig sexy zu gestalten. Auch Calvin Klein, Boss und Bogner stellen zeitgemäße Golfkleidung her. Große Sportartikelhersteller wie Adidas, Nike und Puma bedienen ebenfalls den Markt, und die Traditionsfirma Lacoste profitiert von ihrem sportlichen Image – und davon, dass ein Poloshirt, ob mit oder ohne Krokodil, als perfektes Outfit für eine Runde Golf gilt.

Catherine Zeta-Jones—in stylish golfing attire—lines up a putt, in Haikou, China, 2010

Catherine Zeta-Jones nimmt in stilvoller Golfbekleidung Maß bei einem Putt in Haikou, China 2010.

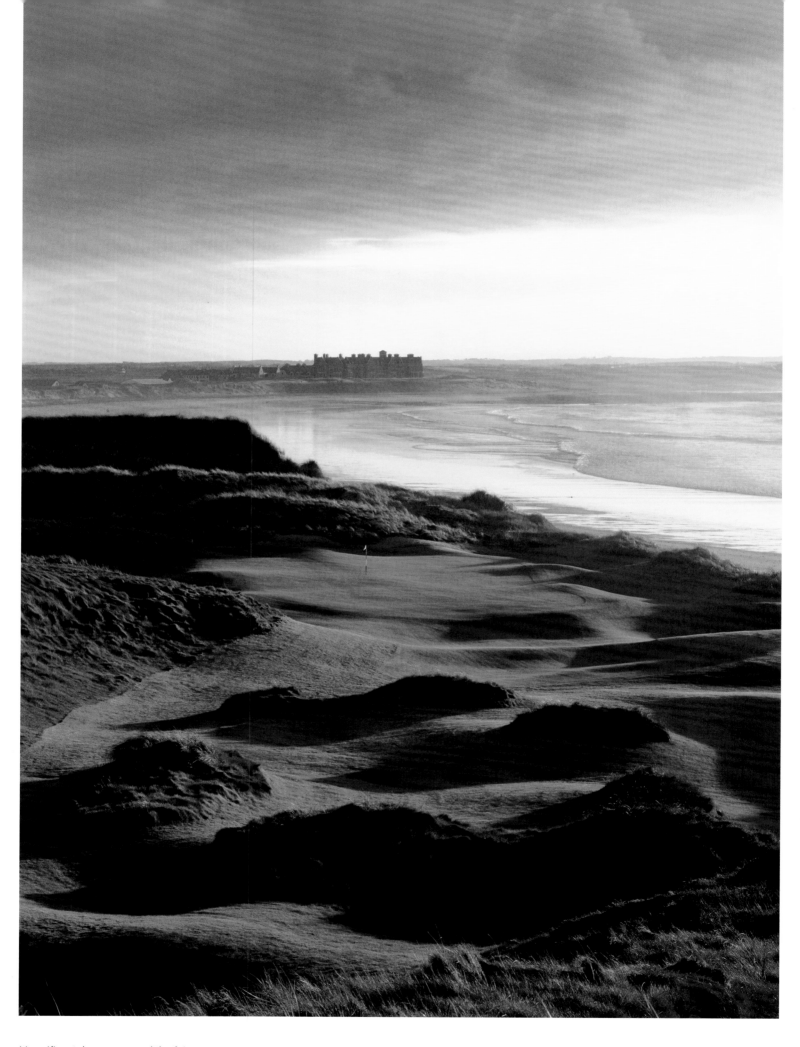

Magnificent dunes surround the fairways

Atemberaubende Dünen umrahmen die Bahnen.

DOONBEG

IRELAND / IRLAND

Money is not an issue. Over the next few years, $45 million will be ploughed into a 150-hectare resort on the west coast of Ireland to finally secure its standing as the number one on the Emerald Isle. Doonbeg, which is particularly popular among North Americans, boasts an 18-hole links course in the midst of a majestic dune landscape; designed by Martin Hawtree, almost all the holes overlook the Atlantic and meld with the natural terrain. It is hard to believe that the course opened as recently as 2002. The first game was a show match between Australian Greg Norman and local hero Pádraig Harrington. The hotel itself offers every

Am Geld soll es nicht scheitern! 45 Millionen Dollar fließen in den nächsten Jahren in das 150 Hektar große Resort an der Westküste Irlands, um es endgültig zur Nummer eins auf der Grünen Insel zu machen. Das vor allem bei US-Amerikanern beliebte Doonbeg bietet schon jetzt einen erstklassigen 18-Loch-Linksplatz inmitten majestätischer Dünen; von fast allen Löchern des von Martin Hawtree designten Course ist der Atlantik zu sehen. Die Löcher vermählen sich ideal mit den natürlichen Gegebenheiten – es ist kaum zu glauben, dass der Platz erst im Jahr 2002 eröffnete, mit einem Showmatch zwischen

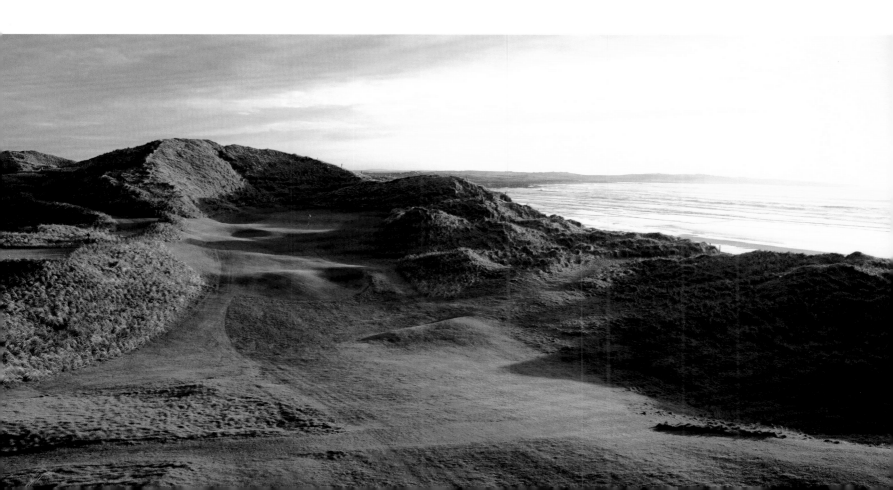

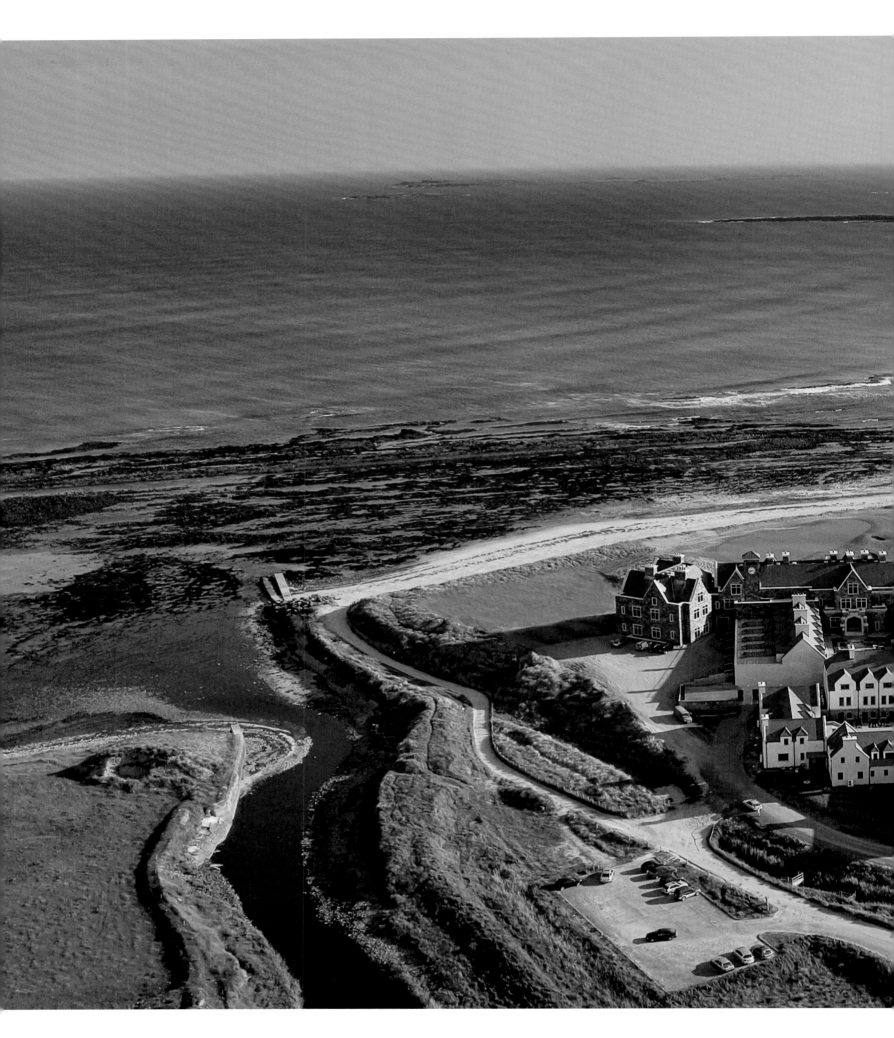

The resort is soon to be expanded

Das Resort soll demnächst erweitert werden.

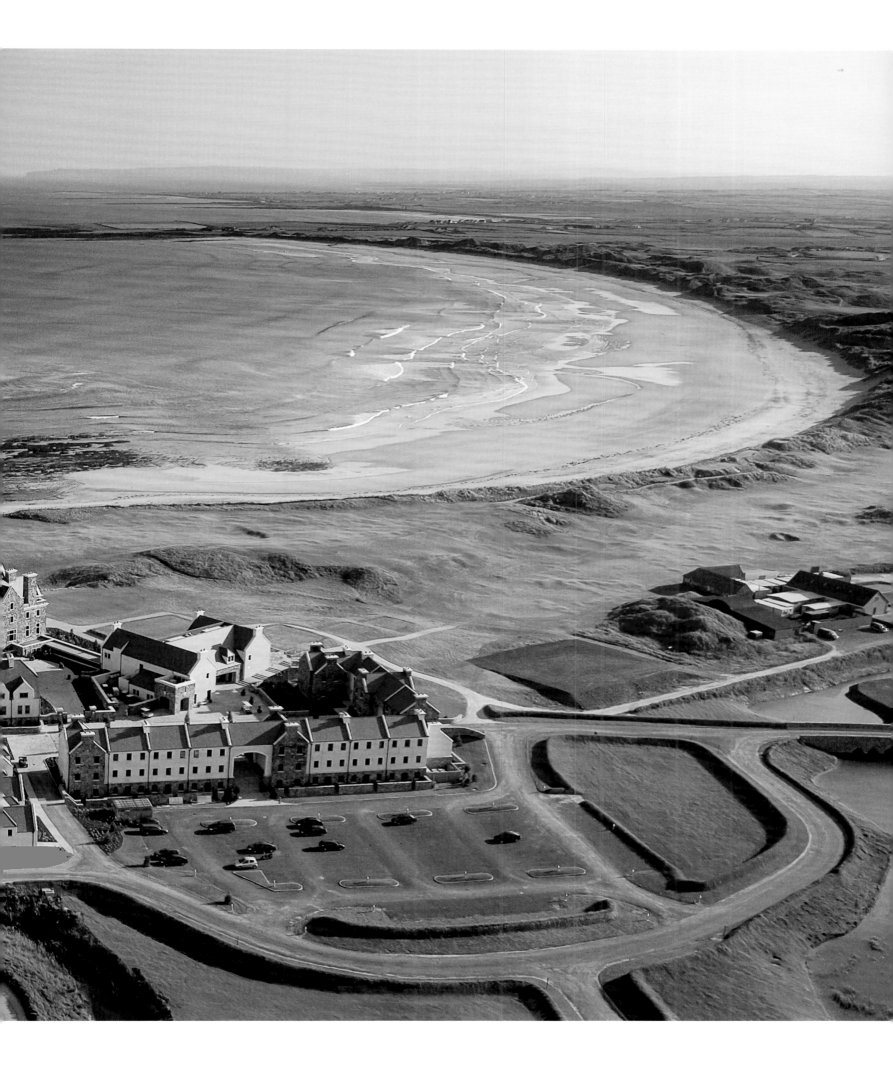

imaginable service including a high-class restaurant with a sea view and the White Horses Spa with a whole range of pamper packages. In 2014, the Trump Organization acquired the course and the new hotel; in the next few years real estate and services will be expanded.

➤ **Ireland, Doonbeg, www.trumphotels.com**

dem Australier Greg Norman und dem Lokalmatadoren Pádraig Harrington. Das Hotel bietet jeden erdenklichen Service, darunter ein erstklassiges Restaurant mit Meerblick und das White Horses Spa mit Dutzenden Verwöhnpaketen.

➤ **Irland, Doonbeg, www.trumphotels.com**

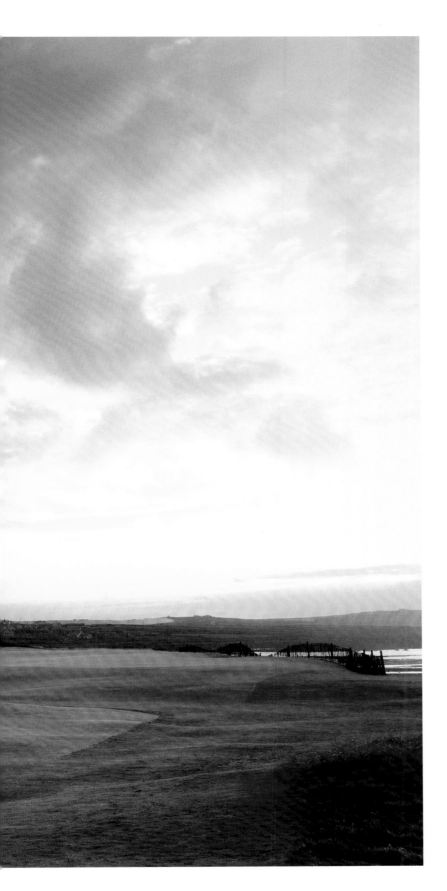

After the game luxury suites await

Nach der Runde warten üppig eingerichtete Suiten.

BAD GRIESBACH

GERMANY / DEUTSCHLAND

A resort of the highest order: five fully-fledged 18-hole golf courses plus an array of short courses and practice holes; three golf hotels for every taste as well as three estates; one of Europe's largest driving ranges, playable in all directions (a bonus during high winds or a low sun), indoor simulators and a first-class golf school. At Quellness

Ein Resort der Superlative: Fünf ausgewachsene 18-Loch-Golfplätze plus jede Menge Kurzplätze und Übungslöcher, drei Golfhotels für jeden Anspruch und drei Gutshöfe, eine der größten Driving-Ranges Europas, die von allen Seiten aus bespielbar ist (ein großer Vorteil bei starkem Wind oder tief stehender Sonne), Indoor-Simula-

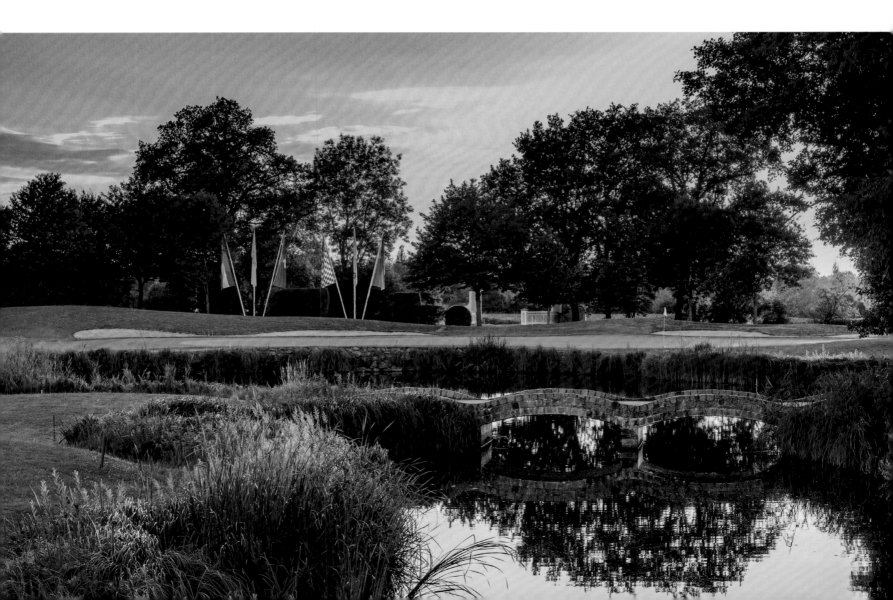

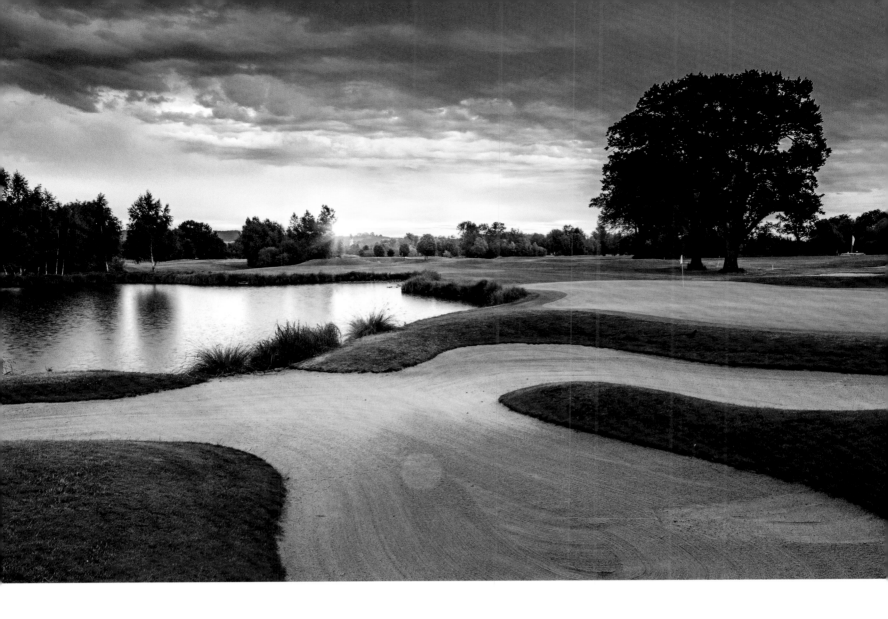

Resort, Bad Griesbach, even the most fanatic golfer can enjoy weeks of variety without coming close to playing all 129 holes.

The resort's showpiece is the Beckenbauer Golf Course designed by Bernhard Langer, which hosted the Challenge Tour and the European Tour from 2013 until 2017. Here water hazards pose the greatest challenge, particularly at the 13th and 18th where skewed shots risk being swallowed up along a generous 18 hectares: streams, ditches, and pools require high-precision shots.

Non-golfers are also guaranteed an inspiring stay: There is a wide range of thermal pools and spas for relaxation. Porsche Experience Days invite car enthusiasts to treat themselves to "horse power wellness" and test-drive their latest sports models. For families with children of all ages there are horseback riding, swimming, golfing, and summer camps.

➤ Germany, Bad Griesbach, www.quellness-golf.com

toren und eine erstklassige Golfschule – hier können selbst fanatische Golfer abwechslungsreiche Wochen verbringen, und sie werden dennoch Mühe haben, alle der insgesamt 129 Bahnen zu bespielen.

Der Vorzeigeplatz des Resorts ist der Beckenbauer Golf Course, auf dem von 2013 bis 2017 die Challenge Tour und die European Tour zu Gast waren. Das Design stammt aus der Feder von Bernhard Langer. Hier stellen Wasserhindernisse die größten Herausforderungen dar, denn an 13 der 18 Bahnen, die auf großzügigen 80 Hektar angelegt sind, können verzogene Bälle im Wasser verschwinden. Bäche, Gräben und Teiche verlangen von den Spielern zusätzliche Präzision.

Und auch Nichtgolfern wird hier garantiert nicht langweilig. Das Angebot der Thermenwelt ist überwältigend, und Autonarren gönnen sich die PS-Wellness der Porsche Experience Days, an denen aktuelle Modelle des Sportwagenherstellers ausgefahren werden dürfen. Für Familien mit Kindern jeden Alters gibt es Reit-, Schwimm-, Golf- und allerlei Sommercamps.

➤ Deutschland, Bad Griesbach, www.quellness-golf.com

A luxurious golf and spa offer in Lower Bavaria

Ein exklusives Golf- und Spa-Angebot in Niederbayern.

Golfing and holidaying on historic grounds

Golfen und Urlauben auf geschichtsträchtigem Gelände

THE GREENBRIER

USA

The Greenbrier is one of the most historic resorts in the US—and probably the only luxury hotel in the world to (for thirty years) accommodate a top-secret underground bunker for Congress to use in the event of nuclear war. By the end of the eighteenth century, wealthy Americans traveled to the White Sulphur Springs in West Virginia to take the waters to ease their aches and pains. It is hardly surprising that, by 1913, luxury hotel The Greenbrier

Es ist eines der geschichtsträchtigsten Resorts der USA – und wohl das einzige Nobelhotel der Welt, das 30 Jahre lang einen streng geheimen, riesigen Bunkerkomplex beherbergte, in der im Fall eines Atomkriegs der gesamte US-Kongress in Sicherheit gebracht werden sollte.
Schon Ende des 18. Jahrhunderts fuhren reiche Amerikaner in den Kurort White Sulphur Springs in West Virginia, um an den heißen Quellen ihre Zipperlein auszu-

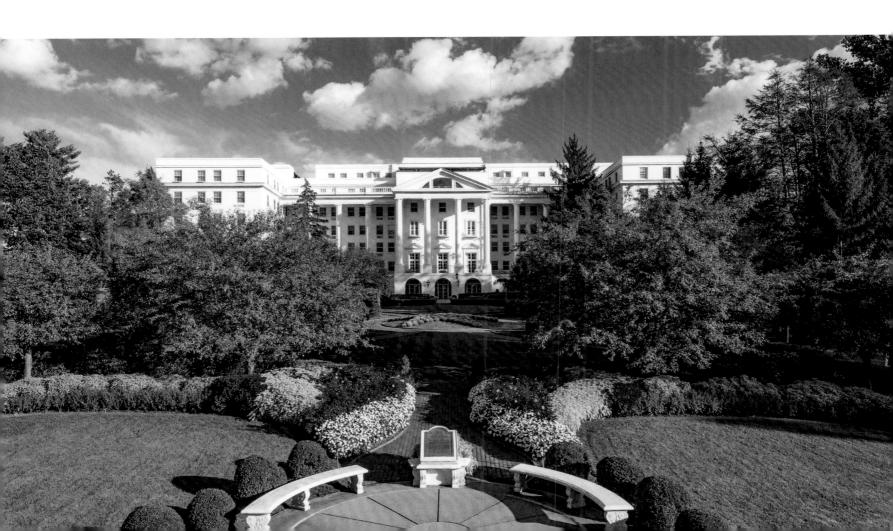

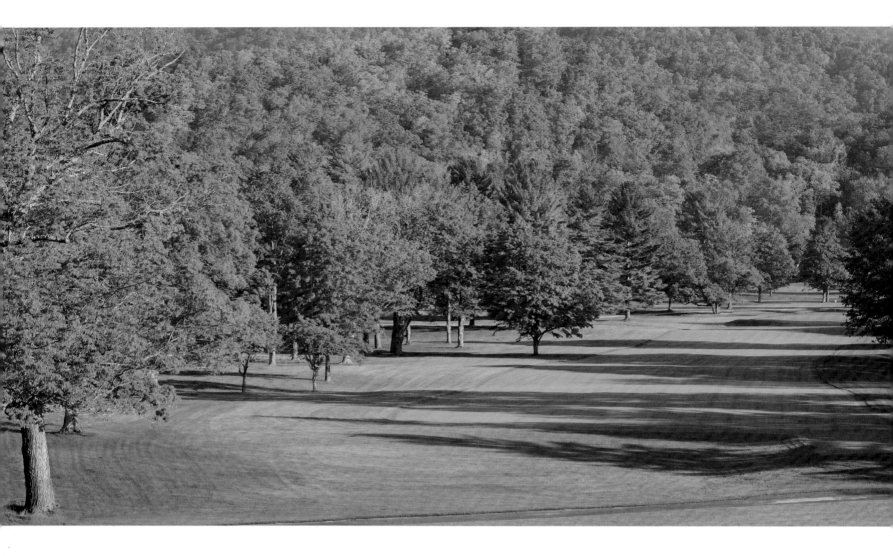

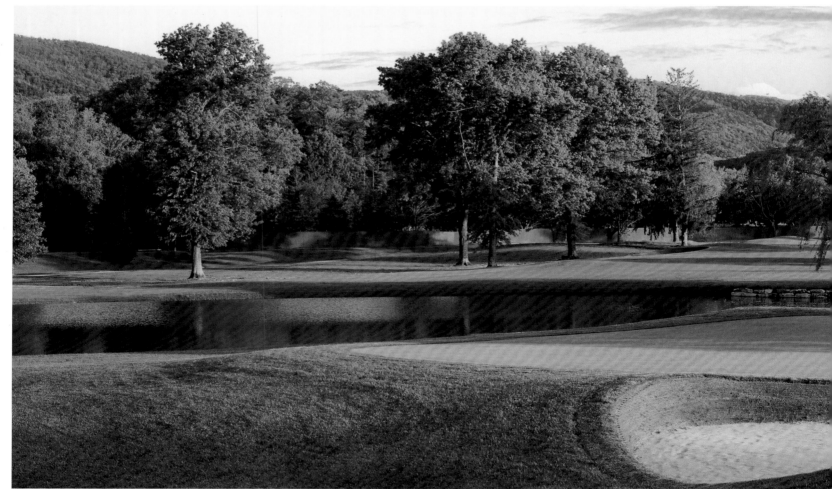

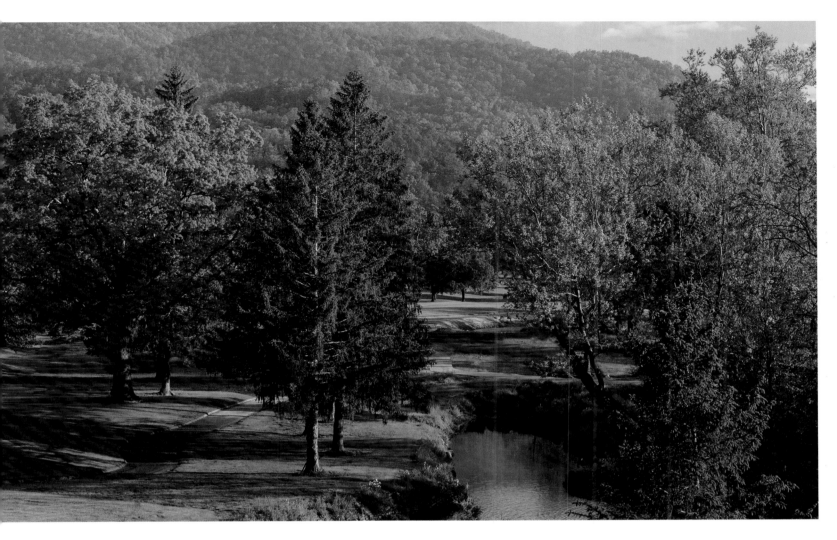

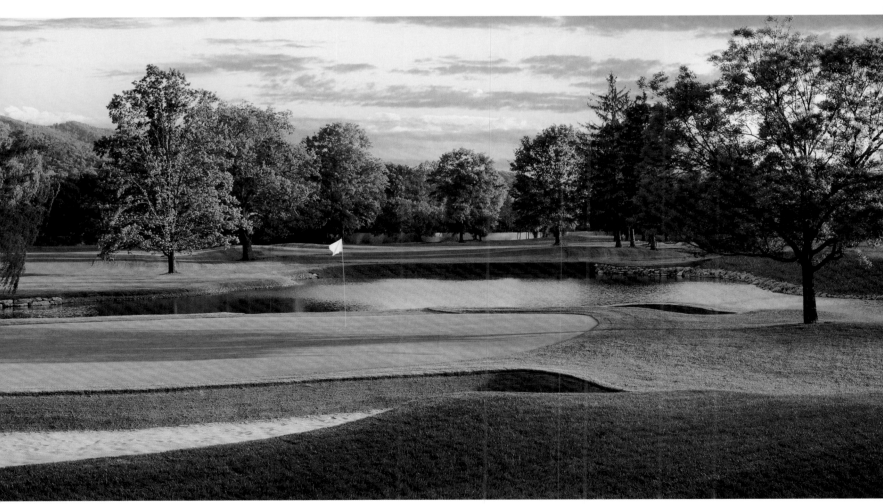

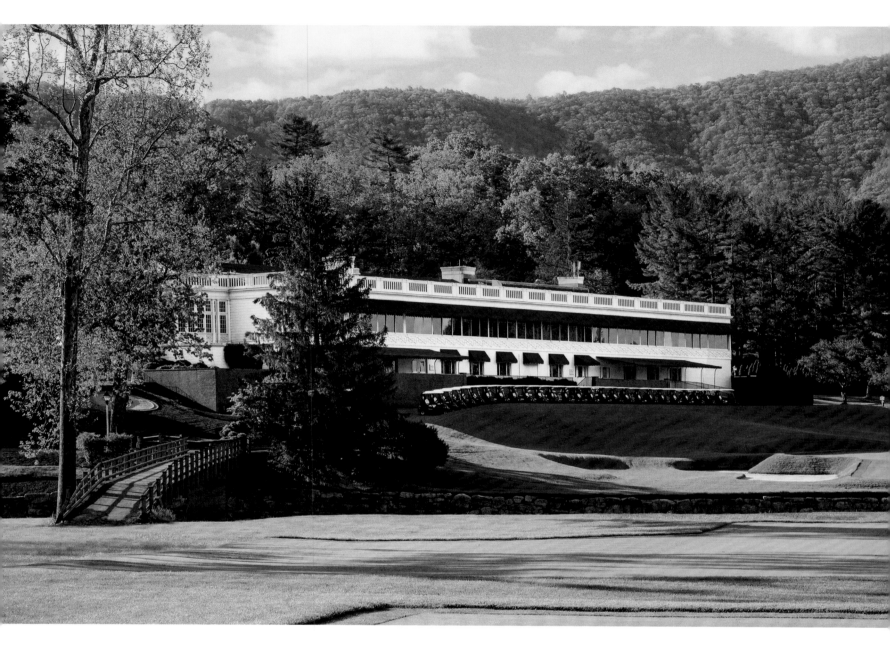

Carts waiting for early birds

Die Carts warten auf die Early Birds.

had opened for business and was quickly breaking records: the facility covers 4,500 hectares and the hotel has over seven hundered rooms as well as twenty bars and restaurants. And another record to add: twenty-six US Presidents have stayed here.

The resort's golf courses too can look back on a past filled with legendary personalities and historic events. From 1944 onwards, Sam Snead, the man with the elegant swing, was the resort's emeritus pro, a title later held by Tom Watson and then Lee Trevino. Though only honorary, the title is a testimony to the long tradition of the golf hotel that hosted, among tournaments, the Ryder Cup in 1979—the first in which the US competed against Europe. In 1994, the Solheim Cup took place here and the US PGA is a reg-

kurieren. Da war es kein Wunder, dass bereits 1913 das Luxushotel The Greenbrier eröffnete, das einige Rekorde aufstellte: Die Anlage ist 4500 Hektar groß, das Hotel verfügt über mehr als 700 Gästezimmer sowie 20 Bars und Restaurants. 26 US-Präsidenten haben dort schon übernachtet – auch das ein Rekord.

Die Golfplätze des Resorts blicken ebenfalls auf eine ereignisreiche Geschichte voller namhafter Persönlichkeiten und historischer Ereignisse zurück: Seit 1944 war hier Sam Snead, der Mann mit dem eleganten Schwung, der offizielle Head Pro, später wurde es Tom Watson und dann Lee Trevino. Auch wenn die Position nur ehrenhalber verliehen wird, zeugt sie doch von der langen Tradition des Golfhotels, das unter anderem den Ryder Cup

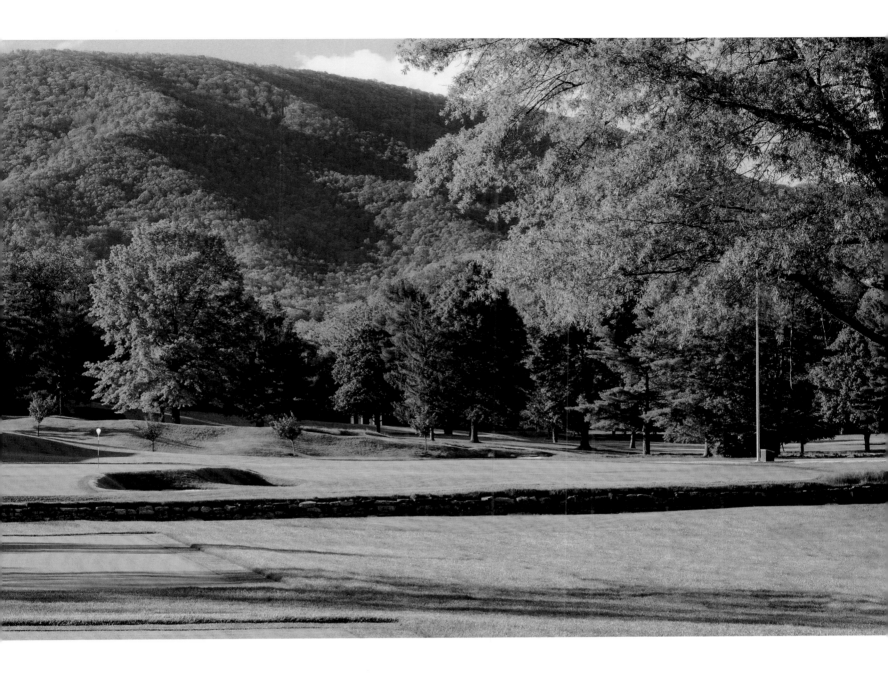

ular guest. For larger tournaments the Old White or the Greenbrier are preferred, whereby the latter currently has only 9 holes. Following a general overhaul, The Meadows now boasts eighteen exciting holes all with beautiful views. The 9-hole Ashford Short is specifically geared toward the intensive training of a short game. The resort also offers a broad range of sports and leisure activities, the most recent addition being a casino.

➤ USA, West Virginia, White Supphur Springs, www.greenbrier.com

1979 zu Gast hatte, den ersten, bei dem die USA gegen Europa antraten. 1994 wurde hier der Solheim Cup ausgetragen, und auch die US PGA Tour ist regelmäßig zu Gast. Für große Turniere wird der Old White oder der Greenbrier Course bevorzugt. Letzterer umfasst derzeit nur neun Löcher, dafür offeriert The Meadows nach einer Generalüberholung 18 spannende Bahnen mit herrlichen Ausblicken. Der 9-Loch-Ashford Short Course ist besonders fürs intensive Training des kurzen Spiels geeignet. Das Sport- und Aktivitätenprogramm ist mehr als üppig, und seit Neuestem gibt es sogar ein Spielkasino.

➤ USA, West Virginia, White Sulphur Springs, www.greenbrier.com

CLUBHOUSES
The Beauty of Slowing Down

CLUBHÄUSER
Die Entdeckung der Langsamkeit

Nothing beats the British clubhouse: dusky brick buildings, shy of light; creaky leather chesterfields; a dimly lit bar; a cloakroom with mahogany lockers, each baring the name of a member—some who have long past, others where it is unclear. Clubhouses pride themselves on adhering to a strict dress code, usually coat and tie and definitely no golf shoes. Incidentally, shoes must never be changed in the car park—as is commonplace anywhere else the world—but only in the cloakroom. The clubhouse, this manifestation of male friendship, this refuge from all life's rigors, this bulwark against wars,

Es gibt nichts Besseres als alte britische Clubhäuser. Düstere Backsteinbauten mit wenig Licht. Tiefe, knarzende Ledersessel. Eine schummrige Bar. Eine Garderobe mit Spinden aus Mahagoni, die mit den Namen der Clubmitglieder versehen sind. Manche sind längst tot, und bei manchen anderen weiß man es nicht so genau. Meistens gibt es einen strikten Dresscode, auf dessen Einhaltung viel Wert gelegt wird. Das Clubhaus ist in der Regel nur mit Sakko und Krawatte zu betreten, und natürlich sind Golfschuhe verpönt. Übrigens werden die Schuhe auch keinesfalls auf dem Parkplatz gewechselt,

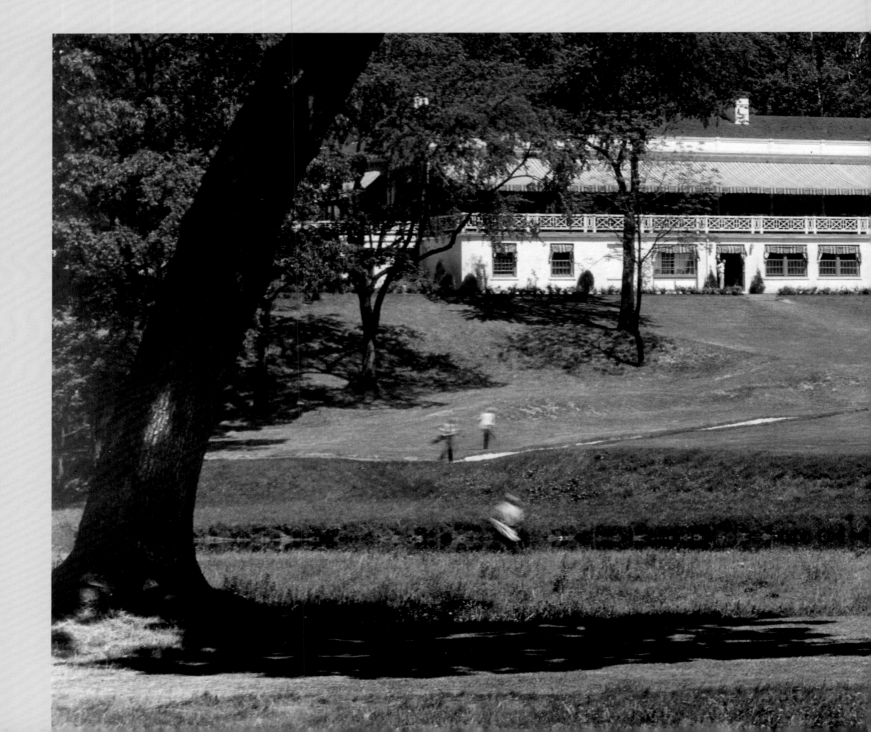

stock market crashes, and the unruly youth of today, honours the past: its corridors are lined with oil paintings of previous club presidents—albeit looking altogether "not amused." The silver trophies have tarnished over time, diligently framed black-and-white photographs tell of the Crown Prince's visit in 1899. The barman serves pints, the whiskey selection is excellent with most bottles at least half empty. Members pour over the newspapers with dedication. And everyone moves about at a very, very relaxed pace. This may be down to aging joints. But it can also be accounted to the dignified atmosphere that is so typical for the British clubhouse.

In the US clubhouses have cocktail bar, a gymnasium-sized dining hall with musical accompaniment, a sports supermar-

wie es sich überall auf der Welt eingebürgert hat, sondern im Umkleideraum. Im Clubhaus, dieser zu Stein gewordenen Männerfreundschaft, diesem Rückzugsort vor allen Unbilden dieser Welt, der Trutzburg vor Kriegen, Börsenpleiten und der ungezogenen Jugend, hängen Ölgemälde der bisherigen Clubpräsidenten, die allesamt so schauen, als hätten sie gerade von der Affäre ihrer Ehefrau mit dem feschen Nachbarn erfahren. Silberpokale sind schwarz angelaufen vor Historie, ein paar sorgfältig gerahmte Schwarzweißfotos erinnern an den Besuch irgendeines Kronprinzen im Jahr 1899. Der Wirt serviert Pints, die Whiskyauswahl ist exzellent, alle Flaschen sind höchstens halb voll. Die Tageszeitungen werden mit Hingabe gelesen. Alle bewegen sich sehr langsam. Das mag auch an den Gelenken liegen, die nicht mehr so können wie früher.

The historic clubhouse at The Greenbrier Golf Resort

Das geschichtsträchtige Clubhaus im Greenbrier Golf Resort

Page 118: The classic interior of the Royal St George's clubhouse

Seite 118: Die klassische Inneneinrichtung vom Clubhaus in Royal St. George´s

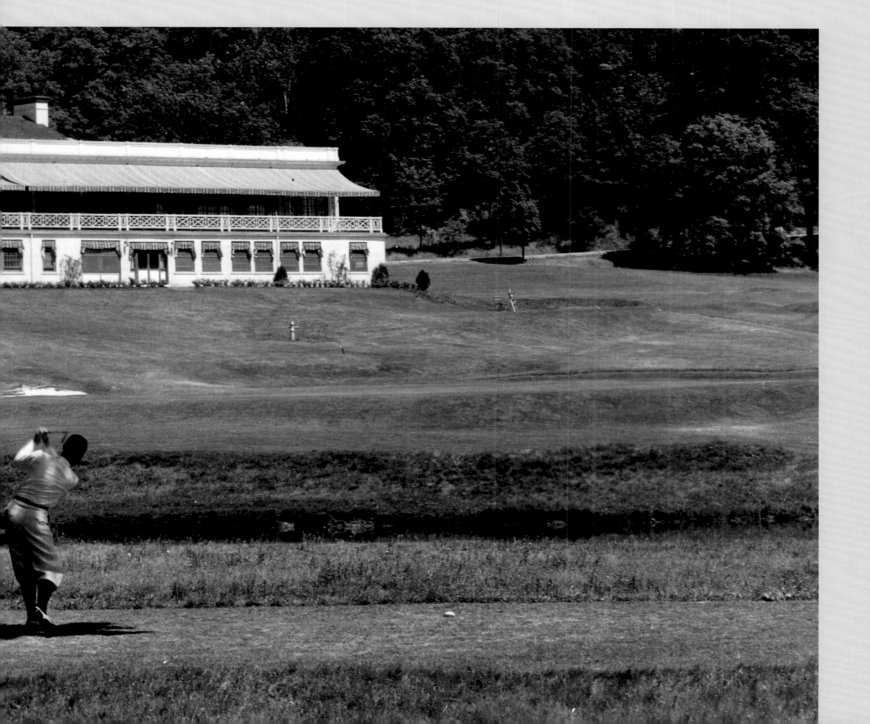

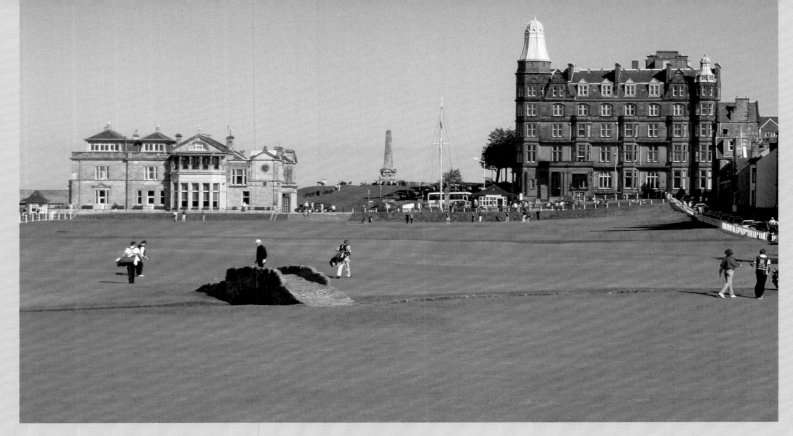

The clubhouse at the Old Course at St Andrews (left), in front of it the famous Swilcan Bridge

Links auf dem Bild das Clubhaus auf dem Old Course von St. Andrews, davor die berühmte Swilcan-Brücke

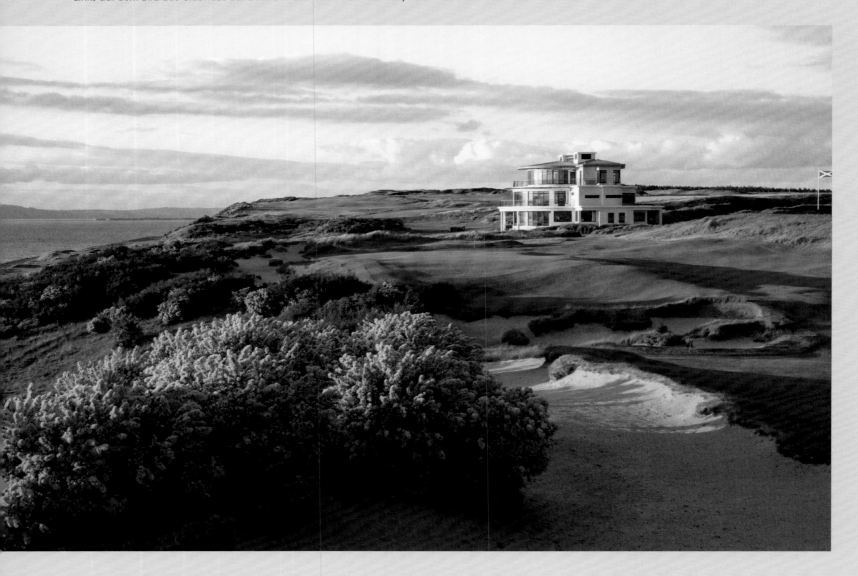

The clubhouse at Stuart Castle Golf Links, Scotland

Das Clubhaus in Stuart Castle Golf Links, Schottland

The Oasis Last Kind Words Saloon at the Furnace Creek Golf Club, Las Vegas

Der Oasis Last Kind Words Saloon im Furnace Creek Golf Club, Las Vegas

ket, and private rooms with artificial log fires. Because in the US the pace is quicker, golfers can pre-order lunch at the 16th to assure it's on the table on time by the end of the round.

In Germany and in other countries relatively new to golf, club-houses have a penchant for adventurous combinations of light wood furniture, generous use of glass, and unfortunate seating, accompanied by light, crossover cuisine—usually of Italian and Asian origin—but lacking true atmosphere.

Aber auch an der würdevollen Atmosphäre in einem typisch britischen Clubhaus.

In den USA haben die Clubhäuser eine Cocktailbar, einen turn-hallengroßen Speisesaal mit Musikuntermalung, einen Sport-supermarkt und Separees mit künstlichem Kaminfeuer. Weil es in den USA ja auch schnell gehen muss, kann man manchmal schon an Loch 16 sein Essen ordern, auf dass es pünktlich zum Ende der Runde auf dem Tisch steht.

In Deutschland und anderen spätgeborenen Golfnationen sind die Clubhäuser zumeist gewagte Kombinationen aus hellem Holz, viel Glas und unbequemen Stühlen. Dazu gibt es »leichte« italo-asiatische Crossover-Küche und wenig Atmosphäre.

Links golf with an Alpine panorama

Golf im Links-Stil, umgeben von alpinem Panorama

GOLF CLUB LEUK

SWITZERLAND / SCHWEIZ

The idea behind Leuk was to create a links course in the middle of Switzerland, which may sound unachievable. Links land describes hard-to-cultivate coastal land strips in Scotland and Ireland that mostly lay fallow; locals would merely let their sheep graze there on the salt grass—until one day a shepherd whacked a small round rock with his crook and set the ball rolling.

Scottish architect John Chilver-Stainer was recruited for the job—which he carried out uncompromisingly. The course is situated at almost 2,000 feet on a high valley in the Valais and opened in 2002.

Die Macher des Golf Club Leuk träumten von einem Linksplatz mitten in der Schweiz. Das klingt erst einmal wie eine unlösbare Aufgabe. Linksland ist in Schottland und Irland der nur schwer zu bewirtschaftende Streifen zwischen Meer und Acker; er lag meistens brach, die Schotten ließen lediglich ihre Schafe auf dem salzigen Untergrund grasen, bis irgendwann ein Schäfer darauf kam, mit seinem Stock gegen einen rundlichen Stein zu schlagen. Als Architekt gewann man den Schotten John Chilver-Stainer, der kompromisslos zu Werke ging. Der Platz im Wallis auf einem Hochtal in 600 Metern eröffnete im Jahr 2002.

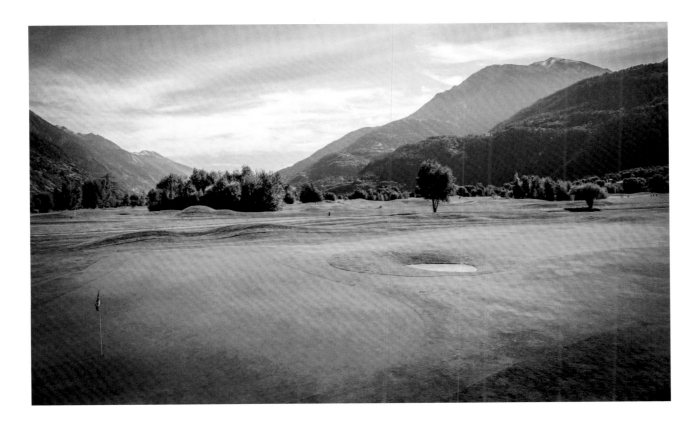

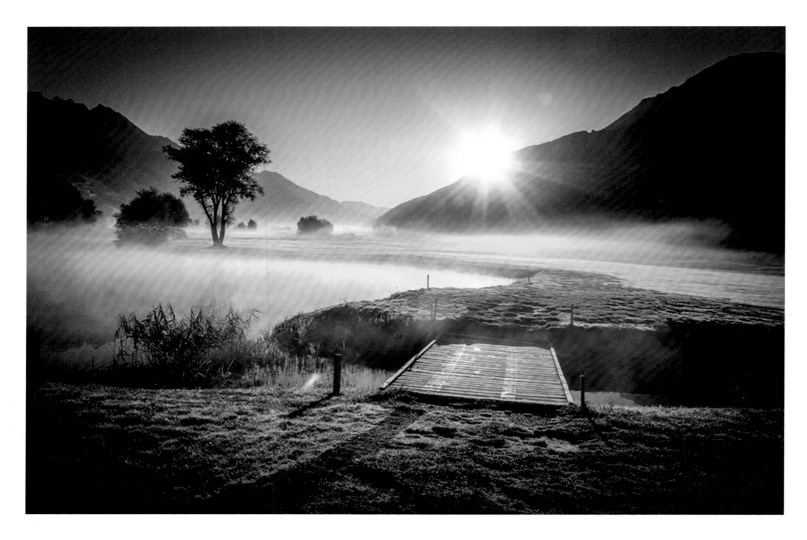

Water hazards add further obstacles

Wasserhindernisse sorgen für zusätzliche Schwierigkeiten.

What defines a links course? First of all it needs hard, sandy ground that absorbs rains easily. When it is wet, sandy soils drain well, meaning that, unlike on loamy grounds inland, no mud forms. Links land can also easily shrug off extremely dry spells in the summer, when clay grounds are crying out for generous watering. Ultimately, links courses are usable in almost any weather. Fortunately the ground in the Valais is naturally sandy. Other typical features include deep bunkers and undulating greens, and because there are no trees players are at the mercy of the elements. At GC Leuk a calm day with low winds is a rarity. The fairways are often hard and fast. Traditionally in Scotland and Ireland the ground game is cherished, whereby the ball is played low and undulations are taken advantage of. By contrast, on US and modern European courses the ball is usually played high, because their soft

Was macht nun einen Linksplatz aus? Als Erstes ein harter, sandiger Boden, der auch Regen gut wegsteckt. Bei Nässe drainieren die Sandböden so gut, dass sich im Gegensatz zu den bei Inlandsplätzen üblichen Lehmböden kein Schlamm bildet. Auch extreme Trockenheit im Sommer, wenn Lehmböden bereits großzügig gewässert werden müssen, übersteht Linksland mit einem müden Lächeln. Daher sind Linksplätze bei fast jeder Witterung bespielbar. Glücklicherweise war der Boden hier im Wallis schon sandig. Typisch für Linksplätze sind zudem tiefe Bunker und stark ondulierte Grüns, und weil auf Linksland keine Bäume wachsen, ist man den Elementen schutzlos ausgeliefert. Auch im GC Leuk ist ein windstiller Tag eine Rarität. Die Fairways sind oft hart und sehr schnell. Daher wird in Schottland und Irland traditionell das Ground Game gepflegt, bei dem der Ball flach und unter Ausnutzung der

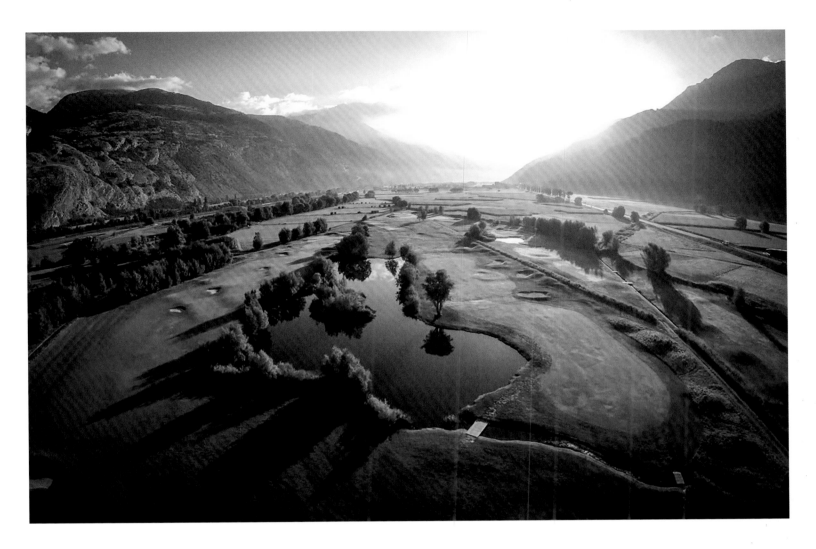

Deep bunkers should be avoided

Die tiefen Bunker sollten gemieden werden.

fairways and greens would all too quickly slow it to a stop. Hole 9 has a significant meaning for a links course, paying tribute to the 9th on Muirfield in Scotland. Players can chose one of several strategies and must heed the four bunkers to the left of the fairway for a par-5 at 580 yards, with challenging head winds to boot.

Until now, the GC Leuk has been a bit of an insider tip, however with its recently opened golf hotel it could easily graduate to a pilgrimage destination for golfing extremists.

➤ Switzerland, Leuk, www.golfleuk.ch

Wellen im Gelände gespielt wird. Auf amerikanischen und modernen europäischen Plätzen wird der Ball dagegen meist hoch aufs Ziel gespielt, weil er auf den weichen Fairways und Grüns schnell zum Halten kommt.

Typisch für Linksgolf ist Loch Nummer 9, ein Tribut an die berühmte Bahn 9 von Muirfield in Schottland. Spieler können mehrere Strategien wählen und müssen vor allem auf die vier Bunker am linken Fairwayrand achten. Es ist ein Par 5 mit 528 Metern. Im Gegenwind spielt es sich heftig.

Bislang ist der GC Leuk noch so etwas wie ein Geheimtipp, aber mit dem gerade eröffneten Golfhotel könnte hier fast eine Art Pilgerziel für Golffanatiker entstehen.

➤ Schweiz, Leuk, www.golfleuk.ch

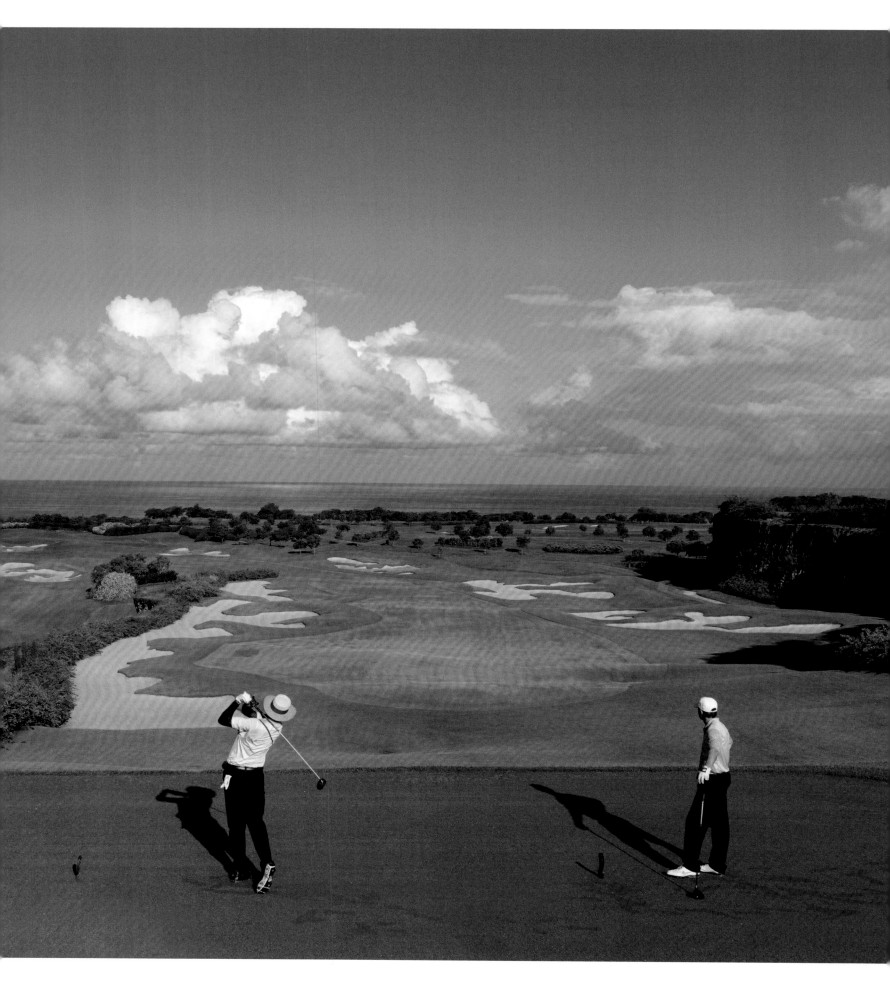

Teeing-off with a view of the Caribbean stretching into the horizon

Abschlag mit Karibik-Blick bis zum Horizont

SANDY LANE

BARBADOS

The three beautiful courses at Sandy Lane in the Caribbean are said to have cost $50 million, and there is no doubt that greens and fairways situated here in this lush landscape were worth every cent. The famous Green Monkey course, by design guru Tom Fazio, is exclusively reserved for resorts guests. The fairways wind their way through gorges and up again to reveal breathtaking views of the Caribbean around Barbados. Golf almost becomes secondary. For those who are still keen on a good score: beware of the tricky par-5 holes such as the 14th, which

Die Baukosten für die drei traumhaften Plätze von Sandy Lane in der Karibik betrugen angeblich 50 Millionen Dollar. Keine Frage, dass die Bahnen mit ihrer eindrucksvollen Szenerie diese Summe wert sind. Berühmt ist der Green Monkey Course von Design-Guru Tom Fazio, der exklusiv den Resortgästen vorbehalten ist. Die Bahnen ziehen sich durch Schluchten, um dann wieder aufzusteigen und atemberaubende Blicke auf die Karibik rund um Barbados zu bieten. Golf wird hier beinahe zur Nebensache. Wer sich dennoch um seinen Score sorgt: Besonders

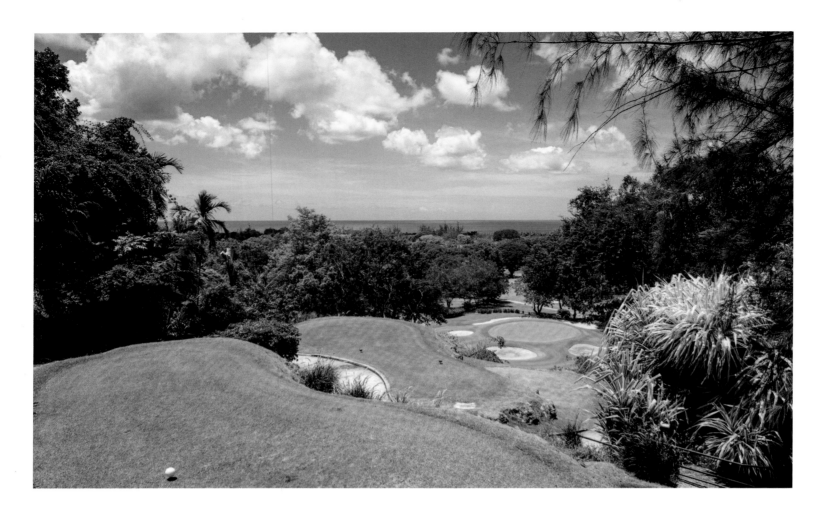

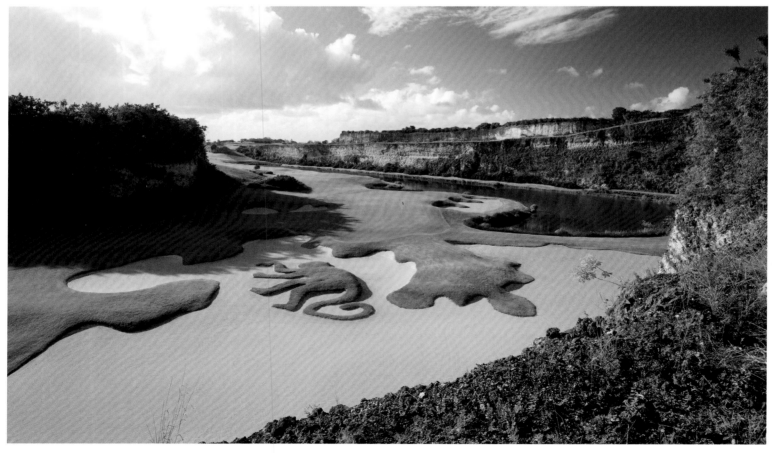

The Green Monkey in the bunker

Der Green Monkey zeigt sich im Bunker.

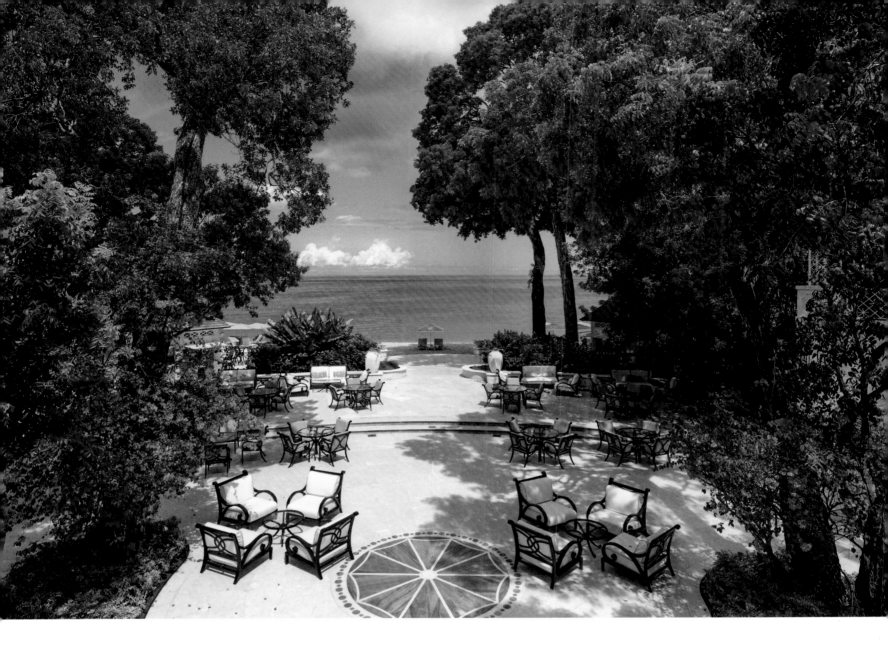

After the round bogeys are soon forgotten

Nach der Runde sind die Bogeys schnell vergessen.

requires teeing-off across a ravine to an elevated green. The final 18th is usually subject to headwinds, and many a player has left a donation in the water hazard left of the green. Another of Tom Fazio's designs, The Country Club proves a little less tricky but equally well-maintained and has been host to several professional tournaments. A nice touch: the five tee boxes are named in degree of difficulty: Ability, Hope, Humility, Respect, and (the shortest one) Reality. The Old Nine Course is very popular for a short, relaxing round of golf.

Besides luxury rooms, the resort offers four restaurants, various bars, a well-stocked wine-cellar, and a spa regarded as the best in the whole Caribbean.

➤ Barbados, Sandy Lane St James, www.sandylane.com

aufzupassen gilt es an den kniffligen Par-5-Bahnen, etwa an der 14, wo der Abschlag eine Schlucht überqueren muss und das Grün erhöht liegt. Die abschließende 18 wird meistens gegen die vorherrschende Windrichtung gespielt; im Wasser links vom Grün hat schon so mancher Spieler ein Erinnerungsstück hinterlassen. Der Country Club, ebenfalls von Tom Fazio gestaltet, ist etwas weniger knifflig, aber ebenso gepflegt und war schon Schauplatz großer Profiturniere. Netter Einfall: Die fünf Abschlagboxen heißen von schwierig bis leicht: »Ability«, »Hope«, »Humility«, »Respect« und (die kürzeste) »Reality«. Der Old Nine Course mit seinen neun Löchern ist beliebt für eine entspannte, schnelle Golfrunde.

Neben luxuriösen Zimmern warten vier Restaurants, diverse Bars und ein Weinkeller auf die Gäste, und das Spa gilt als das beste in der ganzen Karibik.

➤ Barbados, Sandy Lane St. James, www.sandylane.com

JOHN D. ROCKEFELLER

The Immortal Billionaire
Der unsterbliche Milliardär

Rockefeller was convinced that without golf, he'd die. Perhaps that's why he lived so long. The world's wealthiest man of his day and the first dollar billionaire in history was obsessed with golf. He had golf courses installed on every one of his properties and—though cinema was still in its infancy—he was the first golfer to capture his swings on camera.

The eccentric owner of Standard Oil only discovered golf in his mid-fifties. A big believer in daily routine, Rockefeller teed off every morning at precisely 10:15 a.m. Several caddies accompanied him, each fulfilling a very specific duty: one caddie was responsible for reminding his boss prior to each swing to "keep your head down, Mr. Rockefeller, Sir!" Already quite advanced in years, but with golf carts not invented, Rockefeller, mounted a bicycle to traverse the course. However, not wanting to waste his energy peddling, he got his caddies to push him— what a sight to behold. Rockefeller's bank statements confirm that in one year alone he spent $500,000—the equivalent of approximately $10 million today—on golfing. This is all the more astonishing considering he was generally a notorious miser, who didn't even heat his bedroom in the winter.

Convinced that golfing would prolong his life—his ambitious goal was to reach one hundred—he requested meteorological updates from all of his properties, that way he could dodge any bad weather and never miss a day of golf. However, one winter's day in Westchester he did run into some snow. Nevertheless he called his partner: "Shall we have a round?" Rockefeller asked. "Sir, the course is snowed under," the pro replied. "Not anymore it isn't," exclaimed the billionaire. And indeed: when they arrived, the course was bright green. Rockefeller had had the entire course, i.e. fairways, bunkers, roughs, and greens, shoveled clear...

Did Rockefeller become a centenarian? Not quite; he died in 1937, two years shy of reaching his goal. He played golf well into his 91st year.

Er war überzeugt davon, ohne Golf zu sterben. Wurde John D. Rockefeller deswegen so alt? Der seinerzeit reichste Mann der Welt und erste Dollarmilliardär der Geschichte war vom Golf völlig besessen. Auf jedem seiner Anwesen ließ er Plätze anlegen, und er ließ seinen Schwung als erster Golfer überhaupt mit Hilfe von Kameras aufnehmen – obwohl das Kino gerade eben erst erfunden worden war.

Der Besitzer von Standard Oil kam erst mit Mitte 50 zum Golf. Er hielt viel von einem geregelten Tagesablauf. Pünktlich um 10.15 Uhr teete er auf. Er hatte mehrere Caddies dabei, von denen einer nur die Aufgabe hatte, seinen Herrn vor jedem Schwung zu erinnern: »Mr. Rockefeller, lassen Sie den Kopf unten.« Im hohen Alter setzte sich Rockefeller aufs Fahrrad (Golfcarts gab es noch nicht), aber trat nicht in die Pedale, um keine wertvolle Energie zu verschwenden. Die Caddies schoben ihn, was doch ein ziemlich groteskes Bild abgegeben haben muss. Seine Kontobelege beweisen, dass er in einem Jahr 500 000 Dollar für Golf ausgegeben hat – nach heutigem Wert gut und gern 10 Millionen Dollar. Das ist umso erstaunlicher, da er in allen anderen Dingen ein unfassbarer Geizhals war, der nicht einmal im Winter sein Schlafzimmer heizen ließ.

Weil er sich völlig sicher war, dass Golf sein Leben verlängern würde (er hatte das ehrgeizige Ziel, 100 Jahre alt zu werden), ließ er sich die meteorologische Daten von allen seinen Anwesen übermitteln, um zu wissen, wann er wo sein musste, um ja keinen Golftag dem schlechten Wetter opfern zu müssen. In Westchester erwischte ihn dann doch einmal ein Schneetag. Trotzdem ließ er den Pro rufen. »Spielen wir eine Runde?« fragte Rockefeller. »Sir, der ganze Platz ist eingeschneit«, antwortete der Pro. »Jetzt nicht mehr«, antwortete der Milliardär. Und tatsächlich: Als die beiden zum Club kamen, leuchtete er in sattem Grün. Rockefeller hatte den gesamten Platz – Fairways, Bunker, Rough, Grüns – von seinen Angestellten freischaufeln lassen ...

Schaffte John D. Rockefeller die 100? Nicht ganz: Er starb 1937 mit 98 Jahren. Bis zu seinem 91. Lebensjahr spielte er Golf.

A Standard Oil Company share
Eine Aktie der Standard Oil Company

John David Rockefeller introduces a young boy to golf
John David Rockefeller zeigt einem kleinen Jungen das Golfspiel.

JOE LOUIS

Boxer and Golf Legend
Boxer und Golflegende

Joe Louis was one of the best and most adored heavyweight champions of all times. He held the title from 1937 to 1949 losing only one fight—the one against Max Schmeling. His manager blamed this defeat on the boxer's obsessive golf training—and in fact Louis was crazy about golf. However, following the German's victory Louis was no longer allowed to play more than an hour of golf a day, the rest of his time was spent sweating and sparring.

Joe Louis war einer der besten und beliebtesten Schwergewichtler aller Zeiten. Von 1937 bis 1949 hatte er den Weltmeistertitel inne. Er verlor nur einen Kampf – den gegen Max Schmeling. Sein Manager machte sein intensives Golftraining für die Niederlage gegen den deutschen Außenseiter verantwortlich. Denn tatsächlich war Louis golfbesessen. Nach der Niederlage gegen den Deutschen durfte er nur noch eine Stunde pro Tag Golf trainieren, den Rest der Zeit musste er beim Sparring schwitzen.

Joe Louis Congressional Gold Medal

After his boxing career, Louis often played with other stars such as Bing Crosby, Bob Hope, and Frank Sinatra. But most of all he enjoyed travelling with his friends. He was an enthusiastic gambler and extraordinarily generous, often covering the expenses of his whole entourage.

Nach seiner Boxkarriere spielte er oft mit anderen Prominenten wie Bing Crosby, Bob Hope und Frank Sinatra, doch am liebsten ging er mit Kumpels auf Reisen. Er war ein begeisterter Zocker und überaus großzügig (er zahlte seiner gesamten Entourage alle Reisespesen).

Segregation was still being implemented, particularly in golfing. In the forties and fifties African-Americans were only permitted to play on public golf courses. However, Louis didn't let this get in the way of his passion. He desperately wanted to win the Negro National, the country's most significant amateur tournament. After several attempts he finally achieved this is 1951. He later claimed this was the only title he ever really wanted to win.

Es herrschte immer noch Rassentrennung, auch und gerade im Golf. Schwarze durften in den Vierziger- und Fünfzigerjahren nur auf öffentlichen Plätzen spielen, doch Louis ließ sich in seiner Leidenschaft nicht beirren. Er wollte unbedingt die Negro National gewinnen, das wichtigste Amateurturnier des Landes. Nach mehreren Anläufen gelang es ihm 1951 schließlich. »Das war der einzige Titel, den ich wirklich erringen wollte«, sagte er später.

Golf was one of Joe Louis' favorite pastimes
Golf war eine der Lieblingsbeschäftigungen von Joe Louis.

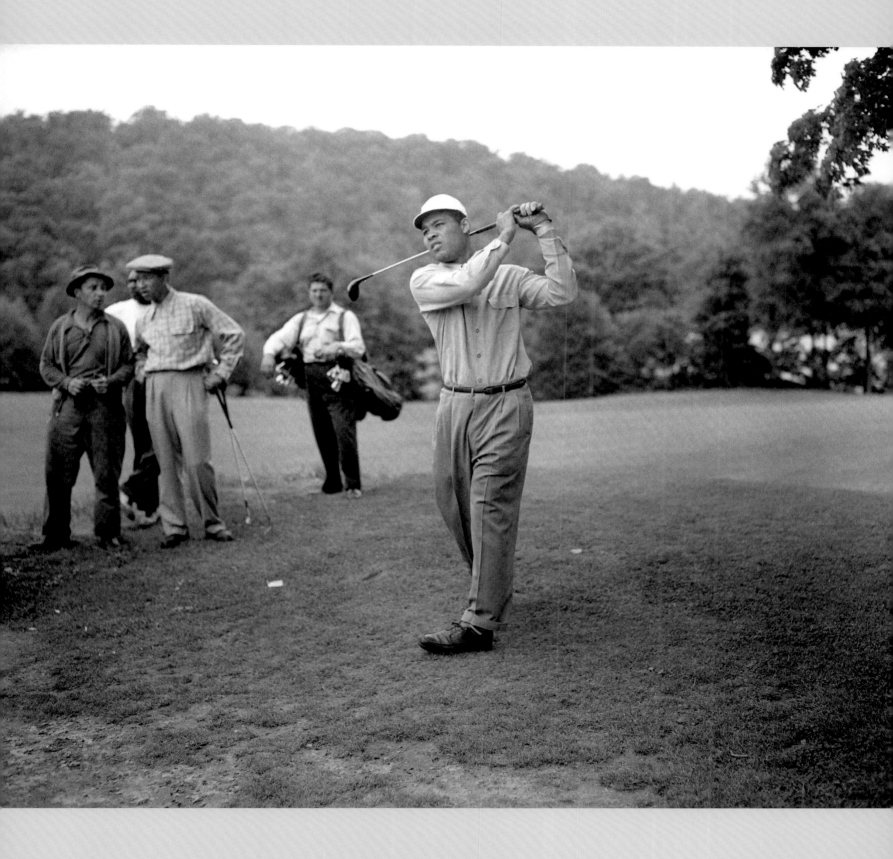

When invited to regular PGA tournament, the San Diego Open, PGA head Horton Smith vetoed it, due to the "Caucasian only" clause—a shameful chapter in golfing history. However, Louis insisted on his right to play and public pressure forced the PGA to concede. Finally in 1961, officials overturned the racist ruling—yet another achievement of the Brown Bomber, the heavyweight champion who'd have preferred a career on the green to in the ring.

Als er 1952 eine Einladung zum regulären PGA-Turnier der San Diego Open erhielt, legte PGA-Chef Horton Smith sein Veto ein. Nur Weiße durften antreten – kein Ruhmesblatt in der Golfgeschichte. Doch Louis bestand auf seinem Startrecht, und unter öffentlichem Druck gab die PGA schließlich nach. 1961 endlich strichen die Verantwortlichen die »No Negro«-Regel, auch ein Verdienst des »Braunen Bombers«, der viel lieber als Golfer denn als Boxer Karriere gemacht hätte.

TERRE BLANCHE

FRANCE / FRANKREICH

West of Grasse in one of the most romantic landscapes in Europe lies Terre Blanche with its two champion league courses designed by Dave Thomas: Le Château and Le Riou. The Château course is quite a challenge due to the sheer length of it. Le Riou, which hosts the Ladies European Tour, requires precision and strategy. The resort's

Das Resort westlich von Grasse liegt in einer der romantischsten Landschaften Europas und bietet die zwei von Dave Thomas entworfenen Meisterschaftsplätze Le Château und Le Riou. Der Château-Course stellt vor allem mit seiner Länge eine Herausforderung dar. Auf dem Riou-Course, wo jedes Jahr die Profidamen gastieren, sind

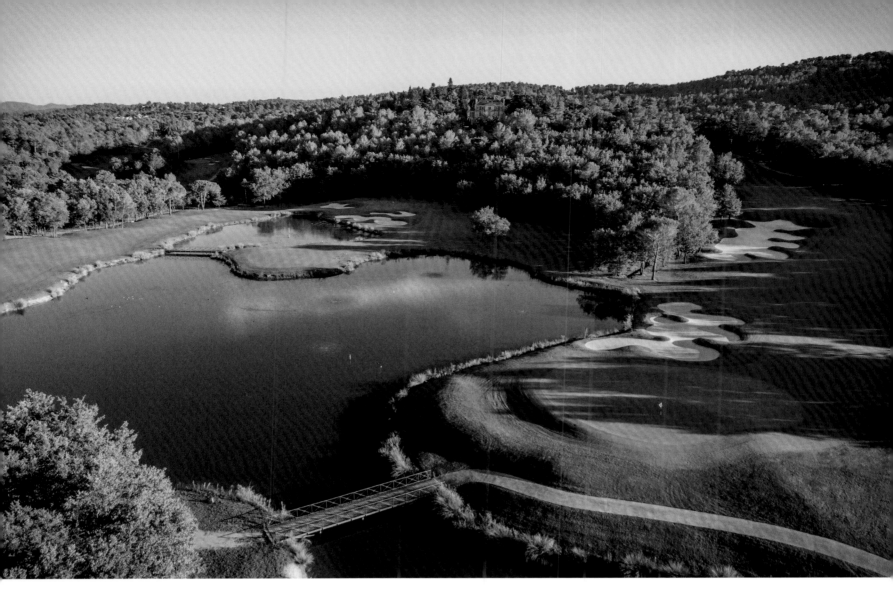

Pretty as a picture and tough: golfing in the Provence

Bildhübsch und anspruchsvoll: Golfen in der Provence

excellent on course service (e.g. all carts have GPS) extends to the training center, which is even popular among tour pros. The hotel offers spacious villas and suites, a spa, a heated infinity pool open all year round, and a wellness center. Philippe Jourdin's Michelin-starred restaurant La Faventia is one of five restaurants in which diners are treated to international and local specialties. The newly-added wine cellar with select rarities offers regular degustations. Children can choose from a range of activities, they have their own pool and even a special restaurant.

And for anyone so enamored by Terre Blanche they wish to stay, there is real estate on offer.

➤ France, Tourrettes, www.terre-blanche.de

Strategie und Präzision gefragt. Der herausragende Service zeigt sich nicht nur auf dem Platz (so sind alle Carts mit GPS ausgerüstet), sondern auch im fantastisch ausgestatteten Trainingszentrum, das sogar von Tour-Pros gern genutzt wird. Das Hotel bietet großzügige Villen und Suiten, einen ganzjährig beheizten Infinity Pool, ein Spa und ein Wellnesscenter. Gleich fünf Restaurants verwöhnen die Gäste mit provençalischen und internationalen Spezialitäten, darunter das Michelin-besternte La Faventia unter Chefkoch Philippe Jourdin. Ganz neu ist der Weinkeller mit besonderen Raritäten und regelmäßigen Degustationen. Auch für Kinder gibt es spezielle Programme, einen eigenen Pool und sogar ein spezielles Restaurant.

Übrigens: Wer von Terre Blanche so begeistert ist, dass er für immer bleiben möchte, kann hier Immobilienbesitz erwerben.

➤ Frankreich, Tourrettes, www.terre-blanche.de

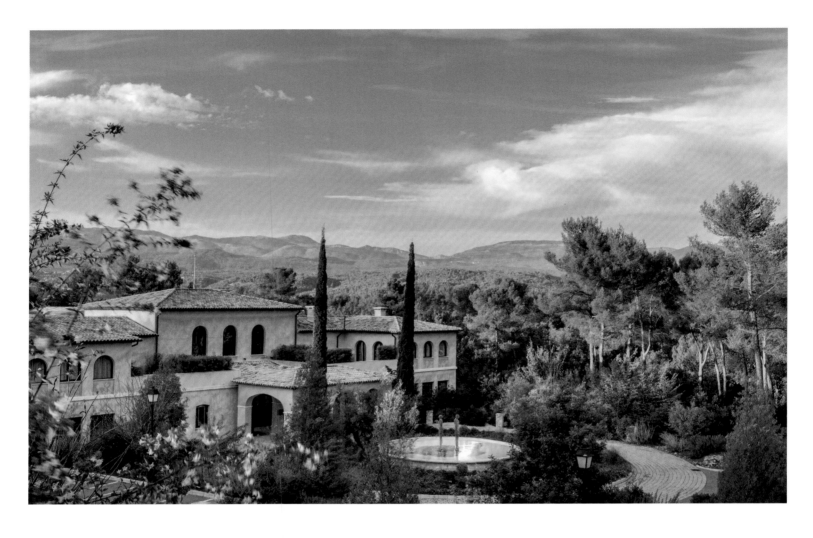

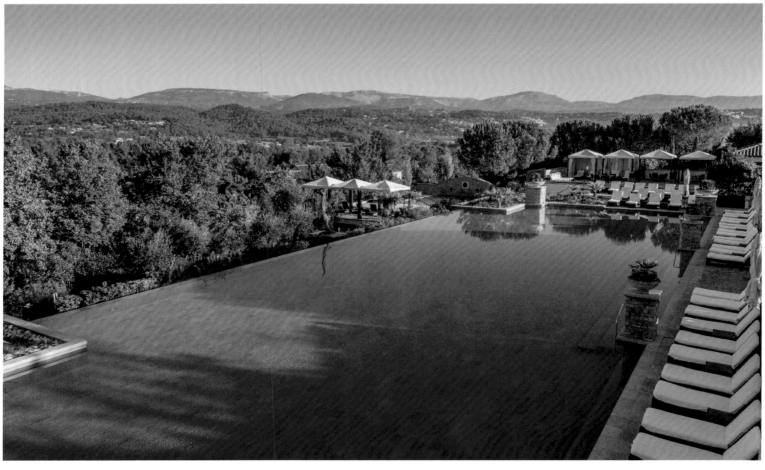

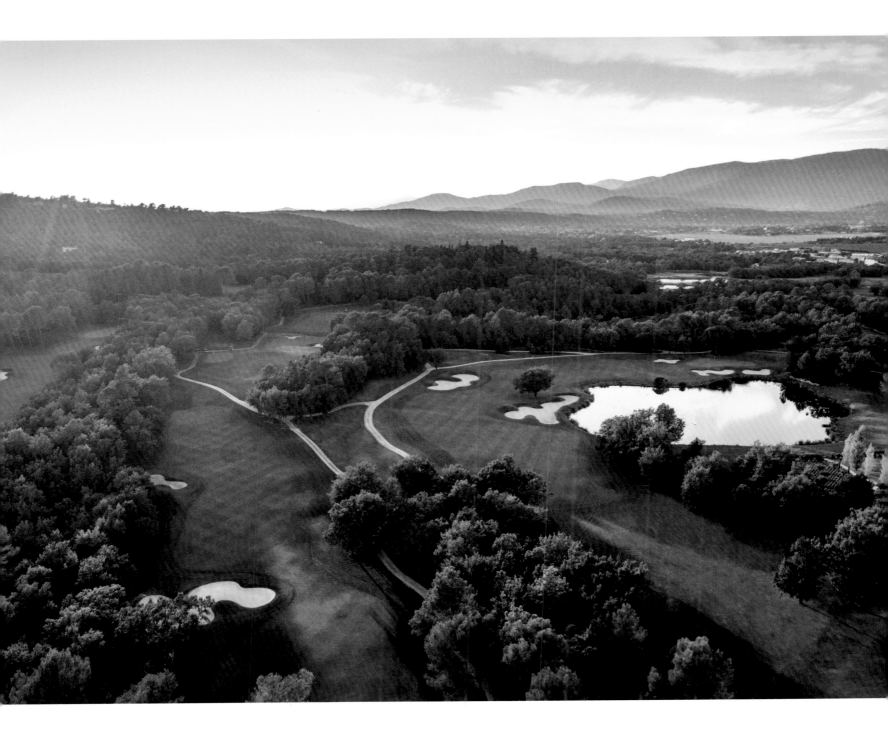

Villas and infinity pool surrounded by challenging holes

Villen und Infinity Pool, umgeben von schwierigen Bahnen

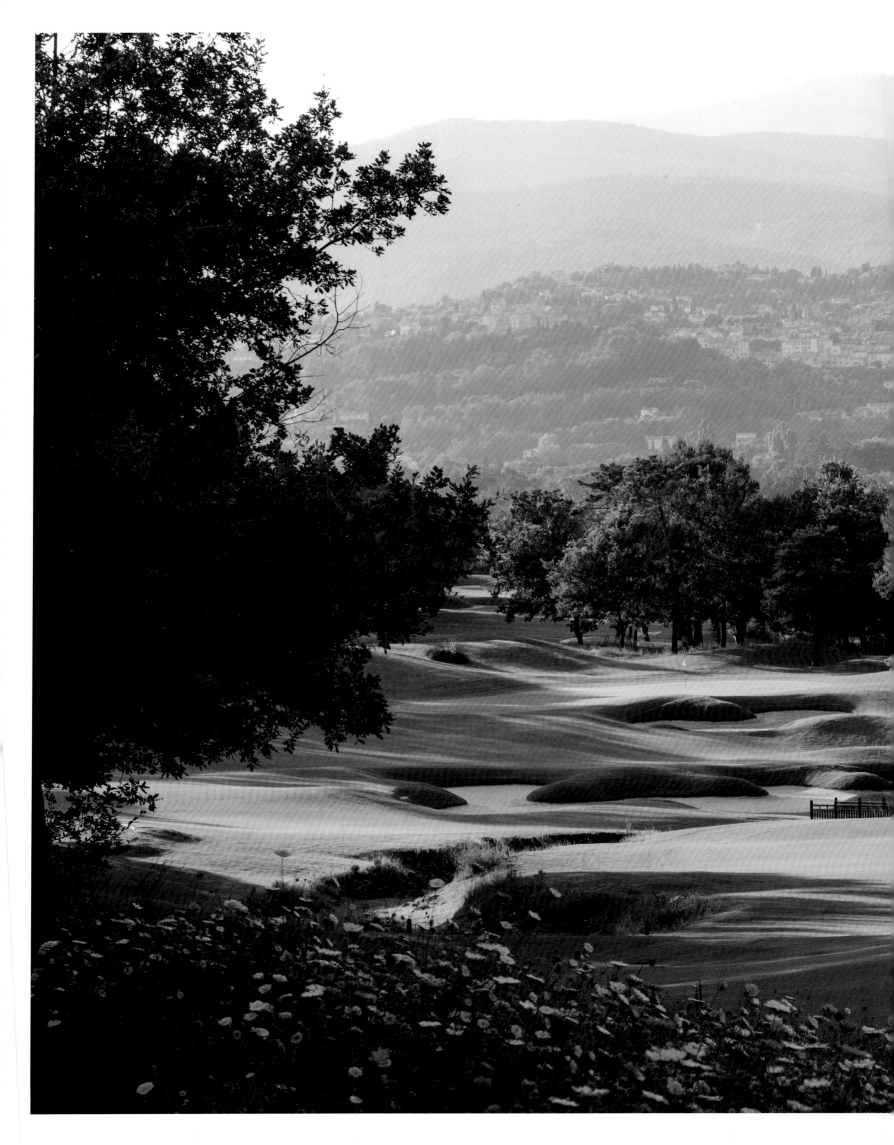

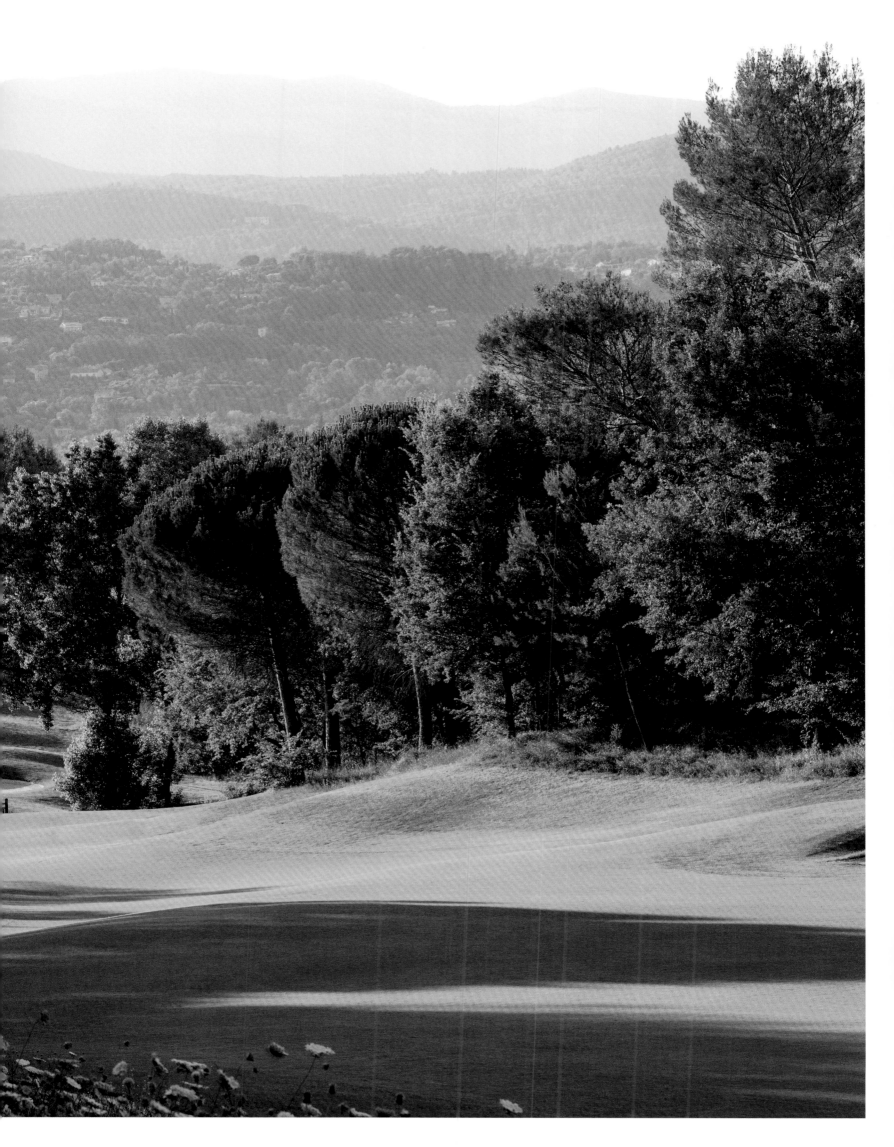

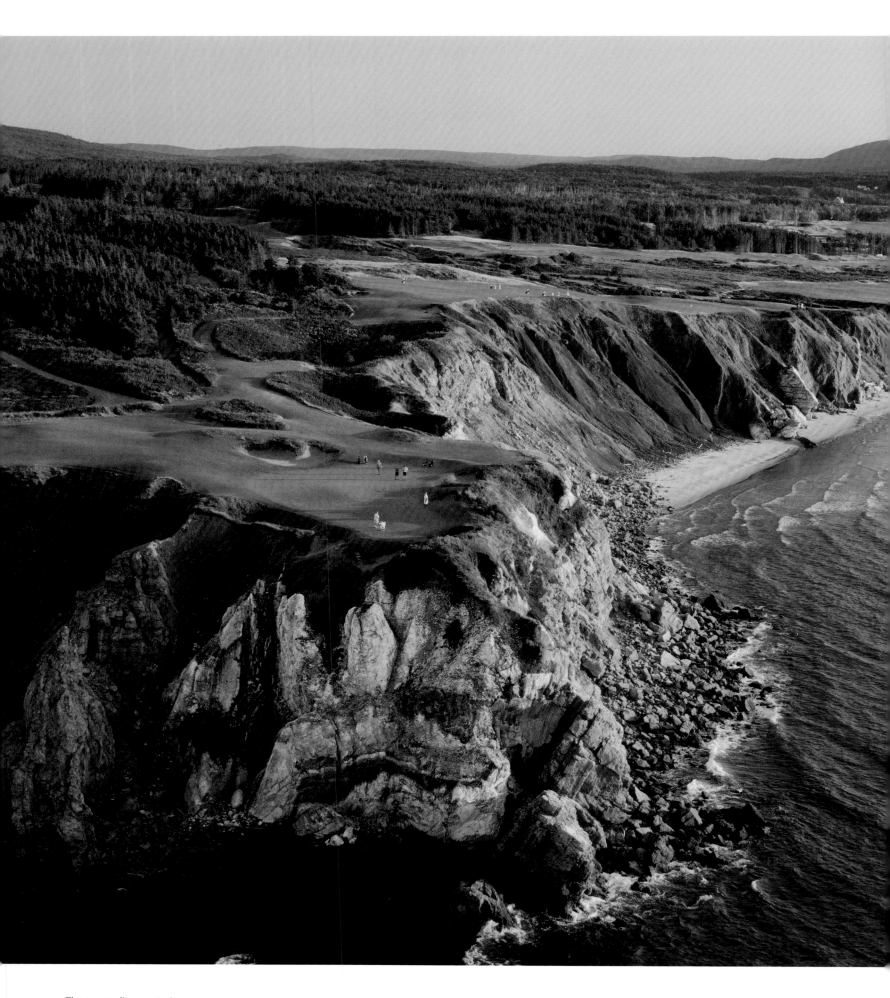

The course lives up to its name

Der Platz trägt seinen Namen völlig zu Recht.

CABOT CLIFFS

CANADA / KANADA

What splendor! The 36 stunning holes lining the coast of the Nova Scotia peninsula in eastern Canada effortlessly made it into the best-of lists. The 18-hole Cabot Links course, designed by Canadian Rod Whitman, offers the finest and purest coastal golf with undulating fairways, natural bunkers and breathtaking sea views from every hole, five of which lead directly along the beach. The neighboring 18-hole Cabot Cliffs course, designed by Bill Coore and major champion Ben Crenshaw, is arguably even more striking. As with all true links courses it offers a variety of options of how to approach the hole—with the weather always ready to foil the best laid schemes. Both courses blend in with natural landscape harmoniously—a clear sign of good design.

Everything at the resort is in walking distance, be it the courses or the three restaurants with their daily menus of freshly-caught seafood. Guests can explore the spectacular landscape on foot or by bike or go whale watching on a sailing boat. If so desired, visitors can spend an unforgettable day on a real fishing boat. And then there is tennis, whereby each court also has a sea view—links courts so to speak.

➤ Canada, Inverness, Noca Scotia, www.cabotlinks.com

Was für eine Pracht! Die 36 umwerfenden Bahnen auf der Halbinsel Nova Scotia im Osten Kanadas haben es mühelos in die internationalen Bestenlisten geschafft. Die 18 Löcher von Cabot Links, vom Kanadier Rod Whitman entworfen, bieten unverfälschtes Küstengolf vom Feinsten, mit heftig ondulierten Fairways, naturbelassenen Bunkern und atemberaubendem Meerblick – von jedem der Löcher ist das Meer zu sehen, und fünf Bahnen führen direkt am Strand entlang. Die nach Plänen von Bill Coore und Major-Sieger Ben Crenshaw gestalteten 18 Löcher von Cabot Cliffs sind fast noch etwas dramatischer. Wie immer bei echtem Linksgolf gibt es viele Optionen, die Löcher zu spielen – und wie immer spielt das Wetter eine entscheidende Rolle und kann die cleversten Pläne zunichtemachen. Beide Plätze fügen sich überaus harmonisch in die Natur ein: seit jeher ein Zeichen guter Platzarchitektur.

Im Resort ist alles fußläufig zu erreichen, ob der Weg zu den Plätzen oder zu einem der drei Restaurants, in denen es fangfrischen Fisch und Meeresfrüchte gibt. Gäste können auf Wanderwegen oder mit Fahrrädern die spektakuläre Natur erkunden oder per Segelboot auf Walbeobachtung gehen. Wer will, kann auch einen unvergesslichen Tag auf einem echten Fischerboot verbringen. Übrigens: Auch die neu angelegten Tennisplätze bieten Meerblick – Links-Tennis sozusagen.

➤ Kanada, Inverness, Nova Scotia, www.cabotlinks.com

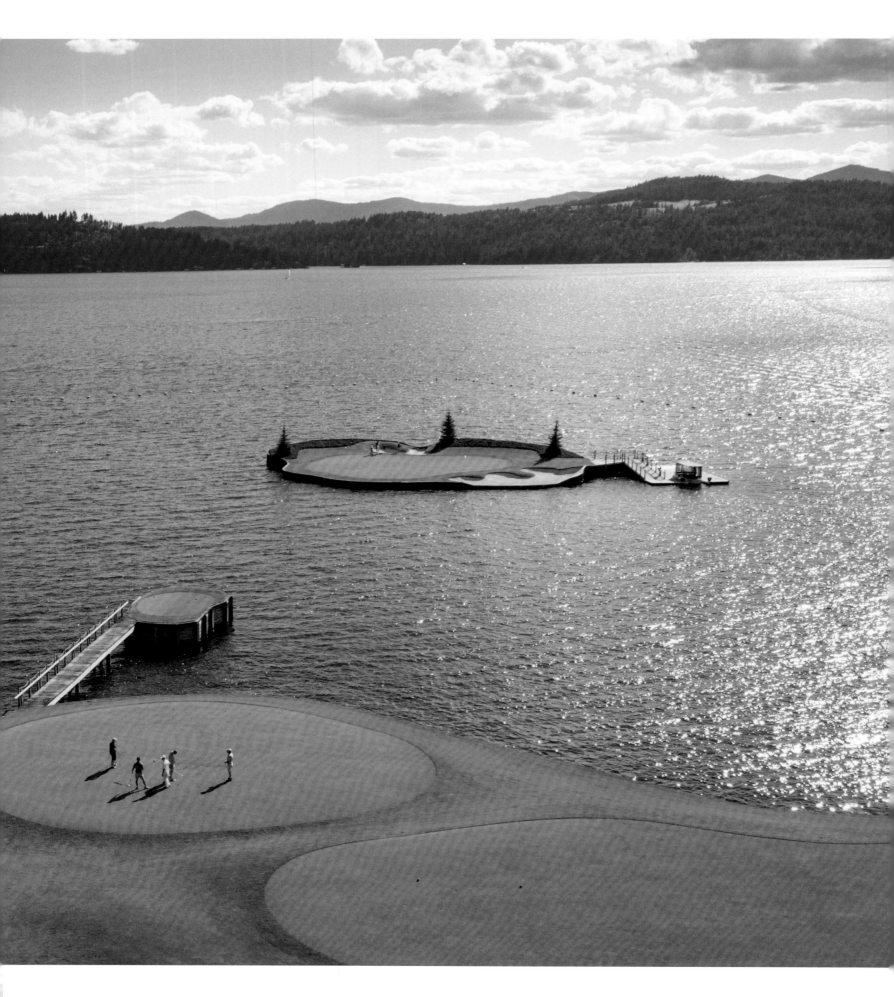

Bobbing up and down is the only floating green in the world

Da dümpelt es, das weltweit einzige schwimmende Grün.

THE COEUR D'ALENE RESORT

USA

The Coeur d'Alene course proves—in a rather unusual way—how far golf course design has come and what architects are capable of constructing in this day and age. In earlier times winds and tides formed the playing area, sheep mowed the lawns and a couple of men with spades built reasonably good fairways. Today, as if by magic, we have floating greens drifting to and fro before our eyes. But first things first: the course in the boomtown of the same name in North Idaho has always been considered one of the most beautiful courses in the country. Only recently the resort on the shore of Lake Coeur d'Alene underwent a full, high-investment refurbishment. With its elegant marina and a restaurant that boasts one of the best wine lists in the whole Northwest, the resort is tailor-made for its regular wine and whiskey festivals—or degustations.

But golfers primarily come here for the course: Coeur d'Alene is the only course in the world with a floating green, the 14th. It drifts about within range of the onshore teeing area and players are shuttled over by boat for their final putt(s). This unusual setting almost distracts a little from the fact that course's other holes—set amidst rich fauna—have much to offer that makes them uniquely remarkable.

➤ USA, Idaho, Coeur d'Alene, www.cdaresort.com

Der Platz beweist auf ungewöhnliche Art, wie sich der Golfplatzbau gewandelt hat und was Menschen heutzutage zu konstruieren imstande sind. Früher formten Winde und Fluten das zu bespielende Terrain. Schafe sorgten für die Mäharbeiten, ein paar Männer mit Schaufeln für halbwegs vernünftige Spielbahnen. Heute schwebt in Coeur d'Alene wie von Zauberhand ein ganzer Grünkomplex vor den Augen der Golfer hin und her. Aber der Reihe nach: Der Platz in der gleichnamigen Boomtown im Norden Idahos gilt seit jeher als einer der schönsten Courses des Landes, und gerade ist das gesamte Resort direkt am Coeur d'Alene Lake mit viel Geld komplett renoviert worden. Es gibt eine schicke Marina, die Gastronomie bietet eine der besten Weinkarten im ganzen Nordwesten der USA und veranstaltet regelmäßige Wein- und Whisky-Festivals und Degustationen.

Aber Golfer kommen vor allem wegen einer Bahn hierher: Coeur d'Alene bietet als einziger Platz der Welt ein schwimmendes Grün, das auf dem See mal näher und mal weiter fort vom Abschlag der Bahn 14 gefahren werden kann. Die Spieler müssen zum Einlochen mit einem Boot übersetzen. Diese ausgefallene Idee lenkt beinahe ein wenig davon ab, dass auch die übrigen Bahnen mit ihrer üppigen Fauna viel zu bieten haben und auf ihre Art unvergesslich sind.

➤ USA, Idaho, Coeur d'Alene, www.cdaresort.com

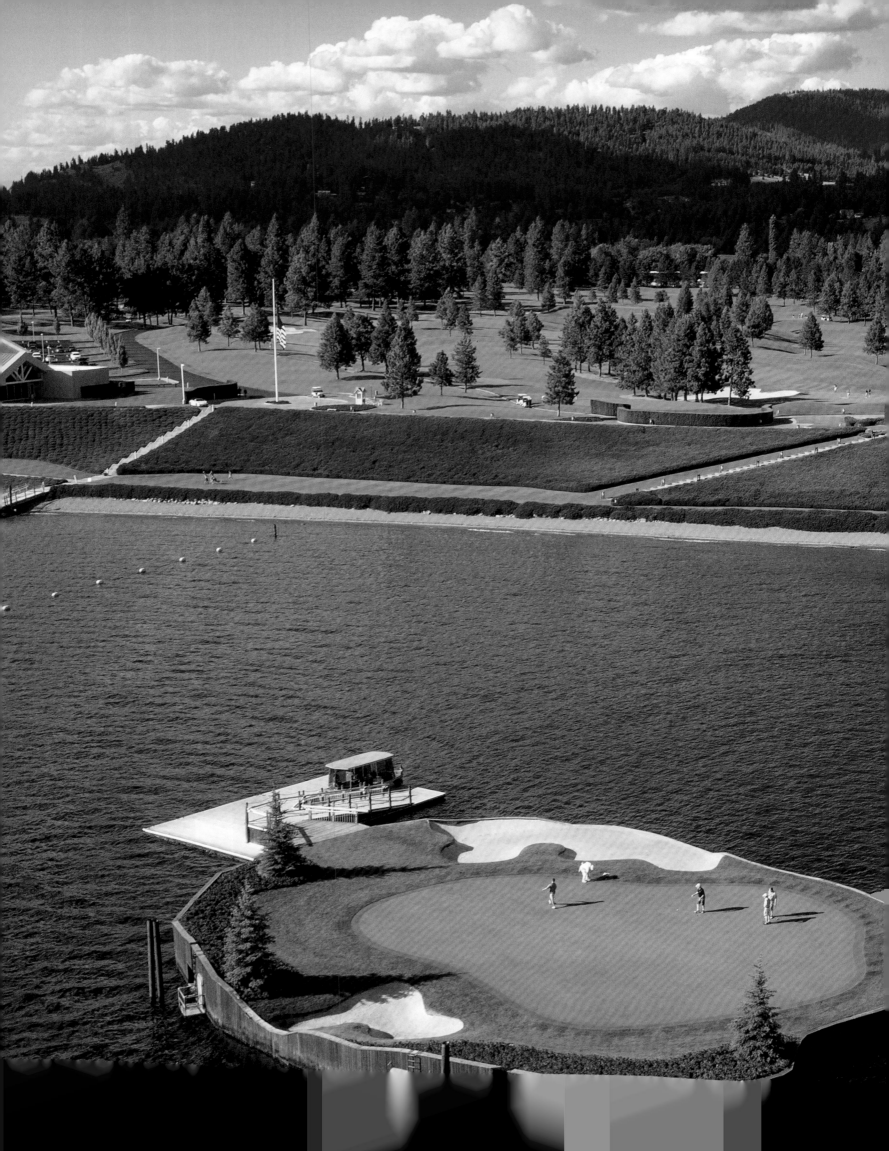

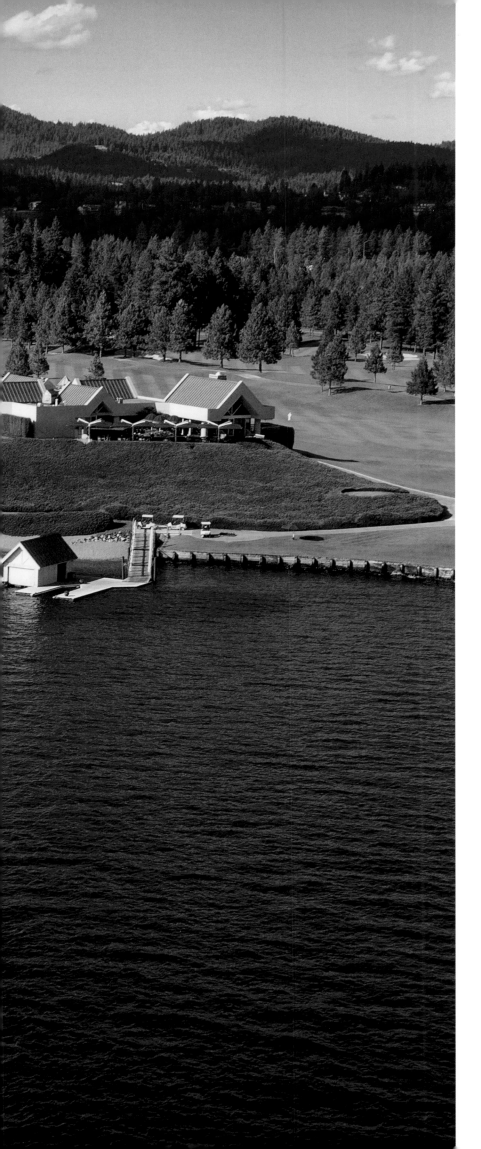

Players are ferried over to putt the ball

Ein Boot bringt Spieler zum Putten und wieder zurück.

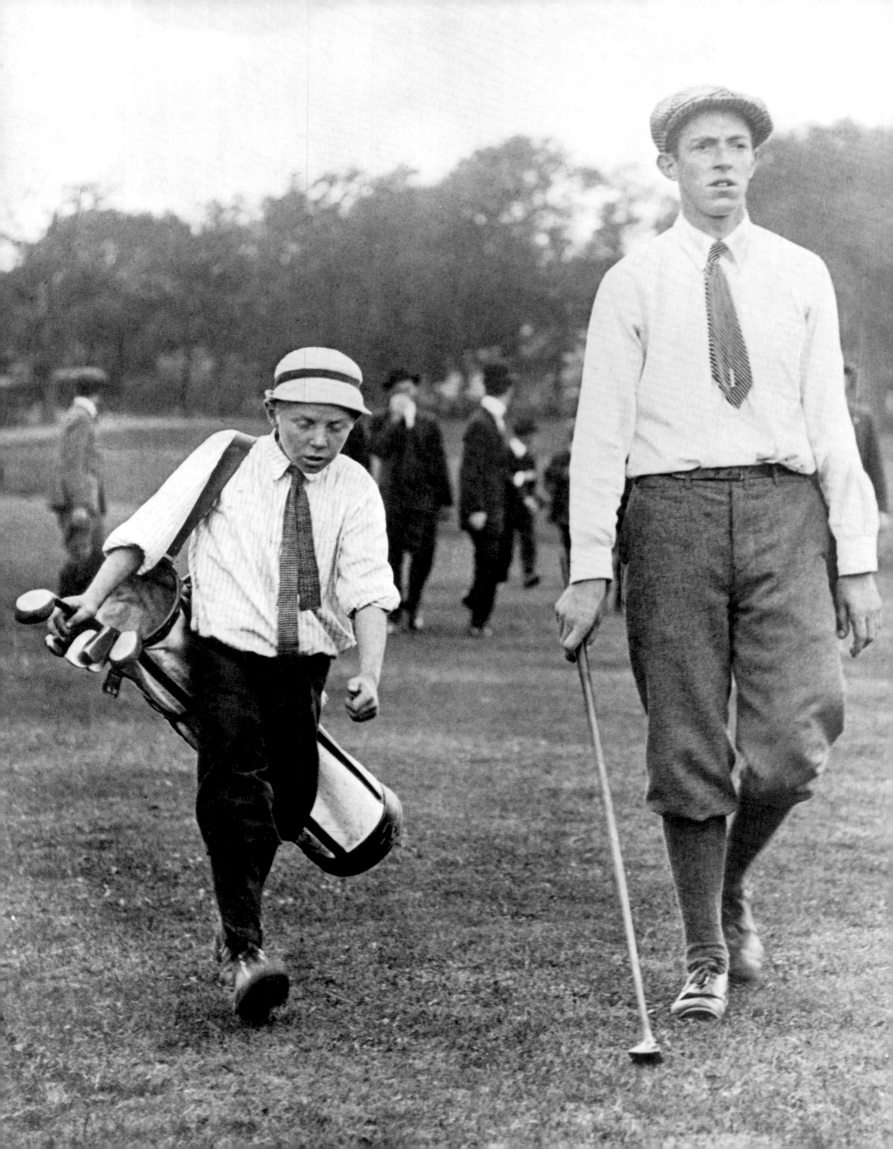

HOW GOLF MADE IT BIG IN THE USA

The founders of the first golf course in the US proudly named it Saint Andrew's—though the three holes on a meadow, which opened in 1888 in Yonkers, New York, had very little in common with its famous namesake. Then in 1893, the Chicago Golf Club opened America's first full-sized 18-hole course. By the turn of the century, there were as many as a few dozen golf courses in the New World.

However, golf was still lacking a founding myth. Then one day that myth turned up in the shape of twenty-year-old Francis Ouimet and his ten-year-old caddie, Eddie Lowery. Ouimet came from a modest background and had taught himself golf in his parents' back garden. The totally unknown amateur proceeded to shoot 72 holes at the US Open, placing him in a three-way tie with famous Brits Harry Vardon and Ted Ray at The Country Club, Brookline, Massachusetts. Just as the title play-off was about to begin, an experienced member of The Country Club approached him, offering to carry his bag. Ouimet, however, would trust no one but his young assistant, Eddie. With him at his side Ouimet went on to win the playoff, beating the English superstars. And thus a legend was borne.

Ouimet had shown that golf was not just an eccentric pastime for bored Brits—and more importantly he had proved that people from humble beginnings could make it right to the top. Within ten years, the number of golfers in the US tripled and public golf courses were finally installed. Today more than thirty million people play golf in the USA—that's almost half of all golfers worldwide.

WIE GOLF IN DEN USA GROSS WURDE

Den ältesten Golfplatz der USA nannten die Gründer stolz St. Andrews, obwohl die drei Bahnen auf einer Kuhwiese, die 1888 in Yonkers, New York, eröffnet wurden, wenig mit ihrem berühmten Namensvetter gemein hatten. Der Chicago Golf Club, der erste 18-Loch-Platz der USA, wurde 1893 gegründet. Um die Jahrhundertwende gab es ein paar Dutzend Plätze in der Neuen Welt.

Doch Golf brauchte noch einen Gründungsmythos. Und dieser Mythos kam in Gestalt des gerade 20-jährigen Francis Ouimet und seines 10-jährigen Caddies Eddie Lowery daher. Ouimet war ein völlig unbekannter Amateur, der im Jahr 1913 bei der US Open nach 72 Löchern mit den großen Briten Harry Vardon und Ted Ray im Country Club von Brookline, Massachusetts, gleichauf lag. Er kam aus bescheidenen Verhältnissen und hatte das Spiel im Garten seines Elternhauses gelernt. Kurz bevor das Play-off um den Titel startete, kam ein erfahrenes Mitglied des Country Clubs auf ihn zu und bot ihm an, für ihn die Tasche zu tragen. Doch Ouimet vertraute weiterhin dem jungen Eddie und gewann sensationell das Stechen gegen die englischen Superstars – eine Legende war geboren.

Ouimet hatte gezeigt, dass Golf keine skurrile Beschäftigung gelangweilter Briten war, und er hatte gezeigt, dass auch Menschen aus normalen Verhältnissen in diesem Sport ganz nach oben kommen konnten. Innerhalb von zehn Jahren verdreifachte sich die Zahl der Golfer in den USA, auch wurden endlich »Public Courses« geschaffen. Heute spielen in den USA 30 Millionen Menschen Golf – fast die Hälfte aller Golfer weltweit.

Francis Ouimet with his caddie Eddie Lowery, 1913

Francis Ouimet mit seinem Caddie Eddie Lowery, 1913

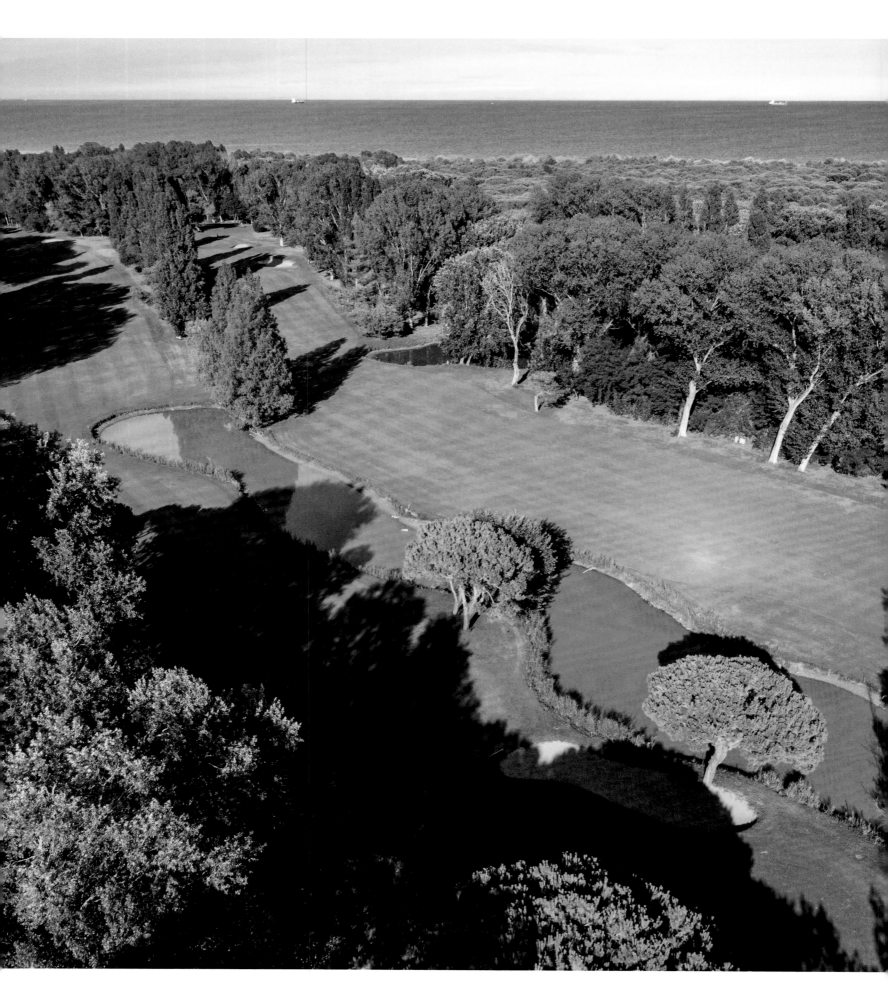

Golfing by the lido: Circolo is one of Italy's oldest courses

Golfen auf dem Lido: Der Circolo gehört zu den ältesten in Italien.

CIRCOLO GOLF VENEZIA

ITALY / ITALIEN

A golf club in Venice sounds a bit unlikely. And yet here are 18 holes that make up one of the oldest and most prestigious courses in Italy. We have Henry Ford to thank for this: The then richest man in the world didn't want to deny himself his golfing pleasures during his well-earned holiday. But there were no courses anywhere near Venice. That had to change—the sooner the better—thought Ford and promptly contacted his good friend Count Giuseppe Volpi of Misurata—an old-school influencer. Together they soon found a suitable plot: a hundred hectares of undeveloped land on the southern end of the Lido, the

Ein Golfplatz in Venedig – das klingt erst einmal komisch, doch tatsächlich gibt es hier 18 Löcher, die sogar zu den ältesten und renommiertesten in Italien gehören. Das haben wir Henry Ford zu verdanken, denn der reichste Mann der Welt wollte im wohlverdienten Urlaub nicht aufs Golfen verzichten. Doch es gab weit und breit keinen Golfplatz in Venedig – das musste sich schleunigst ändern, fand Mr. Ford. Er kontaktierte seinen guten Freund, Graf Giuseppe Volpi di Misurata, einen Influencer der ganz alten Schule. Beide machten sich auf die Suche nach einem geeigneten Gelände und fanden im Süden des Lido

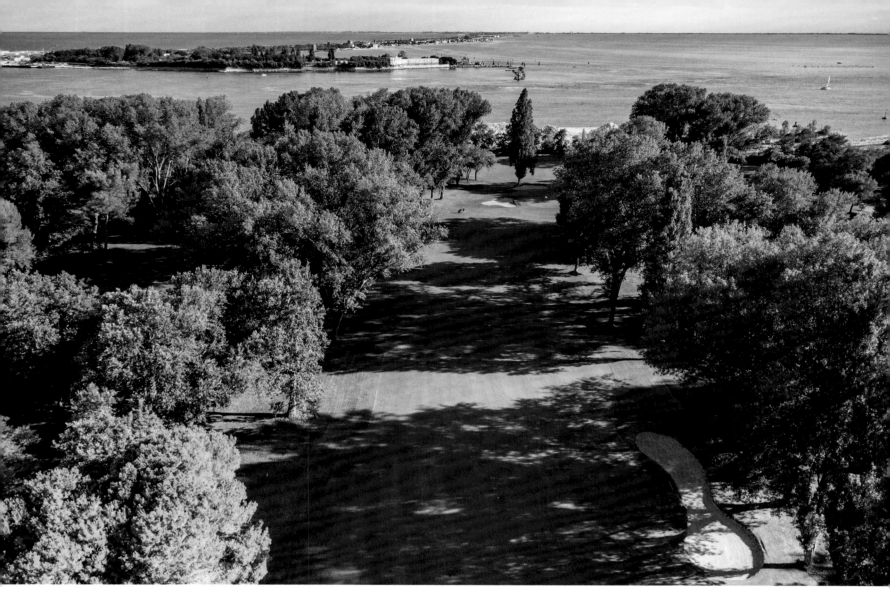

The course has settled since its pioneering days

Heute ist der Platz eingewachsener als zu den Zeiten der ersten Pioniere.

only hitch being that it was state-owned. However, with the Count being fairly well-connected, the project got the go-ahead in 1928 and by 1930, the first 9 holes were completed. The club's twenty-five founding members were the upper crust of Venetian society. A further nine holes opened in 1951, and to this day the course hosts international tournaments. Circolo Golf Venezia has a more sinister claim to fame, being the only (known) golf club to have Adolf Hitler as a guest. He and Benito Mussolini met here in 1934 for confidential talks. In August 1954, the Duke of Windsor, Bing Crosby, and British golf champion Henry Cotton played a round of golf together. During the film festival the course is populated with stars such as Sean Connery, George Clooney, and Clint Eastwood, to name but a few. Golf celebrities like Severiano Ballesteros, Johnny Miller, and Lee Trevino are also captivated by the lido fairways where legendary golfer Arnold Palmer holds the course record of 67.

➤ Italy, Lido di Venezia, (Venice), www.circologolfvenezia.it

100 unverbaute Hektar Land. Das Problem: Es gehörte dem Staat. Doch der Graf hatte gute Kontakte, sodass das Projekt 1928 genehmigt wurde, und 1930 öffneten die ersten neun Bahnen. Der Club hatte 25 Gründungsmitglieder – die alleroberste Schicht Venedigs. 1951 öffneten die zweiten neun Löcher, und bis heute werden immer wieder internationale Turniere auf dem Platz ausgetragen. Der Circolo Golf Venezia hat zudem die zweifelhafte Ehre, als vermutlich einziger Golfplatz der Welt Adolf Hitler zu Gast gehabt zu haben: Der traf sich hier 1934 mit Benito Mussolini zu Geheimgesprächen. Im August 1954 drehten der Herzog von Windsor, Bing Crosby und der britische Golfchampion Henry Cotton eine gemeinsame Runde. Bis heute spielen hier die Stars, die anlässlich der Filmfestspiele in der Stadt sind, darunter Sean Connery, George Clooney und Clint Eastwood. Golfgrößen wie Severiano Ballesteros, Johnny Miller und Lee Trevino beehrten die Lido-Fairways, und Legende Arnold Palmer hielt mit 67 Schlägen lange den Platzrekord.

➤ Italien, Lido di Venezia (Venedig), www.circologolfvenezia.it

PGA DE CATALUNYA

SPAIN / SPANIEN

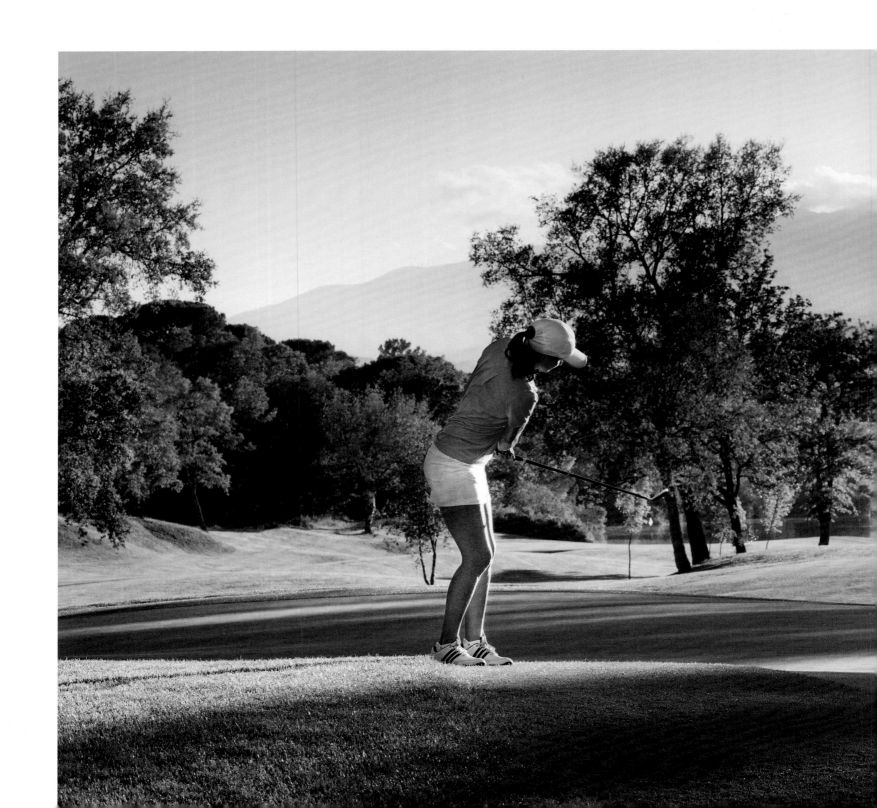

PGA de Catalunya is remarkable: a 36-hole course for first-rate golfing, a new luxury hotel called Camiral as well as numerous comfortable, modern, spacious, and individually designed apartments for rent or for sale as well as endless sporting activities nearby. And Girona airport is less than ten minutes away, the Catalan metropolis Barcelona, merely forty.

Inaugurated in 1999, the course has featured in several European tours. Its notable par-3 holes are as well-designed as they are challenging and its signature green island 13th par-4 has repeatedly been ranked the world's most scenic hole. The course itself is the number one favourite in the whole of Spain, where competition is pretty stiff. Incidentally, despite its name, the Tour course is slightly easier than

Ein beeindruckender Komplex: 36 Löcher Spitzengolf, ein neues Luxushotel namens Camiral sowie zahlreiche moderne und komfortable, großzügig geschnittene und individuell gestaltete Apartments zum Mieten und zum Kaufen, unendlich viele Sportmöglichkeiten – und der Flughafen Girona liegt keine zehn Minuten entfernt, die katalanische Metropole Barcelona nur 40 Minuten.

Die 1999 in Betrieb genommene Anlage war bereits mehrmals Schauplatz von Turnieren der European Tour. Besonders die Par-3-Löcher sind ebenso gelungen designt wie schwierig zu spielen, und Loch 13, ein Par 4 mit Inselgrün auf dem Stadium Course, wurde schon mehrmals zu den schönsten Löchern der Welt gewählt – und der Course selbst zur Nummer eins in ganz Spanien, wo

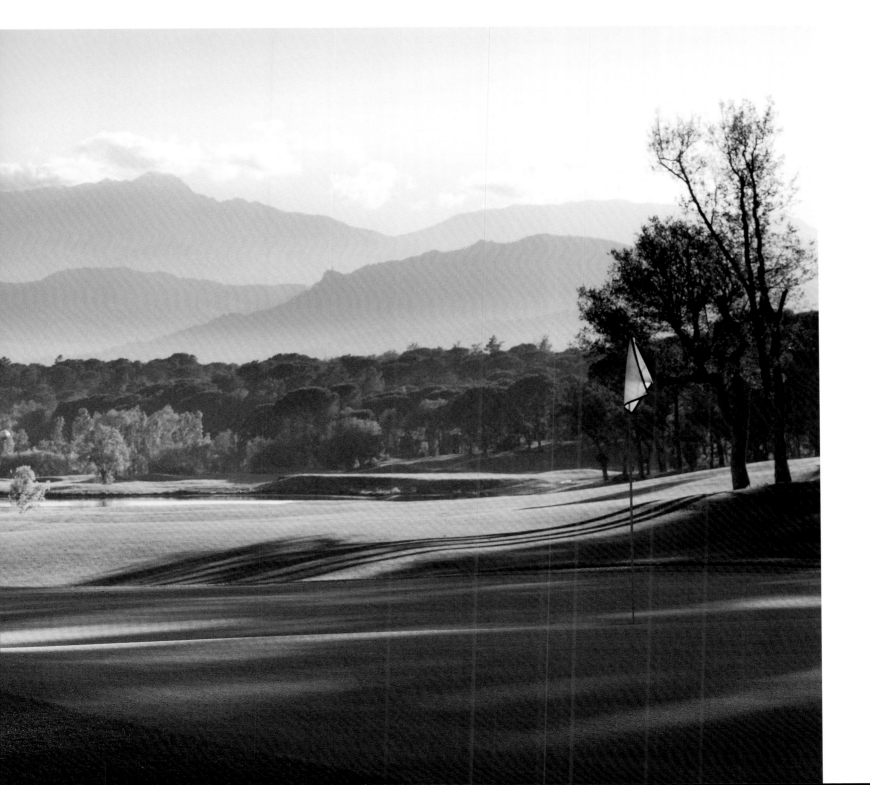

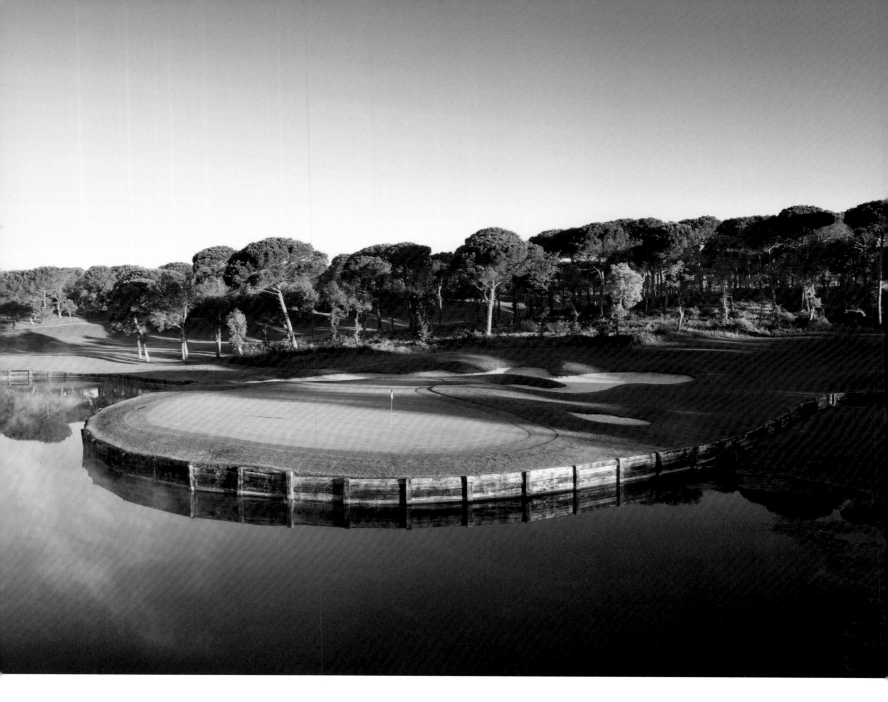

Not just the water hazards make this a tricky course

Nicht nur die Wasserhindernisse machen die Löcher knifflig.

the Stadium course. Generally, this is where all the golfer's abilities are put to the test: added to the long fairways are lightning-speed greens and the dungeon-deep bunkers. Golfers seeking the ultimate challenge will not be disappointed. And those looking to unwind after a day of scores can take advantage of numerous spa offers. Besides golf, there is plenty more to do: rambling, hiking, vineyard bike tours, kayaking, or scuba diving; the resort also offers tennis camps for children.

➤ Spain, Caldes de Malavella, Girona, www.pgadecatalunya.com

die Konkurrenz nicht klein ist. Kuriosität am Rande: Der Tour Course ist, trotz des Namens, ein klein wenig einfacher als der Stadium Course.

Generell wird hier der ganze Golfer gefordert. Zu der Länge der Bahnen kommen blitzschnelle Grüns und kohlengrubentiefe Bunker. Wer die ultimative Herausforderung liebt, ist hier richtig. Und wer sich von seinen Scores entspannen will, findet zahlreiche Spa-Angebote. Auch sonst gibt es viel zu tun, vom Spazierengehen und Wandern über eine Wein-Radtour bis hin zum Kajakfahren oder Tauchen, und dann gibt es noch die besonders für Kinder interessanten Tenniscamps.

➤ Spanien, Caldes de Malavella, Girona, www.pgadecatalunya.com

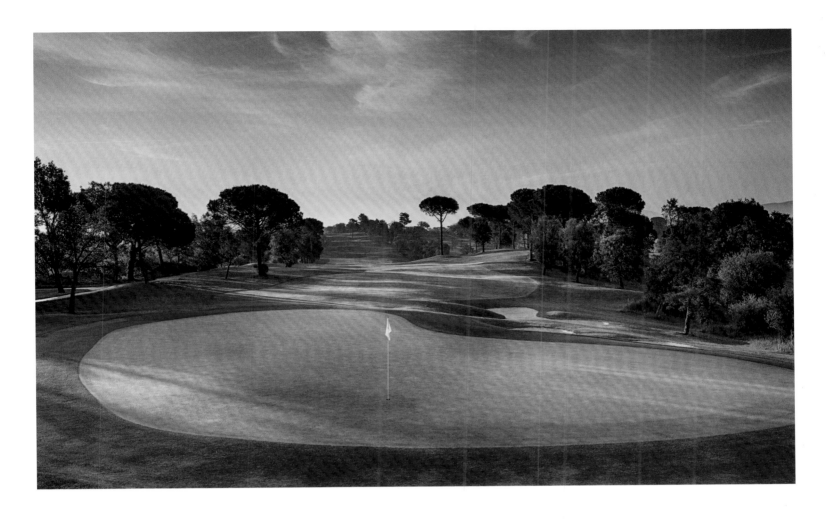

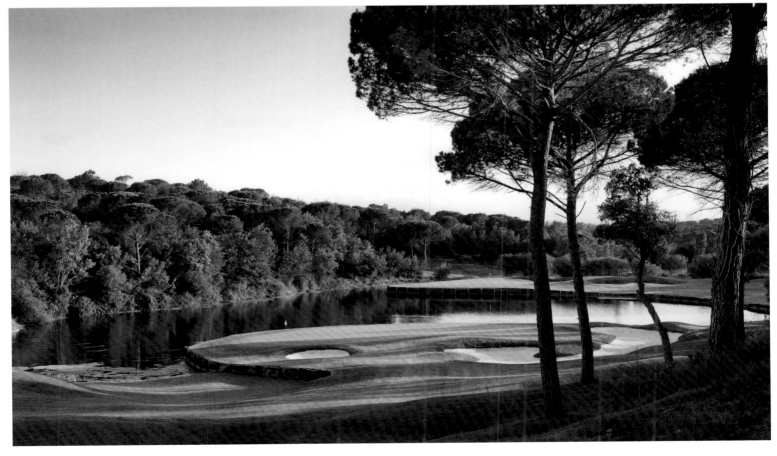

Pros and amateurs love both courses

Pros wie Amateure lieben die beiden Plätze.

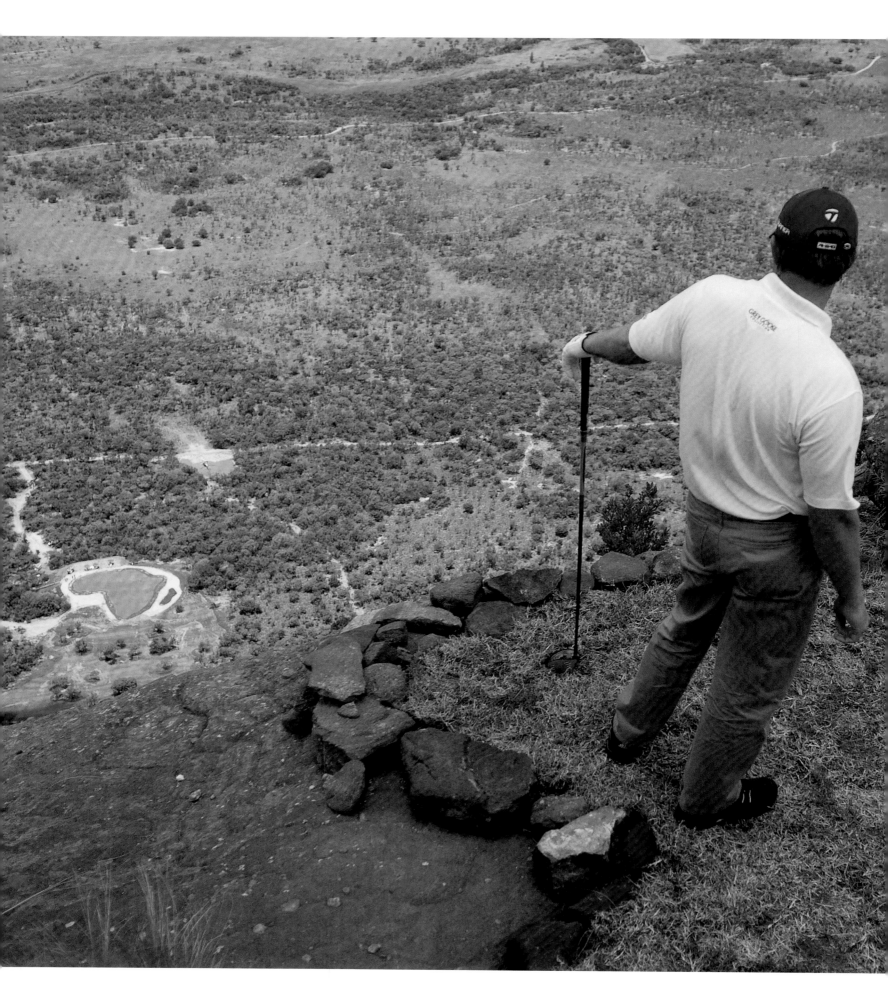

The "Extreme 19th" is no good for golfers with vertigo

Die »Extreme 19« ist nur etwas für Schwindelfreie.

LEGEND GOLF & SAFARI RESORT

SOUTH AFRICA / SÜDAFRIKA

The most spectacular golf hole in the world has to be the Extreme 19th: its tee, shaped to resemble the continent of Africa, is situated over a thousand feet above the green, meaning players have to be helicoptered over to tee off. The par-3 course has not yet seen a hole-in-one, though several golfers have achieved a birdie. Not far from this slightly bizarre attraction the resort, with 205 rooms and thirteen suites, boasts a signature course with eighteen first-class holes designed to be extended to over eight thousand yards to host professional tournaments, making it one of the longest courses in the world. Furthermore, each hole was created by a different pro golfer. The list includes Colin Montgomerie, Pádraig Harrington, Bernhard Langer, and Sergio Garcia. Holes 1 and 18 bear the hallmarks of South African designers Trevor Immelman and Retief Goosen.

Es ist das spektakulärste Golfloch der Welt: Der Abschlag der »Extreme 19« liegt mehrere Hundert Meter über dem Grün, welches wie der afrikanische Kontinent geformt ist. Spieler müssen mit einem Hubschrauber zum Tee geflogen werden. Ein Hole-in-one ist an diesem Par 3 noch niemandem gelungen – ein Birdie aber schon. Doch jenseits dieser etwas skurrilen Attraktion bietet das luxuriöse Resort mit 205 Zimmern und 13 Suiten 18 erstklassige Golflöcher des Signature Courses, die für Profiturniere bis auf enorme 7748 Meter verlängert werden können, was den Platz zu einem der längsten der Welt macht. Damit nicht genug: Jede einzelne Bahn wurde von einem anderen Spitzengolfer entworfen, darunter Colin Montgomerie, Pádraig Harrington, Bernhard Langer und Sergio Garcia. Die Bahnen 1 und 18 tragen die Handschrift der Südafrikaner Trevor Immelman und Retief Goosen.

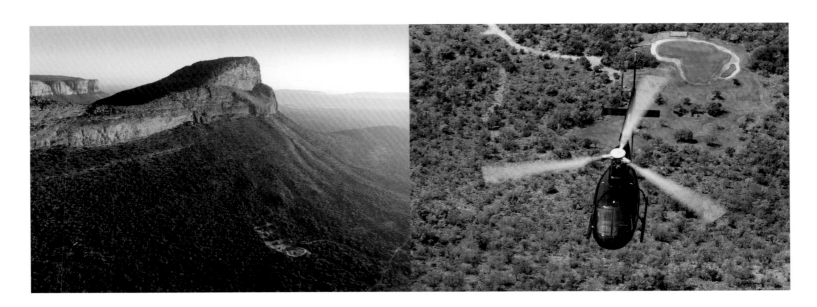

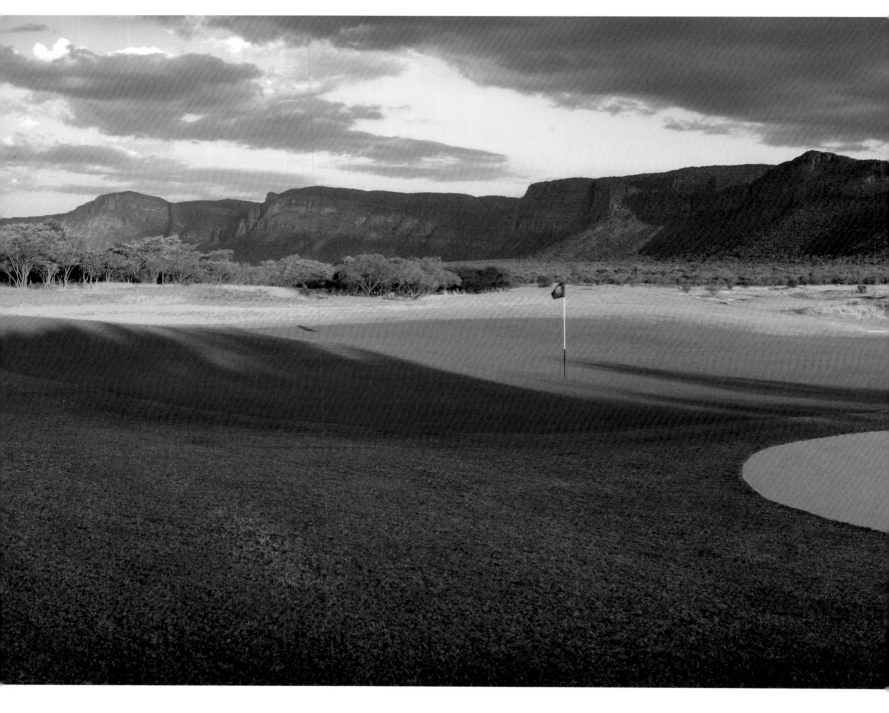

Picturesque holes for every handicap

Wunderschöne Bahnen für jedes Handicap

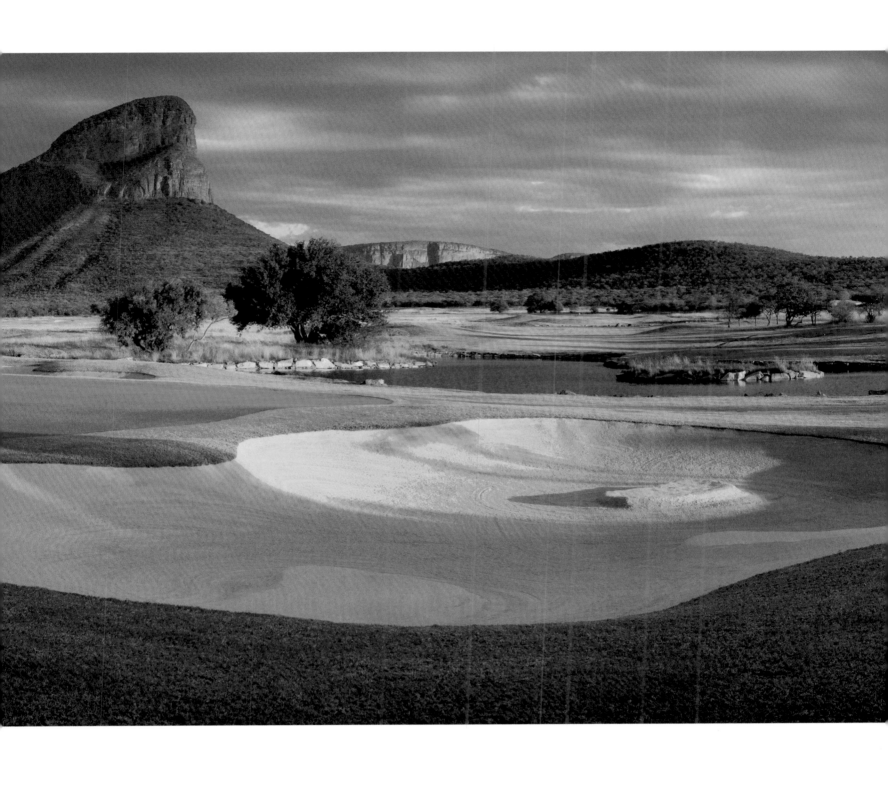

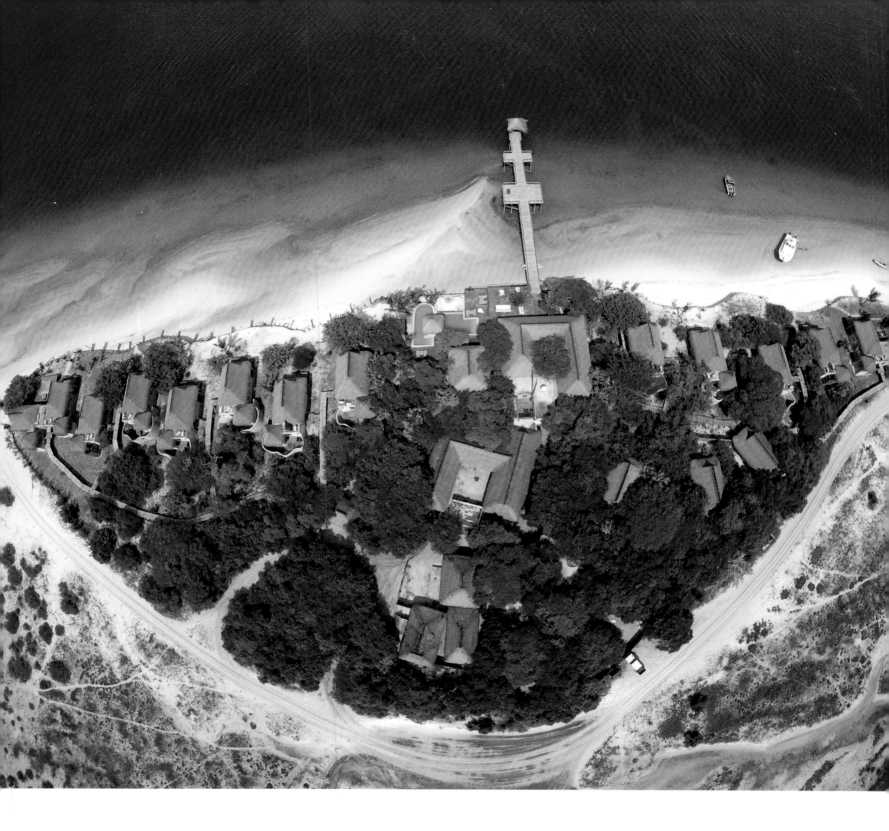

Then there is the Tribute Course, which comprises ten par-3 holes modelled on the some of the most famous holes around the world. Beyond that, the resort offers excellent training conditions as well as a large range of safaris, horseback riding, and hot-air balloon excursions that cater for each guest's individual desires.

Sports programs for children of all ages ensure that boredom is never an issue. Golfers and non-golfers alike can book a massage under the stars at the end of an activity-packed day.

➤ South Africa, Limpopo, www.legendhospitality.co.za

Der zehn Löcher lange Tribute Course besteht nur aus Par-3-Bahnen, die den berühmtesten Löchern der Welt nachgebaut wurden. Darüber hinaus gibt es hervorragende Trainingsbedingungen und ein umfangreiches, auf jeden Gast individuell zugeschnittenes Safariangebot, Ausritte zu Pferd sowie Fahrten mit dem Heißluftballon. Sportprogramme für Kinder jeden Alters sorgen dafür, dass beim Nachwuchs keine Langeweile aufkommt, und zudem können Golfer wie Nichtgolfer Massagen unter dem Sternenhimmel genießen.

➤ Südafrika, Limpopo, www.legendhospitality.co.za

After a round? Relaxation—or off on safari!

Nach der Runde? Entspannung – oder auf Safari!

CADDIE

Confessor or Punching Bag
Beichtväter und Blitzableiter

A caddie holds a tricky position: He must instill confidence in the player whilst at the same time dissuading him or her from taking too big a risk. On top of that he often has to bear the brunt of a poor shot. Australian pro Robert Allenby made headlines when he sacked his caddie mid round following a water hazard incident whereupon a spectator volunteered to carry his bag for the rest of the round.

Friend, confessor, psychologist, punching bag? The challenge for a caddie is to be all of these throughout a round—sometimes even on the same green. Ultimately he has to know when to keep quiet and when to distract his player with jokes and chitchat.

Ein Caddie hat eine heikle Aufgabe: Einerseits muss er seinem Spieler Selbstvertrauen einflößen, andererseits ihn vor allzu riskanten Entscheidungen bewahren. Und er muss es aushalten, den Ärger abzubekommen, wenn der Schlag misslingt. Der australische Berufsgolfer Robert Allenby machte Schlagzeilen, als er seinen Caddie mitten auf der Runde nach einem Wasserschlag entließ – ein Zuschauer schleppte die Tasche für den Rest der Runde.

Kumpel, Beichtvater, Psychologe, Blitzableiter? Das Problem: Auf einer Runde muss ein Caddie oft alles zugleich sein, manchmal sogar auf ein und derselben Bahn. Er muss wissen, wann er den Mund halten und wann er den Spieler mit Geplauder und Scherzen ablenken muss.

A caddie is always at risk of being fired, but that is not the only hazard he faces
Ein Caddie muss damit leben, vom Spieler jederzeit gefeuert werden zu können, aber auch sonst ist sein Job nicht ungefährlich.

Four golfers and four caddies at Lahinch, Ireland, c. 1897
Vier Golfer und vier Caddies in Lahinch, Irland, ca. 1897

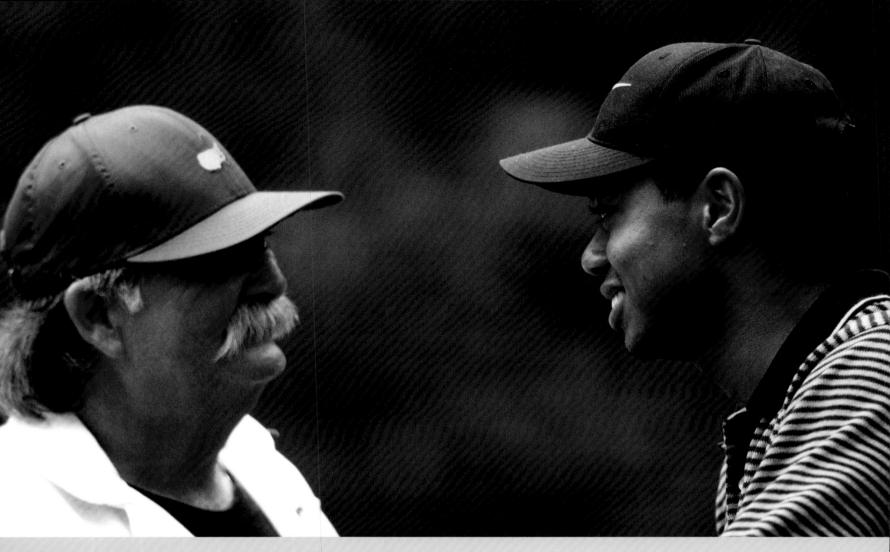

Tiger Woods with his caddie, Mike Cowan, during the 1997 Masters Tournament
Tiger Woods mit seinem Caddie Mike Cowan während des Masters-Turniers, 1997

The relationship between player and caddie is fraught and subject to great strain: the stress of travel; the pressure of tournaments; financial uncertainty; endless standing about and waiting on the range and on the course, interspersed by those few but often career-making—or breaking—decisions. For an outsider it's hard to fully appreciate this rollercoaster of tension, boredom, and jetlag, adrenalin rush and stasis. Player-caddie teams have only been around for a couple of decades. Before that players would be allocated a bag carrier by the club hosting the event.

But a breakup can come about quite suddenly. "I know two colleagues who were fired whilst the ball was still mid-air," a caddie, who wishes to remain anonymous, reveals.

Die Beziehung zwischen Spieler und Caddie ist fragil, weil sie ungeheuren Belastungen ausgesetzt ist: das gemeinsame, oft stressige Reisen; der Druck bei Turnieren; die finanzielle Unsicherheit; das stundenlange Herumstehen und Warten auf der Range und der Runde, unterbrochen durch wenige, oft die Karriere beeinflussende Entscheidungen. Es ist ein für Außenstehende schwer nachvollziehbares Wechselbad von Stress, Langeweile und Jetlag, von hohem und niedrigem Puls. Feste Spieler-Caddie-Teams gibt es erst seit ein paar Jahrzehnten – davor bekamen die Spieler von den jeweiligen Clubs Taschenträger gestellt.

Doch es kann ganz schnell gehen mit dem Bruch. »Ich kenne zwei Kollegen, die gefeuert wurden, während der Ball noch in der Luft war«, erzählt ein Caddie, der anonym bleiben möchte.

Caddie Dion Kipping looks on as Robert Allenby of Australia lines up a putt
Caddie Dion Kipping sieht zu, wie Robert Allenby aus Australien einen Putt ausrichtet.

Suzanne Pettersen (hand in pocket) with her caddie, Kingsmill, 2013
Suzanne Pettersen (die Hände in den Hosentaschen) mit ihrem Caddie, Kingsmill, 2013

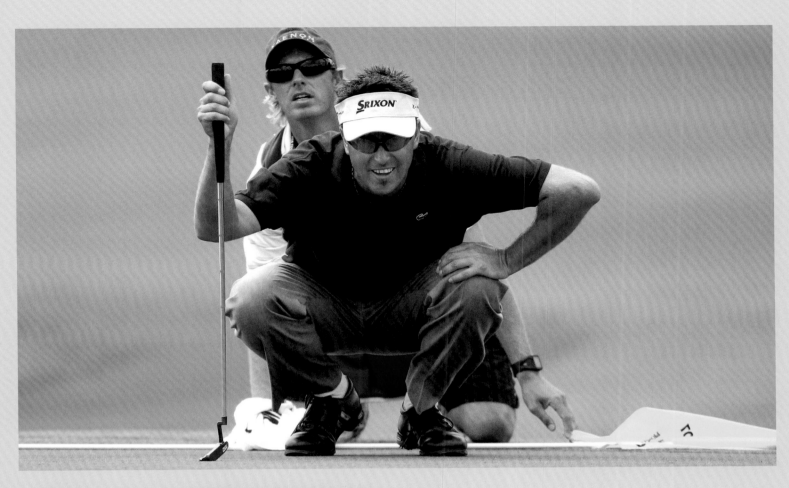

CAPE KIDNAPPERS

NEW ZEALAND / NEUSEELAND

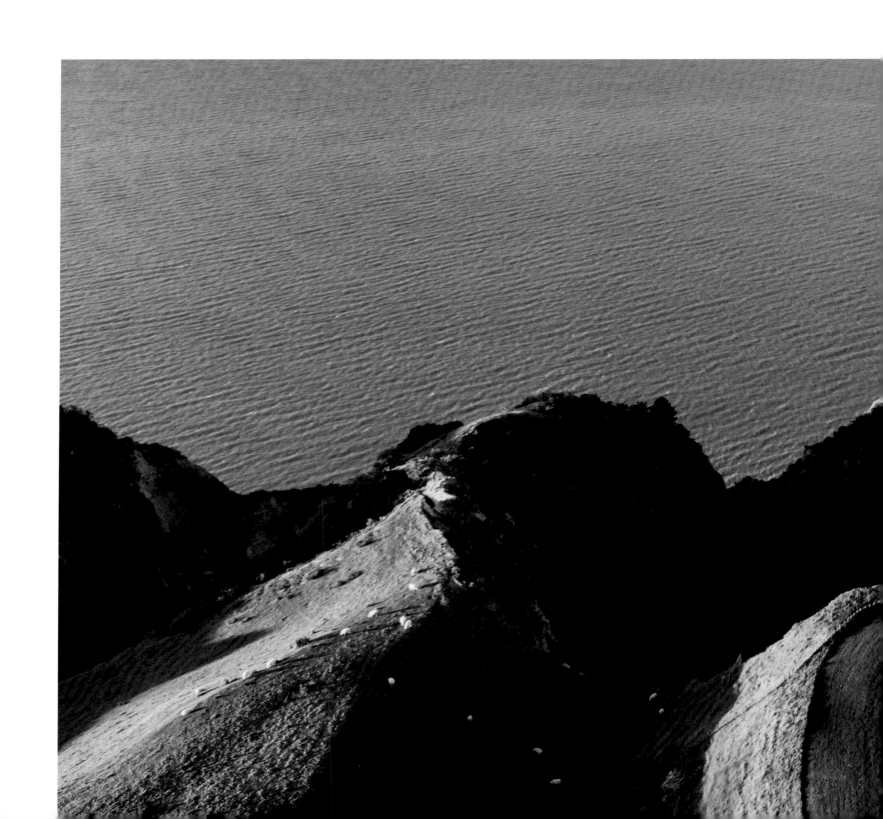

Cape Kidnappers, the headland on New Zealand's North Island with the intriguing name given to it by James Cook, has a riveting story attached: when the circum-navigator anchored here in 1769, local Māori attempted to kidnap one of Capt. Cook's crew. In 2004, Tom Doak built an awe-inspiring costal course atop the 450-feet cliffs. He liked to joke that if the course were only a little more dramatic it would be declared a natural monument. The adjacent 13 hectares of coastal area are indeed well protected, for they are home to the world's largest gannet colony. Here at Cape Kidnappers other birdies almost pale into insignificance as golfers become captivated by the spectacular landscape. Some shots have to make it

An Cape Kidnappers auf der Nordinsel Neuseelands ist nicht nur der Name spektakulär, den das Stück Land von James Cook bekam, sondern auch die faszinierende Geschichte dahinter: Der Weltumsegler landete hier 1769, und einheimische Maori versuchten, ein Besatzungsmit-glied zu entführen. Tom Doak baute im Jahr 2004 auf den Klippen, die 140 Meter über dem Meer aufragen, einen fantastischen Course. »Wäre die Szenerie noch ein klein wenig dramatischer, müssten wir den Platz wohl als Naturdenkmal deklarieren«, scherzt der Designer. Gleich nebenan sind 13 Hektar Küstengebiet tatsächlich streng geschützt, beherbergen sie doch die größte Tölpel-Kolo-nie der Welt.

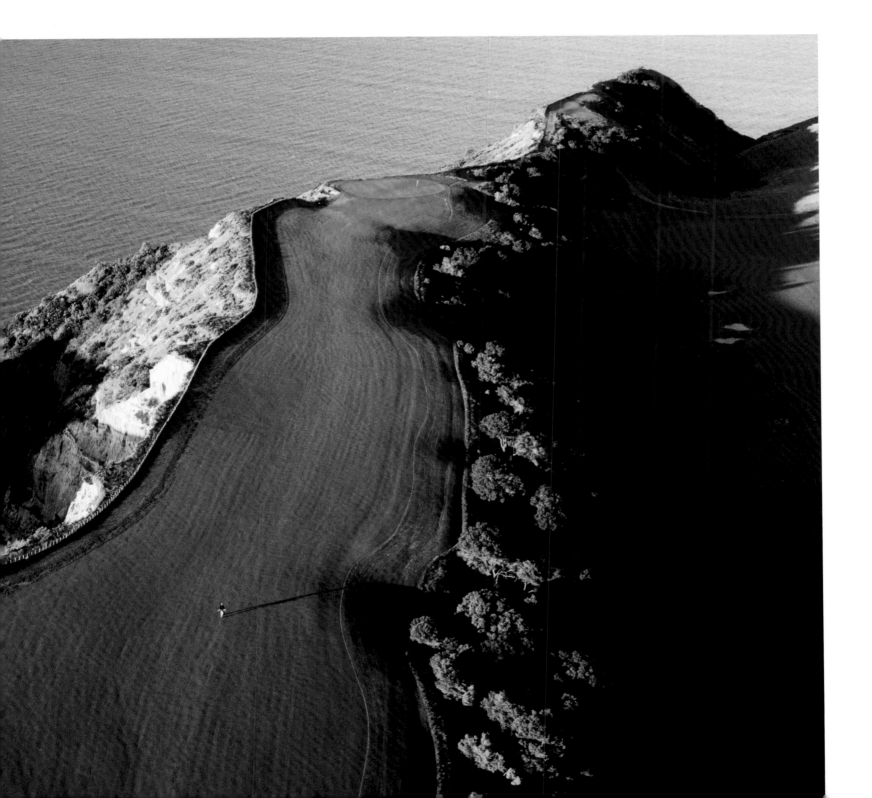

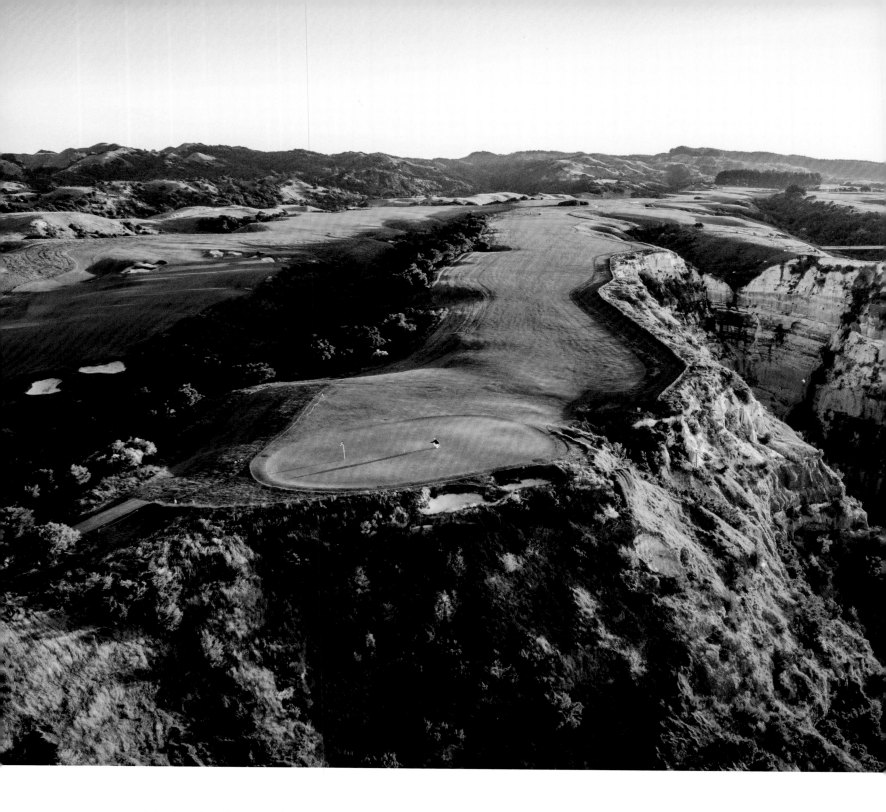

over the surf before landing on the green—or else risk being swallowed by the Pacific forever. Hole 6, an impressive par-3, has a deep gorge between tee and green and is considered one of the best holes in the world. And The Farm hotel offers all imaginable comforts and magnificent views, beautifully rounding off a unique experience.

➤ New Zealand, Cape Kidnappers, www.capekidnappers.com

Birdies ganz anderer Art sind auf Cape Kidnappers beinahe Nebensache, denn Golfer haben genug damit zu tun, die wunderbare Natur zu genießen. Manche Bälle müssen über die Brandung hinweg geschlagen werden, bevor sie auf dem Grün landen – oder von den Wellen des Pazifiks für immer gekidnappt werden. Bahn 6, ein beeindruckendes Par 3, gilt mit der tiefen Schlucht zwischen Abschlag und Grün als eines der besten Golflöcher der Welt. Und das dazugehörige Hotel The Farm, das allen erdenklichen Komfort und eine traumhafte Aussicht bietet, rundet die einmalige Erfahrung aufs Angenehmste ab.

➤ Neuseeland, Cape Kidnappers, www.capekidnappers.com

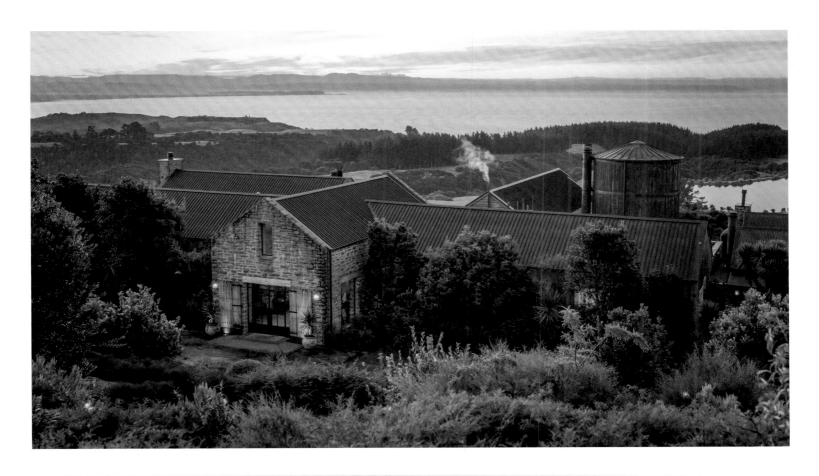

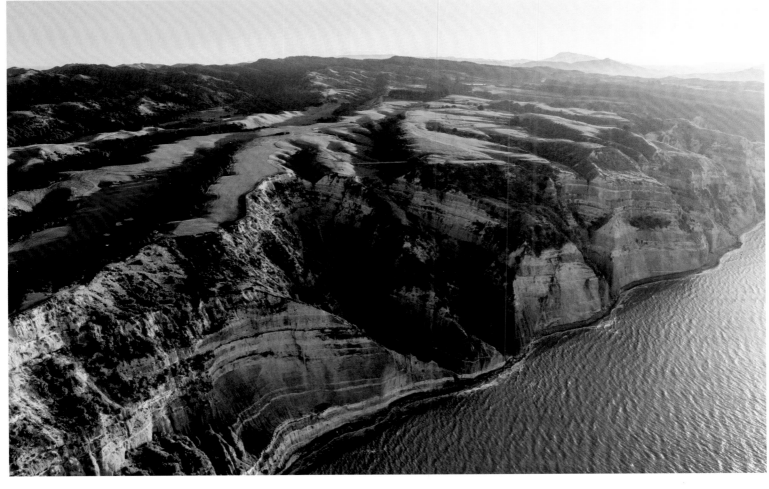

Not simply a golf course but practically a national monument

Nicht nur ein Golfplatz, sondern fast ein nationales Monument

A first-rate course well worth a slightly longer journey

Ein erstklassiger Platz, für den sich die etwas weitere Anfahrt lohnt.

WINSTON GOLF

GERMANY / DEUTSCHLAND

Like every good idea, the whole thing initially sounded slightly mad. For who in their right mind would dream of building a golf course in the economically under-developed region of Mecklenburg-Vorpommern in north-east Germany, miles away from any golfing clientele—and on top of it, a course fully equipped for the first European league? Despite these qualms, in 2002 the WinstonOpen arrived, followed by the WinstonLinks in 2011, which, with its many sand dunes and gorse and heather, is reminiscent of Scotland's top courses. Renowned

Wie jede gute Idee klang das Ganze zunächst etwas verrückt. Denn wer würde im Nordosten Deutschlands, im strukturschwachen Mecklenburg-Vorpommern, also auf dem Gebiet der ehemaligen DDR, weit weg von jeder golf-affinen Klientel, ein Resort errichten – und auch noch eines, das dank seines Angebots mit der ersten europäischen Liga mithalten sollte? Ungeachtet solcher Bedenken eröff-nete das Resort im Jahr 2002 mit dem Platz WinstonOpen, und der WinstonLinks, der 2011 hinzukam, erinnert mit seinen vielen Dünen und subtilen Schwierigkeiten, dem

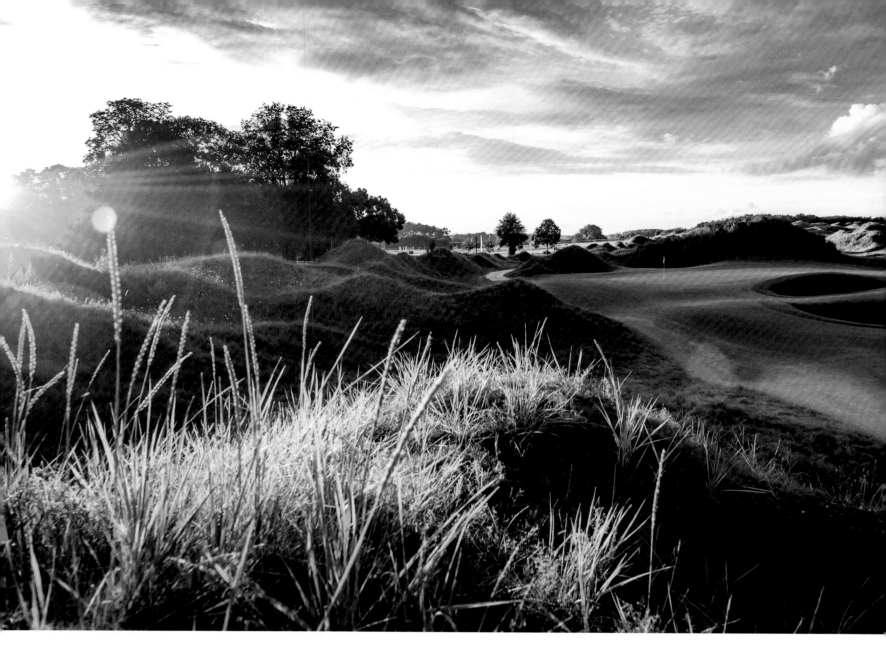

course architect David Krause had 420 million cubic feet of earth shifted in order to create an intriguing landscape with 30-foot dunes. Experts were initially sceptical about the vast re-modelling scheme, but the artificial landscape has since grown in and looks much more natural then when the course first opened. Needless to say that the open landscape on the Baltic coast means wind is a decisive factor—just as in the motherland of golfing.

The 9-hole links WinstonKranich is the best of its kind in Germany with outstanding training facilities. The more than 200-hectare resort with the atmospheric country hotel Gut Vorbeck adjacent to the course is well worth a journey. And the region's economic situation means that you can play first-class golf at a comparatively reasonable price.

➤ Germany, Gneven, www.winstongolf.de

Ginster und dem Heidekraut an schottische Spitzenplätze. Der renommierte Platzarchitekt David Krause ließ 1,2 Millionen Kubikmeter Erde bewegen, um ein faszinierendes Gelände mit bis zu zehn Meter hohen Dünen zu modellieren. Die künstlichen Erdverschiebungen waren zunächst unter Fachleuten nicht unumstritten, sind aber inzwischen bestens eingewachsen und wirken viel natürlicher als noch bei ihrer Eröffnung. Selbstverständlich ist in dem offenen Gelände und der nahen Ostsee, wie im Mutterland des Golfsports auch, der Wind ein entscheidender Faktor.

Der Neun-Loch-Platz WinstonKranich gilt als bester seiner Art in Deutschland, die Übungsmöglichkeiten sind zudem herausragend. Das mehr als 200 Hektar große Resort lohnt auch die Anreise von weither; das atmosphärische Landhotel Gut Vorbeck liegt direkt am Platz.

Im Übrigen ist die Strukturschwäche auch ein Vorteil: Hier gibt es nämlich erstklassiges Golf zu verhältnismäßig niedrigen Preisen.

➤ Deutschland, Gneven, www.winstongolf.de

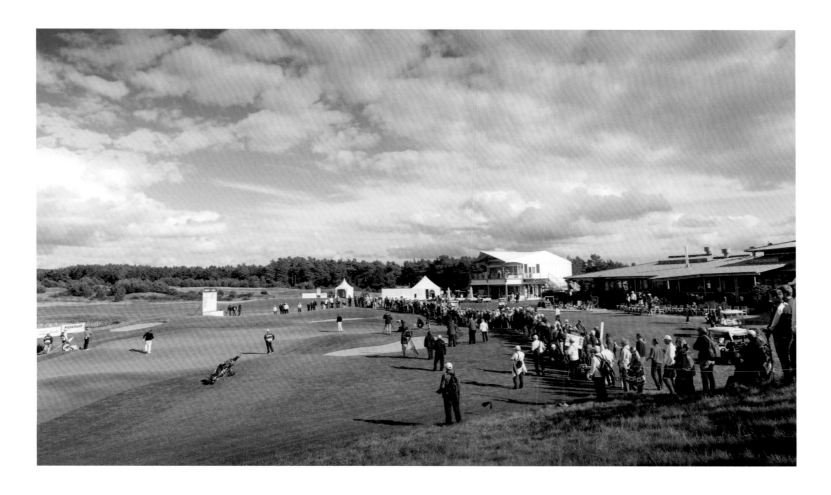

David Krause's design of the course presents even pros with a challenge

Das Platzdesign von David Krause stellt auch die Pros vor einige Schwierigkeiten.

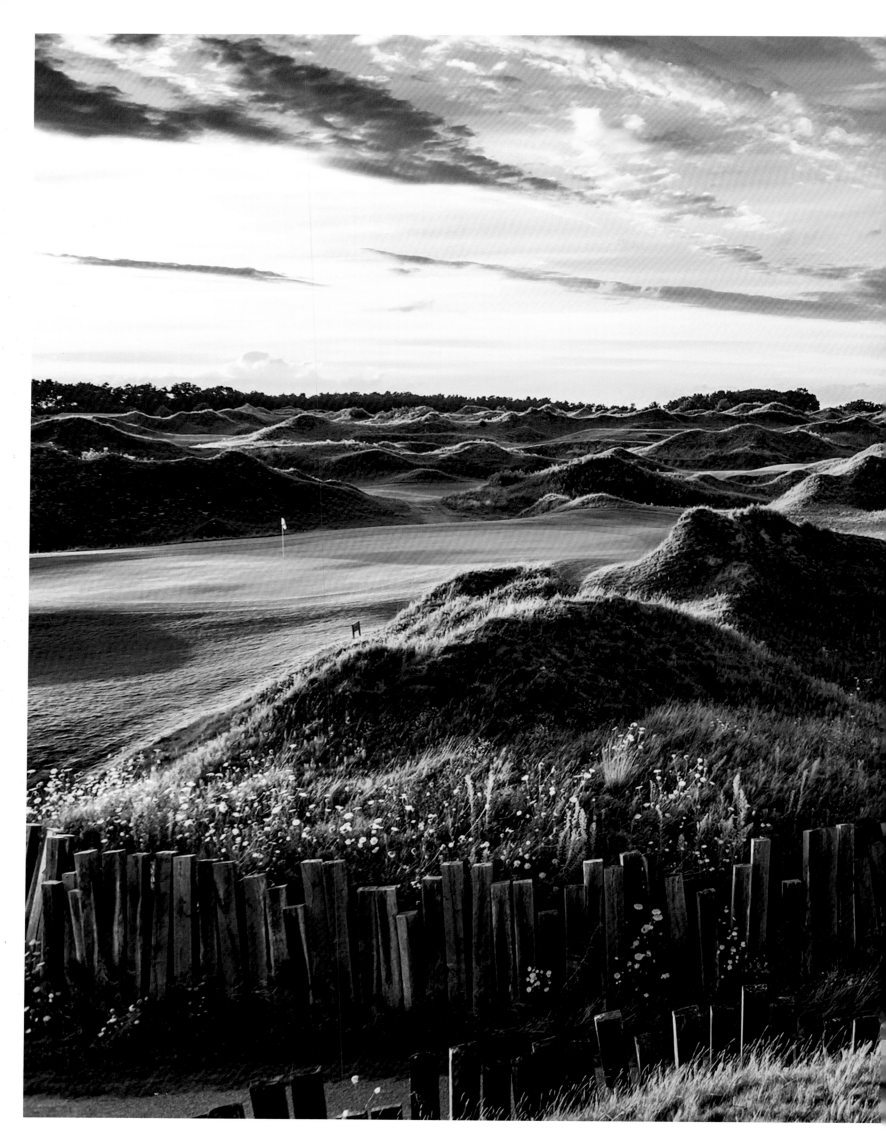

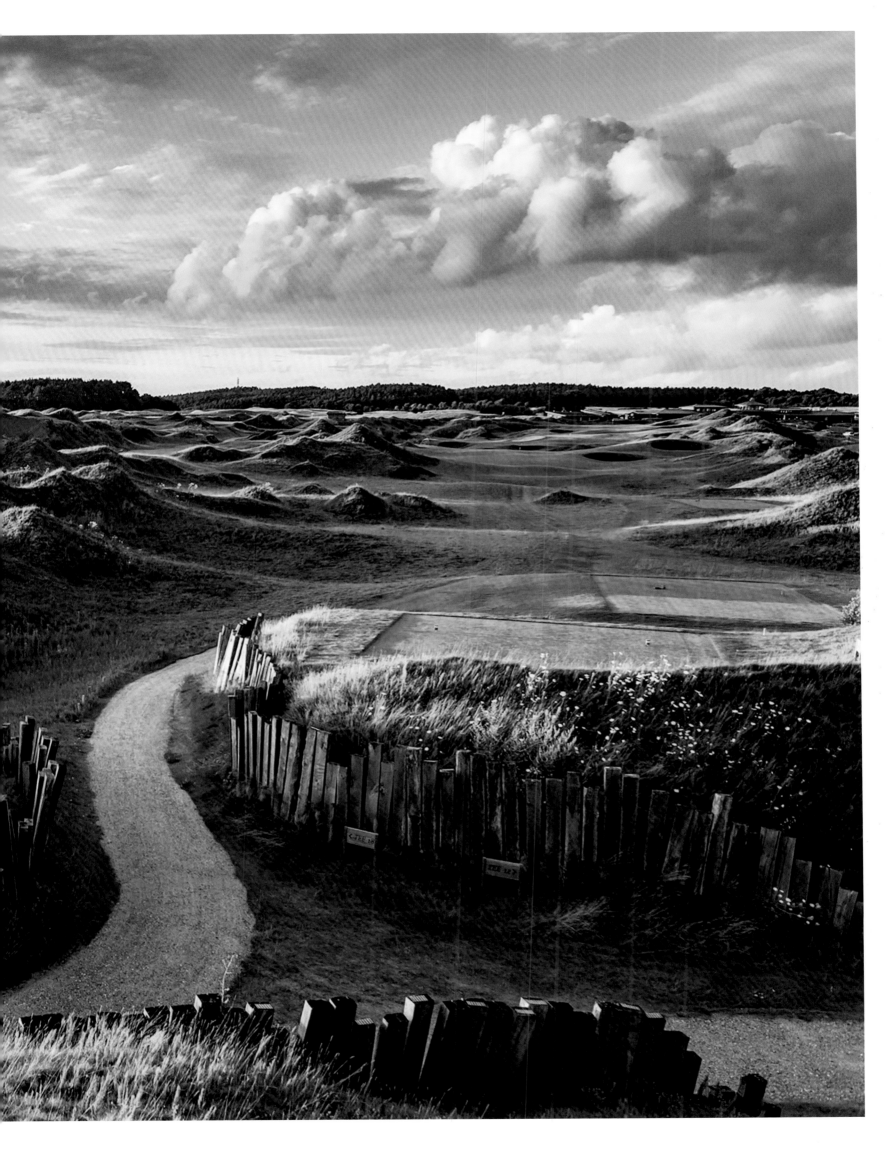

THE MILLIONAIRE GURUS
Where Coaches are Wealthier than the Pros

Golf is a huge business, but it's not just top-level players that are exceedingly wealthy—many a golf coach is up there among them. Butch Harmon, David Leadbetter, and Sean Foley secure hourly rates of $1,000 and up, plus travel expenses, which for such men includes first-class flights or private jets plus five-star hotels. On top of that they enjoy sponsorships by club manufacturers and major sporting goods companies.

But how to join the elite club of high-end coaches—who themselves never have to putt a ball under pressure? The secret is to show up on a Tuesday. "Be Seen Tuesday" is the name given to said day on tour: professional tournaments take place from Thursday to Sunday; people arrive on a Monday; on Tuesday they train; on Wednesday the Pro-Am takes place, i.e. a warm-up round in which a pro plays a round with three ama-

DIE MILLIONEN-GURUS
Golflehrer sind wohlhabender als mancher Profi

Golf ist ein gigantisches Geschäft, und nicht nur die Topspieler sind sehr, sehr reich: Auch viele Golflehrer sind längst Millionäre. Butch Harmon, David Leadbetter und Sean Foley können Stundensätze von 1000 Dollar und mehr aufrufen, zuzüglich eventuell anfallender Reisespesen – was bei diesen Herren Erste-Klasse-Ticket oder gar Privatjet sowie Fünfsternehotel heißt. Zudem haben sie Sponsorenverträge mit Schlägerfirmen oder großen Sportartikelherstellern.

Aber wie schafft man es in den elitären Kreis der coachenden Großverdiener, die selbst nie unter Druck einen Ball schlagen müssen? Das erste Geheimnis heißt: Zeig dich am Dienstag. »Be Seen Tuesday« heißt jener Tag auf den Touren. Denn Profiturniere finden von Donnerstag bis Sonntag statt. Montag ist Anreise, Dienstag wird trainiert, Mittwoch steigt bereits das

Caroline Masson of Team Europe and David Leadbetter warming up for the Solheim Cup at the Des Moines Golf and Country Club, 2017
Caroline Masson vom Team Europe und David Leadbetter während des Trainings für den Solheim Cup im Des Moines Golf und Country Club, 2017

Dustin Johnson (right) plays a shot under coach Butch Harmon's critical gaze, US Open, 2019 at Pebble Beach Golf Links

Dustin Johnson (rechts) spielt einen Ball, während Trainer Butch Harmon kritisch zuschaut, US Open 2019 in Pebble Beach.

teurs—who, if they are not one of the sponsors, usually have to pay through the nose for the privilege. And so Tuesday is the day when golf coaches have access to players on the range. Nutritionists, mental performance coaches, and representatives of equipment firms are also on the prowl for an opportunity. "It's like a zoo..." one anonymous tour pro groans. Some players simply want to train in peace and some have their own coach with them. But others are clearly not on form, unable to secure a clean shot, hesitant on the training green with their putter. That's when the coach will strike: "Hello, I think I can help you." At that moment a tour pro is just like the next man: when things aren't going well, advice is always welcome. And should the advice prove helpful during the tournament, then a new player–coach relationship may blossom.

Those who coach well-known tour players can promote themselves as such and adjust their rates accordingly. The going hourly rate for a club coach in the US is forty to sixty dollars. Those who make it into the elite circle, training top players, can ask for five to ten times that amount. The more famous the player, the better—better for the coach's standing and his wallet. Those who have made it, are allowed to publish their tips in golf or lifestyle magazines; some even make it onto the front cover.

Pro-Am, eine Art Einspielrunde, bei welcher der Pro mit drei Amateuren auf den Platz geht, die zumeist viel Geld dafür zahlen oder zu den Sponsoren gehören. Der Dienstag ist also der Tag, an dem sich die Golflehrer auf der Range den Spielern nähern können. Auch Ernährungsberater, Mental-Coachs und Repräsentanten der Schlägerhersteller suchen ihre Chance – »es ist ein Zoo«, stöhnt ein anonymer Tour-Pro. Manche Spieler wollen in Ruhe trainieren, andere haben ihren eigenen Coach dabei. Doch manche fühlen sich nicht gut, treffen den Ball nicht sauber, hadern auf dem Übungsgrün mit ihrem Putter. Dann schlägt die Stunde des Coachs. »Hallo, ich glaube, ich kann dir helfen.« Ein Tour-Spieler ist in diesem Moment wie jeder ganz normale Golfer auch: Wenn es nicht läuft, ist man für jeden Rat empfänglich. Und wenn es dann im Turnier nach dem erhaltenen Ratschlag gut läuft, könnte eine neue Spieler-Trainer-Beziehung entstehen.

Wer einen bekannten Tour-Spieler coacht, kann damit werben und die Stundensätze sofort vervielfachen. Der übliche Stundensatz für einen Clubtrainer liegt in den USA bei 40 bis 60 Dollar. Wer es in den elitären Kreis jener geschafft hat, die Topprofis trainieren, kann fünf- bis zehnmal mehr verlangen. Je bekannter der Spieler, desto besser. Fürs Renommee und den Geldbeutel. Wer es geschafft hat, darf seine Tipps in den Golf- oder Lifestyle-Zeitschriften veröffentlichen; manchmal schaffen es sogar die Coachs selbst aufs Cover.

Spain's showpiece subtly conceals its perils

Spaniens Vorzeigeplatz, der seine Gefahren dezent verbirgt.

VALDERRAMA

SPAIN / SPANIEN

Valderrama has a unique flair, the course is the trickiest by far. And it made history. Flashback: in 1997 it had not rained in Spain for four months. But just in time for the Ryder Cup the heavens opened over the Costa del Sol and temperatures did not exceed 64 °F. Was this Severiano Balleseros' doing? After all, the charismatic captain didn't leave anything to chance for the first Ryder Cup played in continental Europe. He even had a hole in Valderrama rebuilt because he believed it would better suit the European game. The match was close, but in the end the Europeans

Valderramas Flair ist einzigartig, der Platz knifflig wie kein Zweiter. Und er schrieb Golfgeschichte. Rückblende ins Jahr 1997: Vier Monate lang hatte es nicht geregnet, doch ausgerechnet beim Ryder Cup schüttete es an der spanischen Costa del Sol, und die Temperaturen stiegen nicht über 18 °C. Hatte Severiano Ballesteros da seine Hände im Spiel? Der charismatische Kapitän überließ beim ersten in Kontinentaleuropa ausgetragenen Ryder Cup schließlich nichts dem Zufall und ließ zuvor sogar ein Loch in Valderrama umbauen, weil er glaubte,

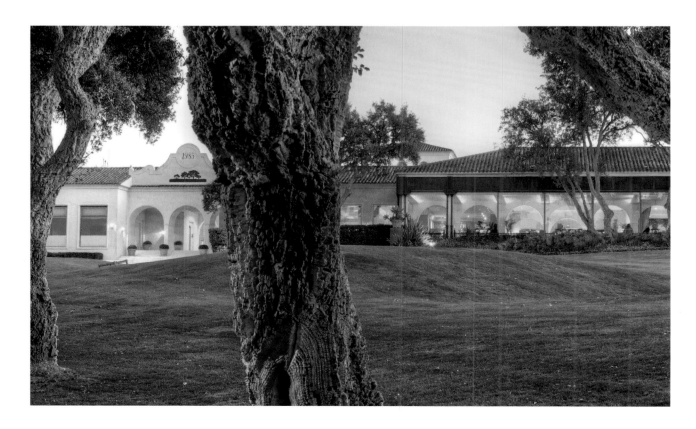

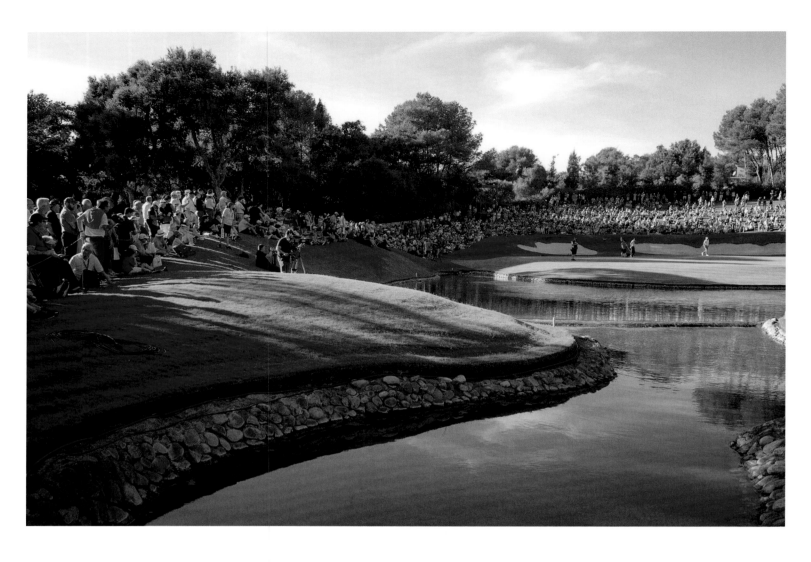

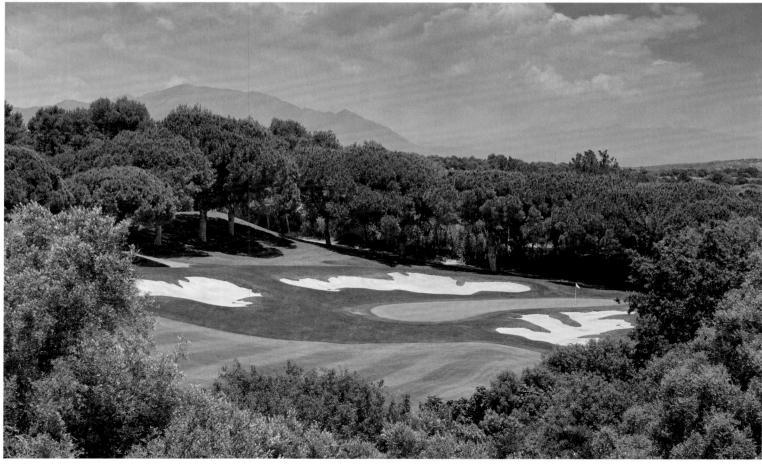

Pros compete here regularly, but otherwise the course is never overcrowded

Pros messen sich hier regelmäßig, doch sonst ist der Platz nie überlaufen.

won 14½ to 13½, not least because the Italian Costantino Rocco managed to beat Tiger Woods 4 to 2. No one celebrated more exuberantly than Seve.

What about us mere mortals? The course doesn't look that hard from the tee box—big mistake! Draw shots are particularly difficult due to the trees and bunkers in the flight path. Having reached the green, the real problems begin: the undulations underfoot are subtle and yet brutal, seemingly straight-forward ten foot putts end up two yards short of the hole.

Valderrama proves that length is not everything: the pro tee-box for its legendary 17th—a par-5 hole with a lake directly in front of the green—is situated so far back that it's almost on the fairway of the 16th, and yet even for the pros the hole lies at only 530 yards. But the long drive pros, who regularly frequent the Spanish Open, don't necessarily dominate these supposedly short holes, for the pitfalls lie in the detail.

Guests will be pleased to know that this is one of Europe's best-maintained courses, with its fairways and holes lush green throughout every season.

➤ Spain, Valderrama, Sotogrande, www.valderrama.com

es käme dem europäischen Spiel entgegen. Am Ende wurde es knapp, aber die Europäer gewannen tatsächlich 14½ zu 13½ – vor allem weil der Italiener Costatino Rocca am Finaltag Tiger Woods mit 4 auf 2 besiegen konnte. Niemand feierte ausgelassener als Seve.

Und für uns Normalsterbliche? Der Platz sieht von den Abschlägen nicht schwierig aus – was für ein Irrtum! Vor allem die Annäherungen sind schwierig, denn Bunker und Bäume verhindern oft den geraden Schlag. Und ist man dann erst einmal auf dem Grün, geht das Gestocher richtig los: Die Wellen sind subtil und brutal zugleich, scheinbar gerade Drei-Meter-Putts liegen plötzlich zwei Meter unter dem Loch.

Valderrama beweist, dass Länge nicht alles ist: Der Profiabschlag der legendären 17, jenem Par 5 mit dem Teich direkt vor dem Grün, ist schon so weit nach hinten gebaut, dass er beinahe auf dem Fairway der 16 liegt, und dennoch ist die Bahn auch für Profis nur 490 Meter lang. Aber die Longhitter, die regelmäßig bei der Spanish Open zu Gast sind, nehmen diese vermeintlich kurzen Bahnen dennoch nicht auseinander, denn die Tücken liegen im Detail.

Was Reisende freuen wird: Kaum ein Platz in Europa dürfte übers Jahr hinweg besser gepflegt sein – das Spiel ist in jeder Saison ein sattgrüner Genuss.

➤ Spanien, Valderrama, Sotogrande, www.valderrama.com

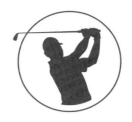

PEBBLE BEACH

USA

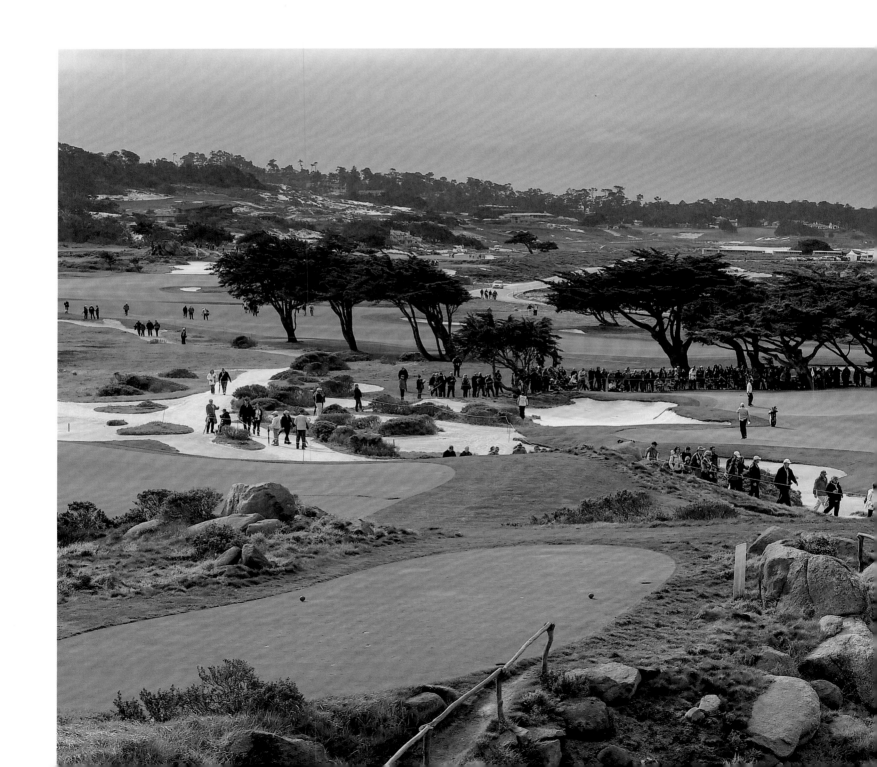

In February 2019, the most famous resort in the US reached its centenary: Pebble Beach in California. With its magnificent backdrops, rich history, famous Pacific Coast fairways, and a total of four courses it leaves nothing to be desired. Spyglass Hill is considered equally eminent and the links at Spanish Bay and Del Monte are also championed by many. The resort has always been a Hollywood favorite. Back in the day Bing Crosby and Jack Lemmon played here, now it's Kevin Costner and Bill Murray. The resort's most-loved hole is the 100-yard 7th on Pebble Beach, with its tiny green that opens on a raised tee box overlooking the sea.

Pebble Beach also has its place in golfing history: in 2000, Tiger Woods put on a perfect display here. In 104 years

Gerade feierte das berühmteste Resort der USA seinen 100. Geburtstag. Pebble Beach in Kalifornien bietet eine großartige Kulisse, viel Historie und berühmte Bahnen direkt an der Pazifikküste. Gleich vier Plätze lassen keine Wünsche offen; neben dem berühmten Pebble Beach gilt Spyglass Hill als mindestens ebenbürtig, aber auch The Links at Spanish Bay und Del Monte haben ihre Fans. Hollywood spielt hier am liebsten; einst waren es Bing Crosby und Jack Lemmon, heute sind es Kevin Costner und Bill Murray. Das berühmteste Loch des Resorts liegt natürlich auf dem Platz in Pebble Beach: Auf der nicht einmal 100 Meter langen 7 mit winzigem Grün schlagen Spieler von einem erhöhten Tee ab und blicken auf die Wellen des Pazifiks.

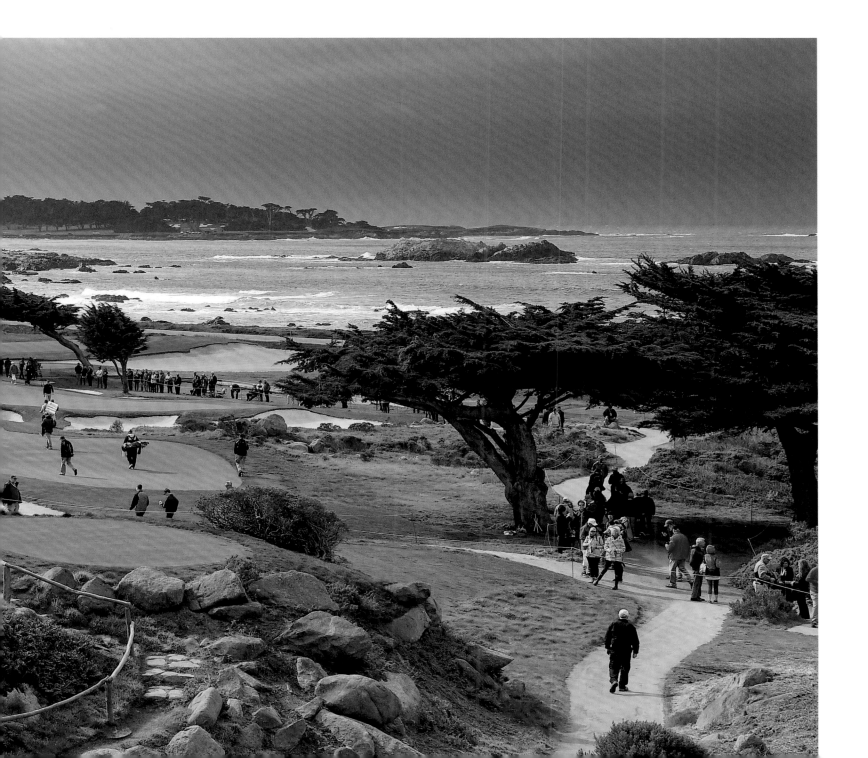

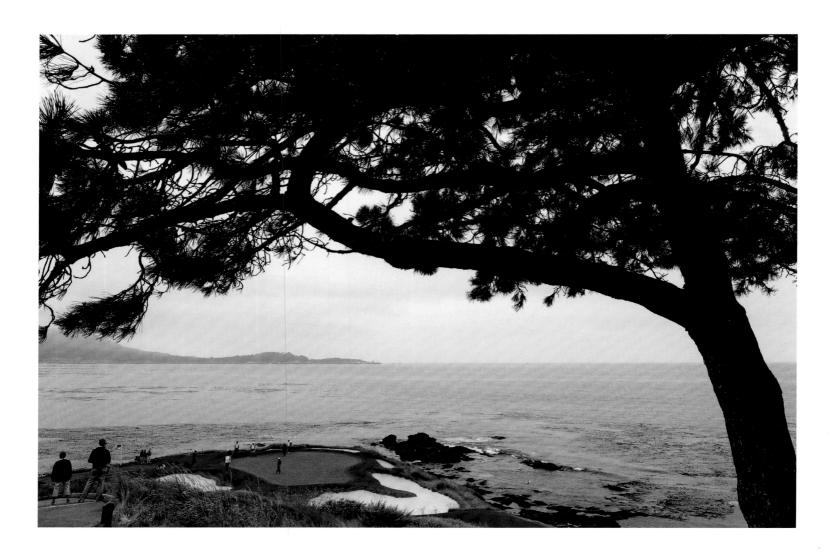

of Open history no one had ever dominated the game like Tiger Woods. In four rounds he remained 12-under-par, 15 ahead of the man in second place, Ernie Els. And with that he broke Old Tom Morris' 138-year-old record of the widest margin in a major tournament. Els admitted it was a bit embarrassing for them and that Woods was simply playing a different level of golf. Former PGA tour golfer Robert Damron recalls: "I can say with absolute certainty that at his best, no one played golf as well as Tiger. Not even close. He came as close to golfing perfection that week as anyone else ever has."

➤ USA, California, Pebble Beach, www.pebblebeach.com

Doch Pebble Beach schrieb auch Golfgeschichte. Im Jahr 2000 zeigte Tiger Woods hier perfektes Golf. In der 104-jährigen Geschichte des Turniers hatte nie jemand die US Open so sehr dominiert wie Tiger Woods. Er blieb in den 4 Runden 12 Schläge unter Par, 15 Schläge besser als der Zweitplatzierte Ernie Els. Damit brach er Old Tom Morris' 138 Jahre alten Rekord in Bezug auf den größten Vorsprung bei einem Major. »Es ist ein bisschen peinlich für uns«, gab Els zu, »er spielt im Moment einfach ein anderes Golf.« Robert Damron, der ebenfalls am Start war, sagte: »Ich kann mit absoluter Gewissheit sagen, dass niemand besseres Golf gespielt hat als Tiger. Nicht mal annähernd. In der Woche näherte er sich der Perfektion wie kein anderer.«

➤ USA, Kalifornien, Pebble Beach, www.pebblebeach.com

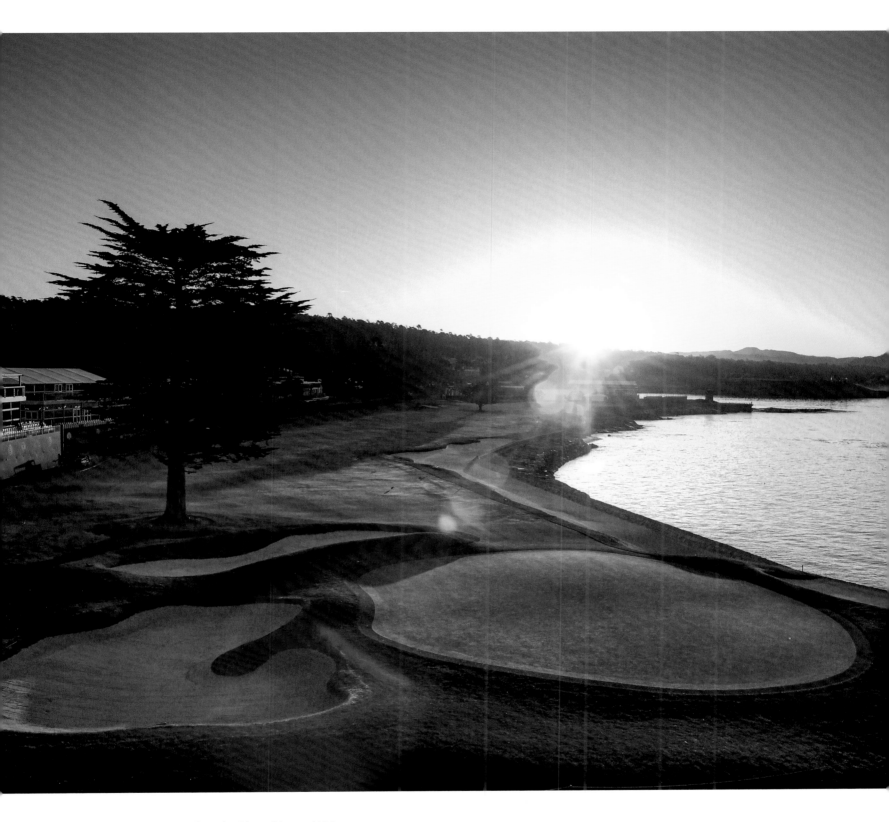

Iconic greens lining the Pacific, rich with tradition and history

Ikonische Bahnen am Pazifik mit reichlich Tradition und Historie

PRESIDENTIAL SWINGS
Golf and the White House

Actors golf. Footballers golf. Managers golf. But no profession appears as committed to golfing as the residents of 1600 Pennsylvania Avenue. In the last one hundred years all US presidents, with the exception of Jimmy Carter, have swung drivers and irons. Bill Clinton claims to have improved his handicap whilst in office, saying this was because he was able to play with fantastic golfers like Jack Nicklaus. Furthermore he always had security guards by his side ready to scour the rough with him to retrieve all the lost balls. His precise handicap remains unclear, "obscured by a cloud of Mulligans," as one journalist puts it. Dwight D. Eisenhower and Gerald Ford on the other hand were both more renowned for their poor golfing skills. Comedian Bob Hope famously said of Ford:

PRÄSIDIALE ABSCHLÄGE
Golf und das Weiße Haus

Schauspieler golfen. Fußballer golfen. Manager golfen. Aber kein Berufsstand golft so intensiv wie die Bewohner der Pennsylvania Avenue 1600: In den letzten 100 Jahren haben alle amerikanischen Präsidenten mit Ausnahme von Jimmy Carter Driver und Eisen geschwungen. Bill Clinton sagte, er hätte im Amt sein Handicap verbessert und erklärte es damit, dass er mit großartigen Golfern wie Jack Nicklaus zusammen spielen durfte. Zudem hatte er immer Sicherheitsbeamte dabei, die gemeinsam mit ihm das Rough durchflügten und alle verzogenen Bälle wiederfanden. Sein exaktes Handicap ist unklar, denn es ist, wie ein anderer Journalist berichtet, »von einer Wolke aus Mulligans verdunkelt«. Berüchtigt für ihr eher maues Spiel waren dagegen Dwight D. Eisenhower und Gerald Ford. Zu Gerald Fords Golf-

Former US President Bill Clinton plays a tee shot at Country Club de Bogotá, Columbia, 2012

Der ehemalige US-Präsident Bill Clinton beim Abschlag im Country Club de Bogotá, Kolumbien, 2012

US President Ronald Reagan trying to get his golf cart started as German chancellor Helmut Schmidt waits patiently, 1981

US-Präsident Ronald Reagan versucht das Golfcart zu starten, während der deutsche Bundeskanzler Helmut Schmidt geduldig wartet, 1981.

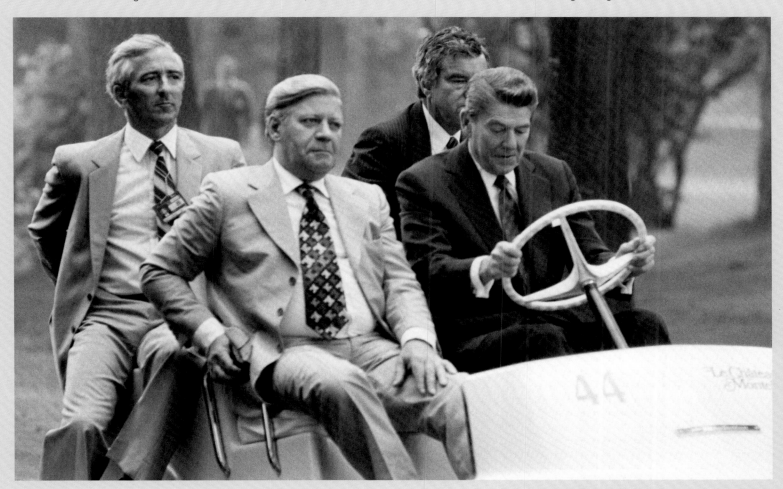

"At least he can't cheat on his score. All you have to do is look back down the fairway and count the wounded."

With a 7 handicap John F. Kennedy was possibly the most talented golfer among US presidents, but ironically he went out of his way to conceal this particular passion. It's not such a surprise, after all he had besmirched Republican Eisenhower as an irresponsible individual, who chose golf over sorting out the country's affairs. Kennedy himself would rather be seen posing on sleek sailing yachts. Recent research confirms that Eisenhower played more than one thousand rounds during his presidency from 1953 to 1961—so Ike was indeed on the course every other day and not at his desk.

The Bush family too has many keen golfers with George W. Bush achieving a respectable handicap of 15. Barack Obama, with a 12 handicap, plays left-handed—a first in presidential golfing history. Donald Trump not only plays, he also invests a good part of his assets in golf resorts.

Incidentally the White House has its own putting green. How often does the President practice? Sorry, state secret.

President Dwight D. Eisenhower and Vice President Richard Nixon ride an electric golf cart, 1961
US-Präsident Dwight D. Eisenhower und der damalige Vizepräsident Richard Nixon fahren mit einem Cart, 1961.

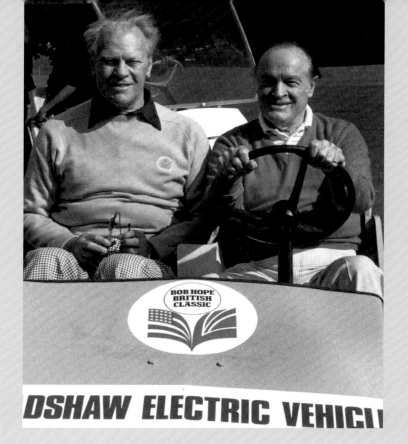

Actor Bob Hope chauffeurs Gerald Ford, 1982
Der Schauspieler Bob Hope chauffiert Gerald Ford, 1982.

bemühungen sagte der Komiker Bob Hope: »Man muss seinen Score gar nicht im Kopf haben. Es reicht, die Verwundeten links und rechts der Fairways zu zählen.«

John F. Kennedy war mit einem Handicap von 7 von allen US-Präsidenten vermutlich der talentierteste Golfer. Ironischerweise tat er alles, um seine Leidenschaft zu verheimlichen. Kein Wunder, hatte er im Wahlkampf doch den Republikaner Eisenhower als unverantwortlichen Kerl verunglimpfen lassen, der lieber golfte, als sich um die Belange seines Landes zu kümmern. Kennedy zeigte sich lieber auf seiner schnittigen Segelyacht. Und tatsächlich belegen neuere Nachforschungen, dass Eisenhower während seiner Amtszeit von 1953 bis 1961 mehr als 1000 Runden drehte – fast jeden zweiten Tag war Ike also auf dem Platz statt im Büro.

Auch die Bush-Familie golft mit Begeisterung. George W. Bush, hat ein respektables Handicap von 15. Barack Obama, Handicap 12, spielt linksherum – ein Novum in der präsidialen Golfgeschichte. Donald Trump ist nicht nur ein begeisterter Golfer, sondern investiert auch einen guten Teil seines Vermögens in Golf-Resorts.

Übrigens: Im Garten des Weißen Hauses ist ein Putting-Grün angelegt. Wie oft der US-Präsident darauf übt? Sorry, Staatsgeheimnis.

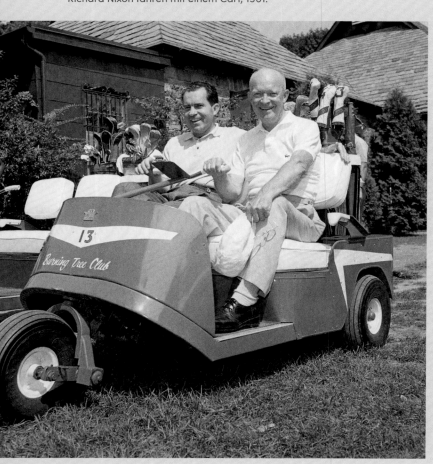

John F. Kennedy playing at the Riddell's Bay Golf & Country Club, 1952
John F. Kennedy spielt auf dem Platz von Riddell's Bay Golf & Country Club, 1952.

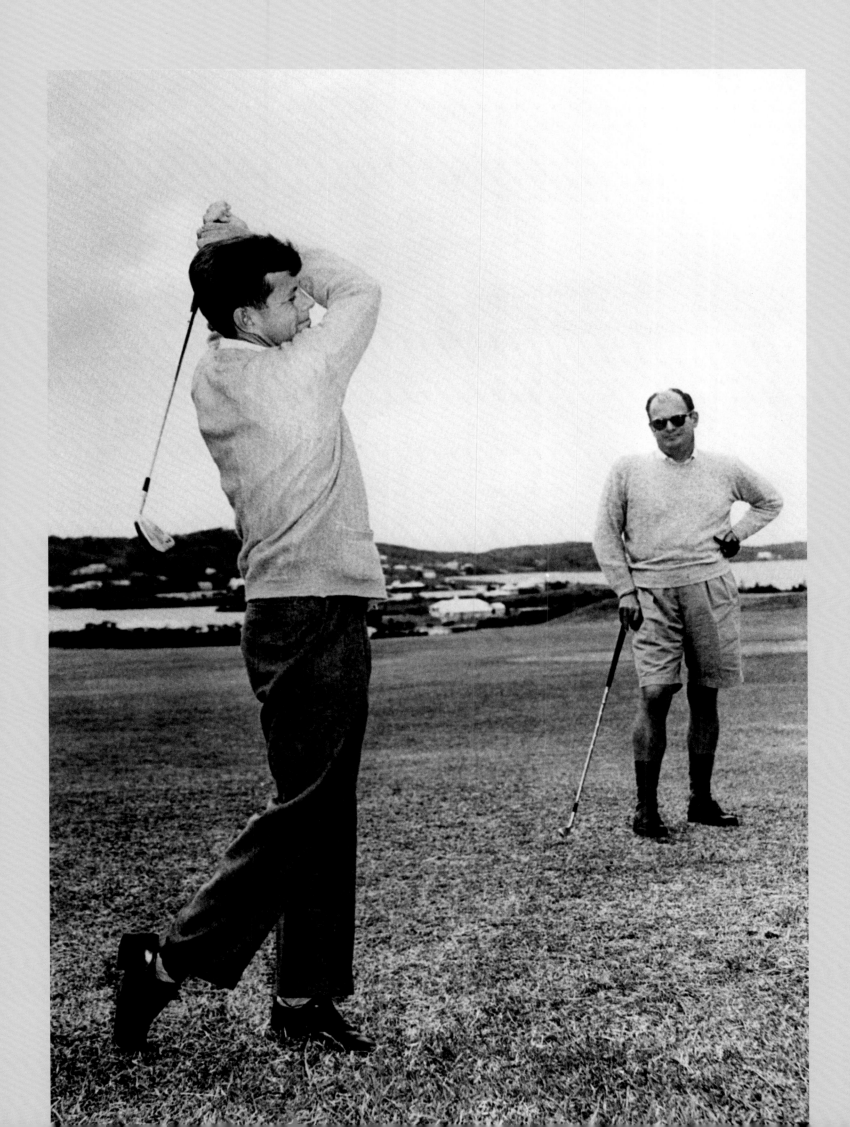

Barack Obama playing a round of golf at the Old Course in St Andrews, Scotland, 2017

Barack Obama spielt eine Runde Golf auf dem Old Course in St. Andrews, Schottland, 2017.

Donald Trump at his golf course on the Palos Verdes Peninsula, about to break ground on a luxury housing project, 2005

Donald Trump auf seinem Golfplatz auf der Halbinsel Palos Verdes, kurz bevor er dort den Grundstein für ein Luxusimmobilienprojekt legt, 2005.

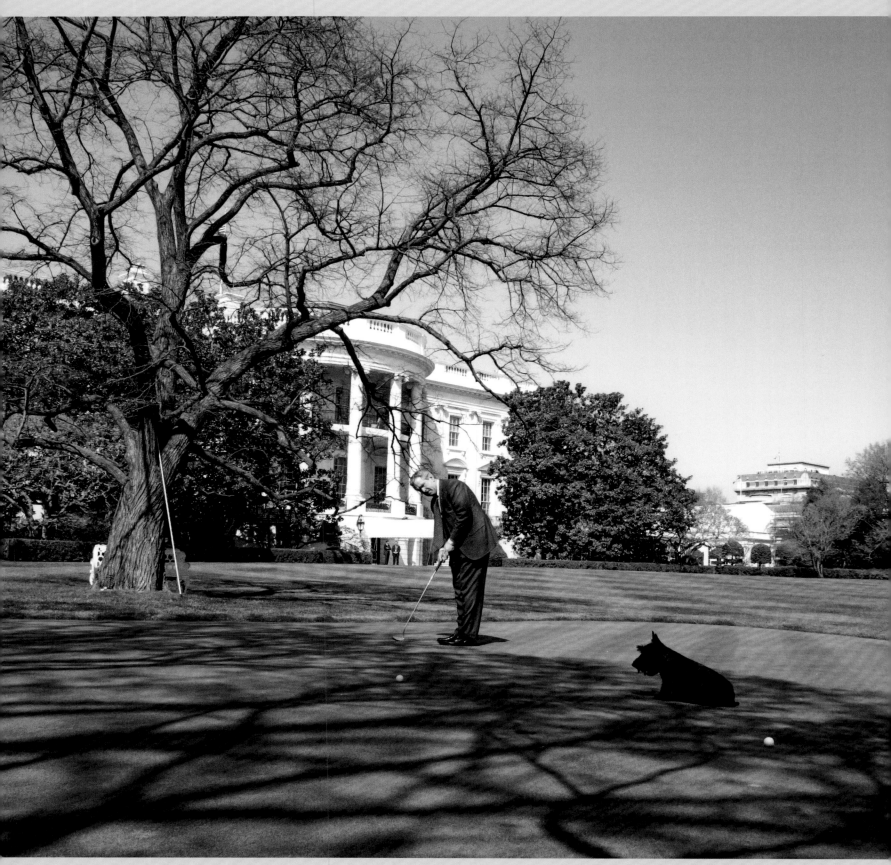

President George W. Bush plays golf on the South Lawn of the White House, 2003

US-Präsident George W. Bush spielt Golf auf dem Rasen des Weißen Hauses, 2003.

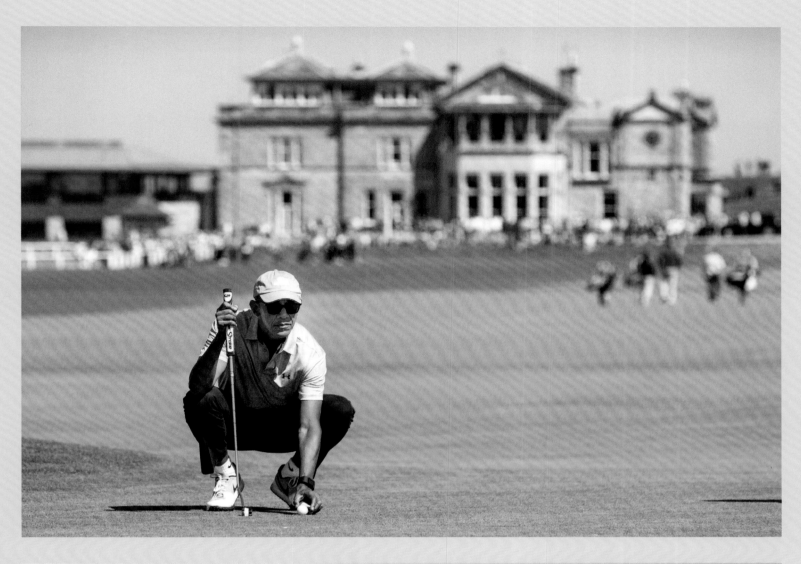

FONTANA

AUSTRIA / ÖSTERREICH

Not far from Vienna lies one of the best and most challenging courses in the whole of Austria: Fontana has hosted the European Tour four times. Highly-acclaimed local hero Markus Brier won the Premier Tournament in 2006, three years later the Spaniard Rafa Cabrera-Bello played a fabulous final round of sixty—at the time this was the Tour's best ever score.

The owners have set their sights high: they want to be one of the top ten courses in Europe, meaning there is always something to optimize. Holes 2, 17, and 18 have recently been remodeled. Besides the diverse course, the resort offers a large spa and multiple wellness areas with saunas, steam baths, personal trainers, group training, yoga, a well-equipped fitness studio, as well as five tennis

Die European Tour gastierte bereits viermal nicht weit von Wien auf einem der besten und anspruchsvollsten Plätze Österreichs. Just beim Premiereturnier 2006 gewann der umjubelte Lokalmatador Markus Brier, drei Jahre später siegte der Spanier Rafa Cabrera-Bello mit einer fabelhaften Schlussrunde von 60 Schlägen – der damals niedrigsten je gespielten Runde der Tour-Geschichte. Das Ziel der Betreiber ist hoch gesteckt: Sie wollen zu den zehn besten Plätzen in Europa zählen, und deswegen gibt es immer etwas zu optimieren – die Spielbahnen 2, 17 und 18 wurden gerade neu gestaltet. Außer dem abwechslungsreichen Platz gibt es ein großes Spa und viele Wellnessangebote mit Sauna, Dampfbad, Personal Trainer oder Gruppentraining, Yogastunden, ein üppig ausge-

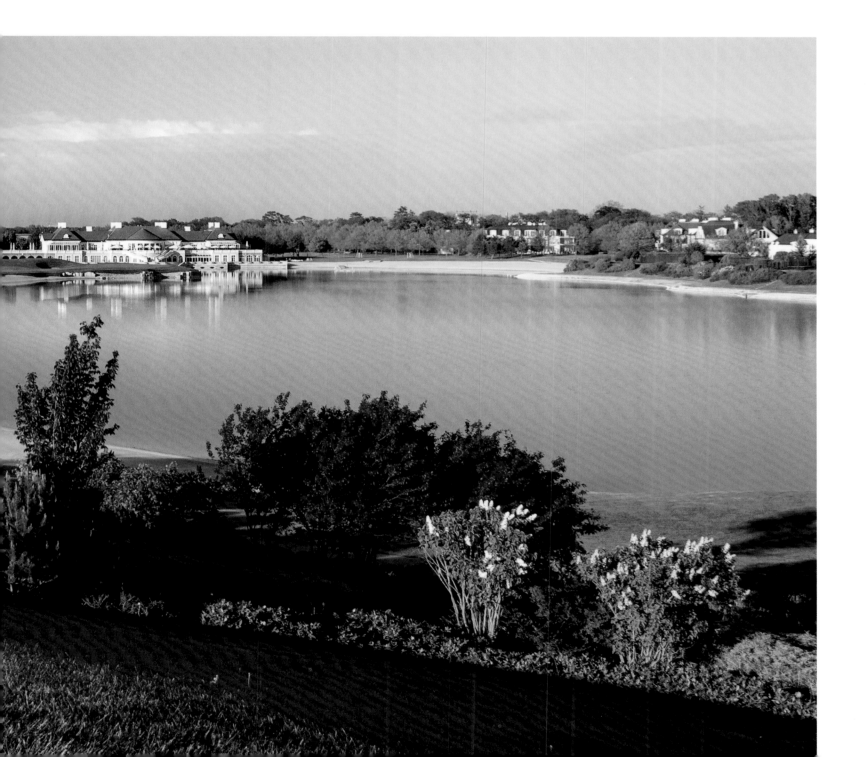

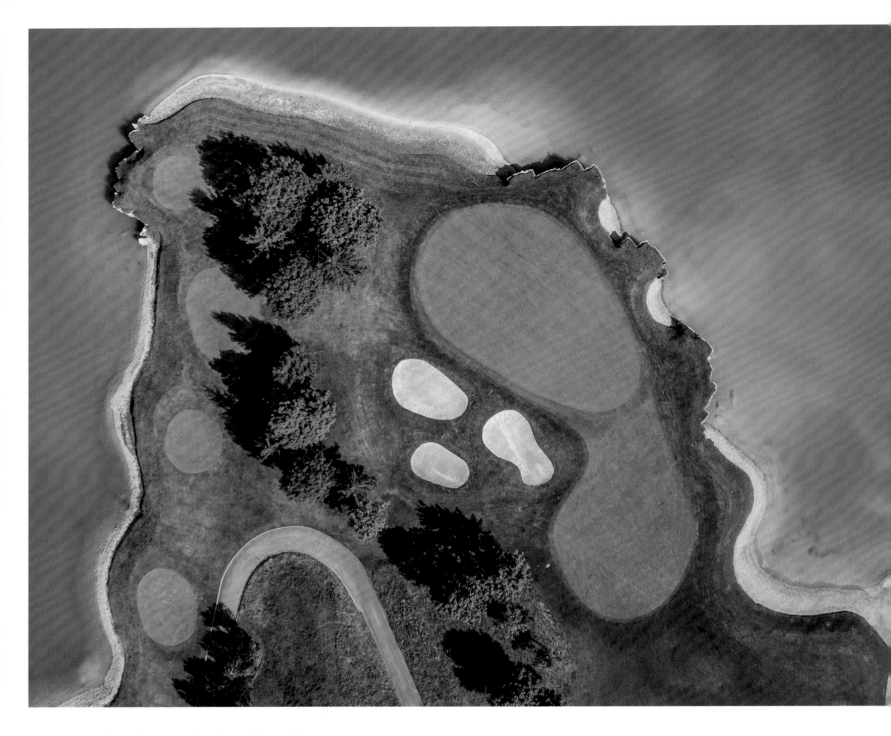

Austria's number one on the shore of a huge lake

Österreichs Nummer eins liegt an einem großen Badesee.

courts. Guests can enjoy a first-rate meal at the restaurant run by chef Josef Balogh and then saunter over to the smoking room. The resort's theme nights are particularly popular, especially the White Parties held in the summer. The jewel in the crown is the ten hectare turquoise lake for swimming.

A rarity in the German-speaking world: Fontana is also a luxury residential area with lakeside views and stunning villas.

➤ Austria, Oberwaltersdorf, www.fontana.at

stattetes Fitnessstudio sowie fünf Tennisplätze. Fürs leibliche Wohl wird in dem sehr guten Restaurant unter der Leitung von Küchenchef Josef Balogh bestens gesorgt, und nach dem Essen wartet die Zigarrenlounge. Beliebt sind die Themenabende sowie die White Partys im Sommer. Heimlicher Star des Platzes ist aber der zehn Hektar große, türkisblaue Badesee.

Eine Rarität im deutschsprachigen Raum: Fontana ist auch eine luxuriöse Wohnsiedlung mit unverbaubarem Blick auf den See, in der etliche prächtige Villen zu bewundern sind.

➤ Österreich, Oberwaltersdorf, www.fontana.at

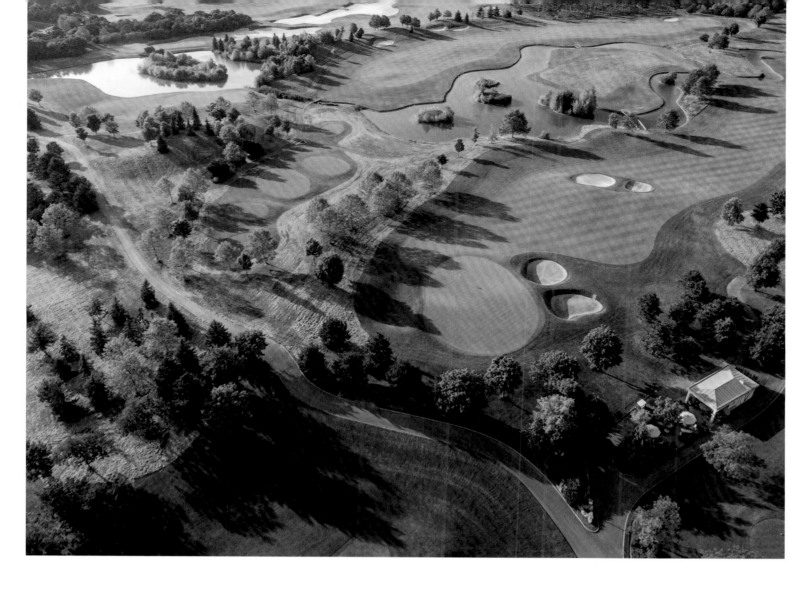
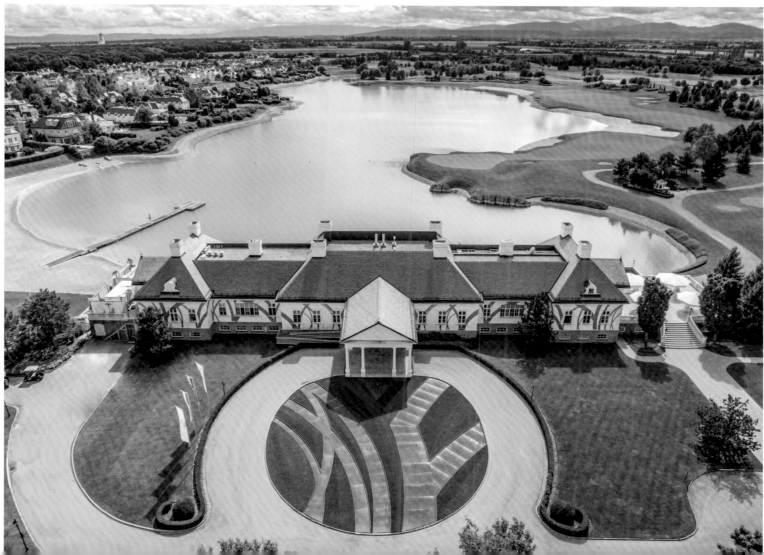

TURNBERRY

SCOTLAND / SCHOTTLAND

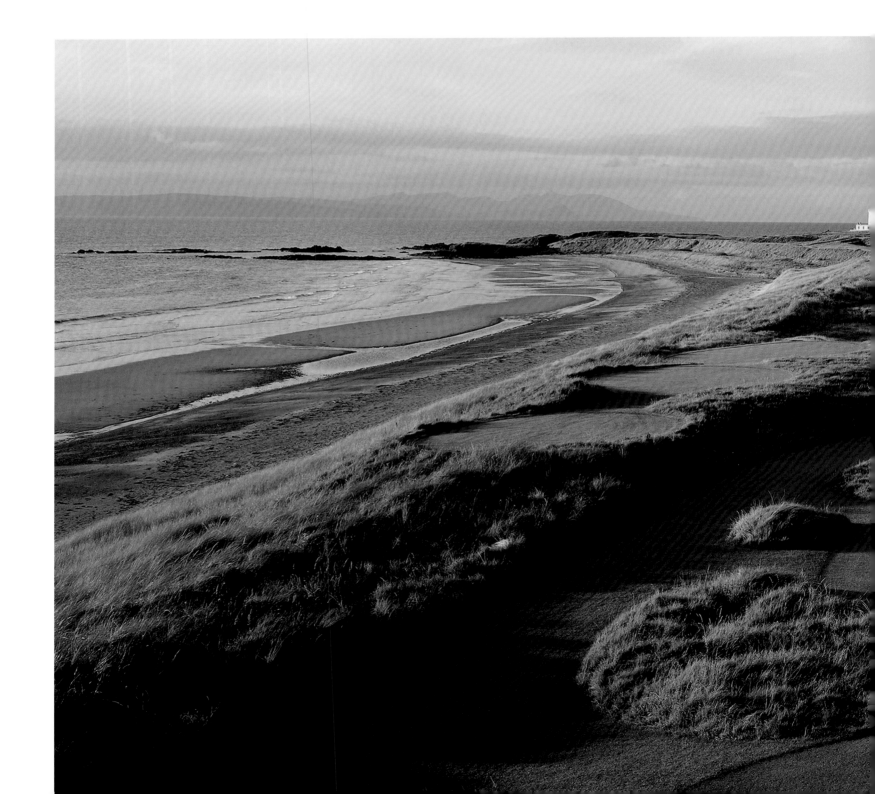

Turnberry is the youngest of all courses to host the British Open and yet the fairways look as if they've been around for centuries. Mackenzie Ross built the Ailsa Course between 1949 and 1951 on a plot used by the Royal Air Force as a runway during the Second World War. In 2001, the Kintyre and the 9-hole Arran courses were added as well as a golf academy, and of course their iconic luxury hotel. Among experts Turnberry, on the west coast of Scotland, is rated as the best Open course, though traditionalists will grumble that it is not a true links

Turnberry ist der jüngste aller Plätze, auf denen die Open Championship ausgetragen werden, dabei sehen die Fairways aus, als gäbe es sie schon seit Hunderten von Jahren. Mackenzie Ross baute von 1949 bis 1951 den Ailsa-Platz auf einem Gelände, das im Zweiten Weltkrieg als Start- und Landebahn der Royal Air Force diente. Im Jahr 2001 kam der Kintyre-Kurs hinzu, der Neun-Loch-Platz Arran sowie die Golfakademie und natürlich das ikonische Luxushotel runden das Angebot ab. Turnberry gilt bei vielen Kennern als bester Open-Course, obwohl Traditio-

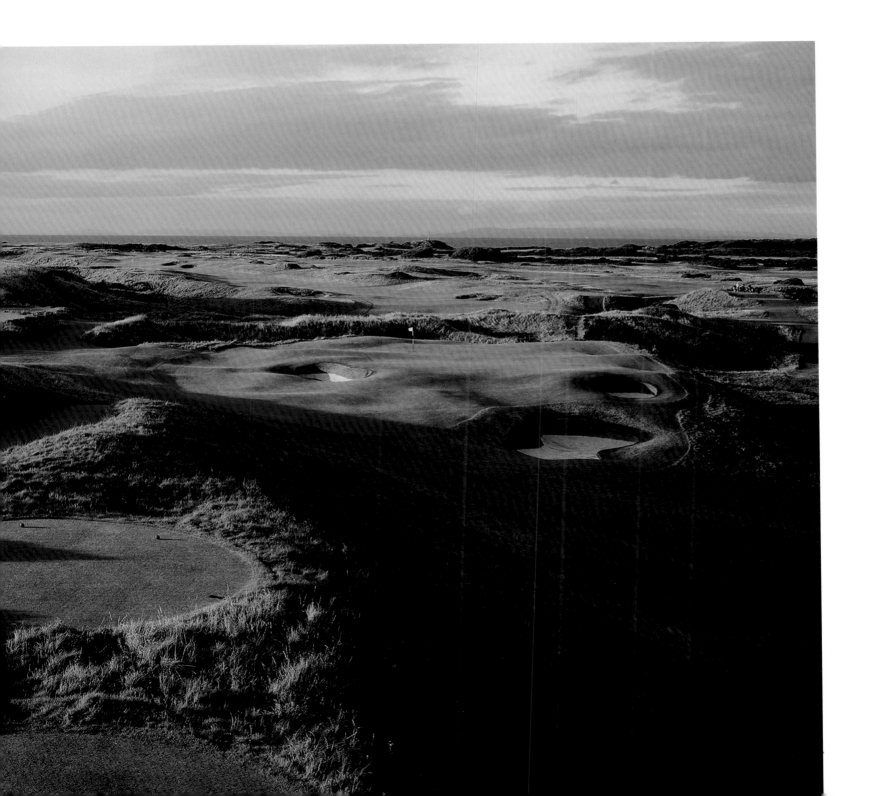

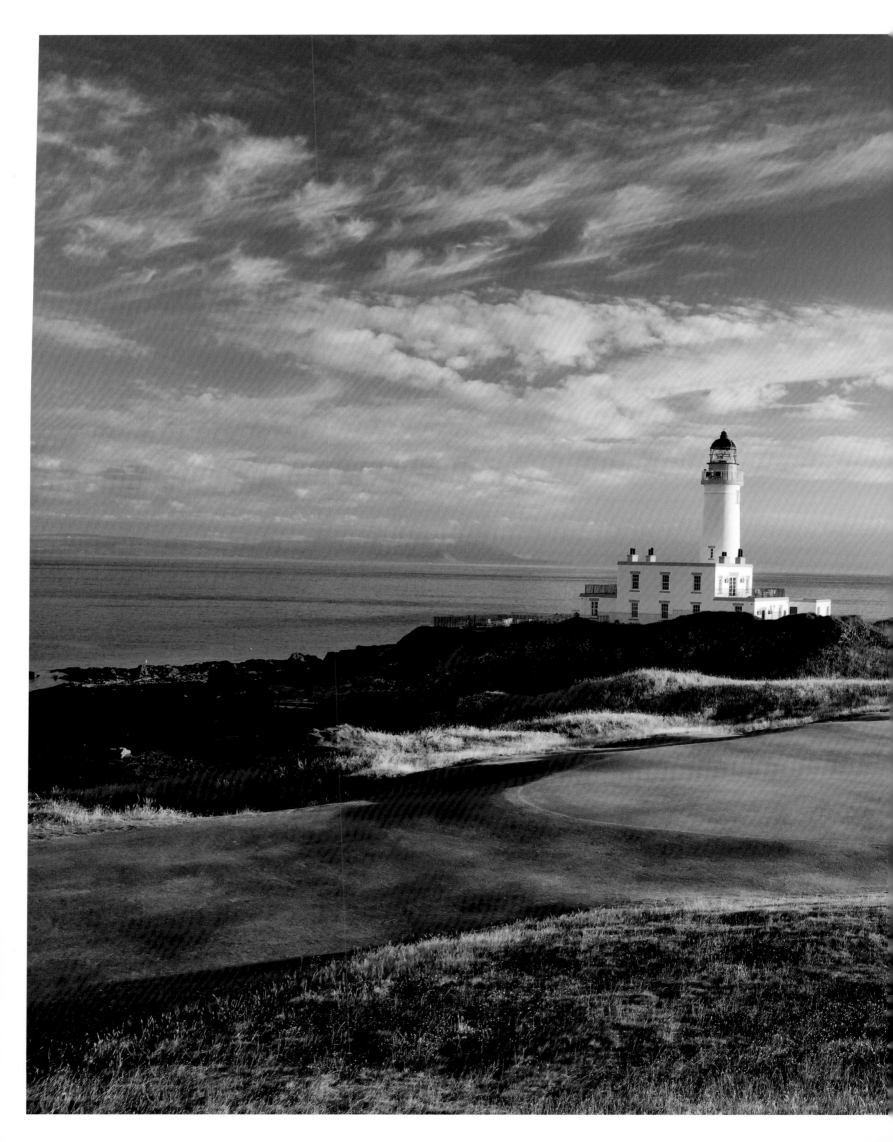

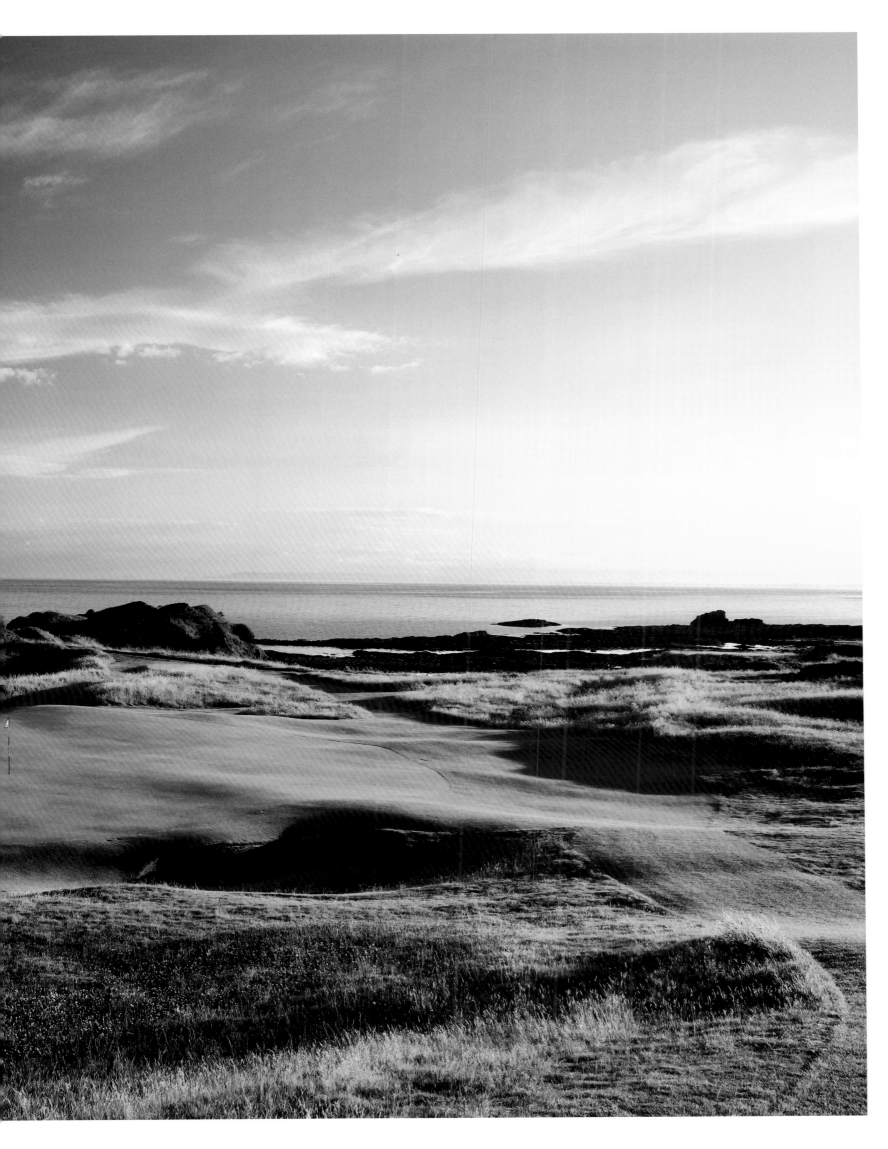

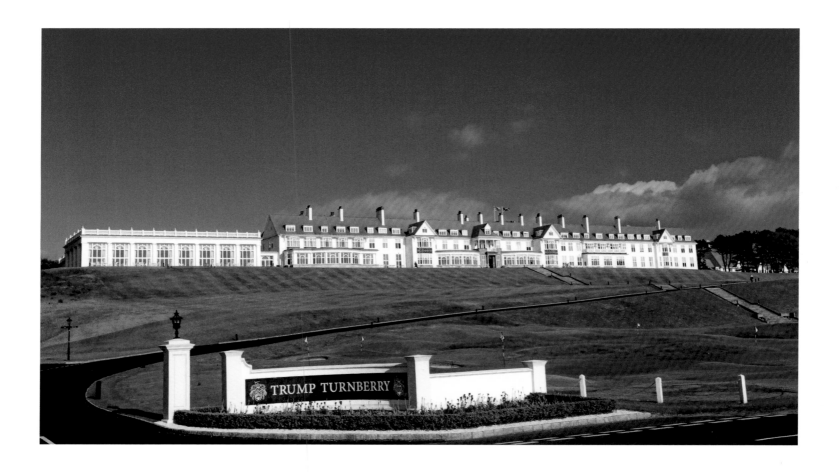

course—a proposition that can be debated for hours in the clubhouse over a Scotch.

The "Duel in the Sun," played out at the 1977 Open between Jack Nicklaus and Tom Watson, went down as the most remarkable match in history, to which sportswriter Dan Jenkins added an equally historic evaluation: "Better than any golf—ever."

Characteristically for the region Turnberry is a place for all the seasons. And the weather forecast is always pretty straightforward: Off the coast of Scotland lies a volcanic rock called Ailsa Craig. According to locals, "if you can see the Craig, it's going to rain, and if you can't see the Craig, it's raining already."

➤ Scotland, Turnberry, www.turnberry.co.uk

nalisten grummeln, dass es sich ja nicht um einen »echten« Linksplatz handle – eine These, über die man stundenlang im Clubhaus beim Whisky diskutieren kann.

Das »Duel in the Sun« ging als der bemerkenswerteste Zweikampf in die Golfgeschichte ein. Jack Nicklaus und Tom Watson duellierten sich bei der Open Championship 1977 mit brillantestem Golf. »Better than any golf – ever«, schrieb der Sportjournalist Dan Jenkins.

Turnberry ist ein Ort für alle Jahreszeiten. Und die Wettervorhersage ist normalerweise ganz einfach. Vor der Küste liegt ein vulkanischer Fels namens Ailsa Craig. »Wenn du den Craig sehen kannst, wird es bald regnen«, sagen die Einheimischen. »Wenn du ihn nicht sehen kannst, regnet es bereits.«

➤ Schottland, Turnberry, www.turnberry.co.uk

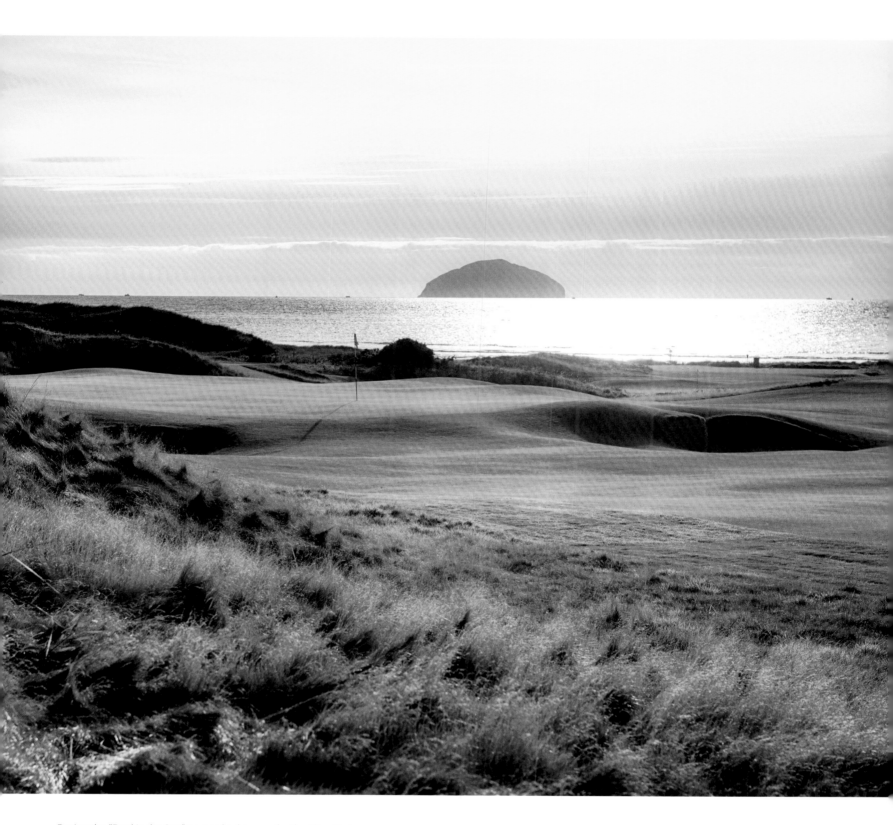

During the "Duel in the Sun" no one had an eye for the Alisa Craig

Beim »Duell in der Sonne« hatte niemand einen Blick für den Alisa Craig übrig.

THE BEST DUEL—EVER

DAS BESTE DUELL DER GOLFGESCHICHTE

The 1977 "Duel in the Sun" between Tom Watson and Jack Nicklaus in Turnberry is one of the most memorable and dramatic final rounds in the history of the majors. At almost 86°F with unusually calm winds, Watson and Nicklaus fought a private duel for victory—for spectators this was golf from another planet. Nicklaus was one stroke ahead at the 15th when Watson caught up with the 60-foot birdie putt. At the 17th another birdie followed placing Watson in the lead by one stroke. At the 18th his 7-iron approach stopped pin-high and two feet left of the flag, But Nicklaus too holed a 40-foot birdie. Watson kept his cool, holed his own putt. With final rounds of 65 and 65 he had beaten the great Nicklaus by one stroke. The dualists left the green together, arm in arm. In third place was Hubert Green, who famously said: "I won this golf tournament—I don't know what game those other two guys were playing."

Das »Duel in the Sun« 1977 zwischen Tom Watson und Jack Nicklaus in Turnberry gehört zur denkwürdigsten und dramatischsten Schlussrunde der Major-Geschichte. Bei fast 30 °C und Windstille fochten Tom Watson und Jack Nicklaus ein Privatduell um den Sieg aus, das den Zuschauern Golf vom anderen Stern bescherte. Nicklaus führte bis zur 15 mit einem Schlag, dann versenkte Watson einen 22-Meter-Putt zum Birdie. An der 17 ließ er ein weiteres Birdie folgen, und an der 18 nagelte er ein Eisen 7 60 Zentimeter an den Stock. Doch auch Nicklaus hatte einen Birdie-Putt aus 15 Metern – und versenkte ihn. Watson blieb cool, versenkte seinerseits den Putt und schlug mit seinen Schlussrunden von 65 und 65 den großen Nicklaus um einen Schlag. Die Duellanten verließen Arm in Arm das Grün. Der drittplatzierte Hubert Green, elf Schläge zurück, sagte später: »Ich habe die Open Championship gewonnen. Diese beiden haben ein völlig anderes Turnier gespielt.«

Tom Watson and Jack Nicklaus during their "Duel in the Sun" at Turnberry on July 9, 1977

Tom Watson und Jack Nicklaus beim „Duel in the Sun" am 9. Juli 1977 in Turnberry

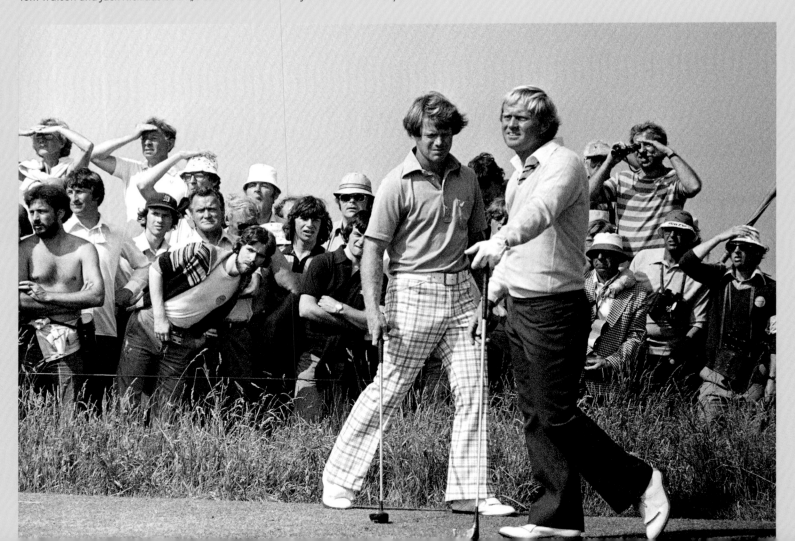

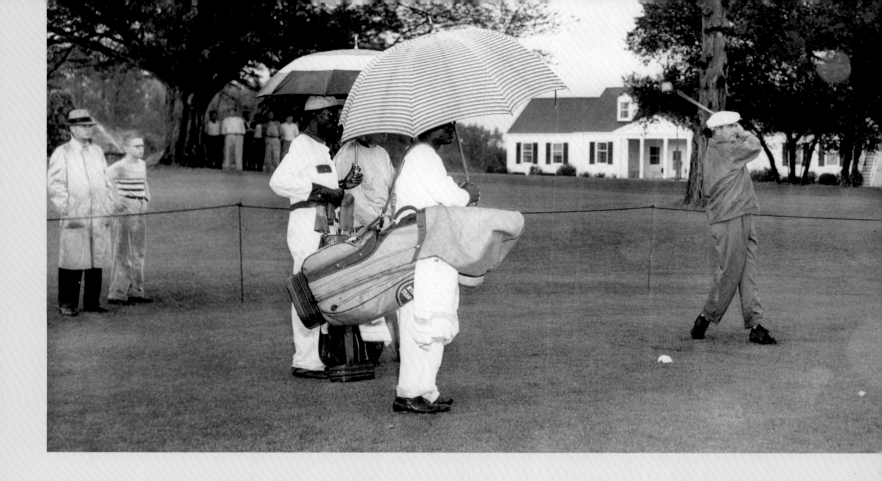

THE WAR HERO

Top golfer Lloyd Mangrum may have looked like a movie star with his pencil moustache, but in reality he was a sergeant in one of the toughest battles of the Second World War: he was the sole survivor of his platoon during the Allied invasion of Normandy on Omaha Beach. He was awarded two Purple Hearts on account of his leg, face, and shoulder injuries, though he preferred to tell his friends a variation on the origin of his scars: "Actually, I got them tripping over a whiskey bottle while running out of a whorehouse in Paris." At the height of the war, Mangrum was offered a chance to retire from the front line and instead teach the officers golf—a suggestion that infuriated him to such an extent—he almost "killed the messenger." After the war he went on the win a US Open and thirty-five other tournaments. He lost three majors in the play-offs. His swing was elegant, but sometimes it simply had a mind of its own—much like the man himself.

Once in a bar with Sam Snead he accidently stepped on a man's foot. Mangrum apologised but the man simply didn't want to let it go and continued hurling insults at him. Mangrum took it for a while and then reached behind the bar for a bottle and brought it down over the man's head. Snead recalls that being the most impressive swing he'd ever seen a golfer take.

Mangrum died of a heart attack in 1973 aged 59. It was his twelfth.

Lloyd Mangrum tees off, c. 1960
Lloyd Mangrum schlägt ab, ca. 1960.

DER KRIEGSHELD

Lloyd Mangrum sah mit seinem Menjoubärtchen aus wie ein Filmstar, doch der Spitzengolfer war hatte an den härtesten Schlachten des Zweiten Weltkrieges teilgenommen. Bei der Invasion der Alliierten in der Normandie war er der einzige Überlebende seines Platoons am Omaha Beach. Er bekam zwei Purple Hearts verliehen für seine Verwundungen am Bein, am Gesicht und an der Schulter. Seinen Kumpels erzählte er eine andere Geschichte über die Herkunft der Narben: »Ich stolperte über eine Whiskyflasche, als ich aus einem Pariser Puff türmen musste.« Als ihm mitten im Krieg angeboten wurde, von der Front abgezogen zu werden, um den Offizieren Golf beizubringen, lehnte er, außer sich vor Wut, ab und wäre dem Boten, der die Nachricht überbracht hatte, beinahe an die Gurgel gegangen. Nach dem Krieg gewann er eine US Open und 35 weitere Turniere. Drei weitere Majors verlor er im Stechen. Sein Schwung war elegant, aber auch äußerst eigenwillig – ziemlich genau so wie er selbst.

Einmal ging er mit Sam Snead in eine Bar und trat aus Versehen einem Gast auf den Fuß. Mangrum entschuldigte sich, doch der Gast wollte sich einfach nicht mehr beruhigen und beschimpfte ihn immer weiter. Mangrum hörte sich das eine Weile lang an, nahm sich schließlich eine Flasche vom Tresen und schlug sie dem Mann ins Gesicht. Snead erinnerte sich später: »Das war der eindrucksvollste Schlag, den ich je von einem Golfer gesehen habe.«

Mangrum verstarb 1973 mit 59 Jahren an einem Herzinfarkt. Es war sein zwölfter.

THE MOST NOTORIOUS HUSTLER OF ALL TIMES

He was a killer. Six foot two, thin, steely blue eyes, close together. "Those eyes could look a hole through you," Byron Nelson recalls. Alvin Clarence Thomas, known as "Titanic" and later, due to a press agency transmission error, "Titanic Thompson" was a legend; he was the most famous hustler of all times. Unbeatable in poker, dice, billiards, and above all on the golf course. Ben Hogan says he was the most creative player he ever saw.

KEVIN COOK

'Ridiculously engaging' Metro

TITANIC THOMPSON

CARD-SHARKING, GUN-SLINGING, FAST-LIVING AMERICAN LEGEND

One of many books on "Titanic" Thompson

Eines der vielen Bücher über „Titanic" Thompson

Alvin Thomas was born in 1892 in the back of beyond of Arkansas. His father left the family when he was a baby and mother and child took refuge in a pig farm. Here Alvin somehow obtained a deck of cards and spent his time practicing—for hours, and days, and weeks. After several months, he had mastered a considerable number of tricks.

How did Alvin come by his nickname Titanic? Alvin once bet he could leap over a pool table lengthways without touching it. No one believed him. But Alvin had developed a head-first-technique and landed with a summersault on the far side. One day, just as news of the sinking of the Titanic was spreading through the country, Alvin was enjoying one of his usual lucrative days in the pool hall wining various bets. One of his victims asked the room what his name was. "It must be Titanic," one of the bystanders called, "He sinks everybody!"

At age 19, Titanic first set foot on a golf course. He was curious, reached for a driver, and hit his first ball sending it 260 yards. "Where did you learn that?" one of the astonished pros wanted to know. "Just now," Titanic replied. And the very next day his gambling friends were standing by his side on the range. Titanic bet $3,000 that he could hit the ball just as far again. But he didn't manage. This was pretty much his last ever golfing loss. One year later, he was able to play under par right-, and left-handed. He practiced his swings as he had done his card tricks, for hours, days, and weeks, and he specifically honed his putting and chipping skills—for it quickly became evident that most bets were placed on the green. His magical hands soon

DER GRÖSSTE ZOCKER ALLER ZEITEN

Er war ein Killer. 1,87 Meter groß und hager, stahlblaue, eng beieinander liegende Augen. »Sein Blick konnte alles und jeden durchbohren«, erinnerte sich Byron Nelson. Alvin Clarence Thomas, genannt »Titanic« und später, wegen eines Übermittlungsfehlers einer Presseagentur, »Titanic Thompson«, war eine Legende. Der berühmteste Zocker aller Zeiten. Unschlagbar beim Pokern, Würfeln, Billard – und vor allem auf dem Golfplatz. »Er war der kreativste Spieler, den ich je sah«, sagte Ben Hogan.

Alvin wurde im Jahr 1892 im tiefsten Arkansas geboren. Der Vater verließ die Familie, als er noch ein Säugling war, Mutter und Kind kamen auf einer Schweinefarm unter. Irgendwoher hatte Alvin ein altes Kartenspiel aufgetrieben, und damit übte er stundenlang. Tagelang. Wochenlang. Nach einigen Monaten hatte er eine Menge Tricks drauf.

Wie kam Alvin zu seinem Spitznamen Titanic? Alvin wettete, er könne in Längsrichtung über einen Billardtisch springen, ohne diesen zu berühren. Das nahm ihm niemand ab, aber er hatte eine Kopf-voran-Technik entwickelt und rollte auf der anderen Seite ab. Eines Tages, als sich gerade die Nachricht vom Untergang der Titanic im Land verbreitete, hatte Alvin einen seiner üblichen großen Tage und im Billardsalon diverse Wetten gewonnen. Eines einer Opfer fragte in die Runde: »Wie heißt der Bursche eigentlich?« »Er sollte Titanic heißen!«, rief einer der Anwesenden. »Er versenkt hier jeden.«

Mit 19 sah Titanic seinen ersten Golfplatz. Er war neugierig, griff zu einem Driver und schlug den ersten Ball auf Anhieb 240 Meter weit. »Wo haben Sie das gelernt?«, fragte der staunende Pro. »Eben gerade«, antwortete Titanic. Und schon am nächsten Tag standen seine Zockerfreunde neben ihm auf der Range. Titanic wettete um 3000 Dollar, dass er den Ball erneut so weit schlagen würde. Doch er schaffte es nicht. Es war so ziemlich die letzte Wette, die er auf einem Golfplatz verlieren sollte. Ein Jahr später konnte er links- wie rechtsherum unter Par spielen. Er übte den Schwung wie einst das Kartenspielen stunden-, tage-, wochenlang, vor allem Putts und Chips. »Ich fand schnell heraus, dass die meisten Wetten rund ums Grün abgeschlossen wurden.« Seine fantastischen Hände machten ihn schnell zu einem großartigen Spieler. »Er hätte problemlos auf der PGA Tour antreten können«, sagte US-Open-Champion Tommy Bolt. »Er hatte einen kompakten, wiederholbaren Schwung, typisch Zocker.« Aber warum hätte er das tun sollen? Damals konnte man mit Profigolf nicht reich werden. Mit Zocken dagegen schon.

made him a great golfer. "He could easily have played at the PGA tour," said US Open champion Tommy Bolt. "He had a compact swing that didn't require much practice, a gambler's swing." But why should he do that? Back in the day professional golf didn't make you rich. Betting on the other hand did.

He placed bets with Ben Hogan, Byron Nelson, and even with the good-hearted Harvey Penick. Left or right-handed, he could beat them all. His favorite trick went like this: he traveled to a club and challenged the local pro to a competition, say ten dollars for each hole. The pro won easily, for Titanic played poorly. At the end of the round Titanic offered a revenge match for the following day, only this time for real money, say a hundred or even a $1,000 per hole. The pro agreed believing it to be easy money and even gave the poor hacker a head start. The following day Titanic played his best golf—or at least well enough for an all square.

Titanic was unbeatable in a team too. Lee Elder, the first African-American to compete in the Masters, spent several months playing the caddie. A perfect setup: "I bet you couldn't even win against my caddie," he'd goad the white country club snobs he'd just beaten.

Er wettete mit Ben Hogan, Byron Nelson und sogar mit dem gutmütigen Harvey Penick. Ob links- oder rechtshändig, er konnte alle schlagen. Sein beliebtester Trick ging so: Er fuhr zu einem Club und forderte den dortigen Pro zu einem Wettspiel heraus, 10 Dollar pro Loch. Der Pro gewann locker, denn Titanic spielte schlecht. Am Ende der Runde bat Titanic um eine Revanche am nächsten Tag, aber diesmal um richtige Summen – 100 oder gar 1000 Dollar pro Loch. Der Pro willigte ein, glaubte an leicht verdientes Geld und gab dem armen Hacker sogar noch Schläge vor. Am nächsten Tag spielte Titanic sein bestes Golf – beziehungsweise gerade so gut, um all square zur 18 zu kommen, wo er noch einmal eine Verdopplung anbot.

Auch im Team war Titanic unschlagbar. Lee Elder, der erste Schwarze, der beim Masters antreten sollte, mimte einige Monate seinen Caddie. Ein perfekter Trick. »Ich wette, du kannst nicht mal gegen meinen Caddie gewinnen«, provozierte er die weißen Country-Club-Schnösel, nachdem er sie geschlagen hatte.

GOLFING DURING WARTIME

GOLFEN IM KRIEG

When in 1940 a bomb fell on the grounds of Richmond Golf Club in Surrey, England, their response was to issue a list of temporary golf rules to suit the circumstances: "Players are asked to collect Bomb and Shrapnel splinters to save these causing damage to the Mowing Machines. In Competitions, during gunfire or while bombs are falling, players may take cover without penalty for ceasing play. The positions of known delayed action bombs are marked by red flags placed at reasonably, but not guaranteed, safe distance therefrom. Shrapnel / and/or bomb splinters on the Fairways, or in Bunkers within a club's length of a ball, may be moved without penalty, and no penalty shall be incurred if a ball is thereby caused to move accidentally." Richmond Golf Club, near London: Wartime Rules during World War II.

»Falls während eines Turniers Bomben fallen, dürfen die Spieler in Deckung gehen, ohne einen Strafschlag für Spielverzögerung zu erhalten. Die Positionen nicht detonierter Bomben sind mit roten Flaggen gekennzeichnet. Es empfiehlt sich, von einer sicheren Distanz zu spielen, obgleich eine Garantie nicht übernommen werden kann. Ein Ball, der durch Feindeshand bewegt wurde, darf ohne Strafschlag an die ursprüngliche Stelle zurückgelegt werden. Falls er zerstört wird, darf der Spieler einen zweiten Ball straffrei nicht näher zum Loch droppen. Ein Spieler, dessen Schlag durch die gleichzeitige Explosion einer Bombe gestört wurde, darf einen zweiten Ball vom selben Ort spielen, allerdings mit einem Strafschlag.« Die Platzregeln des Richmond Golf Clubs bei London während des Zweiten Weltkriegs.

TEMPORARY RULES. 1940

1. Players are asked to collect Bomb and Shrapnel splinters to save these causing damage to the Mowing Machines.
2. In Competitions, during gunfire or while bombs are falling, players may take cover without penalty for ceasing play.
3. The positions of known delayed action bombs are marked by red flags at a reasonably, but not guaranteed, safe distance therefrom.
4. Shrapnel and/or bomb splinters on the Fairways, or in Bunkers within a club's length of a ball, may be moved without penalty, and no penalty shall be incurred if a ball is thereby caused to move accidentally.
5. A ball moved by enemy action may be replaced, or if lost or destroyed, a ball may be dropped not nearer the hole without penalty.
6. A ball lying in a crater may be lifted and dropped not nearer the hole, preserving the line to the hole, without penalty.

Extract from the golf course rules during the Second World War
Auszug aus den Platzregeln während des Zweiten Weltkriegs

Germany's only Jack-Nicklaus-Course

Der einzige Jack-Nicklaus-Platz in Deutschland

GUT LÄRCHENHOF

GERMANY / DEUTSCHLAND

Jack Nicklaus' highly-acclaimed Gut Lärchenhof course in North Rhine-Westphalia, has for many years—in turn annually with GC München Eichenried—hosted Germany's most significant golf tournament: the BMW International Open. And before that the Linde German Masters and the Mercedes Benz Championship took place here. Many a famous name has been added to the list of winners here including Bernhard Langer, Sergio García, Pádraig Harrington, Retief Goosen, and Henrik Stenson. Gut Lärchenhof opened in 1996 and remains the only

Ein hochgelobter Jack-Nicklaus-Course in Nordrhein-Westfalen, auf dem viele Jahre lang – im Wechsel mit dem GC München Eichenried – die BMW International Open stattfand, das wichtigste Golfturnier auf deutschem Boden. Zuvor waren schon die Linde German Masters und die Mercedes Benz Championship zu Gast. Ruhmreiche Namen trugen sich in die Siegerlisten ein, darunter die Major-Sieger Bernhard Langer, Sergio García, Pádraig Harrington, Retief Goosen und Henrik Stenson. Das 1996 eröffnete Gut Lärchenhof ist der bislang einzige

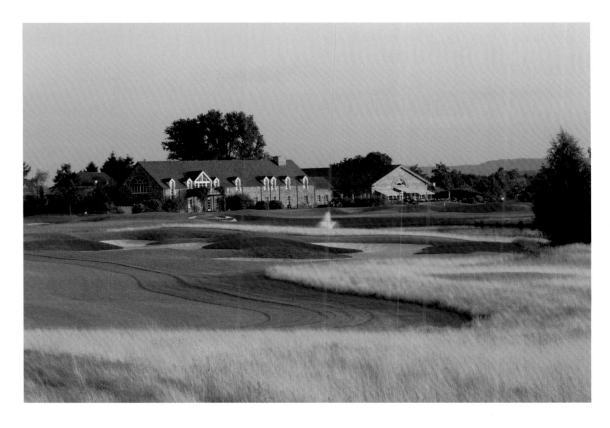

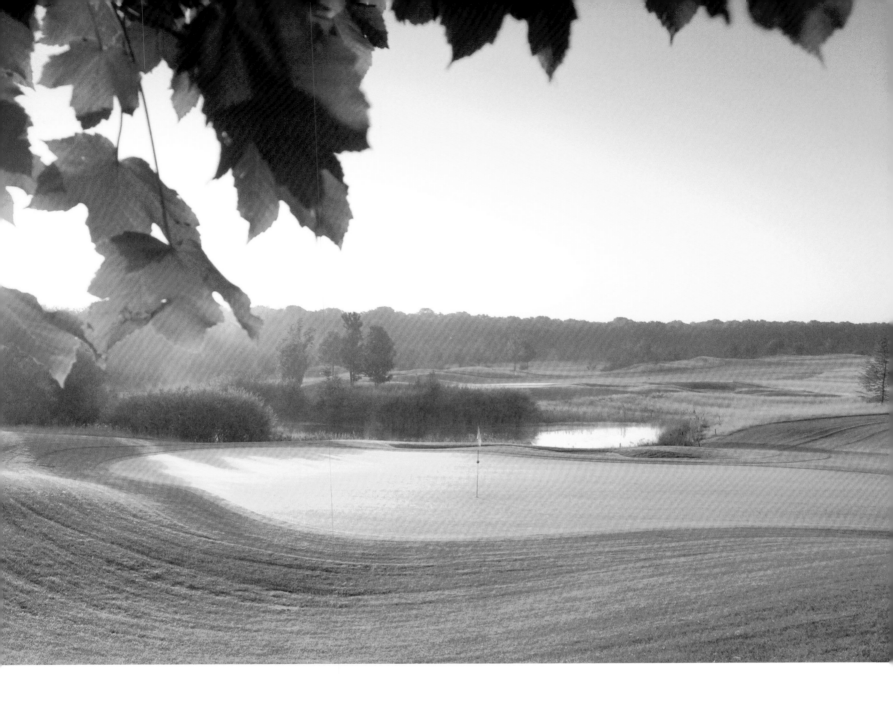

Nicklaus course in Germany to date. The course is hard but fair and often calls for strategy rather than strength of force. The first four holes can be achieved with relative ease, but by the 5th (a par-4 with a slight dogleg and a lake to the left of the green) concentration is crucial. Hole 7 is a hole to be reckoned with: the par-5 at 577 yards is considered the most punishing. The 16th, 17th, and 18th are outstanding final holes. But the day needn't end here, for the gastronomy at Gut Lärchenhof is also first rate.

Their sizable Center of Excellence is equipped with state-of-the-art data tracking devices to help amateurs and professionals alike refine their swings. A rarity in Germany and good news for all future champions: range balls are handed out free of charge.

➤ Germany, Pulheim, www.gutlaerchenhof.de

Nicklaus-Platz in Deutschland. Der Course ist schwierig, aber immer fair – oft ist Strategie statt roher Kraft gefragt. Die ersten vier Bahnen sind noch recht mühelos zu bewältigen, doch spätestens ab der fünften Bahn, einem Par 4 mit leichtem Dogleg und einem Teich links vor dem Grün, ist Konzentration gefragt. Ein Kracher ist die 528 Meter lange 7, ein Par 5, das als schwerstes Loch des Platzes gilt. Die 16, 17 und 18 sind herausragende Schlusslöcher. Damit sollte der Tag aber noch nicht vorbei sein, denn auch die Gastronomie gilt als erstklassig.

Im 200 Quadratmeter großen Center of Excellence helfen allerlei hochmoderne Analysegeräte Amateuren und Pros, ihren Schwung zu verbessern. Eine Seltenheit in Deutschland und eine gute Nachricht für alle Trainingsweltmeister: Die Range-Bälle werden in beliebiger Zahl kostenlos zur Verfügung gestellt.

➤ Deutschland, Pulheim, www.gutlaerchenhof.de

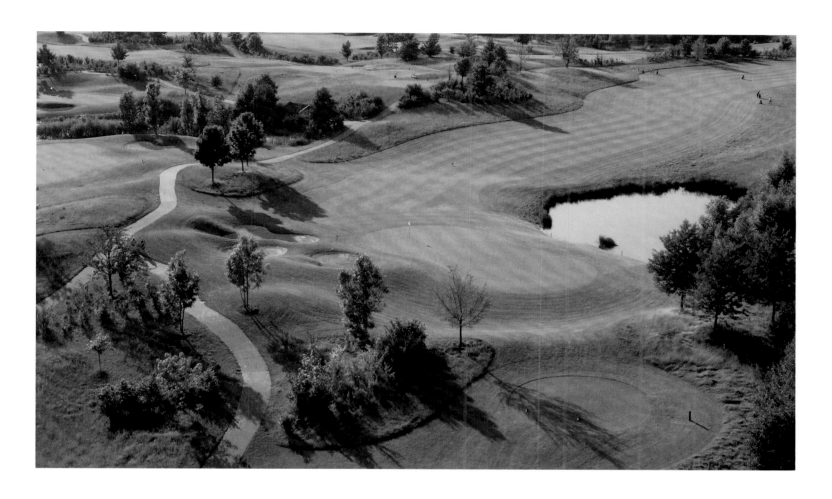

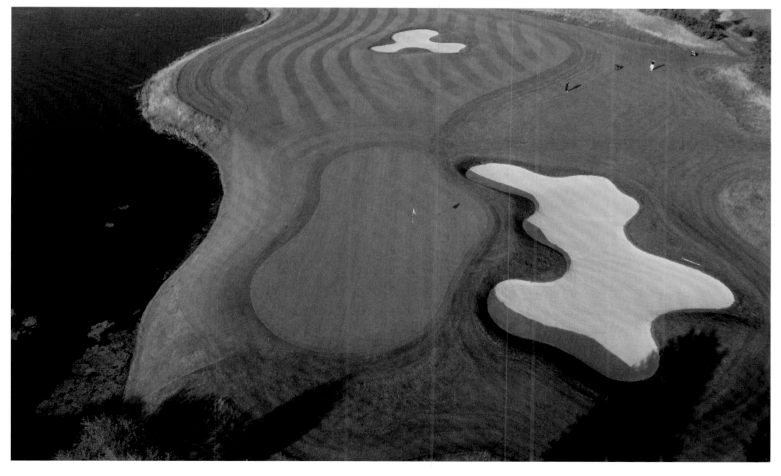

The holes call for clever strategies

Die Löcher verlangen nach einer klugen Strategie.

SECOND WIND
From Tour Golfer to
Course Architect

Jack Nicklaus does it, Bernhard Langer does it, and Tiger Woods is in there too: numerous former and active players go in for the designing of golf courses. Professional golfers are already quite fortunate, for in no other sport can you compete for such large sums until the age of sixty. But to top that, stars also get to design their own golf courses situated in the most stunning places on earth—and are paid handsomely to do so. A course designed by Gary Player or Jack Nicklaus comes in at $2 million. And that's just for the design before any building work has even started. The advantage for investors is clear: a course drawn up by a big name has a unique allure. And with the designer attending the opening, press interest is guaranteed.

Jack Nicklaus and Gary Player have each designed approximately 300 golf courses worldwide; Greg Norman and Ernie Els have also joined the trend. Norman, who dominated the golfing world back in the 80s, has meanwhile branched out into various fields enabling him to create a small empire: the pro shops at his golf courses sell his clothing, the wine cellars in

DIE ZWEITE LUFT
Vom Tour-Spieler zum
Platzarchitekten

Jack Nicklaus tut es, Bernhard Langer tut es, und auch Tiger Woods mischt längst mit: Viele ehemalige und aktive Golfer sind unter die Platzdesigner gegangen. Ohnehin haben Profigolfer mit ihrem Sport Glück, denn nirgends sonst kann man bis ins 60. Lebensjahr um viel Geld spielen. Aber das Beste ist, dass die Stars auch noch an den schönsten Orten der Erde eigene Golfplätze entwerfen dürfen – und dafür ebenfalls ordentlich kassieren. Wer einen Platz von Gary Player oder Jack Nicklaus haben will, zahlt zwei Millionen Dollar. Nur fürs Design, wohlgemerkt, nicht für den Bau selbst. Der Vorteil für die Investoren liegt auf der Hand: Ihr Platz hat eine ganz andere Strahlkraft, wenn ein großer Name ihn gezeichnet hat. Der Designer ist zudem bei der Eröffnung anwesend, was für zusätzliche Presse sorgt.

Jack Nicklaus und Gary Player haben je rund 300 Plätze weltweit entworfen. Doch auch Greg Norman und Ernie Els sind inzwischen dick im Geschäft. Norman, der in den 1980er-Jahren die Golfwelt dominierte, ist mittlerweile auf vielen Feldern

Greg Norman designing The Eastern Golf Club in Yering, Australia
Greg Norman entwirft den Eastern Golf Club in Yering, Australien.

his club restaurants stack his wines, and as for the surrounding hotels and holiday homes, they too are all Norman businesses.

Tiger Woods the designer has already opened his first course in the US, the Bluejack National Golf Club in Texas. The broad fairways and pine trees are reminiscent of the Augusta National Golf Club where Tiger won the US Masters five times. He'll undoubtedly be a successful designer—though fans hope to see him on the green for many years to come, rather than at the drawing board.

Jack Nicklaus working on the design of a new golf course.
Jack Nicklaus arbeitet an dem Design für einen neuen Golfplatz.

tätig, was ihm eine ideale Verwertungskette ermöglicht: Die Pro-Shops seiner Courses werden mit seiner Bekleidungslinie bestückt, die Weinkeller des Clubrestaurants mit seinen Weinen. Und die Hotels und Ferienvillen drumherum? Baut ebenfalls eine Norman-Firma.

Tiger Woods hat schon seinen ersten Platz in den USA eröffnet, den Bluejack National Golf Club in Texas. Die breiten Fairways und Pinien erinnern an den legendären Augusta National Golf Club, wo Tiger schon fünf Mal das US Masters gewinnen konnte. Sicher wird Tiger auch als Designer Erfolg haben – obwohl jeder Fan hofft, ihn noch viele Jahre auf den Grüns statt am Reißbrett zu erleben.

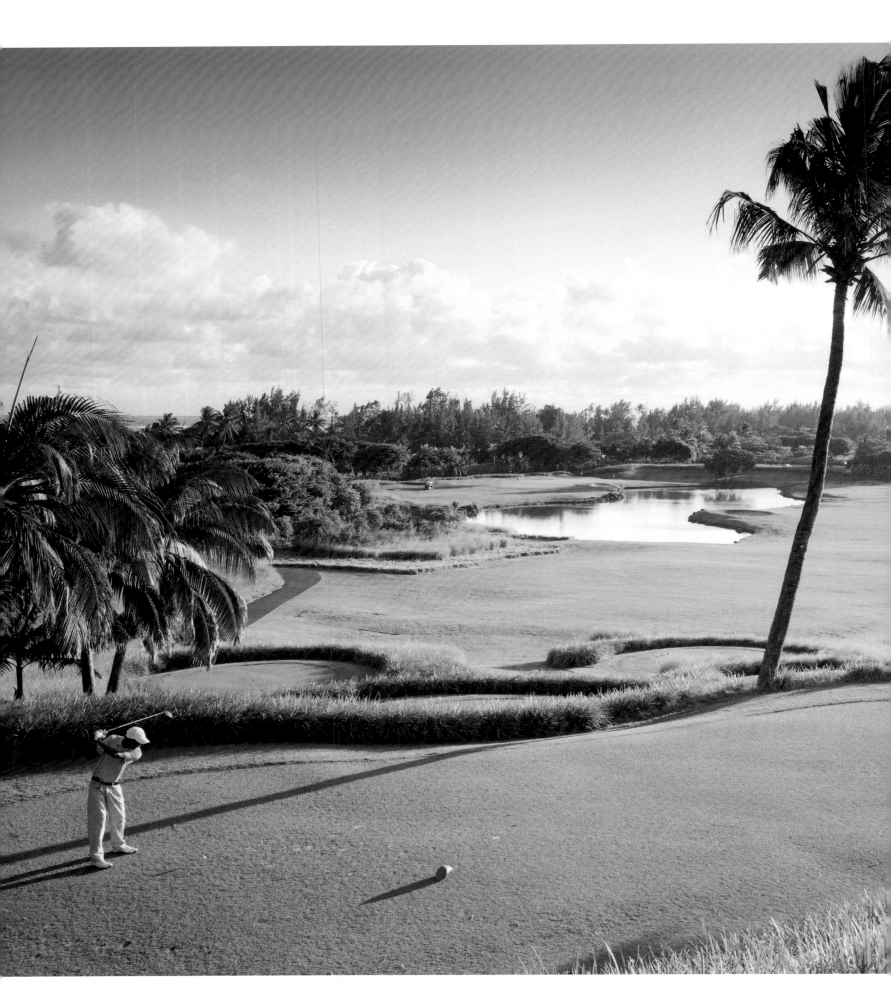

Stunning tee box—with a water hazard waiting patiently

Traumhafter Abschlag – das Wasserhindernis wartet geduldig.

HERITAGE LE TELFAIR

MAURITIUS

Heritage Le Telfair is the good life through and through: luxury suites on the Indian Ocean in southwest Mauritius, twelve restaurants, and an idyllic golf course on gently undulating terrain with several tricky water hazards and challenges for every handicap. Besides the 18-hole course, created by South African designer Peter Matkovich, there is a 9-hole short course ideal for beginners or for training. Tour pros regularly visit the resort to compete in the Mauritius Open.

Guests looking for activities other than golf can play beach volleyball or enjoy the modern fitness center. And with the ocean on your doorstep, windsurfing, paddle board-

Das gute Leben in seiner ganzen Fülle: luxuriöse Suiten im Südwesten von Mauritius direkt am Indischen Ozean, zwölf Restaurants, ein idyllischer Golfplatz in sanft onduliertem Terrain mit einigen kniffligen Wasserhindernissen und Herausforderungen für jedes Handicap. Neben dem von dem Südafrikaner Peter Matkovich entworfenen Platz mit 18 Löchern gibt es auch noch einen 9-Loch-Kurzplatz, der sich gut für Anfänger oder zum Trainieren eignet. Regelmäßig sind auch die Tour-Pros zu Gast, um die Mauritius Open auszuspielen.

Wem Golf nicht reicht, kann sich auf den drei Flutlichttennisplätzen, beim Beachvolleyball oder im modernen

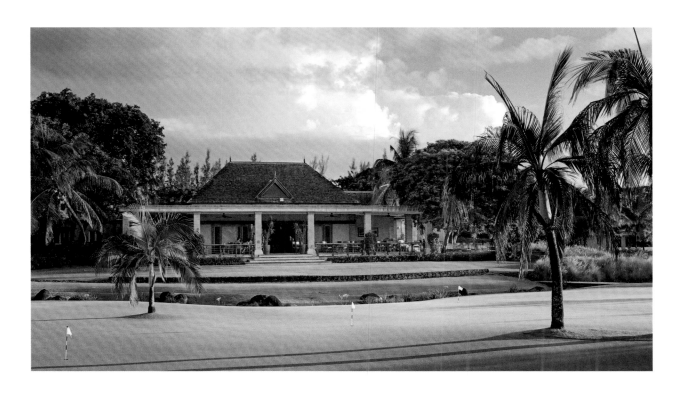

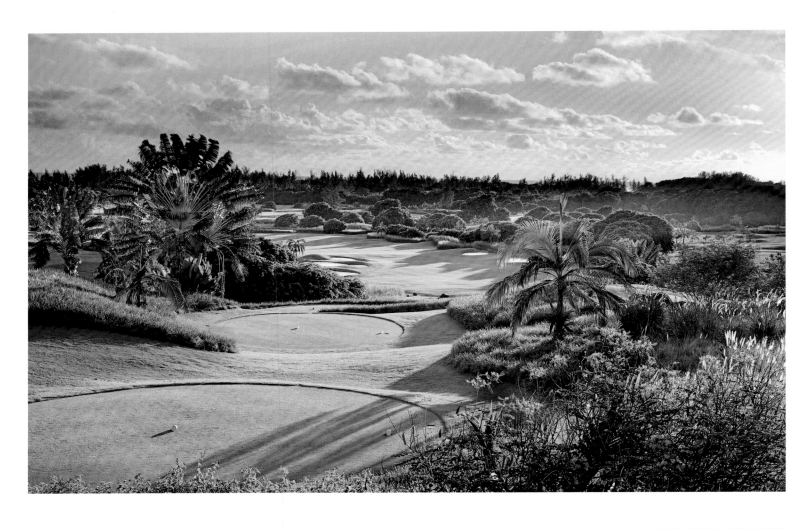

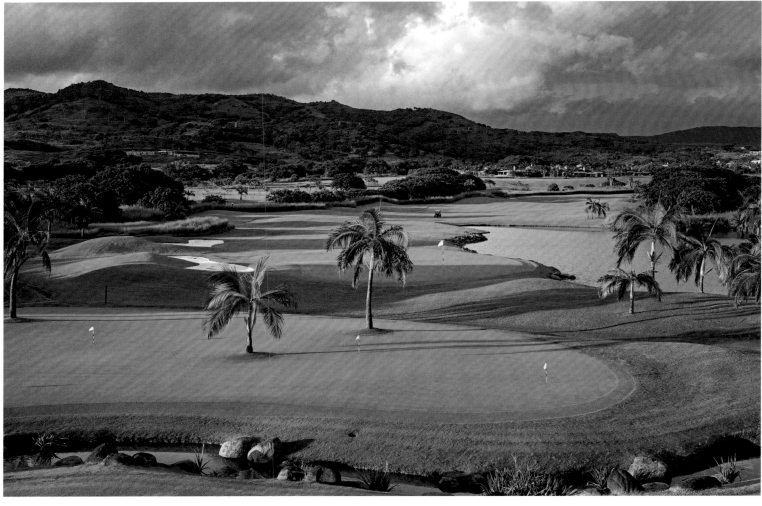

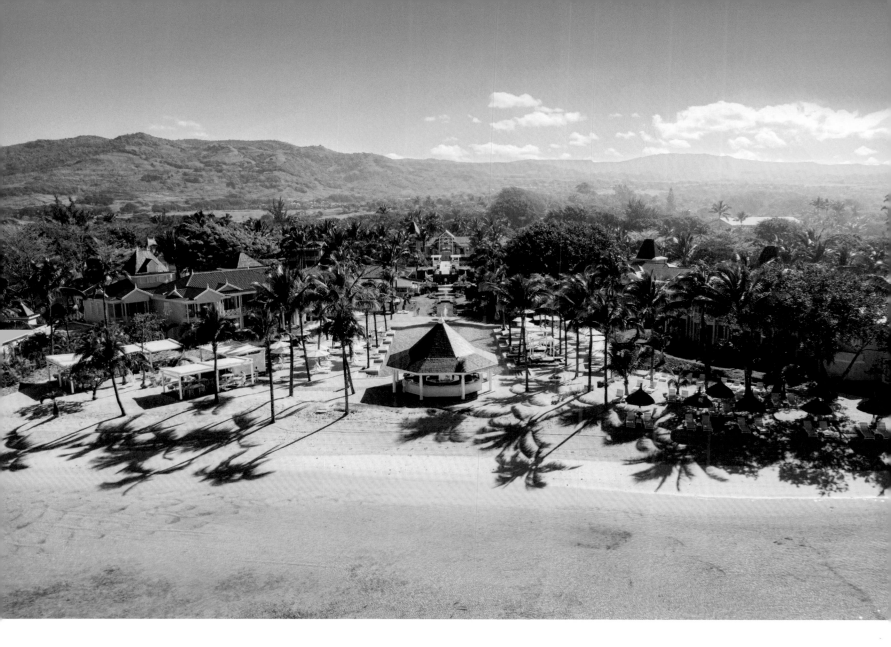

Idyllic conditions on the course and beyond

Paradiesische Zustände dies- und jenseits des Platzes

ing, kayaking, and canoeing (e.g. in a glass-bottomed boat) present enticing alternatives. Guided inland tours through unspoiled nature, on foot or with off-road vehicles, also promise memorable experiences.

The spa offers all imaginable feel-good treatments and activities including yoga and tai chi courses for individuals or groups. One exquisite service is the resort's "in-room-wellness" idea: the minibar is stocked with fresh fruit and healthy snacks and the scent of the room and the chromotherapy lighting is adjusted individually to suit each guest.

➤ Mauritius, Domaine de Bel Ombre, www.heritageresorts.mu

Fitnesscenter vergnügen. Und wenn der Ozean schon direkt vor der Resorttür liegt, sollte man sich auch daran erfreuen, etwa beim Windsurfen, auf dem SUP oder im Kajak mit durchsichtigem Kiel. Ein besonderes Erlebnis sind auch die geführten Touren durch die unberührte Natur im Inneren der Insel, ob zu Fuß oder im Offroad-Fahrzeug. Das Spa bietet alle erdenklichen Wohlfühlbehandlungen sowie Yoga- und Tai-Chi-Kurse, ob individuell oder in der Gruppe. Eine feine Idee ist die »in-room wellness«: Die Minibar wird mit frischen Früchten und gesunden Köstlichkeiten gefüllt, der Raumduft und die Farben der Chromtherapie-Lampen werden auf die Wünsche der Gäste abgestimmt.

➤ Mauritius, Domaine de Bel Ombre, www.heritageresorts.mu

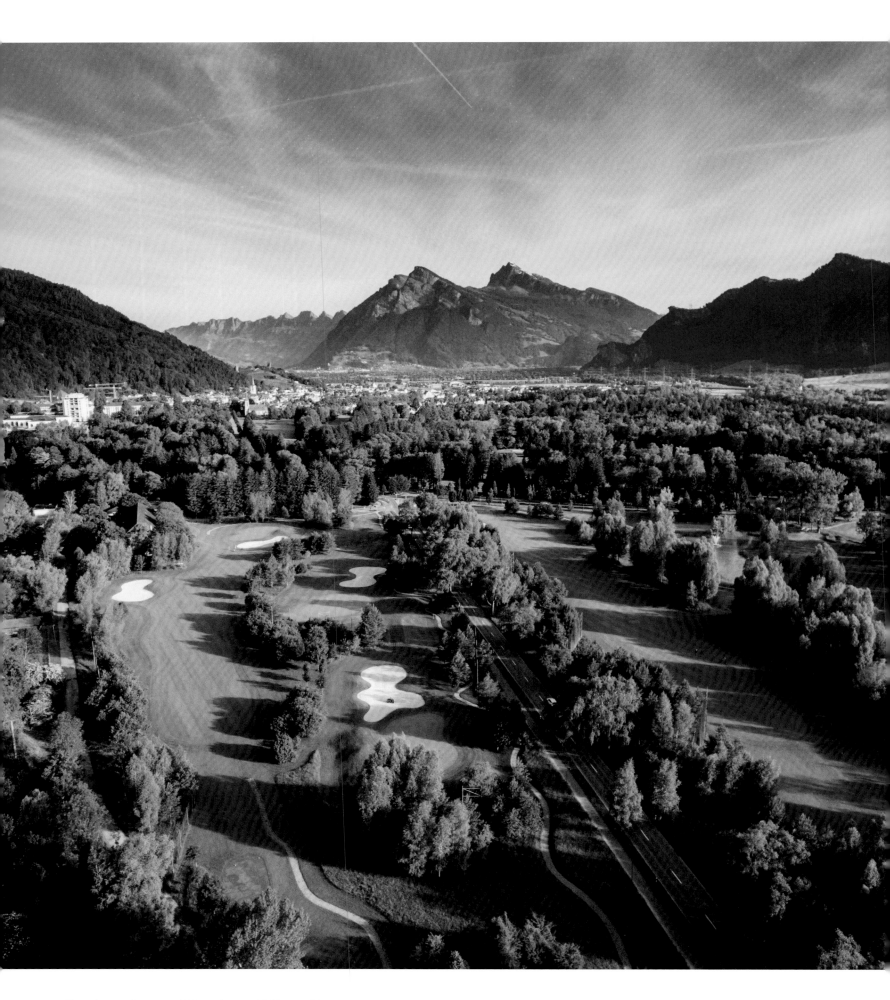

Time-honored course with lots of trees—idyllic rounds!

Alter Platz, viel Baumbestand – idyllische Runden!

BAD RAGAZ

SWITZERLAND / SCHWEIZ

Many of the oldest courses in continental Europe can be found in the Alps. This is due to the advent of Alpine tourism, which was largely fueled by the British, who—having given birth to football, tennis, rugby, cricket, and of course golf—pioneered the leisure industry. But though they relished the mountain air and Alpine panorama they also longed for their favorite pastime. In 1890, a couple of golf enthusiastic holidaymakers reportedly stuck some flags in a meadow. The first course was built in 1904. Nestled between two massifs in a beautiful park, Bad Ragaz offers stress-free golfing challenges for beginners and

Viele der ältesten Plätze in Kontinentaleuropa sind in den Alpen entstanden. Das hat mit dem Aufkommen des Alpentourismus zu tun, der weitgehend von Briten befeuert wurde – jenes Volkes, das sich durch die Erfindung zahlreicher Sportarten – neben Fußball, Tennis, Rugby, Kricket und Bergsteigen eben auch Golf – um die Freizeitindustrie verdient gemacht hat.

Und als die Briten in die Sommerfrische fuhren, erfreuten sie sich zwar am bergigen Panorama, aber vermissten bald ihre Lieblingsbeschäftigung. So sollen in Bad Ragaz schon um das Jahr 1890 von golfbegeisterten Urlaubern

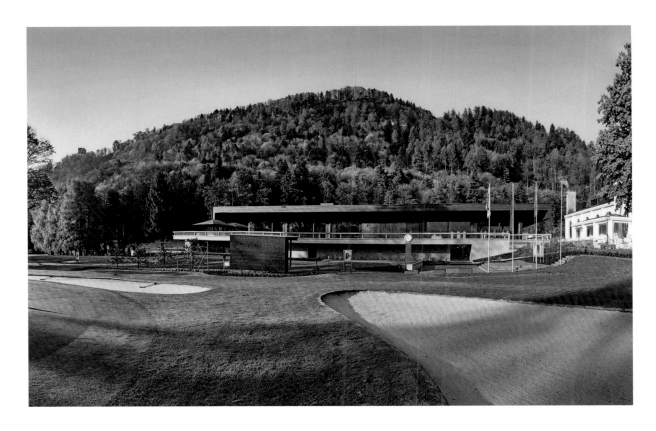

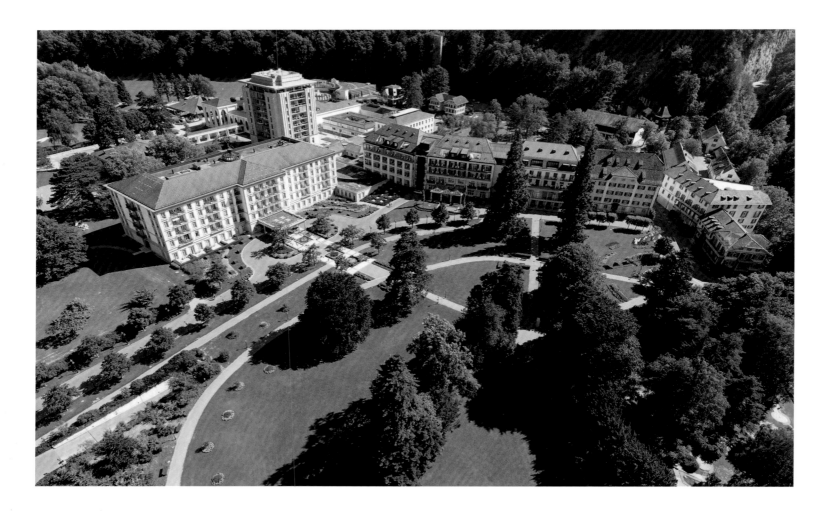

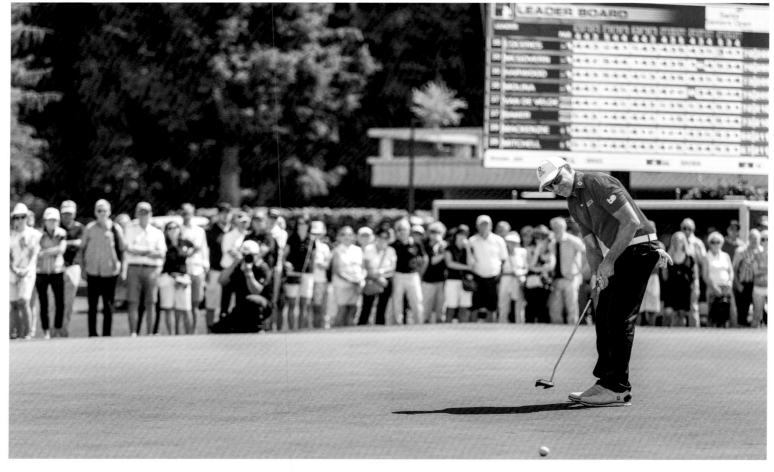

The pros enjoy staying here, not least because of the luxury hotel

Die Pros sind gern zu Gast, nicht zuletzt wegen des Luxushotels.

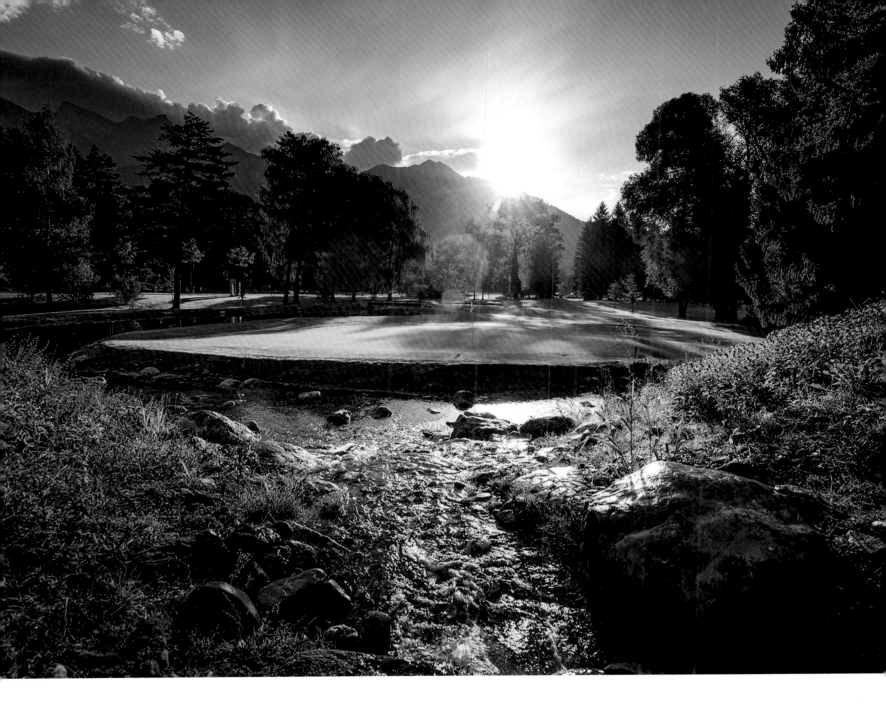

With these views golf can almost become secondary

Bei solchen Ausblicken wird Golf fast nebensächlich.

veterans alike. Like so many older courses (in this case 1957) Bad Ragaz is not overly long, and Don Harradine's design, in particular the first tees, guarantee a fun game for all. Furthermore, it hosts the European Seniors Tour every year. The luxury hotel in Grand Resort Bad Ragaz is perfection at its peak; the spa, complete with medical facilities, is second to none; the restaurant is Michelin-starred.

➤ Switzerland, Bad Ragaz, www.resortragaz.ch

ein paar Fahnen auf eine Wiese gesteckt worden sein. Der erste echte Platz wurde 1904 angelegt.

Eingebettet in eine traumhaft schöne Parkanlage und inmitten zweier Bergmassive finden hier Einsteiger und Könner eine Herausforderung ohne allzu viel Stress. Wie viele ältere Anlagen – an seinem jetzigen Standort existiert er seit 1957 – ist der Platz in Bad Ragaz nicht übermäßig lang, daher garantiert das Design von Don Harradine vor allem von den vorderen Abschlägen Spielspaß für alle. Jedes Jahr ist zudem die European Seniors Tour zu Gast. Das Grand Resort Bad Ragaz bietet Luxushotellerie in Vollendung – das Spa samt medizinischer Abteilung sucht seinesgleichen, die Küche ist Michelin-besternt.

➤ Schweiz, Bad Ragaz, www.resortragaz.ch

GOLF IN SPACE

"I hit more dirt than ball. Here we go again!" Alan Shepard, commander of the Apollo 14, took a swing and missed, but then he didn't have it easy: his bulky spacesuit restricted him to a one-handed swing and the ball rolled to the right into a crater about 40 yards away. However, using a 6-iron he'd smuggled aboard, his second shot was on target and the ball sailed a whole 200 yards—which wasn't such a feat considering the moon's low gravity. And with that, golf became the first and only sport ever played outside the earth's atmosphere. The iron itself is on display in the Golf Hall of Fame in Florida. The two golf balls remain on the surface of the moon until this day. But this was not to be the last golf swing in space. In 2006, Russian cosmonaut Mikhail Tyurin launched a ball from the ISS into Earth's orbit. Experts figure the ball will travel approximately 1.1 million miles before burning out in the atmosphere.

Russian cosmonaut Mikhail Tyurin holding a golf club shortly after the landing of the Russian space capsule in 2007

Der russische Kosmonaut Mikhail Tyurin hält kurz nach der Landung der russischen Raumkapsel 2007 einen Golfschläger in der Hand.

Al Shepard, the first man to hit a golf ball on the moon.

Al Shepard schlägt als erster Mensch einen Golfball auf dem Mond.

GOLF IM WELTRAUM

»Hab mehr Staub als Ball erwischt. Neuer Versuch.« Der erste Schwung Alan Shepards, Kommandant von Apollo 14, ging daneben, aber er hatte es ja auch nicht leicht – wegen des sperrigen Raumanzugs konnte er nur einhändig schwingen, und der Ball rollte nach rechts in enen Krater, etwa 30 Meter entfernt. Den zweiten Ball aber erwischte er mit seinem Eisen 6, das er zuvor an Bord geschmuggelt hatte, ziemlich gut; das Spielgerät segelte fast 200 Meter weit, was wegen der geringeren Gravitation des Trabanten allerdings kein Kunststück war. Damit wird Golf zum ersten und bislang einzigen Sport, der außerhalb der Erde ausgeübt wurde. Der Schläger ist in der Golf Hall of Fame in Florida ausgestellt. Die zwei Golfbälle liegen bis heute auf der Mondoberfläche.

Doch es blieb nicht der einzige Golfschlag im Weltraum: Im Jahr 2006 schlug der russische Kosmonaut Mikhail Tyurin von der ISS aus einen Ball in die Erdumlaufbahn; Experten schätzen, dass der Ball etwa 1,8 Millionen Kilometer zurücklegte, bevor er in der Atmosphäre verglühte.

PHANTOM OF THE OPEN
The Crane Driver who Hoodwinked Them All

Maurice Flitcroft called himself the "Phantom of the Open." Twice the chain-smoking crane driver from Barrow-in-Furness in England snuck into qualifying rounds of the world's most prestigious golf tournaments. In 1976, he started the round with 11- and then 12-over-par on the first two holes. Flitcroft excused himself claiming he was a bit tense at first, but later got it together. However, that's a matter of perspective: playing 61 on the first nine holes and 60 on the second he managed to card a 49-over-par 121, the worst score recorded in Open Championship history. When a British reporter phoned his mother and said: "It's about your son and the Open..." she answered: "Does that mean he's won?" When confronted with the truth she was as loyal as only a mother can be: "Well, he's got to start somewhere, hasn't he?" In 1990, Flitcroft once again joined the qualifying round of the Open, this time under the French pseudonym Jean Beau Jolley. When at 3-over-par on the 2nd hole, an improvement since 1976, he was escorted off by an official, he excused himself claiming he hadn't warmed up enough.

In Great Britain eccentrics are valued and Flitcroft rose to stardom of sorts. One club hosts an annual Flitcroft Invitational fun tournament where mulligans are allowed, the holes are a foot wide, and one of the greens has two holes, giving even the worst shot the chance of a par. On one occasion the aging Flitcroft was invited to a tournament together with his wife. "This is the first time we've left the house together since the gas cooker exploded in the kitchen," he said for the record—and went on to card a 92-over-par.

A final statement from the master, who died in 2007: "I was looking to find fame and fortune but only achieved one of the two."

DAS PHANTOM DER OPEN
Der Kranfahrer, der alle narrte

Maurice Flitcroft bezeichnete sich selbst als »Phantom der Open«. Zweimal gelang es dem kettenrauchenden Kranfahrer aus dem englischen Barrow-in-Furness, sich ins Qualifikationsfeld des wichtigsten Golfturniers der Welt zu schleichen. 1976 begann er die Runde mit einer 11 am ersten und einer 12 am zweiten Loch. »Am Anfang war ich etwas verkrampft«, sagte er später, »am Ende habe ich mich dann in den Griff gekriegt.« Ansichtssache: Auf den ersten Neun spielte er eine 61, auf den zweiten Neun eine 60, insgesamt eine 121 und damit 49 über Par, das höchste jemals notierte Ergebnis einer Open-Qualifikation. Als ein britischer Reporter danach Flitcrofts Mutter anrief und sagte: »Es ist wegen ihrem Sohn und der Open«, da antwortete sie: »Oh, hat er gewonnen?« Als sie mit der herben Wahrheit konfrontiert wurde, blieb sie loyal, wie es nur Mütter sein können, und befand: »Na, irgendwo muss er ja anfangen, nicht wahr?«

1990 schaffte es Flitcroft erneut in ein Qualifikationsturnier der Open, diesmal unter dem französischen Pseudonym Jean Beau Jolley. Als er nach zwei Löchern 3 über Par lag (immerhin eine Verbesserung gegenüber 1976), wurde er von Offiziellen vom Platz geleitet. »Ich habe mich nicht optimal aufgewärmt«, entschuldigte er sich.

In Großbritannien schätzt man skurrile Gestalten; er wurde eine Art Star. Ein Club veranstaltet jedes Jahr ein Flitcroft-Invitational-Gauditurnier, wo Mulligans erlaubt sind, ein Loch einen Durchmesser von 30 Zentimetern hat und an einem Grün sogar zwei Lochpositionen gesteckt sind, damit auch der schlechtesten Annäherung noch die Chance auf ein Par gegeben ist. Einmal wurde der ältliche Flitcroft mit seiner Frau zu dem Turnier eingeladen. »Das ist das erste Mal, dass wir gemeinsam das Haus verlassen, seit der Gasofen in unserer Küche explodiert ist«, gab er zu Protokoll – und spielte immerhin eine 92.

Der letzte Satz gehört dem Meister, der 2007 verstarb: »Ich wollte reich und berühmt werden. Ich habe nur eines von beiden geschafft.«

Maurice Flitcroft posing as a professional golfer, 1976
Maurice Flitcroft gibt sich als professioneller Golfer aus, 1976.

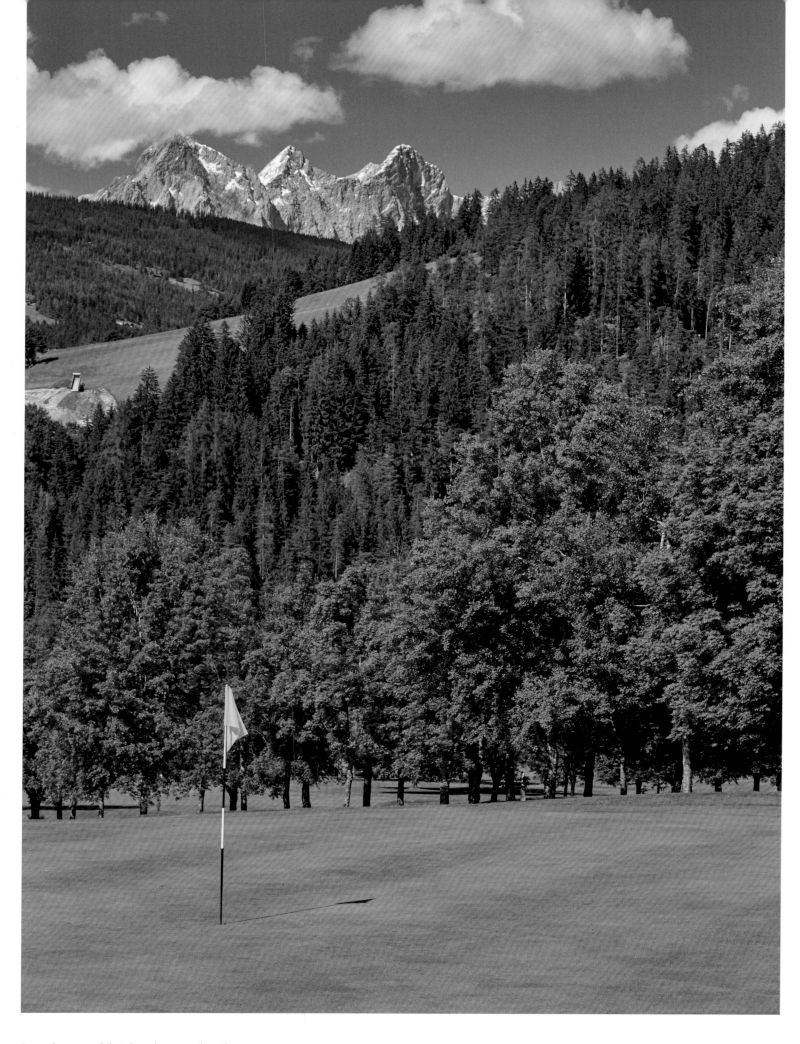

A novelty: a gondola takes players to the 12ᵗʰ tee

Einmalig: Zum zwölften Abschlag geht es mit der Gondel.

GC RADSTADT

AUSTRIA / ÖSTERREICH

The world has some really quite eccentric golf courses—with alligators and kangaroos, multiple time zones, and tee boxes situated high above ocean bays. Golf Club Radstadt too distinguishes itself with a rather unique service: an actual gondola transports golfers from the 11th hole to the 12th tee box. And then there is of course the quality of the air. However, not its health benefits or its irresistible scent of Alpine herbs are what makes it so spe-

Es gibt die verrücktesten Plätze auf dieser Welt, mit Alligatoren und Kängurus, mit wechselnden Zeitzonen und Abschlägen über Ozeanbuchten. Doch der Golfclub Radstadt kann mit einem einzigartigen Erlebnis aufwarten: Eine veritable Gondel transportiert die Golfer vom 11. Grün hoch auf den 12. Abschlag. Und dann ist da natürlich die Luft. Nicht, dass sie besonders gesund ist oder erfrischend wirkt oder unwiderstehlich nach Almkräutern

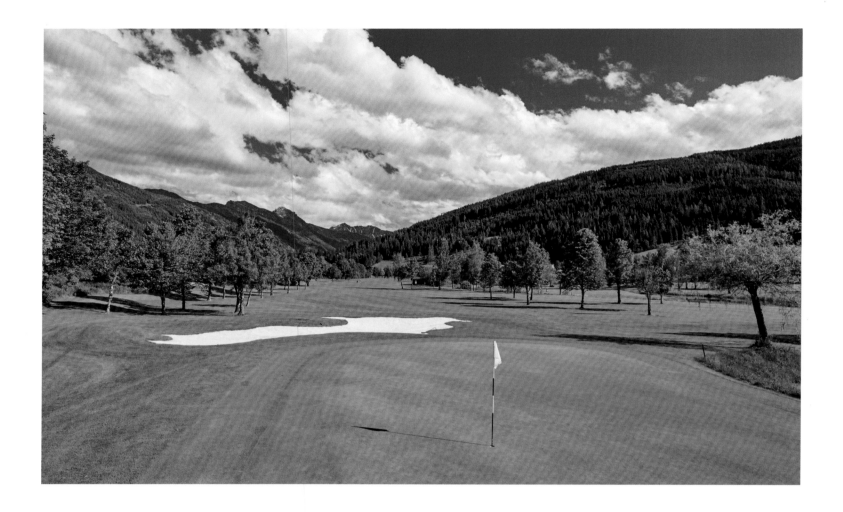

cial (though of course they add to it): the thin mountain air allows the ball to fly measurably further than it would at sea level. Approximately every 1,000 feet added in altitude gives the ball an extra five yards in distance. This doesn't just effect a golfer's game, but it is a real confidence boost—a bit like adding 20 PS to your car.

Added to that is the visual impression of the ball flying from the elevated tee and then growing smaller and smaller as it swoops down towards the green in a majestic curve. Notably the 13th offers a fantastic view as the ball sails down from a 3,000-foot elevation to the fairway below. The resort also has a 9-hole practice course. Directly next to the course is the highly-acclaimed Hotel Gut Weissenhof and its large riding stable with fifteen horses. The restaurant is dedicated to serving local, seasonal dishes.

➤ Austria, Radstadt, www.radstadtgolf.at

duftet. Das ist zwar auch der Fall, aber für Golfer zählt etwas ganz anderes: In der dünnen Höhenluft fliegt der Golfball messbar weiter als im Flachland. Etwa alle 400 Höhenmeter legt der Drive fünf Meter mehr zurück – das hat nicht nur eine gewaltige Wirkung auf das eigene Spiel, sondern gibt auch dem Selbstbewusstsein einen ordentlichen Schub. Es ist, als hätte das Auto plötzlich 20 PS mehr.

Dazu kommt der visuelle Eindruck eines Balls, der hoch oben vom Abschlag startet und dann, kleiner und kleiner werdend, sich in einer majestätischen Parabel nach unten in Richtung Grün senkt. Gerade an der 13 ist das ein bildhübscher Anblick, wenn der Ball aus 1000 Metern Höhe auf das 100 Meter tiefer gelegene Fairway zusteuert. Es gibt außerdem noch eine 9-Loch-Übungsanlage und das stimmungsvolle Hotel Gut Weissenhof direkt am Platz mit großer Reitanlage (indoor und outdoor) und 15 Pferden. Das Restaurant setzt konsequent auf regionale Produkte.

➤ Österreich, Radstadt, www.radstadtgolf.at

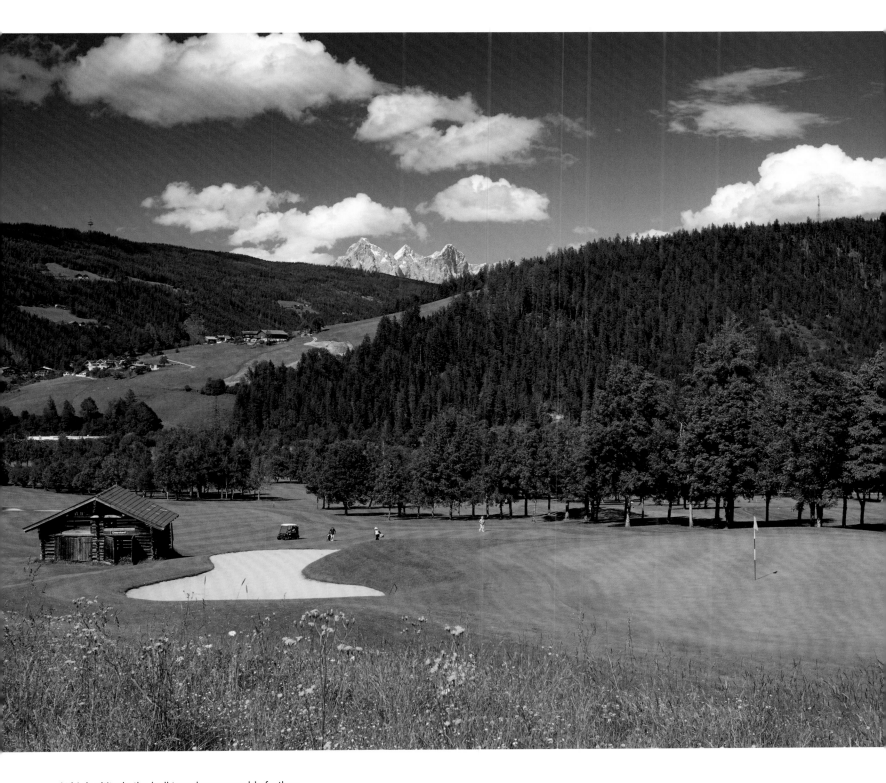

At high altitude the ball travels measurably further

In 1000 Metern Höhe fliegen die Bälle deutlich weiter.

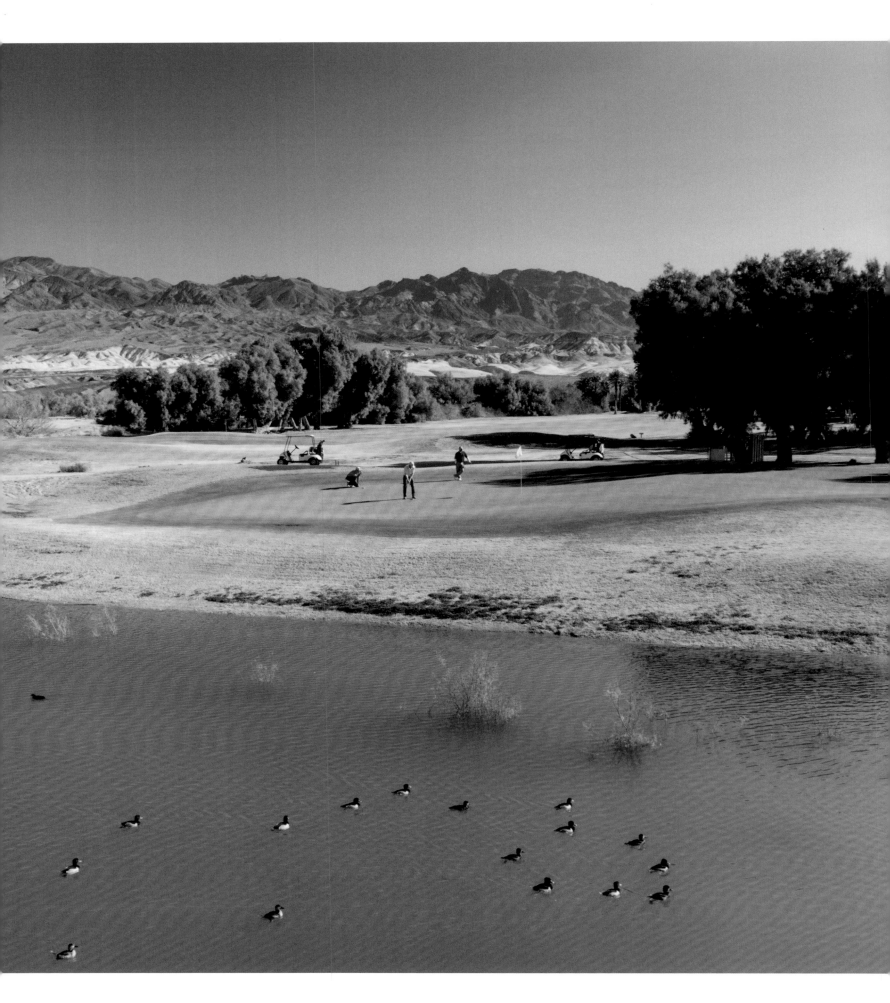

It's as low as it can go: golfing beneath sea level

Tiefer geht's nicht: Golfen unter dem Meeresspiegel.

FURNACE CREEK

USA

Furnace Creek—welcome to the most challenging course of all. But what makes it so tricky? Is it particularly long or does it have too many bunkers? No. Does it have undulating greens, narrow fairways or endless water hazards? Neither. Furnace Creek lies the heart of Death Valley National Park. At 190 feet below sea level it is the lowest course in the world—and also the hottest. The merciless sun and relentless heat are the real enemies here. And yet the game will be remarkable: the rough desert terrain has a fascinating, unparalleled allure.

Willkommen auf einem der härtesten Plätze überhaupt. Aber warum ist er bloß so tückisch? Ist er besonders lang oder hat er viele Bunker? Nein. Sind die Grüns onduliert, die Fairways schmal und die Wasserhindernisse zahlreich? Ebenfalls nicht: Furnace Creek ist der am tiefsten gelegene Platz der Welt – und damit auch einer der heißesten. Er liegt mitten im Death Valley Nationalpark, 65 Meter unter dem Meeresspiegel; hier kommen bei jeder Runde die gnadenlose Sonne und die unerbittliche Hitze als Gegner hinzu. Und doch ist es etwas Besonderes, hier zu

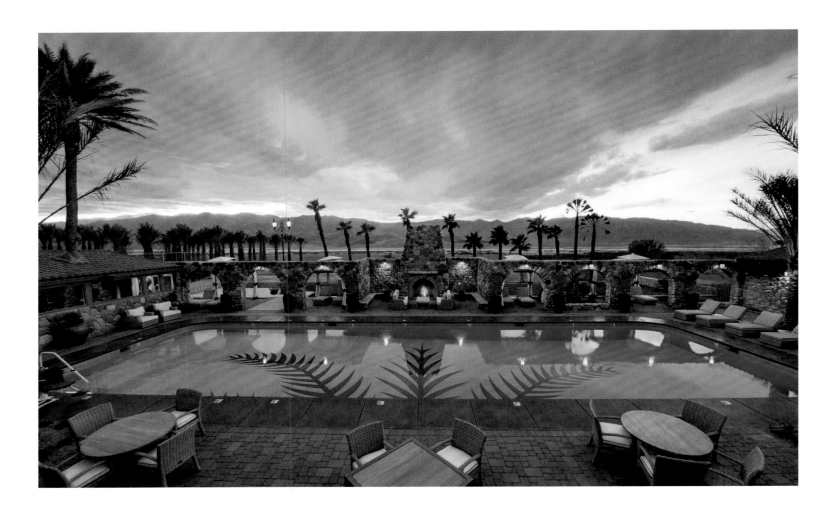

However, Furnace Creek's unusual location is far from its only appeal: renowned golf course architect Perry Dye, son of legendary Pete Dye, is responsible for the restructured 18-hole, par-70, current layout. Furthermore, the course is well-maintained and the resort itself has a long and glamorous tradition dating back to 1927: guests seeking relaxation here have included Hollywood stars Marlon Brando and Clark Gable, who both valued seclusion. A complete overhaul in the range of $100 million means the resort is well on the way to resuming its place as a sought-after hideaway.

➤ USA, California, Death Valley, www.oasisatdeathvalley.com

spielen: Die raue Wüstenlandschaft ist auf einzigartige Weise reizvoll und faszinierend.

Dabei ist Furnace Creek alles andere als ein Platz, der nur dank seiner ungewöhnlichen Lage Golfbegeisterte anlockt: Perry Dye, einer der renommiertesten Golfarchitekten und Sohn des legendären Pete Dye, zeichnet – nach einem Re-Design – für das aktuelle 18-Loch-Layout mit Par 70 verantwortlich. Der Platz ist zudem gut gepflegt, und das Resort selbst hat eine lange und glamouröse Tradition: Seit 1927 kommen Gäste hierher, um sich zu erholen, darunter Hollywoodstars wie Marlon Brando und Clark Gable, die die Abgeschiedenheit schätzten. Nach einer Komplettrenovierung, die 100 Millionen Dollar gekostet hat, ist das Resort auf dem besten Weg, wieder ein gefragtes Hideaway zu werden.

➤ USA, Kalifornien, Death Valley, www.oasisatdeathvalley.com

The location takes its toll on players—a reward waits by the pool

Die Lage verlangt den Spielern viel ab – die Belohnung wartet am Pool.

THE MOST EXTREME GOLF COURSES

Golf is played everywhere in the world, even on the frozen terrains of Greenland: in Uummannaq, almost 4,000 miles north of the Arctic Circle, the annual World Ice Golf Championship is held at temperatures as low as –60 °F. (And in case you're wondering, players use a red ball.)

DIE EXTREMSTEN PLÄTZE

Golf wird überall gespielt, sogar auf den vereisten Flächen von Grönland: In Uummannaq, 600 Kilometer nördlich des Polarkreises, findet jedes Jahr bei Temperaturen von bis zu –50 °C die World Ice Golf Championship statt. (Und falls Sie sich fragen sollten: Die Spieler benutzen rote Bälle.)

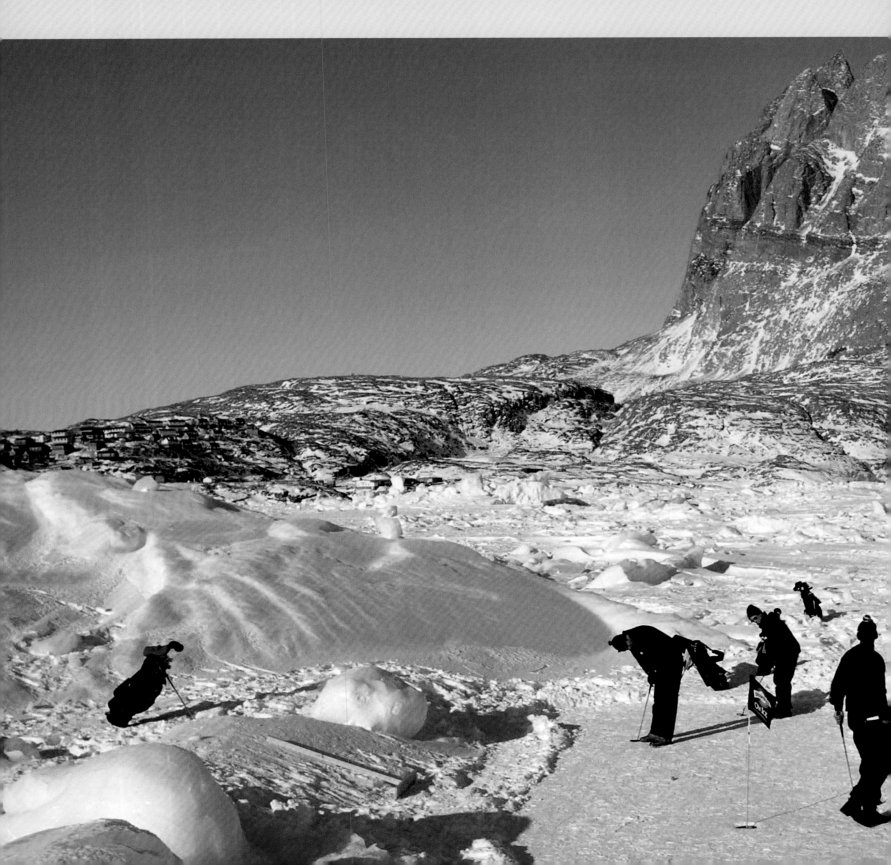

The polar opposite can be found at the Merapi Golf Club in Indonesia, nestled at the foot of an active volcano—a volcano clearly lacking polite reserve: its last notable eruption in 1930 took a total of 1,300 lives.

The Kabul Golf Club in Afghanistan is the only one in the war-torn country. Security staff are equipped with AK47 rifles. The 9-hole course, which opened in 1967, is steeped in tradition. The highest course in the world is in India: the Yak Course is located at an altitude of 13,054 feet. However, it is reserved

Das hitzige Gegenteil ist der Merapi Golf Club in Indonesien, der direkt unterhalb eines aktiven Vulkans liegt. Und dieser Vulkan hält sich keineswegs vornehm zurück: Beim letzten größeren Ausbruch im Jahr 1930 kamen mehr als 1300 Menschen ums Leben.

Der Kabul Golf Club in Afghanistan ist der einzige in dem kriegsverwüsteten Land; das Security-Personal ist mit AK47-Gewehren bewaffnet. Der 9-Loch-Course hat eine beachtliche Tradition und ist seit 1967 in Betrieb.

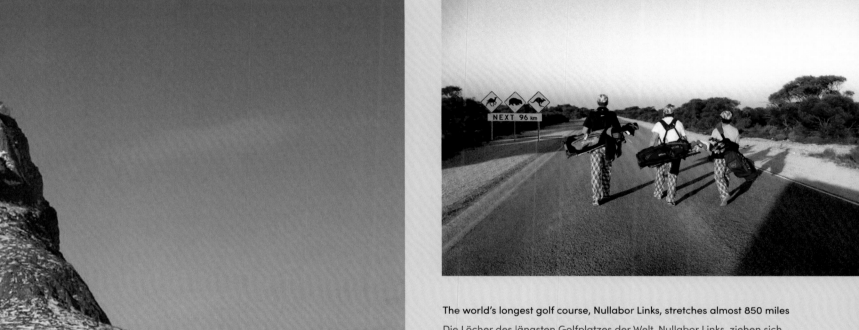

The world's longest golf course, Nullabor Links, stretches almost 850 miles
Die Löcher des längsten Golfplatzes der Welt, Nullabor Links, ziehen sich über 1365 Kilometer.

World Ice Golf Championships in Uummannaq, Greenland, played with a high visibility red ball
Eisgolf-Weltmeisterschaften in Uummannaq, Grönland. Der Ball ist rot, um besser gesehen werden zu können.

The Kabul Golf Club Course has existed for decades, but war and poverty have taken their toll on the landscape; grass and trees are sparse

Der Golfplatz von Kabul existiert seit Jahrzehnten, aber Krieg und Verelendung haben längst ihre Spuren hinterlassen. Es gibt kaum Bäume und auch kein Gras.

for soldiers at the military base. At 10,965 feet above sea level La Paz Golf Club in Bolivia is considered the highest course accessible to the public. The longest course is Nullabor Links with 18 holes that span South Australia for 850 miles crossing two time zones.

By far the most dangerous game can be played at South Korea's Panmunjom Course, located on the boarder to North Korea. The course has but one hole, a par-3 of 200 yards. However, to the left and the right of the green are mine fields—searching lost balls is not recommended.

And then there is a course for the boldest of players: La Jenny on the French Atlantic coast is the only nudist golf course in the world. Complete nudism is required to play the 4-hole course; only golf shoes, gloves, and a visor are permitted. Naturally the trainers teach clothes-free. A word of advice: choose your partners wisely.

Der höchste Platz der Welt befindet sich in Indien: Der Yak Course liegt auf 3970 Metern, ist allerdings den Soldaten einer Militärbasis vorbehalten. Als höchster für alle Spieler zugängliche Course gilt der La Paz Golf Club in Bolivien auf 3342 Metern. Der längste Platz ist der Nullarbor Links Course, dessen 18 Löcher sich quer durch Südaustralien auf eine Strecke von 1365 Kilometern und durch zwei Zeitzonen ziehen.

Am gefährlichsten ist es zweifellos auf dem Panmunjom Course in Südkorea direkt an der Grenze zu Nordkorea. Der Platz besteht nur aus einer einzigen Bahn, einem 180 Meter langen Par 3, doch links, rechts und hinter dem Grün lauern Minenfelder. Verlorene Bälle sollten Sie lieber nicht suchen.

Und hier noch ein Platz für die wirklich Mutigen: La Jenny an der französischen Atlantikküste ist der einzige FKK-Golfplatz der Welt. Die komplette Entkleidung auf den vier Löchern ist zwingend vorgeschrieben; nur Schuhe, Golfhandschuh und ein Sonnenschutz sind erlaubt. Ja, auch der Golflehrer unterrichtet nackt. Tipp: Suchen Sie sich Ihre Flightpartner gut aus.

La Jenny, the world's only naturist golf course

La Jenny ist der einzige FKK-Golfplatz der Welt.

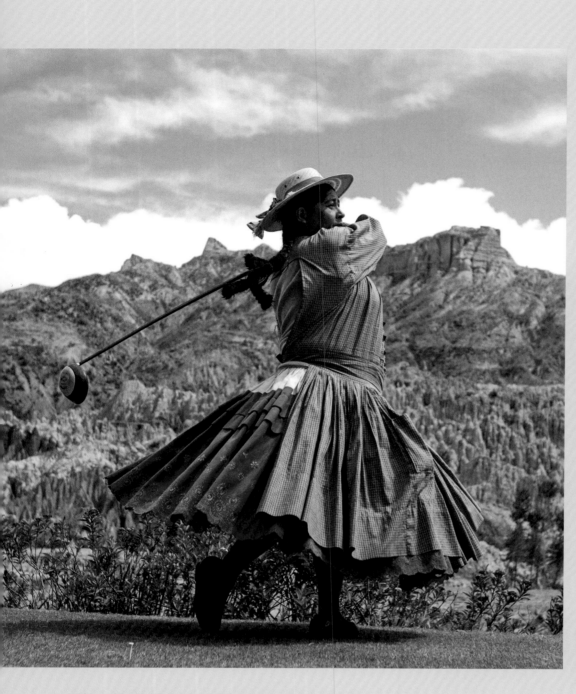

With an altitude of between 10,650 to 10,965 feet above sea level
La Paz Golf Club is the highest in the world
Der La Paz Golf Club gilt mit 3277 bis 3342 Metern über dem
Meeresspiegel als höchster Club der Welt.

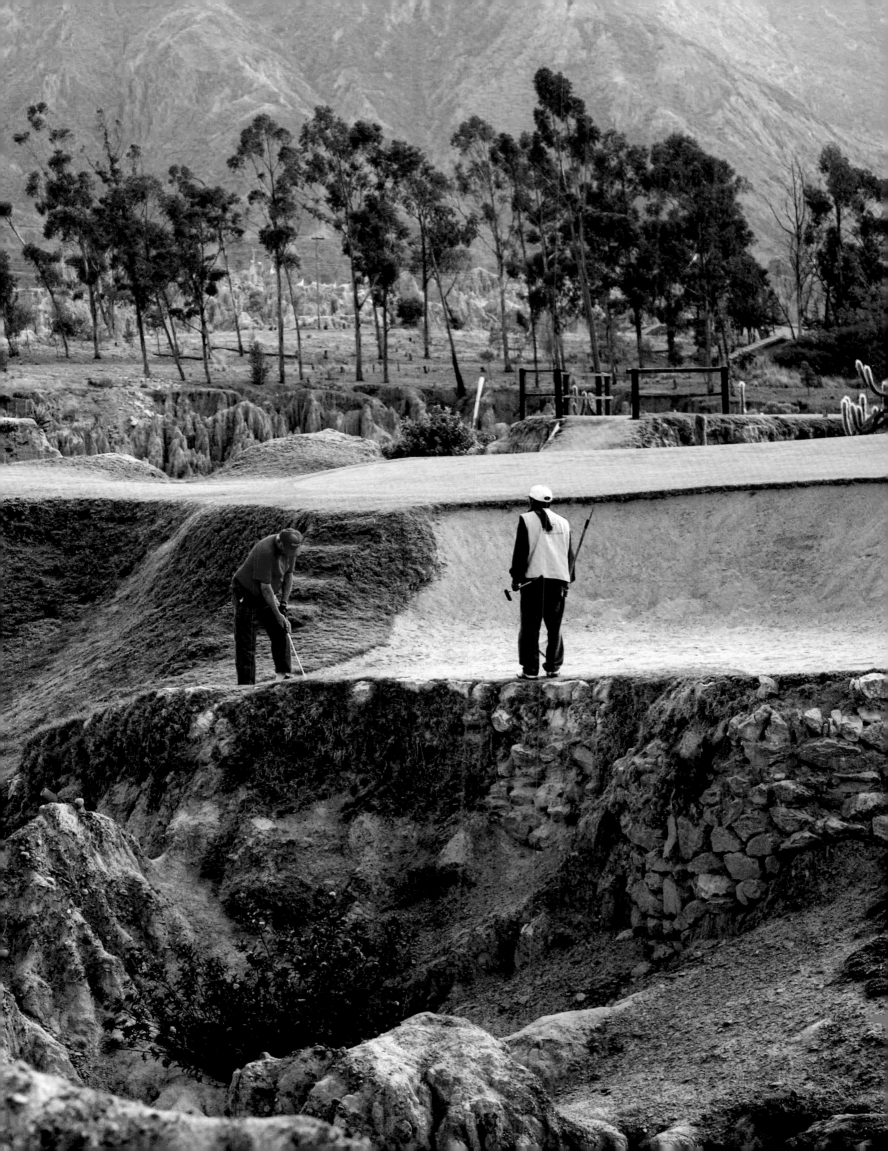

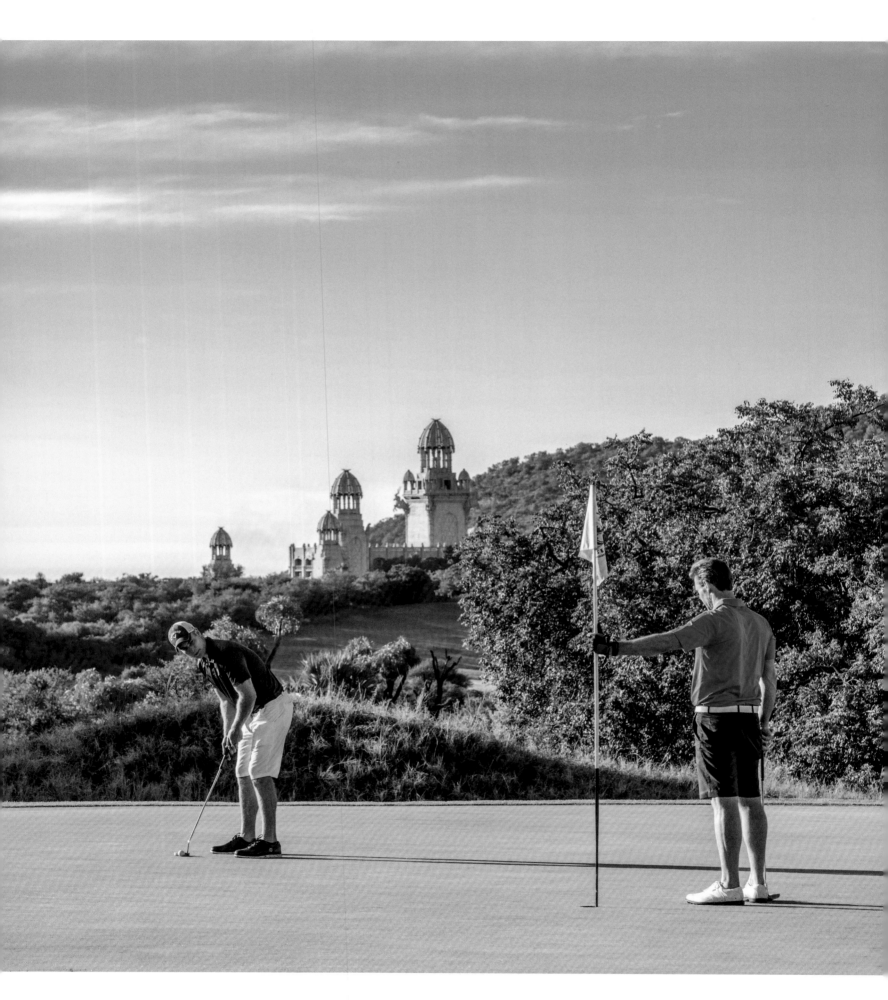

Magical backdrop, thrilling landscape, well-maintained greens

Märchenhafte Kulisse, aufregende Landschaft, gepflegte Grüns

SUN CITY

SOUTH AFRICA / SÜDAFRIKA

Sun City is the most fantastical of worlds. Stretching over 55,000 hectares, this one-of-a-kind resort attracts up to twenty-five thousand guests a day, eager to try their luck in the casino or on the one-armed bandits. Visitors are wise to invest their winnings in a balloon voyage that sets off every morning at sunrise allowing passengers to drift high above the neighboring Pilanesburg Game Reserve in majestic silence without worrying the wildlife below. Equally recommendable is a stint of relaxation in one of over three hundred suites. Though of course the casino can be all too seductive. Not surprisingly Sun City is known as "Sin City"—like its role model Las Vegas.

The architecture is reminiscent of an ancient lost culture in the jungle—or an *Indiana Jones* film set. However, the luxury resort boasts two state-of-the-art courses both designed by legendary South African golfer, Gary Player. The Lost City course, where top tour pros regularly play, is worth a visit with its vast water hazards and so-called waste areas, i.e. untouched sandy grasslands that make for a tricky shot. Warning: the water around hole 13 is populated with thirty-eight crocodiles.

➤ South Africa, Sun City, www.sun-city-south-africa.com

Eine Fantasiestadt der Superlative, die sich über 55 000 Hektar erstreckt: Bis zu 25 000 Besucher täglich kommen in dieses weltweit einmalige Resort, um im Kasino zu spielen und ihr Glück an den tausend Einarmigen Banditen zu versuchen. Das gewonnene Geld sollte in die Ballonfahrt investiert werden, die jeden Morgen zu Sonnenaufgang stattfindet. Gäste schweben in majestätischer Stille über das angrenzende Wildreservat Pilanesberg Game Reserve, ohne die faszinierende Tierwelt zu stören. Ebenso empfehlenswert ist ein mehrtägiges Ausspannen in den 338 Suiten, auch wenn das Casino allzu verführerisch sein kann – kein Wunder, dass Sun City auch »Sin City« heißt, wie das große Vorbild Las Vegas.

Die Architektur erinnert an eine untergegangene Hochkultur im Dschungel und wirkt wie eine *Indiana Jones*-Kulisse, doch das Luxusresort ist von zwei modernen Spitzenplätzen umgeben, die beide von Südafrikas Golflegende Gary Player entworfen wurden. Besonders der Lost City Course lohnt die Anreise – auf ihm messen sich auch regelmäßig die besten Tour-Professionals. Er ist mit großen Wasserhindernissen und sogenannten Waste-Areas gestaltet, naturbelassenen Flächen aus Sand und Gestrüpp, aus denen der Schlag zur Fahne besonders knifflig wird. Achtung: Im Wasserhindernis von Bahn 13 leben 38 Krokodile.

➤ Südafrika, Sun City, www.sun-city-south-africa.com

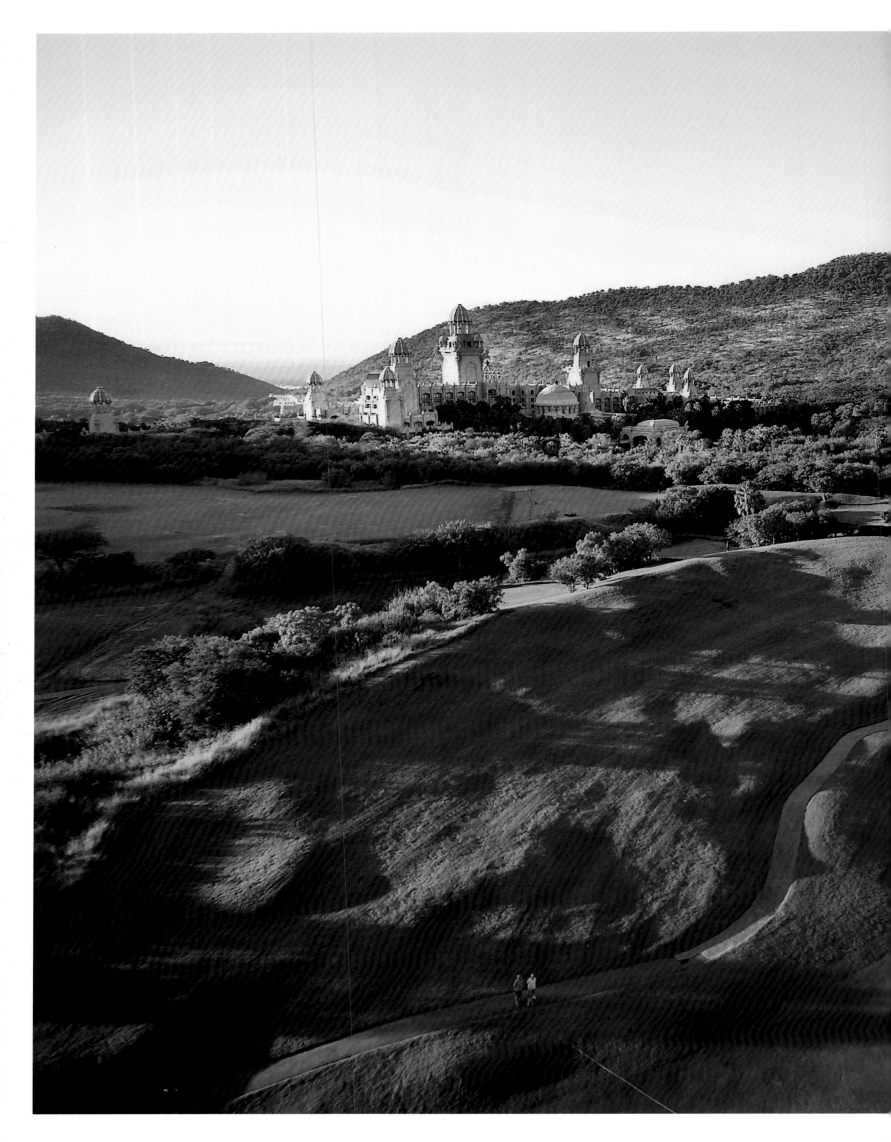

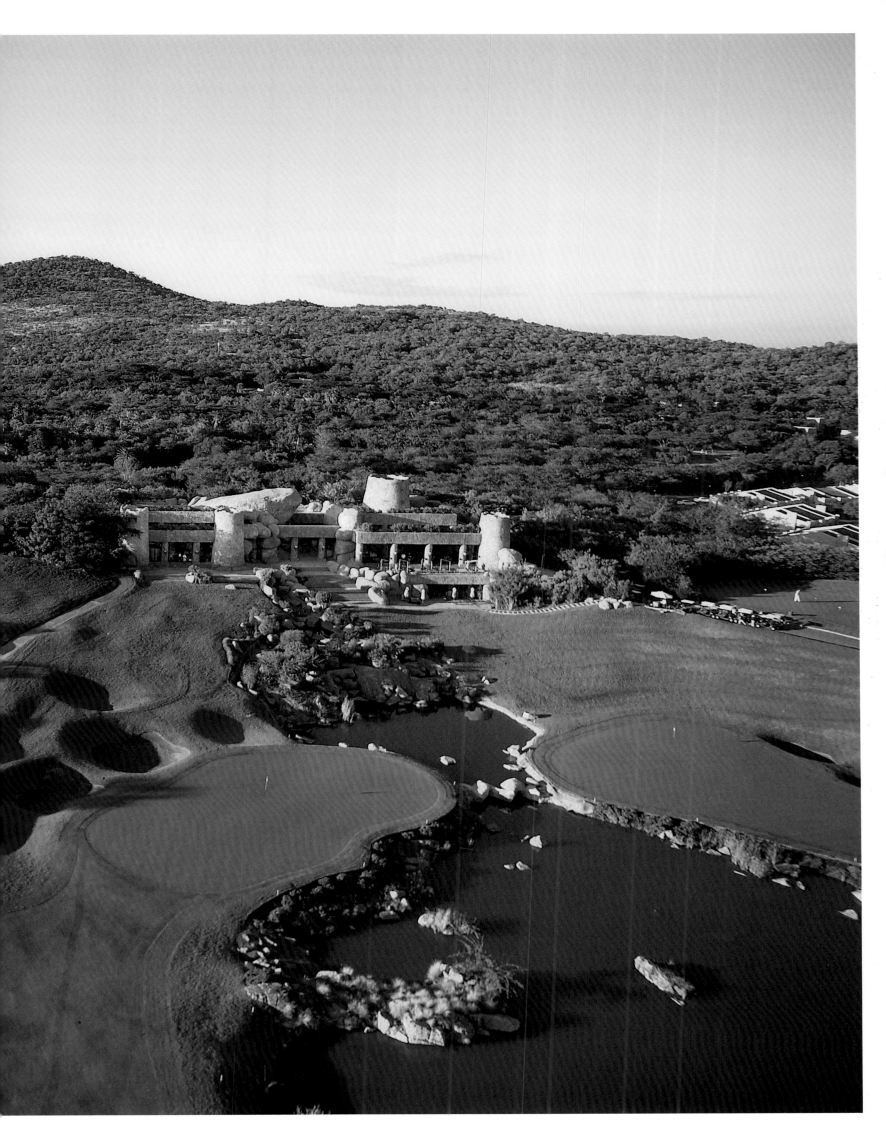

Surprise encounters on the fairway are guaranteed!

Überraschende Begegnungen auf den Fairways sind garantiert!

EASTERN AUSTRALIAN

AUSTRALIA / AUSTRALIEN

Not far from Melbourne, nestled into the landscape, lies an oasis created by golf legend, Greg Norman, the Eastern Australian: 27 holes (three times nine rounds) plus a short par-3 course, which are occasionally visited by kangaroos. The three 9-hole loops can be combined as wished to make up the full round. The South Course, comprising holes 1 to 9 and 10 to 18, is particularly recommendable. Golfers of all handicaps are made to feel welcome here for Greg Norman's aim was for players to enjoy their round without despairing at the challenges ahead.

Die australische Golflegende Greg Norman erschuf unweit von Melbourne eine Oase, die sich malerisch in die Landschaft einfügt. Auf den 27 Löchern (drei mal neun Bahnen) samt einem Par-3-Kurzplatz können schon einmal Kängurus kreuzen. Die drei 9-Loch-Schleifen können beliebig für eine Runde kombiniert werden; am gelungensten sind die Bahnen 1 bis 9 und 10 bis 18, die South Course heißen. Hier fühlen sich Golfer aller Handicapklassen wohl, denn Greg Norman legte Wert darauf, dass Spieler den Platz genießen können und nicht an den ihnen

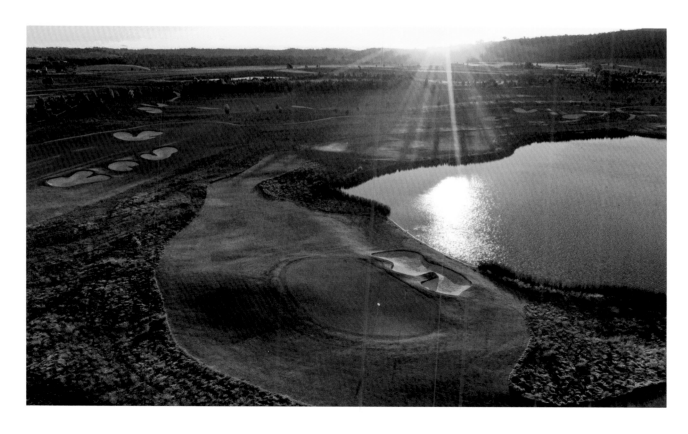

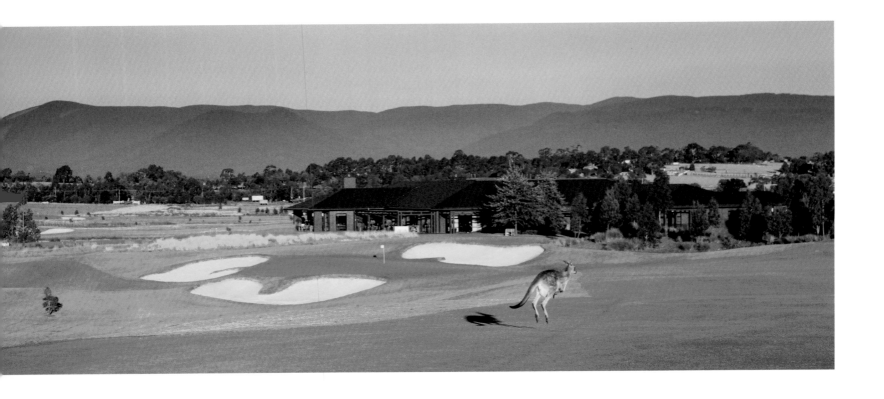

Being a second shot course the shot onto the green is particularly demanding and requires good iron play. Following a rather gentle opening the South Course becomes quite spectacular by the 3rd hole, a par-4: following the tee box is a steep slope and golfers eager to tackle the green will need a long iron or hybrid to play across the water. Those wishing to play it safe will take a right with their second shot and approach the flag on their third. The score is determined by the 12th and 13th. The TaylorMade Performance Centre provides first-rate practise conditions with state-of-the-art monitoring devices such as Trackman, K-Vest and SAM Putt Lab. And because playing golf is challenging enough, an established clubfitter is there to assure visitors have the right equipment.

Guests wanting to stay longer than a round of golf can rent one of the club's fully-equipped cosy cottages complete with a fireplace and a view over Yarra Valley and the golf club.

➤ Australia, Yering, www.easterngolfclub.com.au

gestellten Aufgaben verzweifeln. Anspruchsvoll ist insbesondere der Schlag ins Grün – die Eisen sollten einigermaßen sicher sein. Nach einem eher sanften Auftakt wird es auf dem South Course schon auf Bahn 3, einem Par 4, spektakulär: Der Abschlag fällt steil ab, und wer das Grün angreifen möchte, muss ein langes Eisen oder Hybrid über das Wasser spielen. Wer auf Nummer sicher gehen will, legt den zweiten Schlag rechts ab und greift die Fahne erst mit dem dritten Schlag an. Die ebenso schwierigen Bahnen 12, 13 und 14 entscheiden über den Score. Erstklassige Übungsbedingungen sind dank des TaylorMade Performance Centers garantiert, das mit allen modernen Messgeräten wie Trackman, K-Vest und SAM Putt Lab ausgestattet ist. Und weil Golf schon schwierig genug ist: Ein renommierter Clubfitter sorgt dafür, dass die Spieler mit den passenden Schlägern antreten.

Wer länger als nur für eine Runde Golf bleiben will, findet in den clubeigenen, vollausgestatteten Cottages eine gemütliche Bleibe mit Kamin und Blick auf das Yarra Valley und den Golfclub.

➤ Australien, Yering, www.easterngolfclub.com.au

Atmospheric ambience once the golfing day is over

Stimmungsvolle Atmosphäre, wenn der Golfbetrieb ruht.

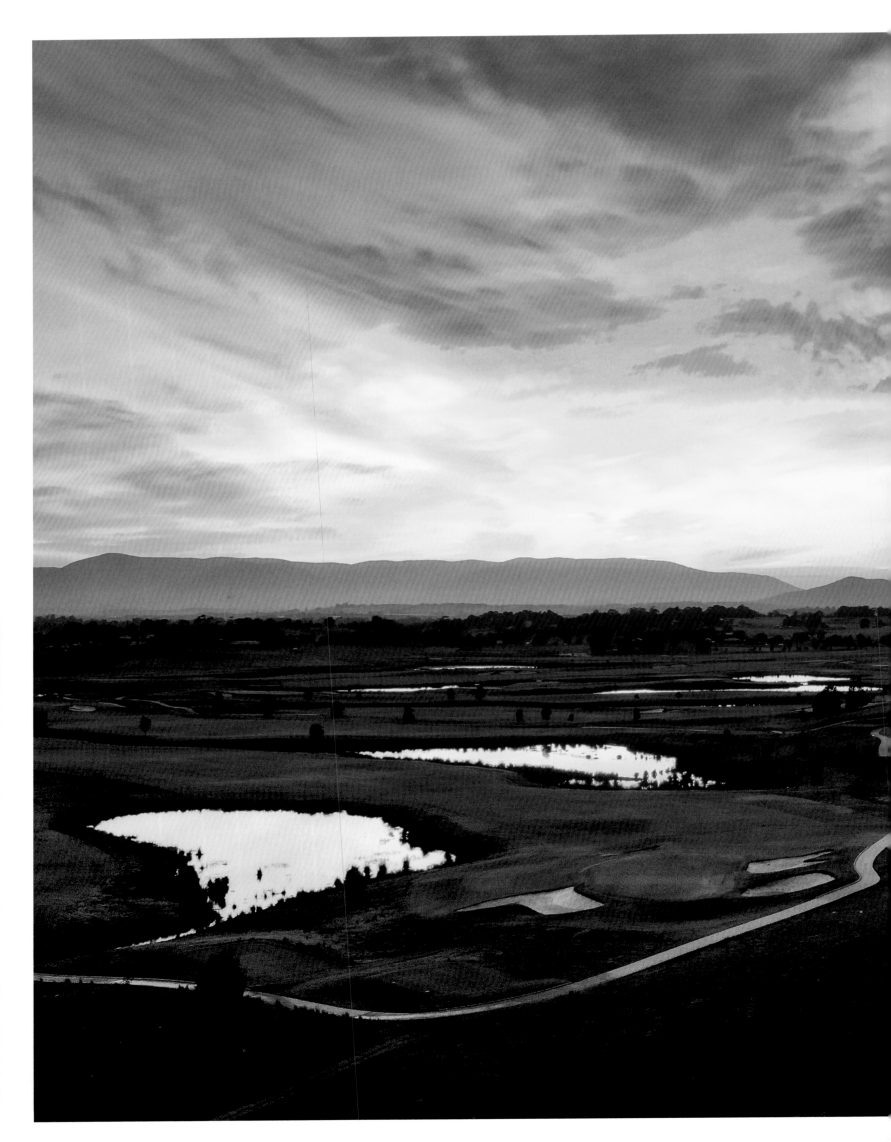

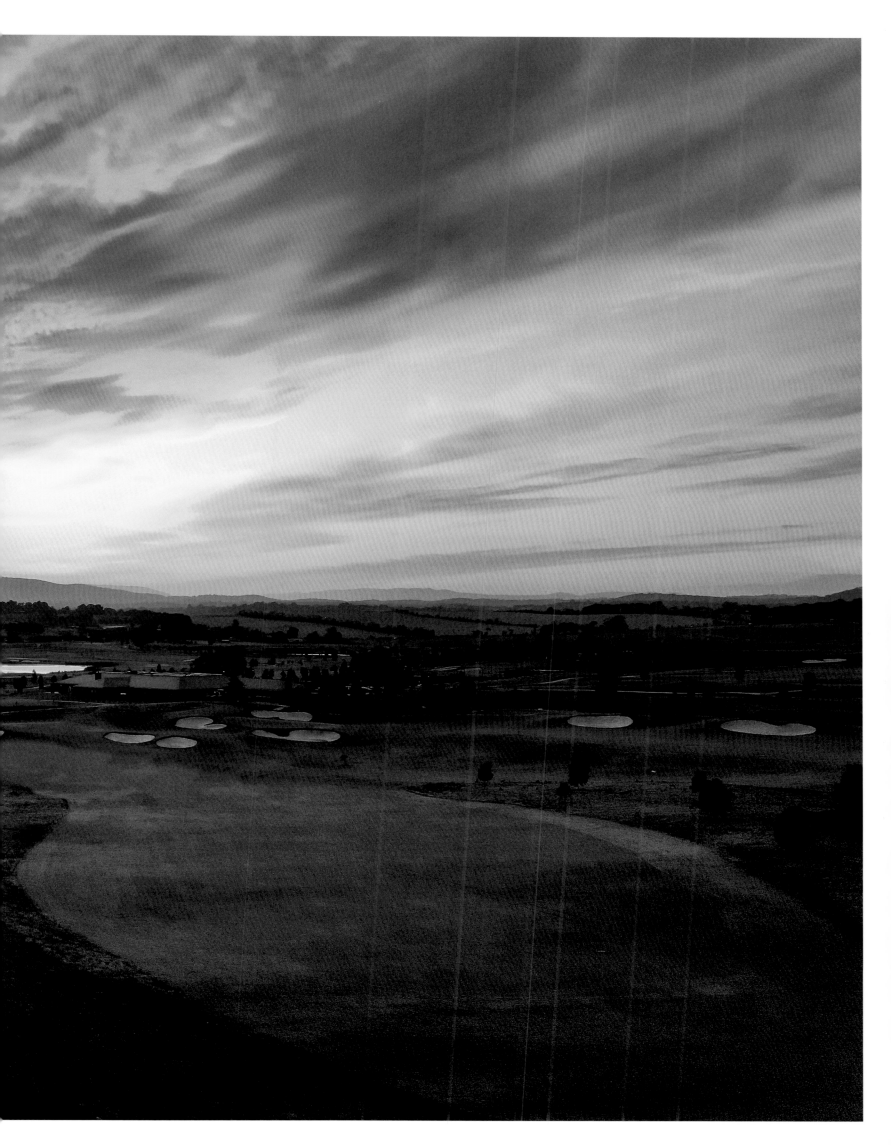

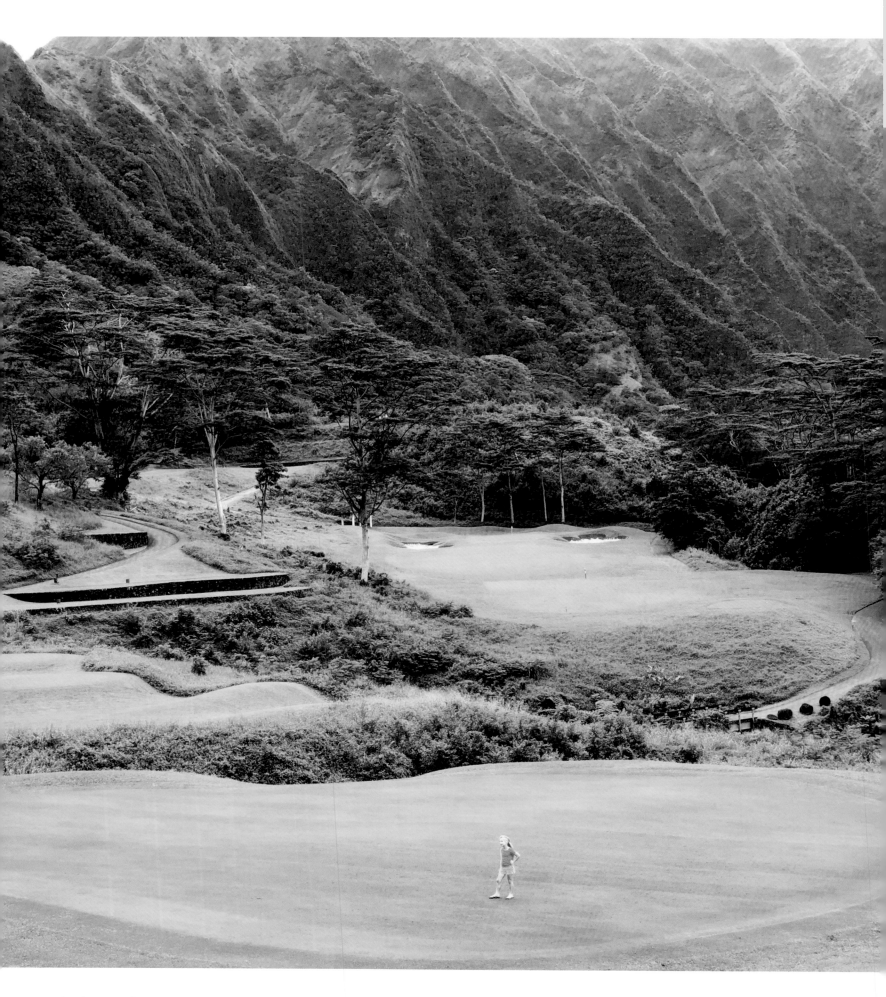

Landscape and course are equally breathtaking

Landschaft und Platz sind gleichermaßen atemberaubend.

KO'OLAU HAWAII

USA

If you love majestic natural surroundings as well as a sports challenge, Ko'olau is the place for you. The course on the Hawaiian island of Oahu perfectly combines scenic beauty with top-level golfing challenges. Between gorges, waterfalls, and stunning views amidst the rainforest's rich vegetation, players have their hands full trying keep up their score. The course is considered one of the most difficult in the world; with a rating of 78.2 and a slope of 150, very few other courses are deemed harder.

Wer beeindruckende Natur und sportliche Herausforderung liebt, ist in Ko'olau richtig. Der Platz auf der hawaiianischen Insel Oahu vereint perfekt landschaftliche Schönheit und hohen Anspruch an die Spieler. Zwischen Schluchten, Wasserfällen und fantastischen Ausblicken haben die Spieler alle Hände voll zu tun, um inmitten der üppigen Vegetation des tropischen Regenwalds ihre Scores zusammenzuhalten, gilt der Platz doch als einer der schwierigsten der Welt. Bei einem Course Rating von 78,2 und einem Slope von 150 gibt es nur wenige Plätze, die härter bewertet sind.

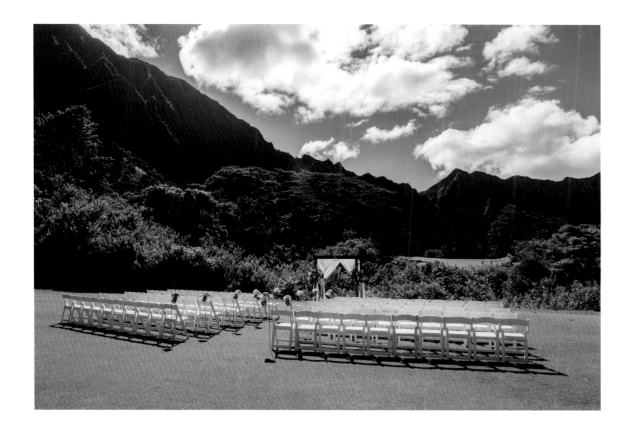

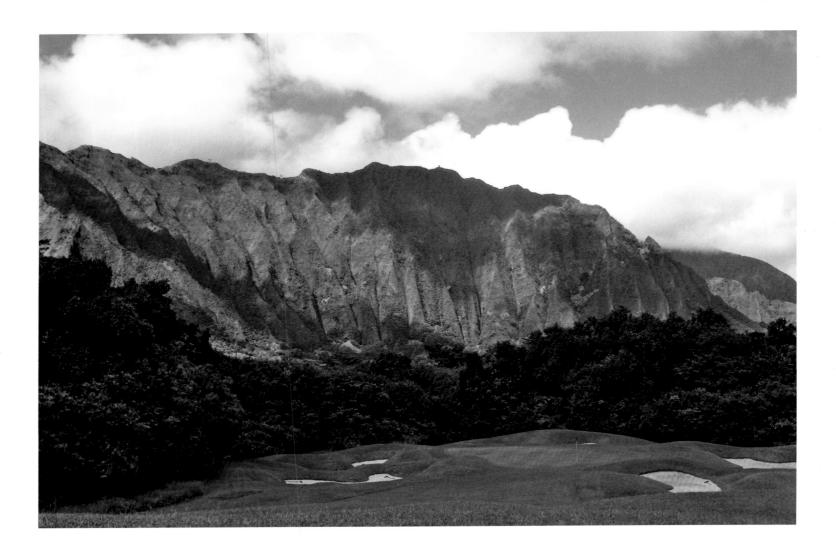

When Dick Nugent's fabled course opened in northeast Honolulu in 1992, it quickly became known for its hospitality: non-members are welcome; the green fees are affordable. Those desiring a relaxing game can begin on a later tee which still makes for an engaging round, but with more time to drink in the scenery. The hardest hole is the last: the over 450-yard, par-4 18th requires traversing a sprawling bunker landscape. A shortcut might be worth the risk, but if the swing is not dead-on, then it's sandpit playtime.

➤ USA, Hawaii, Kaneohe, www.koolaugolfclub.com

Im Jahr 1992 eröffnete der von Dick Nugent entworfene Fabel-Course im Nordosten von Honolulu, der sich auch durch seine Gastfreundschaft auszeichnet – Gäste sind willkommen, und die Greenfees sind bezahlbar. Wer die Runde einfach nur genießen will, kann den Platz von den vorderen Abschlägen spielen; das macht immer noch genug Spaß und lässt mehr Zeit, um sich an der einmaligen Natur zu berauschen. Das schwierigste Loch wartet zum Abschluss: Bei der mehr als 400 Meter langen 18, einem Par 4, müssen gewaltige Bunkerlandschaften überquert werden. Wer es riskiert, kann abkürzen. Wenn der Schlag aber schiefgeht, beginnen echte Sandkastenspiele.

➤ USA, Hawaii, Kaneohe, www.koolaugolfclub.com

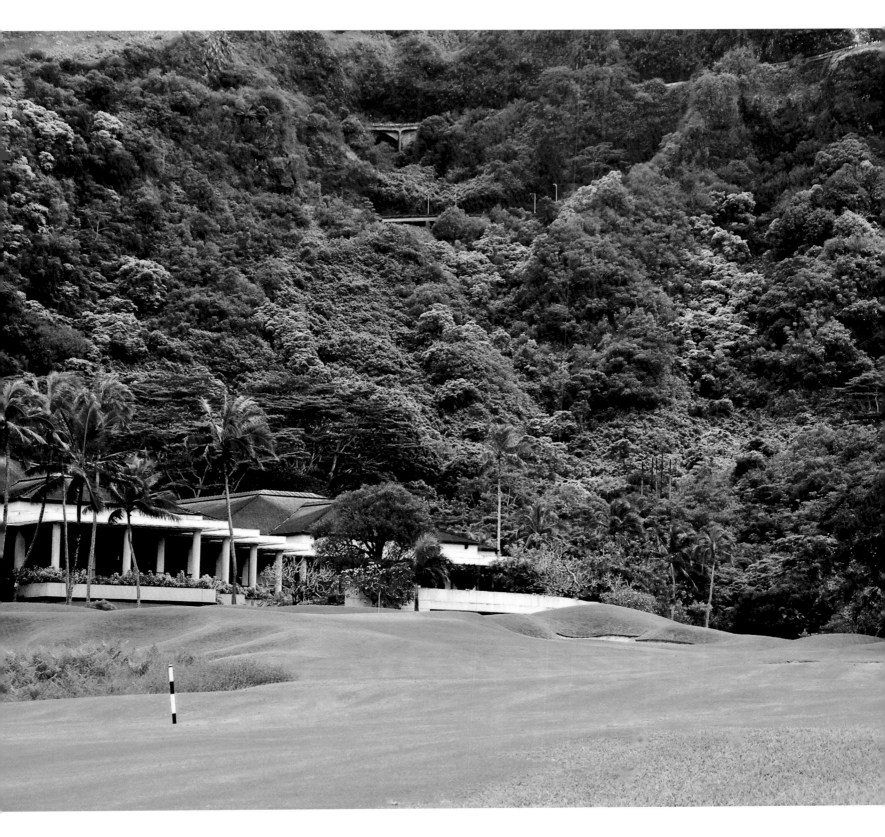

Ko'olau is one of the hardest courses in the world

Ko'olau gilt als einer der schwierigsten Plätze der Welt.

A NICE SMILE FOR A LUXURY WATCH Golf and Advertising

Golfers have long been a popular target group for advertisers, particularly in the "golden age" of advertising. Top players, such as Ben Hogan or Arnold Palmer, enjoyed dozens of endorsement contracts, preferably with tobacco and beverage companies—after all, a couple of drinks for lunch and a cigarette between courses were in those days a sign of mettle and manliness. But golfers were equally happy to "smile for the camera" for car tyres, brilliantine, sunglasses, cordless phones, pipes, luxury watches, or rental cars, and of course for golf equipment. And the skilfully-drawn advertisements promoting Scottish courses have long been recognised as artworks—with the originals highly sought-after today.

Arnold Palmer: Rolex

Arnold Palmer - Rolex

LÄCHELN FÜR DIE LUXUSUHR
Golf und Werbung

Golfer sind nicht erst seit Neuestem eine beliebte Zielgruppe – und sie waren es erst recht im »Goldenen Zeitalter« der Werbung. Spitzensportler wie Ben Hogan oder Arnold Palmer freuten sich über Dutzende Verträge, am liebsten mit Tabakkonzernen und Getränkeherstellern, denn damals galten ein paar Drinks zum Lunch und eine Zigarette zwischen den Gängen ja noch als Ausweis von Verwegenheit und urwüchsiger Männlichkeit. Aber auch für Autoreifen und Brillantine, Sonnenbrillen und erste schnurlose Telefone, Pfeifen und Luxusuhren, Mietwagen und natürlich Golfzubehör lächelten Golfer gern in die Kamera. Kleine Kunstwerke sind die Plakate der schottischen Plätze, die mit brillant gestalteten Zeichnungen für sich warben – bis heute sind die Originale begehrt.

Sam Snead: Granger Pipe Tobacco

Sam Snead - Granger Pipe Tobacco

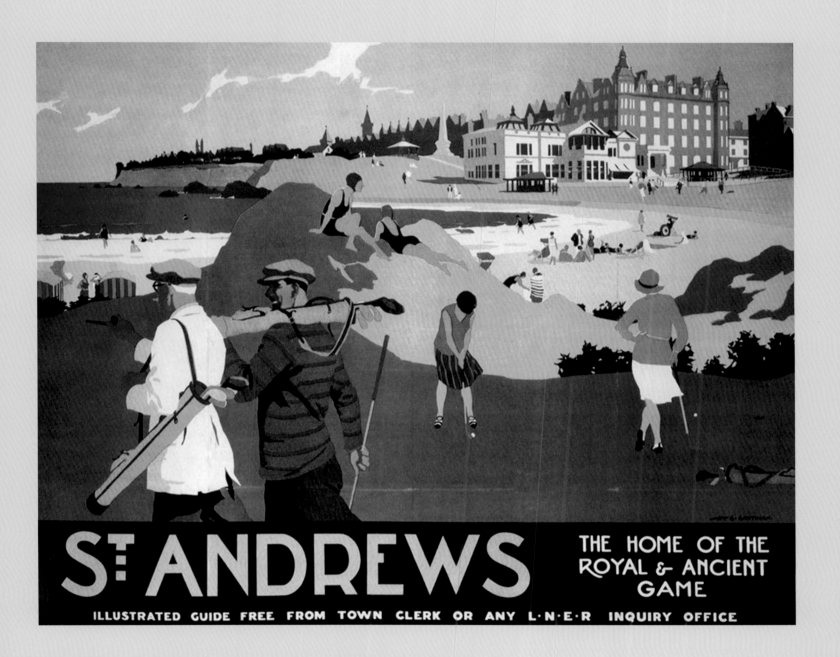

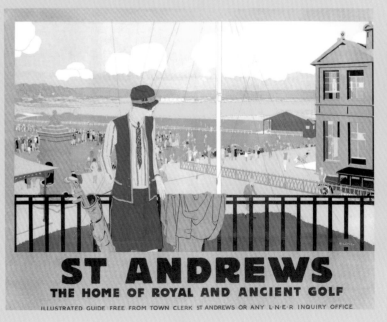

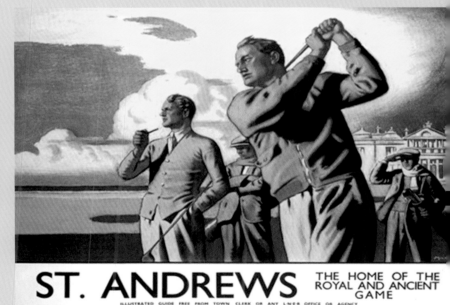

British Rail advertisements enticing golfers from England to Scotland

Die Britischen Eisenbahnen lockten Golfer mit diesen Werbeplakaten von England nach Schottland.

Ben Hogan: Chesterfield

Ben Hogan – Chesterfield

Jack Nicklaus: Computer games

Jack Nicklaus – Computerspiele

Arnold Palmer: Ray-Ban

Arnold Palmer – Ray-Ban

Tiger Woods: Accenture

Tiger Woods – Accenture

The Best Is Yet To Come.

Tee it up this Spring with Tradewest! JACK NICKLAUS GOLF for the Super NES improves upon the popular Accolade "Greatest 18 Holes of Golf" by allowing you to design an unlimited number of courses to play. You'll experience an incredibly realistic feel of the course via the enhanced digitized graphics. One to four players can compete on beginner to expert levels, and a password feature lets you take a break at the turn. The Game Boy version will pack many of the same great features, and both games will be available this Spring — so why not wait for the best?

TRADEWEST

Tradewest, Inc.
2400 South Highway 75
Corsicana, Texas 75110

© 1991 Tradewest, Inc. Jack Nicklaus Golf is a trademark of Golden Bear International, Inc. Nintendo, Super Nintendo Entertainment System, Game Boy, and the official seal are trademarks of Nintendo of America Inc.

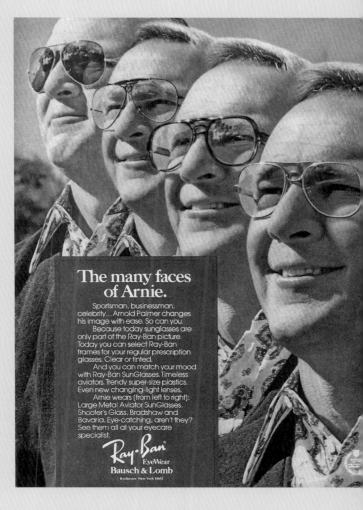

The many faces of Arnie.

Sportsman, businessman, celebrity... Arnold Palmer changes his image with ease. So can you. Because today sunglasses are only part of the Ray-Ban picture. Today you can select Ray-Ban frames for your regular prescription glasses. Clear or tinted.

And you can match your mood with Ray-Ban SunGlasses. Timeless aviators. Trendy super-size plastics. Even new changing-light lenses.

Arnie wears (from left to right): Large Metal Aviator SunGlasses. Shooter's Glass. Bradshaw and Bavaria. Eye-catching, aren't they? See them all at your eyecare specialist.

Ray-Ban
EyeWear
Bausch & Lomb
Rochester, New York 14602

logical

technological

IT Consulting for High Performance

Information Management
Technology Consulting
Systems Integration Consulting
Technology R&D

To see how we optimize the alignment of technology and business strategy, visit accenture.com/itconsulting

• Consulting • **Technology** • Outsourcing

accenture
High performance. Delivere

253

ACKNOWLEDGMENTS DANKSAGUNG

Thanks to all those who contributed to the success of the project, in particular the golf clubs and golf resorts, which have provided extensive material.

An dieser Stellen sei allen gedankt, die zum Gelingen des Projekts beigetragen haben, insbesondere die Golfclubs und Golfresorts, die umfangreiches Material zur Verfügung gestellt haben.

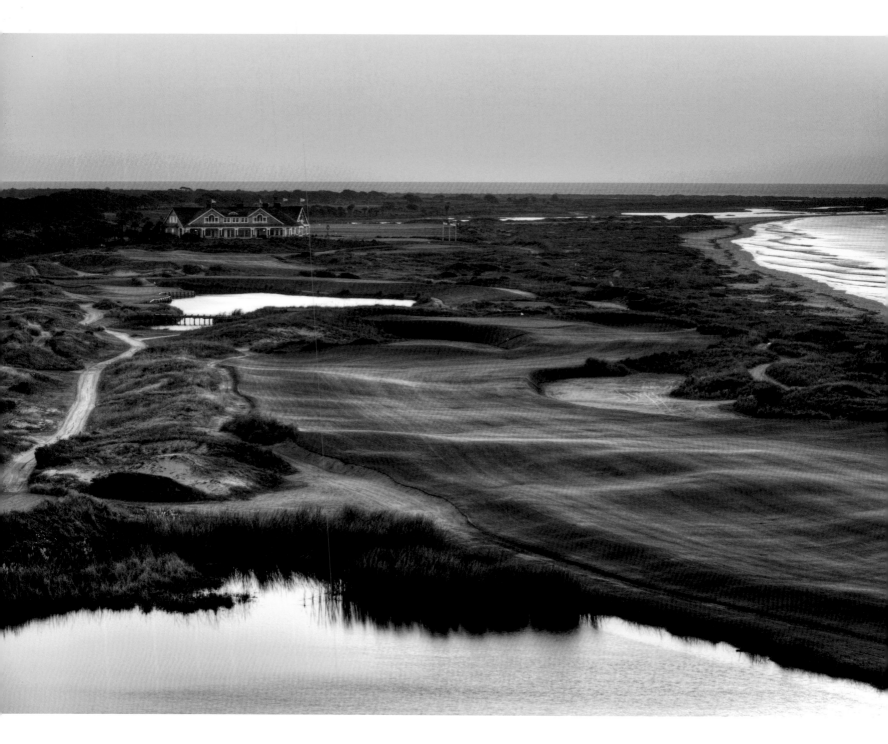

Kiawah Island (page/Seite 70)

PHOTO CREDITS BILDNACHWEISE

IMPRINT

First published in 2019
by teNeues Media GmbH & Co. KG, Kempen

© 2023 teNeues Verlag GmbH

Editing and Creative Direction by Peter Feierabend
Design by Frank Behrendt
Picture research by Feierabend Unique Books

Texts by Stefan Maiwald
Proofreading by Alexander Kerkhoffs
Translation by Julie Kamprath

Editorial coordination by Arndt Jasper
Production by Nele Jansen
Color separation by Robin Alexander Hopp

English Edition
ISBN 978-3-96171-206-9
Library of Congress Number: 2019945052

German Edition
ISBN 978-3-96171-235-9

Printed in Slovakia by Neografia a.s.

Published by teNeues Publishing Group

teNeues Verlag GmbH
Ohmstraße 8a
86199 Augsburg, Germany

Düsseldorf Office
Waldenburger Straße 13
41564 Kaarst, Germany
e-mail: books@teneues.com

Augsburg/München Office
Ohmstraße 8a
86199 Augsburg, Germany
e-mail: books@teneues.com

Press Department
e-mail: presse@teneues.com

teNeues Publishing Company
350 Seventh Avenue, Suite 301
New York, NY 10001, USA
Phone: +1-212-627-9090
Fax: +1-212-627-9511

www.teneues.com

teNeues Publishing Group
Augsburg / München
Berlin
Düsseldorf
London
New York

teNeues

Bibliographic information published by the Deutsche Nationalbibliothek
The Deutsche Nationalbibliothek lists this publication in the Deutsche
Nationalbibliografie; detailed bibliographic data are available on the Internet
at dnb.dnb.de.

Cover: Doonbeg (page 96), Bobby Jones (page 77)
Back cover: Tom Watson and Jack Nicklaus during their "Duel in the Sun" (page 202)